Springer Praxis Books

D0754112

For further volumes:
http://www.springer.com/series/4097

Starry Night Over Texas State University

Donald W. Olson

Celestial Sleuth

**Using Astronomy to Solve Mysteries
in Art, History and Literature**

Donald W. Olson
Department of Physics
Texas State University
San Marcos, TX, USA

SPRINGER–PRAXIS BOOKS IN POPULAR ASTRONOMY

ISBN 978-1-4614-8402-8 ISBN 978-1-4614-8403-5 (eBook)
DOI 10.1007/978-1-4614-8403-5
Springer New York Heidelberg Dordrecht London

Library of Congress Control Number: 2013946216

Springer is part of Springer Science+Business Media (www.springer.com)

To Marilynn and Christopher

Preface

How did a physicist who wrote a Ph.D. thesis on relativity and cosmology happen to publish articles that date a Vincent van Gogh night-sky painting, solve a mystery about the Moon and tides at a World War II battle, discuss Shakespeare's skies, or analyze the moonlit night when Mary Shelley conceived of *Frankenstein*? When did I become a "celestial sleuth" applying astronomical analysis to problems from art, history, and literature?

I can identify the precise moments more than 25 years ago when my research career changed direction. There were two such moments.

The first came when Edgar Laird, an English professor at Texas State, asked if I would work with him to understand some complex astronomical passages in "The Franklin's Tale," one of Chaucer's *Canterbury Tales*. Laird and I eventually published several articles (see Chap. 8) on Chaucer's celestial references, which are probably the most complex, sophisticated, and interesting in all of English literature.

The second moment came when a history professor, James Pohl, overheard us discussing the details of "The Franklin's Tale" and Chaucer's plot device involving the Moon and unusually high tides. Pohl, himself a former Marine, suggested that I try to solve the mystery of the tides at the Battle of Tarawa, the first major amphibious opposed landing of World War II in the Pacific and a legendary moment in the history of the U. S. Marines. A publication entitled "The Tide at Tarawa" became my first article to appear in *Sky & Telescope* magazine (see Chap. 7).

None of the projects described in this book would have occurred without those two initial conversations with Edgar Laird and James Pohl.

The chapters are arranged in three parts. Part I includes projects applying astronomy to art. This part is organized by artist and includes analysis of

night-sky paintings by Claude Monet, J. M. W. Turner, Vincent van Gogh, and Edvard Munch, along with moonrise photographs by Ansel Adams.

Part II looks at historical events influenced by astronomy, usually involving the effects of moonlight or ocean tides. Sometimes *both* moonlight and tides are involved, as on the night of the Boston Tea Party, the night of Paul Revere's ride, the sinking of the *Titanic*, and the D-Day invasion of Normandy. This part is ordered chronologically, from the time of the first Marathon run in ancient Greece, through American colonial times and the Civil War, and finally to important battles and events of World War II.

Part III analyzes astronomical references in literature, especially in cases where an actual celestial event apparently inspired the literary passage. This part is ordered chronologically and ranges from the skies above the Persia of Omar Khayyam, a supernova that Shakespeare could have witnessed, the moonlight shining on Mary Shelley's window as she conceived of the idea for *Frankenstein*, to a spectacular meteor procession observed by Walt Whitman and a meteor that dropped from the sky over James Joyce's Dublin.

Texas State University, San Marcos, TX, USA Donald W. Olson

Foreword

One day in 1987 at *Sky & Telescope* magazine, a manuscript arrived "over the transom" from Donald W. Olson, a young physics professor in Texas. It dealt with the phase of the Moon, ocean tides, and a famous battle of World War II. All of us on the staff liked it a lot, but we didn't know quite what to do with it: Where in the magazine could it go?

Probably because I rooted for it the loudest, Olson's article wound up in the Astronomical Computing Department that I conducted at the time. Little did any of us then realize, it was to launch a whole new type of article the magazine had never carried before. Today, his contributions to *Sky & Telescope* alone number three dozen and counting.

In this book, Olson reopens many of those same topics and presents some new ones besides. Without exception, they share a common thread. Each one explores a subtle but pivotal connection between astronomy and a famous historical event or creative work of art or literature.

So how, you ask, did he come up with this fascinating material? Almost all of it grows out of the honors course he teaches at Texas State University. Olson likes to pick topics his students might already know a little about, like a poem they learned in high school or a painting they could have seen hanging in a museum. Together, professor and students examine astronomical clues typically overlooked or misunderstood by historians and art critics. As the students become involved, quite often they make a new finding that corrects a widely accepted but inaccurate historical date or event.

Their discoveries never fail to interest a far broader audience. In fact, they *make news* – the kind the wire services pick up, or that ricochets around the web. Imagine our surprise at *Sky & Telescope* when Olson's article about one of Chaucer's tales produced a reaction in France's widely respected newspaper, *Le Monde*. After a piece about Ansel Adams was noticed and reported in

the *Los Angeles Times*, about 300 camera buffs and a media crew from Japan converged on Glacier Point in Yosemite National Park to watch the moonrise on September 15, 2005. His discovery about the expression "blue moon" led to a segment on National Public Radio's *All Things Considered*, not to mention an editorial in the *New York Times*! His articles resonate with people everywhere.

To appreciate why, we can contrast Olson's approach with that of the best-known detective of all time, Sherlock Holmes. In the first of those Arthur Conan Doyle stories, *A Study in Scarlet*, Holmes's idiosyncrasies make a deep impression on his future sidekick, Dr. Watson. As soon as they meet, Watson becomes aware of certain fields in which Holmes is a consummate master and certain others where he's not. Under "his limits," Watson lists "Knowledge of literature – nil. Knowledge of philosophy – nil. Knowledge of astronomy – nil." As Holmes explains to Watson, "It is of the highest importance…not to have useless facts elbowing out the useful ones."

For Conan Doyle, then, astronomy and literature seemed irrelevant to the skills needed by a successful sleuth, a view likely shared by the public at large. Perhaps that prevailing attitude helps explain why Olson's readers are so startled and delighted when a simple astronomical fact can add the final piece to a baffling jigsaw puzzle. (In fairness, Holmes's creator does allow the detective some knowledge of astronomy and literature in later stories, as astronomer Bradley E. Schaefer pointed out in a 1993 paper. Usually this was for added color or character development, not as part of the deductive process.)

I've been fortunate to accompany the Texas researchers on several recent trips. What strikes me is their use of simple tools, like a tape measure, spherical trigonometry, and a handheld GPS for obtaining coordinates. Once I saw them use a laser rangefinder made for golf enthusiasts. Sometimes they take digital photographs at night to record stars rising behind a hilltop, from which they can later deduce the slope angle. In Google and eBay searches, they hunt down old postcards in order to find out where missing buildings once stood, or they visit art museums and antique shops for clues. My college days were never like this!

Don't assume, however, that Olson's projects are of purely tutorial or entertainment value, or that his aim is simply to needle scholars and art critics who have their own pet theories to defend. I'll never forget what Don told me after the first of his articles came out – the one about the unusual tide that almost spelled disaster for the U. S. Marines in their amphibious landing

on Tarawa during World War II. That article was read aloud at an annual meeting of Tarawa survivors. Soon afterward, *Time-Life* correspondent Robert Sherrod (who had been at the battle himself) told Don, "Although the astronomical details were somewhat arcane for the military men, they were very glad to hear that there was an explanation for what happened to the tide at Tarawa."

Going a step further, military historian Col. Joseph Alexander, in his 1995 book on Tarawa called *Utmost Savagery*, wrote that the tide's unexplained behavior had lacked scientific interpretation until Olson's "seminal essay" appeared.

The studies of Tarawa, Chaucer, Ansel Adams, and the "blue moon" are just a few of the fascinating projects that Don Olson has brought together for this book.

Sky & Telescope, Cambridge, MA, USA Roger W. Sinnott

Acknowledgments

In addition to the seminal conversations with Edgar Laird and James Pohl, mentioned in the preface, several other scholars provided key ideas that helped to guide the research methods of our Texas State group.

Owen Gingerich of Harvard University pioneered the use of modern computers to understand the skies of Copernicus, Galileo, Kepler, and other astronomers in history. Gingerich's example inspired us to use computers not just to predict celestial events in the future but also to understand the skies of the past.

Our projects about the skies of Chaucer and the tide at Tarawa began during the early days of personal computers. The books authored by astronomical computing expert Jean Meeus were invaluable and provided algorithms to calculate the positions of the Sun, the Moon, stars, and planets at any time and any place.

Dennis di Cicco of *Sky & Telescope* provided another key idea. He had visited Hernandez, New Mexico, three times in his successful attempt to analyze and date the famous Ansel Adams moonrise photograph taken there. We adopted his method and made field trips to relevant sites, whenever possible, for every research project in the last two decades. Just as he did in New Mexico, we determined the precise spots where Ansel Adams set up his tripod for moonrise photographs in Yosemite National Park (see Chap. 4).

My sister, Karen Hasenfratz, suggested that we try to find a Vincent van Gogh site, a white house in the town of Auvers-sur-Oise near Paris. We eventually found locations where Vincent van Gogh took his views of the night sky not only in Auvers-sur-Oise but also near Saint-Rémy-de-Provence in the south of France (Chap. 2). On other research trips, we visited a mountain range in southeastern France where J. M. W. Turner had a stagecoach accident at night on a snowy road (Chap. 1), followed in the

footsteps of Edvard Munch in Norway (Chap. 3), and watched in Switzerland as the Moon passed in the sky over Villa Diodati, where Mary Shelley first told her tale of *Frankenstein* (Chap. 9). Our most recent research trip took us to Étretat, France, one of Claude Monet's favorite spots on the Normandy coast. In August 2012, our Texas State group found dozens of his painting locations there, including the site where Monet witnessed a beautiful sunset for which we could determine a date and a precise time, accurate to the minute (Chap. 1).

Charles Whitney of Harvard University gave us the idea for another key research method. After we completed our astronomical analysis of Vincent van Gogh's *Road with Cypress and Star*, Whitney used weather records to support our result. Whitney had visited archives in France and collected weather observations from van Gogh's lifetime. Whitney could tell that our proposed date had the first clear skies after a week of bad weather, and van Gogh probably would have gone outside to paint on that day. For every project since then, we have followed Whitney's lead and worked with meteorological archives to check the sky conditions when Vincent van Gogh, Edvard Munch, and Claude Monet set up their easels or to check that the sky was clear and the rising Moon was visible when Ansel Adams tripped the shutter of his camera.

The chapters will often refer to "our Texas State group." Marilynn Olson of the Department of English and Russell Doescher of the Department of Physics worked with me on almost every project. Margaret Vaverek, research librarian at our Alkek Library, provided especially valuable assistance by locating primary sources, difficult-to-find articles, early almanacs, tide tables, and any other documents that we needed for our research.

Since 1994, I have taught an Honors College course titled "Astronomy in Art, History, and Literature," and many of the students over the years have worked with me and appeared as coauthors on the resulting publications: Kellie N. Beicker, Laura E. Bright, Amanda K. Burke, Jennifer A. Burleson, Hui-Yiing Chang, Harvey E. Davidson, Mario E. Delgado, Lana D. Denkeler, Marillyn A. Douglas, Kevin L. Fields, Robert B. Fischer, Elizabeth D. FitzSimon, Patricia D. Gardiner, Amanda F. Gregory, Joseph C. Herbert, Kara D. Holsinger, Thomas W. Huntley, Brandon R. Johns, Thomas E. Lytle, Kellie E. McCarthy, Ryan P. McGillicuddy, Amber G. Messenger, Dianne N. Montondon, Robert H. Newton, Ava G. Pope, Ashley B. Ralph, Hannah N. Reynolds, Beatrice M. Robertson, Tomas Sanchez, Kelly D. Schnarr, Louie Dean Valencia, Vanessa A. Voss, Jennifer L. Walker, and Amy E. Wells.

Ron Brown, the director of the Honors College in 1994, encouraged me to develop this course. In the years since then, other administrators, including Eugene Bourgeois and Heather Galloway, along with my physics department chairs, Jim Crawford and Dave Donnelly, and our science dean, Stephen Seidman, have offered encouragement and financial support for student participation on the research trips. I am also grateful to the Student Undergraduate Research Fund in the Honors College and to Texas State University for granting Developmental Leave in the fall of 2010. External funding from the American-Scandinavian Foundation assisted the projects about Edvard Munch's Norway skies. Support from Laura H. Peebles and also from the Deloitte Foundation helped us to carry out the research trip to the Claude Monet sites in Normandy during the summer of 2012.

Many helpful consultations about astronomy and the humanities took place over the years with Brad Schaefer of Louisiana State University.

At *Sky & Telescope* magazine, editors Leif Robinson, Rick Fienberg, and Bob Naeye provided encouragement and wise advice. The majority of the topics in this book began as projects that became articles published in *Sky & Telescope* between 1987 and the present. Those versions, written in a style intended for an audience of amateur astronomers, can be found on the DVD archive set called "The Complete Sky & Telescope: Seven Decade Collection."

Roger Sinnott of *Sky & Telescope* has become a valued colleague and an honorary member of our Texas State group. In addition to editing many of our articles, Roger has checked numerical calculations and participated in half a dozen of our research trips. Most recently, Roger used sextants and other devices to measure the slope of a road painted under a starry sky by Edvard Munch and the angular height of a cliff painted at sunset by Claude Monet.

For teaching me how to think scientifically and how to judge evidence, I am grateful to my graduate school advisor Ray Sachs of the University of California at Berkeley and also to my postdoctoral advisors, Ed Salpeter of Cornell University and Gérard de Vaucouleurs of the University of Texas at Austin.

Special thanks go to Laurie E. Jasinski, a coauthor on several projects, for her careful reading and editing of each of the chapters in this book.

I am also grateful for research assistance from the following local history experts and individuals at museums, archives, and research institutions: Lasse Jacobsen and Frank Høifødt at the Munch Museum in Oslo, Norway; Tove Dahl Johansen at the National Library of Norway; Knut Christian

Henriksen, Vidar Lund Iversen, Randi Bretting, and Sven Arne Trolsrud in Åsgårdstrand, Norway; the staff of the Bymuseum in Oslo, Norway; Janine Demuriez, Catherine Galliot, and Claude Millon at Auvers-sur-Oise, France; Claude Suc, Vincent Suc, and Bruno Massal of the Les Astronomes Amateurs Du Delta in Arles, France; Bruno Rambaldelli and Norbert Aouizerats at Météo-France; Jacky Lamoureux, Thierry Maillet, Jacqueline Canonier, and Colette Chanel of the Société d'Histoire et d'Archéologie des Monts de Tarare in Tarare, France; Jean Langlois of Société Astronomique du Havre at Le Havre and Étretat, France; Linda Eade at the Yosemite Research Library, California; Jeff Nixon at the Ansel Adams Publishing Rights Trust; Michael Adams and Glenn Crosby at the Ansel Adams Gallery at Yosemite National Park; Ranger David Balogh at Yosemite National Park; Richard Ozer of the Mount Diablo Astronomical Society, California; Leslie Squyres of the Center for Creative Photography in Tucson, Arizona; Anthony Ayiomamitis at Marathon, Greece; tide experts Ed Wallner of Boston, Massachusetts, and Fergus Wood of Bonita, California; Thomas Schwartz, curator of the Lincoln collection at the Illinois State Historical Library in Springfield, Illinois; Mark Neely, Jr., director of the Louis A. Warren Lincoln Library and Museum in Fort Wayne, Indiana; Gisa Power of the Mason City Public Library in Illinois; Daniel Martinez at the USS *Arizona* Memorial, Pearl Harbor, Hawaii; war correspondent Robert Sherrod of Washington, DC; the staff of the Naval Historical Center in Washington, DC; the staff at the Indiana Historical Society Library in Indianapolis, Indiana; librarians Ewa Basinska at Harvard, Brenda Corbin at the United States Naval Observatory, Judy Bausch at Yerkes Observatory, and Louise Hinkley at the Maine State Library; Evelyn Trebilcock, Valerie Balint, and Ida Brier at the Olana State Historic Site in Hudson, New York; Shirley McGrath at the Vedder Research Library in Coxsackie, New York; and Charles Robinson of the University of Delaware.

Contents

Part I

Astronomy in Art

Part I

Astronomy in Art

1

Monet and Turner, Masters of Sea and Sky

Claude Monet, a founding member of the Impressionist movement, and Joseph Mallord William Turner, often described as England's greatest painter, are both famous for spectacular landscapes accurately capturing the changing nature of skies and seas. Astronomical considerations of daylight, twilight, night skies, and tides can be used to enhance our understanding of the creative process for these artists. Monet painted a dramatic scene in his *The Cliff, Étretat, Sunset*, created in 1883 at a popular resort on the Normandy coast. The canvas shows the orange disk of the Sun sinking toward the horizon near a spectacular line of cliffs and an arch called the Porte d'Aval. In the background, behind the arch, rises a pyramid-like rock formation called the Needle.

More than a century later, can a modern visitor to Étretat reach the spot where Monet set up his easel? Do the existing books and articles about Monet in Normandy direct visitors to the correct location? How can we determine Monet's precise location, accurate to within a few feet? How do astronomical analyses, tide calculations, meteorological records, and the artist's letters allow us to determine the exact date and the precise time, accurate to the minute, when Monet observed the sky that inspired this painting?

J. M. W. Turner in 1829 exhibited a watercolor depicting a stagecoach accident on a snowy mountain road in southeastern France, with a night sky overhead. Turner, who appears wearing a top hat in the foreground of the painting, was a passenger returning to England from a sojourn in Italy. The sky above the mountain includes the Moon and several bright stars or planets. On what date did this stagecoach accident occur? Did Turner paint the Moon in the appropriate lunar phase for that date? Can we identify the celestial bodies near the Moon? Are they stars or planets? Can we verify that Turner's painting gives an accurate portrayal of the celestial scene?

D.W. Olson, *Celestial Sleuth: Using Astronomy to Solve Mysteries in Art, History and Literature*, Springer Praxis Books, DOI 10.1007/978-1-4614-8403-5_1, © Springer Science+Business Media New York 2014

Monet's *The Cliff, Étretat, Sunset*

Claude Monet (1840–1926) created almost 2,000 paintings during his long career. More than 80 of these works depict the spectacular cliffs, arches, rocks, and beaches near the town of Étretat. The canvas entitled *The Cliff, Étretat, Sunset* (Fig. 1.1) shows a late afternoon sky on a winter day in 1883.

The town lies near the center of a crescent-shaped bay that faces out onto the English Channel. A cliff known as the Falaise d'Amont forms the northeastern half of the crescent and includes, near its seaward end, a small arch called the Porte d'Amont ("upstream portal"). To the southwest of the town is the cliff known as the Falaise d'Aval, with the impressive arch called the Porte d'Aval ("downstream portal"). Beyond this arch stands a tall pyramid-shaped

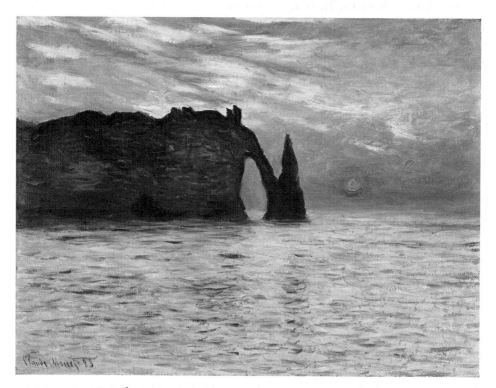

Fig. 1.1 *The Cliff, Étretat, Sunset, W817, Claude Monet, 1883. The position of the Sun, the level of the tides, Normandy weather observations, and Monet's letters allow us to date this striking sunset scene to February 5, 1883, at 4:53 p.m. local mean time (North Carolina Museum of Art, Raleigh, purchased with funds from the State of North Carolina)*

rock called the Aiguille ("Needle"). Even farther to the southwest lie another bay and the Jambourg beach, accessible only at low tide. From the Jambourg beach, visitors can look back northeast to gain an entirely different perspective on the Porte d'Amont and Needle, or they can look southwest to see an enormous arch called the Manneporte ("great portal").

As a visitor walks along the curve of the central Étretat beach, interesting changes take place in the way that the Porte d'Aval overlaps the more distant Needle. From viewing locations near the far southwestern end of the Étretat beach, the Needle disappears from view, hidden behind the Aval cliff. As the person begins to walk along the beach to the northeast, the Needle first becomes partly visible through the Porte d'Aval arch. As seen from most of the beach near the center of the town, the Needle rises behind the Porte d'Aval. If a person continues past the town and walks northeast toward the Porte d'Amont, eventually the Needle separates from the seaward end of the Aval arch. From viewpoints near the Porte d'Amont, the entire Needle becomes visible as an impressive isolated pyramid rising from the waves.

As pointed out by art historian Robert Herbert, Monet shows all these views in his large series of Étretat paintings (Herbert 1994: 61). By looking at the topography, especially the way the Porte d'Aval arch overlaps the Needle in these canvases, we can determine the exact positions where Monet set up his easel.

Monet's Painting Campaign in 1883

Monet arrived at the Hotel Blanquet in Étretat on January 31, 1883. The artist created 18 works during a 3-week stay before departing on February 21st.

Étretat, Sunset, created during this campaign and with the signature and date at the lower left "Claude Monet 83," shows the disk of the setting Sun near the Porte d'Aval and the Needle. This canvas now resides in the permanent collection of the North Carolina Museum of Art, where curator David Steel has remarked on its unique quality: "Monet painted several sunset views at Étretat, but only this one actually shows the declining orb, a single, clockwise whorl of pigment set on top of the blue-gray horizon" (Steel 2006: 128).

William Fuller, an early owner of the painting, provided a vivid and enthusiastic text in a small catalog that he wrote to accompany an 1899 Monet exhibition at the Lotos Club in New York City:

> The red sun is struggling through a bank of sullen clouds, apparently shorn of its power, as it slowly sinks to the horizon; but it still flings its radiance across

the dome of the sky, from which are reflected the colors and the light that fall upon the restless, foam-covered waters below. In the middle distance, with its flying buttress and its half-submerged cathedral spire, grim in its solitude, stands the dark, impressive cliff of Étretat. Unique in composition, splendid in color, suggestive in sentiment, Monet has painted in this picture one of the most transient as well as one of the most beautiful phases of the glory of the sky and sea. (Fuller 1899: 17)

Daniel Wildenstein prepared a complete catalog of Monet's works and letters in 1979, with a revised edition appearing in 1996. Ever since, art historians have identified each Monet canvas by its number in these Wildenstein catalogs. For example, this sunset painting is known as W817.

Two Monet Paintings from the Same Location

Our Texas State group noticed that another canvas exists with almost the identical perspective as the sunset painting. The second view, known as W907 and titled *Étretat: The Beach and the Porte d'Aval* (Fig. 1.2), shows the scene in daytime and bears the signature and date at the lower left, "Claude Monet 84."

The Porte d'Aval arch overlaps the Needle almost identically in both W817 and W907, proving that Monet's location for the sunset painting must have been within just a few feet of the spot where he created the daytime view.

W817 features only water in the lower half of the canvas. The foreground of W907 includes some interesting topographic details, with part of the Amont cliff overhanging on the left, along with a group of large rocks that had come loose from the cliff overhead and fallen down to the beach.

A major rock fall had occurred at exactly this spot in 1882. The weekly journal *Le Monde Illustré* published a woodcut (Fig. 1.3) in October 1882 depicting limestone blocks that appear to be the same fallen rocks painted by Monet in 1884. Étretat fishermen at the time stated that a rock fall of this magnitude "had not been seen for over a hundred years" (Toly 1882: 262). The journal's 1882 woodcut shows the Porte d'Aval and the Needle in the background with a perspective identical to Monet's W817 from 1883 and W907 from 1884.

Monet's Sunset Painting: Where and When?

Robert Herbert offered an opinion regarding Monet's specific location for the daytime scene W907. The companion sunset painting W817 would have to be from nearly the same spot.

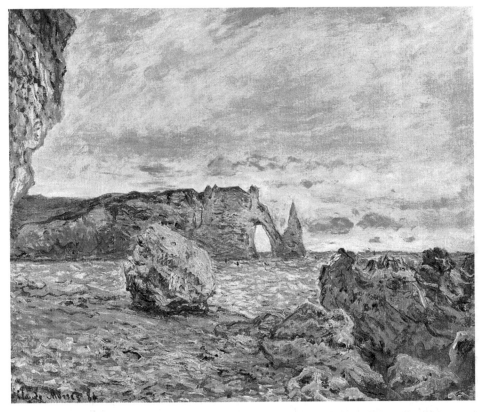

Fig. 1.2 *Étretat, the Beach and the Porte d'Aval, W907, Claude Monet, 1884. Based on the way the Port d'Aval overlaps the Needle, Monet's location for this painting must be within a few feet of the spot where he created the sunset view W817 in 1883. The limestone blocks in the foreground were deposited in 1882 by a major rock fall from the Amont cliff, which overhangs the beach at this point*

Herbert first mentioned a different painting created in the 1860s at the Porte d'Amont and then deduced that Monet returned there in the 1880s:

> [Y]ears before, in the winter of 1868–9, Monet had taken one of those upland paths to reach the far side of the Porte d'Amont…he returned to nearly the same place, this time inside the bay a few yards from the forward point of the prom-ontory, to paint *Étretat, the Beach and the Porte d'Aval* [W907]…the Aval across the bay, framed on the left by a portion of the cliff and in the foreground by fallen chunks of limestone that low tide has exposed. (Herbert 1994: 83)

Daniel Wildenstein attempted to use astronomical methods to estimate the date of the sunset painting W817, judging that this canvas "belongs to the end

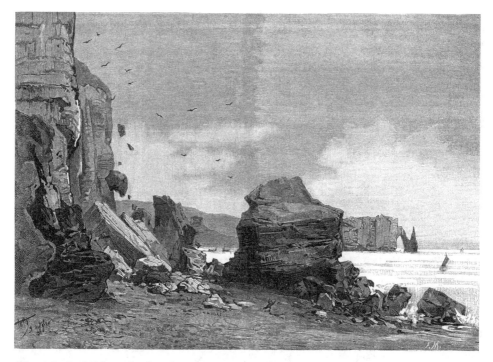

Fig. 1.3 *A child on the beach runs in terror during a major rock fall on the Amont beach, as shown in this woodcut published by the French journal Le Monde Illustré on October 21, 1882. The article quoted the Étretat fishermen as saying that such an event of this magnitude "had not been seen for over a hundred years." These appear to be the same limestone blocks painted by Monet in 1884. The journal's woodcut shows the Porte d'Aval and the Needle in the background with a perspective identical to Monet's sunset painting W817 and daytime scene W907*

of the artist's stay, as can be seen from the spot at which the sun is setting over the sea, to the right of the Falaise d'Aval" (Wildenstein 1979: 100, 1996: 304).

If Wildenstein is correct about the date, then the sunset view depicts an afternoon near the end of the 3-week stay, therefore just a few days before February 21, 1883, when Monet departed from Étretat.

If Herbert is right about the location, then Monet created the sunset canvas from a location just inside the bay, only "a few yards" from the seaward end of the Amont promontory.

Fact-Finding Trip to Étretat

In order to carry out an independent analysis of the date and the location, our Texas State group spent 5 days in Étretat during August 2012.

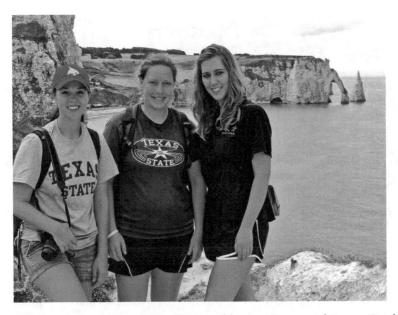

Fig. 1.4 *Texas State students Hannah Reynolds, Ava Pope, and Laura Bright on a trail that leads from the top of the Amont cliff down to the beach. Visible in the background are the Porte d'Aval and the Needle, included by Monet in his sunset painting created from a viewpoint on the Amont beach, more than 100 ft [30 m] below this spot on the trail (Photograph by the author)*

In our attempt to solve the Monet problem, the members of our group were acting as "celestial sleuths." Appropriately, we stayed in Étretat at the Detective Hotel in rooms named after famous detectives: Sherlock Holmes, Inspector Clouseau, Charlie's Angels, Columbo, and Hercule Poirot! Inspired by these famous examples, our sleuthing on the beach and cliffs found dozens of Monet painting locations (Figs. 1.4, 1.5, 1.6, and 1.7).

As a first step in understanding the sunset painting, we visited the spot described by Herbert. As we walked out along the beach to the northeast, it quickly became apparent that Herbert's suggested location for W907 (and W817) could not be correct. As seen from near the seaward point of the Amont promontory, the Porte d'Aval arch does not overlap the Needle at all. Any visitor to Étretat can verify that, by walking out to the vicinity of the Porte d'Amont, the view from there reveals the Needle as free-standing and detached, well to the right of the Porte d'Aval arch, with open water in between the arch and the Needle. Monet could not have created W817 or W907 from the spot advocated by Herbert.

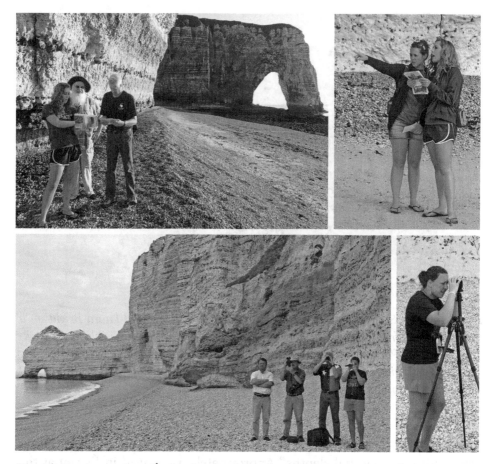

Fig. 1.5 *During a trip to Étretat in August 2012 our Texas State group found locations where Monet set up his easel. Upper left: Laura Bright, Russell Doescher, and Don Olson on the Jambourg beach, with the Manneporte arch in the distance. Upper right: Hannah Reynolds and Laura Bright on the Jambourg beach. Lower right: Ava Pope uses a laser rangefinder on the Amont beach. Lower left: Astronomer Jean Langlois joins Roger Sinnott, Don Olson, and Ava Pope on the Amont beach near Monet's location for the sunset painting W817. The Porte d'Amont arch is visible in the distance, about 425 yards (390 m) away (Photographs by Marilynn Olson. Used with permission)*

To find the correct location for W817 and W907, we then walked systematically from one end of the beach to the other, starting at low tide on the rocks at the seaward tip of the Falaise d'Amont. Our digital photographs matched these two painted views only from one point. Visitors with GPS devices will find the spot near the coordinates 49.7112° north, 0.2044° east.

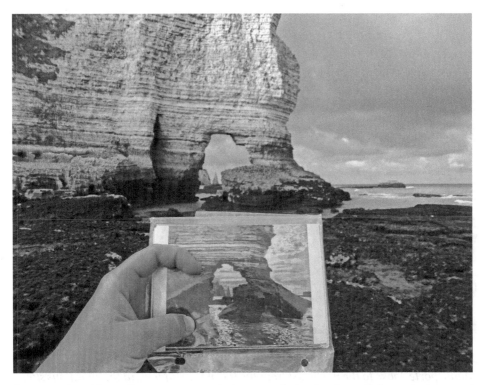

Fig. 1.6 *Our Texas State group carried postcard-sized prints of the paintings and used them to find dozens of Monet's locations during our August 2012 visit to Normandy. For the canvas known as W258, The Porte d'Amont, Étretat, this match-ing photograph looks to the southwest as the small Amont arch frames a view of the distant Needle (Photograph by Ava Pope. Used with permission)*

Herbert had suggested that Monet set up his easel on the Amont side, "inside the bay a few yards from the forward point of the promontory" (Herbert 1994: 83). Our Texas State group found that the correct location for both W817 and W907 is fully 425 yards (390 m) from the seaward end of the Amont promontory. Monet was actually much closer to central Étretat when he set up his easel, only about 100 yards (90 m) from the northeast end of the terrace that parallels the beach near the town's casino and hotels.

Regarding the colorful pile of rocks that dominate the foreground of W907, Herbert judged that Monet framed this painting "in the foreground by fallen chunks of limestone that low tide has exposed" at a location "just beyond the Porte d'Amont at low tide" (Herbert 1994: 62, 83). The correct

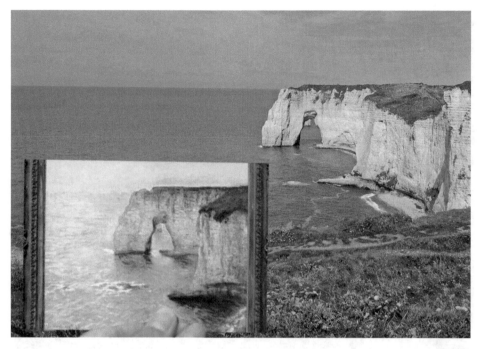

Fig. 1.7 This matching photograph for the painting known as W1037, The Manneporte, looks to the northeast from the top of the cliff toward the enormous stone arch. The alignment to the base of the Needle, visible through the Manneporte arch, allowed our Texas State group to determine Monet's viewpoint with precision (Photograph by Hannah Reynolds. Used with permission)

location for these foreground rocks actually lies a quarter mile to the southwest, at the spot where the Amont cliff overhangs the beach and the major rock fall had occurred in 1882.

The limestone cliff still overhangs the correct Monet location, and rocks like those seen in W907 still come loose and fall to the beach (Fig. 1.8). In August 2012 we noticed that one especially large block of limestone lay on the beach very close to the spot where Monet must have worked to create the sunset painting W817 and the daytime painting W907.

The Green Flash ("Le Rayon Vert")

During our entire stay in Étretat we were impressed, just as Monet had been, by the spectacular sunsets. We were even able to see and to photograph the rare sunset phenomenon called the "green flash," caused by a combination of the scattering of light and refraction (the bending of light) during mirage-like conditions. Twice we saw the upper edge of the Sun appear a vivid shade

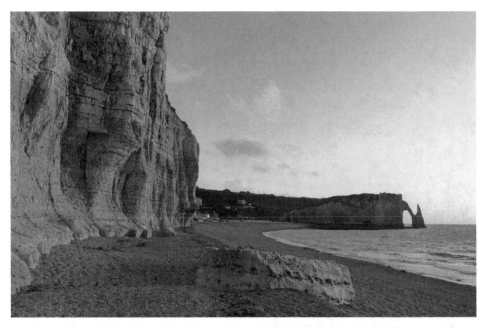

Fig. 1.8 *This photograph shows Monet's location for the sunset painting W817. Rocks still fall onto the beach from the overhanging cliff above this spot (Photograph by the author)*

of green for 1 or 2 s, just as the solar disk disappeared into the waters of the English Channel.

Moonset, Étretat

Monet created his sunset painting in February, but university calendars required that our research trip take place in August. The position of our summer sunsets on the horizon (Fig. 1.9) could not match the winter sunset observed by Monet, with the solar disk just to the north (to the right) of the Needle. But we were able to arrange our trip so that we could photograph the Moon (Fig. 1.10) passing through this part of the sky.

On several evenings we watched as the waxing crescent Moon passed just to the right of the Needle, not far from the position where Monet painted the solar disk. After the Moon had set and the sky became darker, we were able to photograph stars near the Aval cliff. Prior to our trip, we had corresponded with the Société Astronomique du Havre. One of the members, Jean Langlois, took a series of February photographs (Fig. 1.11) from the Amont beach. Combining all the photographs of Moon, summer stars, and winter Sun, we now could calculate accurate values for the celestial and topographic coordinates of this region of the sky.

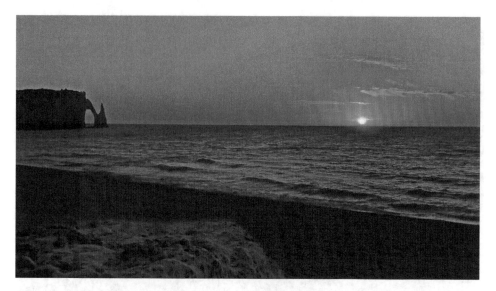

Fig. 1.9 *During the summer the Sun sets far to the north (to the right) of the Étretat Needle, as shown in this August 2012 photograph from Monet's location on the Amont beach. During the first week of February each year the setting Sun sinks to the horizon just slightly to the right of the Needle, as seen in Monet's sunset painting W817 (Photograph by the author)*

Using computer planetarium programs to compare the modern sky to the nineteenth-century sky, and allowing for some uncertainty, we could be confident from the astronomical analysis that the setting Sun depicted in W817 corresponded to a date between February 3 and February 7, 1883.

Tides at Étretat

As a next step to determine a more precise date, our Texas State group calculated the Étretat tide levels in February 1883.

The Normandy coast is famous for its remarkable tides, with a mean range near Étretat of about 18 ft [5.5 m], a spring range of about 24 ft [7.3 m] near new or full Moons, and extreme tide ranges that can reach 28 ft [8.5 m] near the equinoxes, if a new or full Moon then happens to coincide with the Moon's closest approach to Earth.

Monet scholar Charles Stuckey, discussing the paintings from Normandy, pointed out the importance of tides: "For these coastscapes, Monet must synchronize his work sessions with both solar and tidal clocks" (Stuckey 1995: 209).

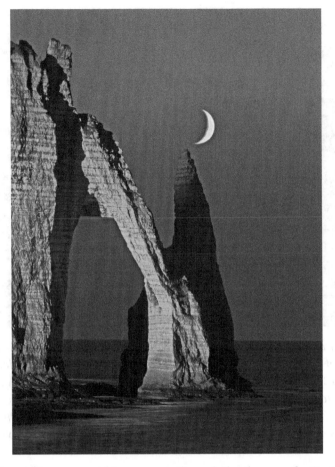

Fig. 1.10 *The waxing crescent Moon passes through the sky near the Porte d'Aval and the Needle in this photograph taken during August 2012 from the northeast end of the Étretat terrace, which runs along the beach near the town's hotels. For the benefit of tourists, the town directs artificial lighting at the cliff, arch, and needle in the evenings after the sunlight fades. Compared to our camera position for this lunar photograph, Monet's location for his sunset painting lies about 100 yards (90 m) farther to the northeast (Photograph by Russell Doescher)*

Once Monet had begun a canvas under certain conditions of the sky and the sea, he needed similar conditions in order to continue the work on a later day, as the artist himself pointed out in a letter from Étretat: "I need the Sun or the cloudy weather to coincide again with the tide, which must be low or high in accordance with my motifs" (Letter 328, Claude Monet to Alice Hoschedé, February 15, 1883).

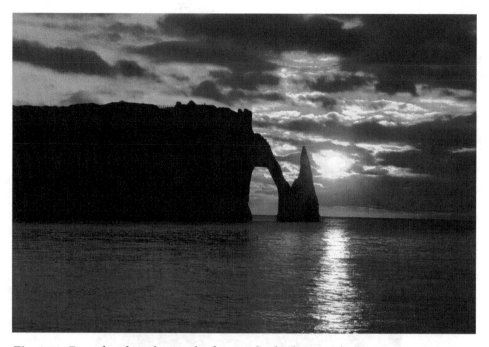

Fig. 1.11 *For a few days during the first week of February, the setting Sun passes just to the right of the Porte d'Aval and the Needle, as seen from Monet's location. This February 2012 photograph is a near-match to Monet's sunset painting. A few minutes after this photograph was taken, the Sun dropped to an altitude corresponding better to Monet's canvas, but thick clouds near the horizon blocked the view (Photograph by Jean Langlois, used with permission of the Société Astronomique du Havre)*

In the case of the sunset painting W817, Monet shows water all along the base of the Falaise d'Aval and water passing through the Porte d'Aval. The time depicted therefore cannot be near the time of a low tide.

When the tide is low at Étretat, large areas of rock and seabed on the Aval side of the bay become dry and completely exposed. During our visit in August 2012, we joined hundreds of others at low tide and walked out on the seabed near the Porte d'Aval and the Needle. Signs near the trails contain strong warnings: "For your safety, please don't forget to read the tide table." Modern pedestrians pay close attention to the tide tables, just as Monet did.

During several periods of rising tides, our Texas State group watched as the water level rose, covered the beach near the Porte d'Aval, and then began to pass through the arch. We established exactly how high the tide had to rise to match the water level in Monet's sunset painting.

Weather in February 1883

Our Texas State group also collected Normandy meteorological observations from three sources for February 1883, in order to compare the reported weather to the appearance of the sky in Monet's sunset canvas. The *Times of London* published daily weather maps and remarks, with stations on both sides of the English Channel. A volume entitled *Bulletin International du Bureau Central Météorologique de France* preserves daily meteorological observations at Le Hève, only 15 miles south of Étretat. The almost-daily letters from Monet provide additional details, as the artist discusses how the rainfall and sky conditions affect his work.

All of these sources describe a series of gales and winter storms in late January 1883, when Monet was trying unsuccessfully to work at Le Havre. But, after the move to Étretat, the weather improved markedly during the 4-day period, including February 3rd, 4th, 5th, and 6th, described as a "very pleasant spell" in a *Times of London* review at the end of the week. On February 7th, rainstorms began again.

From the astronomical analysis we knew that the setting Sun depicted in W817 corresponded to a date between February 3 and February 7, 1883. Our Texas State group could now identify the precise day for the sunset painting.

February 3, 1883, Ruled Out

The weather was favorable on Saturday, February 3rd, but we can rule out this date for the sunset painting because Monet's own words make it clear that on this day he was not working on the Amont beach to the northeast of Étretat. Instead of remaining in the familiar and easily accessible Étretat bay, on February 3rd for the first time the artist made the difficult descent down the steep path to the Jambourg beach and its spectacular views of the terrain to the southwest of town (Fig. 1.12). Monet chronicled this new experience in a letter: "As for the cliffs here, they are like nowhere else. I went down today to a place I had never dared to venture and I saw the most amazing things, so I quickly returned to get my canvases."

And he also mentioned: "I am going to meet my brother who arrives this evening" (Letter 314, Claude Monet to Alice Hoschedé, Étretat, February 3, 1883).

February 4, 1883, Ruled Out

The weather was again excellent on Sunday, February 4th, but Claude Monet complained that his entire day of work was lost as he entertained his visiting

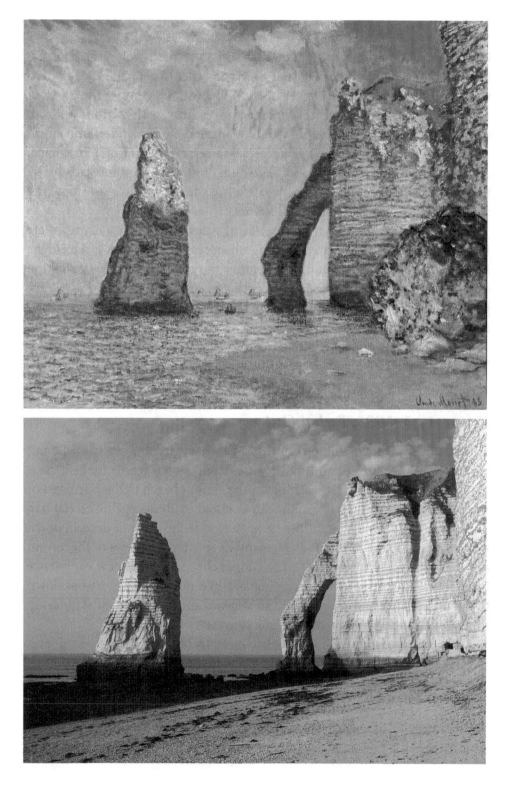

brother Léon. The artist attempted to take him on the steep and dizzying path from the top of the Aval cliff down to the Jambourg beach to see the remarkable sights discovered there on the previous day. But Léon was over-come by vertigo on the nearly-vertical sections of this trail:

What a beautiful day…I wish that this weather could last for a little while, because today I could not enjoy it as much as if I were alone. My brother became terribly ill following me on the paths through the cliff. I even had to give him my hand as I would for a lady, otherwise he would pause half-way down the path, dizzy with vertigo. I had to give up my afternoon for him, and I just put him in the coach. But what beautiful things I see, and I could not capture even a quar-ter of this with so little time…I promise myself a hard day of work tomorrow, if I have the same weather. (Letter 315, Claude Monet to Alice Hoschedé, Étretat, February 4, 1883)

The trail described in this passage is so steep and dangerous that the town of Étretat has now posted a sign reading "Access Prohibited."

February 5, 1883, Perfect Match

After the departure of his brother, Monet hoped to have a good day of work on Monday, the next day. The weather cooperated.

Recalling the gales and storms experienced at Le Havre that had prevented him from working there in late January, Monet wrote on February 5th to his art dealer in Paris that he was now optimistic about his progress in Étretat: "I work a lot. The weather is happily becoming quite beautiful, and I will make up for the time that I lost at Le Havre" (Letter 316, Claude Monet to A. P. Durand-Ruel, Étretat, February 5, 1883).

Monet made a similar weather comment in another letter written on the same day: "I have to work, happily it is going well, and the weather is quite beau-tiful" (Letter 317, Claude Monet to Alice Hoschedé, Étretat, February 5, 1883).

Fig. 1.12 This Monet painting known as W1034, The Needle and the Porte d'Aval, and the matching photograph both look to the northeast from the Jambourg beach. The artist first made the difficult descent down the steep path to this beach on February 3, 1883. In a letter that evening, Monet described the sights as "the most amazing things." This Monet painting probably dates from his Étretat campaign during the fall of 1885. Morning light illuminates Monet's 1885 scene, while our photograph shows the beach near sunset and with the tide level much lower than that shown by Monet (Photograph by the author)

The meteorological observer at nearby Le Hève reported good weather with a few clouds ("nuag") at sunset, perfectly matching the sky as painted by Monet. The calculated low tide on February 5th occurred about 2¼ h before sunset, and thereafter the tide level was rising. Shortly before sunset the tide had already risen enough to cover the rocks and seabed near Porte d'Aval, exactly as seen in the sunset painting.

February 6, 1883, Ruled Out

The pleasant spell of good weather continued on Tuesday, February 6th. But this date can be ruled out for W817 because the tide reached its lowest level only 1¼ h before sunset. As the Sun was sinking toward the horizon, the rocks under the Porte d'Aval would still have been exposed, in conflict with the appearance of the sea level in Monet's sunset painting.

February 7, 1883, Ruled Out

This date can be rejected for reasons of both weather and tide level. Low tide occurred only a half hour before sunset on Wednesday, February 7th, with the tide level near sunset even lower than on the previous day. Moreover, the weather had taken a turn for the worse, with Monet complaining in a letter: "Alas, my beautiful Sun has departed, with rain all morning. I am desolated, because with one or two sessions I could have finished several studies…but who knows when the fine weather will return" (Letter 318, Claude Monet to Alice Hoschedé, Étretat, February 7, 1883).

Monet's 1883 painting campaign in Étretat extended from January 31st to February 21st. In a pioneering attempt at dating, Daniel Wildenstein judged that the sunset painting W817 "belongs to the end of the artist's stay" (Wildenstein 1979: 100, 1996: 304). Our Texas State group instead determined that the only date matching the sunset painting fell early in this campaign: February 5, 1883.

Measuring the Needle's Height

To obtain a precise clock time on this date, we needed to know the height of the Needle. As seen from Monet's location, the actual height of the Needle (in meters) translates into an angular height (in degrees) that measures how far the spire extends up into the sky above the sea. The angular height of the Needle helps to set an angular scale for the entire painting. Estimating the

Sun's angular height (in degrees) above the horizon allows us to determine the precise time when Monet observed this scene.

Is the height of the Needle approximately 69 m? 70 m? 51 m? Art historian David Steel described the Étretat topography, including "the detached 'Needle', rising some 225 ft [69 m] above the waves" (Steel 2006: 124).

Art historian Robert Herbert previously had offered exactly the same figure in his passage about the spectacular Aval cliff and "its detached Needle (the Aiguille), a towering pyramid some 225 ft [69 m] high" (Herbert 1994: 61). The bibliography at the end of Herbert's book includes the nineteenth-century Adolphe Joanne guidebook, which may have been Herbert's original source. The popular Joanne guide, published in Paris, called attention to the height of the Needle: "Next to the Porte d'Aval, there stands a limestone obelisk completely isolated from the cliff: this is the Needle of Étretat, which is not less than 70 m [230 ft] in height" (Joanne 1872: 121).

A guidebook written in Great Britain by Charles Black gave the same figure: "standing by itself, is the Aiguille d'Etretat, an isolated pinnacle rising 230 ft. [70 m] above the water" (Black 1884: 56).

The Baedeker series of guidebooks likewise advised tourists to enjoy a "[f]ine view…of the *Aiguille d'Étretat*, a pyramid 230 ft. [70 m] high" (Baedeker 1909: 152).

Modern guidebooks still give the height of the Étretat Needle as "70 m" (Automobile Association of Britain 2000: 32; Michelin 2006: 48; Fodor's 2011: 166). This consensus at first may seem impressive. But all of the succeeding descriptions may have originated from one early source, perhaps an early Joanne volume. If the height in the Joanne guide is wrong, then all of the following authors are likewise incorrect.

Indeed, an authoritative navigation manual, advising mariners how to recognize features along the Normandy coast, provides quite a different height for the Aiguille (Needle): "L'Aiguille d'Étretat, 51 m high, is a pointed detached rock located close off the W cliff" (National Geospatial-Intelligence 2007: 136).

Which is the correct height of the Needle: near 69 m [225 ft], 70 m [230 ft], 51 m [167 ft], or some other value?

There is a complication in determining the height of the Needle. The amount of the Needle that is visible above the waves varies tremendously with the state of the tide! The tide range in Étretat can reach 8½ m (28 ft), with that much more or less of the Needle exposed, depending on the state of the tide.

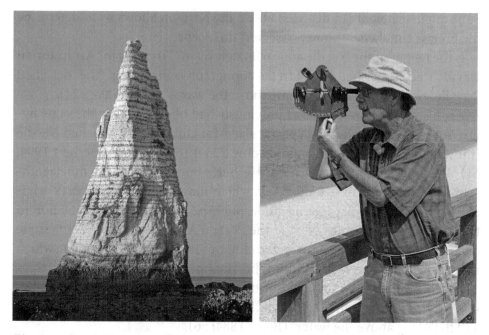

Fig. 1.13 *Roger Sinnott employs a sextant to measure the height of the Étretat Needle. Several early guidebooks gave the Needle a height of 70 m (230 ft), an exaggerated value adopted by many recent authors. Our results showed that even near low tide the top of the Needle stands only about 54½ meters (179 ft) above the exposed base. When the highest possible tides occur, 46 m (151 ft) of the Needle remain visible above the waves. The left-hand photograph shows a view from the Jambourg beach near low tide, with the high-water mark clearly visible on the Needle about 8½ meters (28 ft) above the exposed base (Photographs by the author)*

During our visit to Étretat we measured the height of the Needle by several independent methods. We employed a laser rangefinder to measure distance and a laser inclinometer and a sextant to measure angles (Fig. 1.13). We carefully allowed for the exact height of the tide at the moment when each measurement was done. Our results established that the exaggerated values of near 70 m [230 ft] for the Needle's height are clearly incorrect.

We observed that, at the time of the lowest possible tides, the top of the Needle stands about 54½ m (179 ft) above the exposed base. When the highest possible tides occur, only 46 m (151 ft) of the Needle remain visible above the waves.

An intermediate case prevailed as Monet watched the orange disk of the Sun sink toward the horizon. For a time shortly before sunset on February 5, 1883, we calculated that the top of the Needle stood 51 m (167 ft) above the waves.

Erosion of the Needle?

Our method would have to be modified if the height of the Needle had changed significantly between Monet's time and the present. Daniel Wildenstein suggests that this may be the case in his discussion of the painting W1014, which shows the view from the terrace near the center of the Étretat beach: "…nowadays the tip of the Needle, which has suffered from erosion, is less clearly seen above the Porte d'Aval" (Wildenstein 1996: 382). This statement, if true, would require a modification of our method.

To check how much erosion may have occurred, we studied dozens of vintage photographic postcards, which are easy to find because Étretat was such a popular resort. We selected three of the clearest views of the Needle and during our August 2012 visit found the precise spots where the postcard photographers had stood. Using Photoshop™ to overlay our modern digital photographs on top of the century-old views conclusively showed that any change in the height of the Needle has been almost non-existent (Fig. 1.14). In both the vintage and modern photographs, we could trace exactly the same sedimentary layers as dark and light bands all the way to the top of the Needle. Thus, we can be certain of the (somewhat surprising) result that erosion of the height of the Étretat Needle is negligible over the last century.

Precise Date and Time for Monet's Sunset

From Monet's location on the Amont beach, the top of the Needle extends about 2.6° above the horizon. As painted by Monet, the disk of the Sun stood about 0.9° above the horizon. Our analysis based on astronomical calculations, the state of the tides, Normandy weather observations, and Monet's letters, yields a date and a precise time for the scene in W817, *Étretat, Sunset*: February 5, 1883, at 4:53 p.m. local mean time.

The Sun's seasonal path has not significantly changed since the nineteenth century. Visitors to Étretat can check our results on any February 5th by walking out along the Amont beach to a point about 100 yards [90 m] beyond the northeast end of the Étretat terrace. If the weather cooperates,

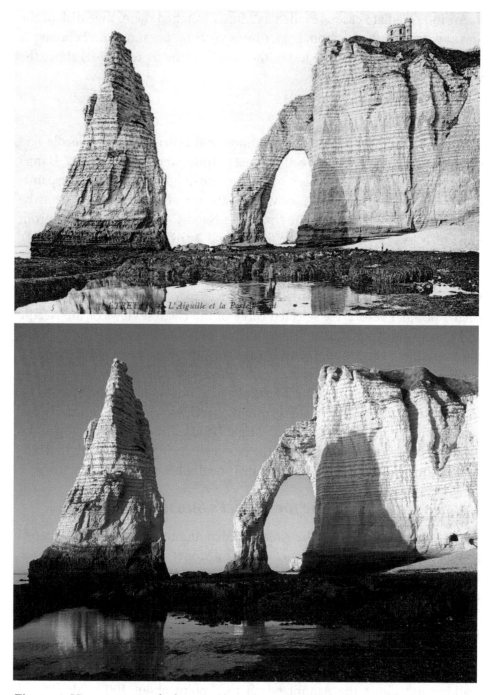

Fig. 1.14 *Vintage postcard photograph and modern photograph of the Needle and the Port d'Aval as seen from the Jambourg beach, accessible only at low tide. A comparison of the vintage postcard view from about 1905 to our photograph from 2012*

the Sun will sink to the horizon just north of (to the right of) the Needle, repeating the dramatic scene captured by Claude Monet in his beautiful *The Cliff, Étretat, Sunset*.

J. M. W. Turner's Night Sky Over a Snowy Road

At the Royal Academy Exhibition in the summer of 1829 the British artist J. M. W. Turner exhibited a watercolor depicting a stagecoach accident on a snowy mountain road in southeastern France, with a night sky overhead. The sky above the mountain includes the Moon and several bright stars or planets.

On what date did this stagecoach accident occur? Do meteorological observations from 1829 mention a snowstorm on this date? Did Turner paint the Moon in the appropriate lunar phase for that date? Can we identify the mountain road? Toward what direction was Turner facing to witness this scene? Can we identify the celestial bodies near the Moon? Are they stars or planets? Can we conclude that this work by Turner accurately portrays the stagecoach incident, the weather, the local topography, and the objects in the night sky?

J. M. W. Turner's Popularity

Any conversation about Britain's greatest artists includes Joseph Mallord William Turner (1775–1851). When BBC Radio asked listeners in 2005 to select the greatest painting in any museum in Britain, Turner's *The Fighting Temeraire* took first place in the voting. Turner created many examples of sunsets and twilights, including the dramatic and colorful sky in *The Fighting Temeraire*.

Fig. 1.14 (continued) demonstrates that the height of the Needle has not eroded significantly over the past century. The "Fort de Frefosse" castle, visible in the postcard, was constructed on the cliff circa 1890 and then demolished in 1911. A pedestrian tunnel was cut through the Aval cliff in the 1920s to improve access to the Jambourg beach, with the tunnel portals visible on the right edge of the modern photograph. Otherwise, the scene remains much the same today as when Monet worked here. Compared to Monet's viewpoint for the painting W1034 (see Fig. 1.12), the postcard photographer set up the camera much closer to the English Channel. The distant Porte d'Amont therefore becomes visible through the arch of the Porte d'Aval in both the postcard photograph and our matching photograph (Photograph by Ava Pope. Used with permission)

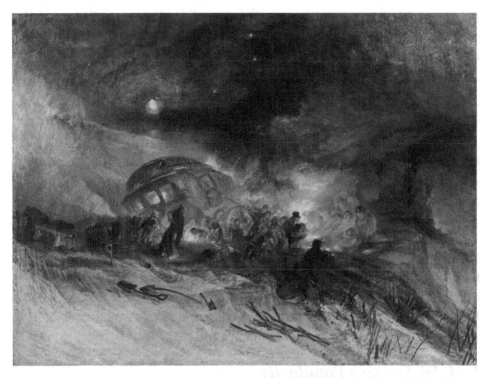

Fig. 1.15 Messieurs les voyageurs on their return from Italy (par la diligence) in a snow drift upon Mount Tarrar, 22nd of January, 1829, J. M. W. Turner, 1829 (© Trustees of the British Museum)

Turner's Night Sky

Turner rarely featured night skies in his works, but he did so in the watercolor with this interesting title: *Messieurs les voyageurs on their return from Italy (par la diligence) in a snow drift upon Mount Tarrar, 22nd of January, 1829.*

Messieurs les voyageurs (Fig. 1.15) shows a stagecoach that has slipped off a snowy mountain road. A team of oxen is preparing to pull the coach out of a snow bank, while the passengers try to remain warm around a bonfire. Silhouetted with his back to us, Turner himself sits in a top hat and observes the scene. The night sky above the mountain includes the Moon and several bright objects, either stars or planets.

For projects applying astronomy to art, our Texas State group always attempts to answer four questions: Where was the location of the artist? When was the artist there? Which way was the artist looking? What objects did the artist see in the sky?

In the case of *Messieurs les voyageurs*, the answers to the first two questions are in the title of the work! To make the location more precise and to answer the last two questions, we began by consulting biographical material about the artist.

First Stagecoach Accident in the Snow: Italy

After spending several months in Rome, Turner made his return trip to England during January 1829. He traveled in a diligence, a kind of large stagecoach used on the main routes of Europe. After arriving in London, Turner wrote a letter recalling the horrors of his trip home, which included two similar accidents when ice and snow caused his stagecoach to slide off the road, first in Italy and then later in France.

The first incident happened early in the trip, when the diligence "ziz'd into a ditch" during an ice and snow storm in the mountains of central Italy:

> Now for my journey home. Do not think any poor devil had such another, but quite satisfactory for one thing at least, viz. not to be so late in the season of winter again, for the snow began to fall at Foligno, tho' more of ice than snow, that the coach from its weight slide about in all directions, that walking was much preferable, but my innumerable tails would not do that service so I soon got wet through and through, till at Sarre-valli [Serravalle di Chienti] the diligence ziz'd into a ditch and required 6 oxen, sent three miles back for, to drag it out; this cost 4 Hours, that we were 10 Hours beyond our time at Macerata, consequently half starved and frozen we at last got to Bologna. (J. M. W. Turner to Charles L. Eastlake, February 16, 1829 [Gage 1980: 125])

Second Stagecoach Accident in the Snow: France

Conditions did not get better after Turner had managed to cross the Alps and reach southeastern France. The second incident occurred when his diligence slid into a snow bank in January 1829 at the side of a road on the slopes of Mont Tarare. The passengers were then: "…bivouacked in the snow with fires lighted for 3 Hours on Mont Tarare while the diligence was righted and dug out, for a Bank of Snow saved it from upsetting – and in the same night we were again turned out to walk up to our knees in new fallen snow to get assistance to dig a channel thro' it for the coach, so that from Foligno to within 20 miles of Paris I never saw the road but snow!" (J. M. W. Turner to Charles L. Eastlake, February 16, 1829 [Gage 1980: 125–126]).

This letter excerpt describes the scene memorialized in the *Messieurs les Voyageurs* watercolor.

The slopes of Mont Tarare were notoriously difficult and treacherous, according to the advice for travelers available in Turner's time. An 1829 guidebook, published in London and entitled *A Descriptive Road-Book of France*, included a warning in the entry for Tarare: "Oxen are kept at this place in order to draw carriages up the mountain of Tarare, the passage of which is safe in summer, but dangerous in winter, on account of the deep snows that lie on its surface" (Reichard 1829: 136).

Turner shows two of these oxen near the left edge of his watercolor.

Turner's Moon, Planet, and Stars

Many artists have created paintings that feature crescent Moons or full Moons. *Messieurs les Voyageurs* is one of the few works in the history of art to portray a waning gibbous Moon. The lunar phase called waning gibbous refers to the time period of about a week between full Moon and third quarter, when the Moon's light is decreasing as the illuminated fraction drops from 100 % to 50 %. Our computer calculations verify that a full Moon fell on January 20, 1829, placing the Moon in the waning gibbous phase on January 22nd, exactly as depicted by Turner.

Turner's tilt of the waning gibbous Moon contains an astronomical clue. The circular arc at the edge of the Moon's brighter side is called the bright limb. The opposite side of the Moon is bounded by the dark limb.

Turner shows the bright limb of the Moon on the lower left and the dark limb of the Moon to the upper right. For a gibbous Moon, a line connecting the center of the bright limb to the center of the dark limb and then extending into the sky always runs near the path called the ecliptic. Astronomers define the plane of the ecliptic as the plane containing Earth's orbit around the Sun. Observers will find the planets and the familiar zodiacal constellations along the ecliptic. Comparing Turner's sky to planetarium program simulations allows us to identify the bright star-like objects in the watercolor, visible to the west of (to the right of) the lunar dark limb.

Computer calculations of the sky on January 22, 1829, show that the single brilliant body to the right of the Moon must be the planet Saturn. Farther to the right and just above (north of) the ecliptic, the two objects with nearly equal brightness must be Castor and Pollux, the twin stars of the constellation Gemini.

Our Texas State group discovered an interesting astronomical coincidence that makes the identification of Saturn (Fig. 1.16) even more plausible. The planet Saturn reached the astronomical configuration called opposition

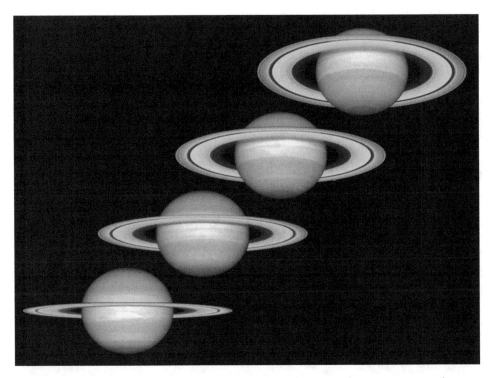

Fig. 1.16 *Saturn on January 22, 1829, was only 1 day away from opposition, the configuration that brings the planet closest to Earth and therefore increases its brightness. The rings of Saturn can also take on different orientations, as seen in this sequence of four images taken by the Hubble Space Telescope over the course of several years. The image at the far upper right closely matches the 20° tilt of the rings on the night when Turner observed the planet. When the ring plane is inclined by 20° to the line of sight, the reflected light from the rings contributes to making the total luminosity twice as bright as the light coming from the round ball of the planet alone, further helping to explain why brilliant Saturn caught Turner's eye (Images courtesy of NASA and the Hubble Heritage Team)*

on January 21, 1829. Astronomers use the term opposition because the planet then appears in the part of the sky directly opposite the Sun, and the planet's rising and setting occur in an opposite manner to the Sun. On both January 21st and 22nd, Saturn was rising in the northeast as the Sun was setting in the southwest. At the time of planetary opposition, Saturn is closest to Earth and attains its maximum brightness.

Saturn reaches opposition, on average, only once every 378 days. The remarkable coincidence, that a Saturn opposition occurred only 1 day before Turner crossed Mont Tarare, helps to explain why the bright planet caught Turner's eye as he looked up at the night sky.

Fig. 1.17 *The members of the Société d'Histoire et d'Archéologie des Monts de Tarare warmly welcomed our Texas State group at the archives in Tarare (Photograph by Russell Doescher. Used with permission)*

Which Was Turner's Road?

Based on the tilt of Moon and the relative positions of the other celestial bodies, our computer calculations place the Moon in the sky to the southeast of Turner. This in turn means that the road and the stagecoach pointed generally toward the north, even slightly toward the northeast.

This may seem an unexpected direction of travel, since a coach going from Lyon to Paris should be headed generally toward the northwest. But, of course, curving roads are common in mountainous regions.

To identify Turner's road, our Texas State group visited Tarare in August of 2010. The members of the Société d'Histoire et d'Archéologie des Monts de Tarare (Fig. 1.17) gave us a warm welcome to their town. Old maps in the Tarare archives clearly showed the mountain road that Turner's stagecoach would have employed in 1829 (Lépinasse 2000: 18). Nicolas Céard, famed for his accomplishments as Napoleon's road engineer and celebrated

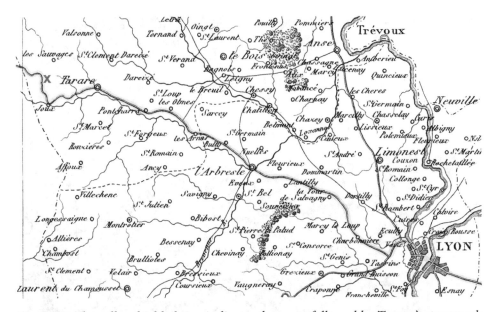

Fig. 1.18 *The yellow highlighting indicates the route followed by Turner's stagecoach on January 22, 1829. The highway from Lyon toward Paris travels generally toward the northwest, but the road swings toward the north just west of the town of Tarare. The red "X" marks the probable location of Turner's stagecoach accident on the snowy road just below the summit of Mont Tarare. This map appeared as Plate 68 in Charles Monin's Petit Atlas National, published in 1835*

especially for the mountain road over Simplon Pass in Switzerland, supervised the design of this route on the slopes of Mont Tarare (Céard 1820: 50). Documents in the Tarare archives showed that the builders completed the highway construction northwest of the town in 1821.

After leaving Tarare in the direction of Paris, the road makes several large curves and then swings toward the north and even slightly toward the northeast, just as we expected based on Turner's sky. A map (Fig. 1.18) published in the 1830s shows the most likely location for Turner's stagecoach incident, near the highest point on the road and therefore a plausible spot to expect heavy snow during the storms of January 1829.

When we visited the location (Fig. 1.19), we could see that the ground on the west side of the highway drops off sharply, matching perfectly the steep slope visible on the right side of Turner's watercolor. Users of Google Earth or GPS devices will find the location of Turner's *Messieurs les voyageurs* at 45.912° north, 4.357° east, near a sweeping turn just below the summit of Mont Tarare.

Fig. 1.19 *This daytime photograph, taken during our Texas State group's visit to the scene of the painting, shows a waxing gibbous Moon over Mont Tarare shortly before sunset on August 20, 2010. The probable site of Turner's stagecoach accident is just to the left of the farm buildings with orange roofs, on the curving road now known as the route nationale N7 (Photograph by Russell Doescher. Used with permission)*

National Road N7 – The "Route 66" of France

Turner's stagecoach accident in 1829 took place on the road now known as the N7, where the "N" indicates that the modern paved highway is an important national road, or *route nationale*. The N7, a favorite site for car clubs to organize road rallies in vintage automobiles, plays a similar role in French automotive and traveling history as does the historic Route 66 in the American southwest.

Snowstorm in January 1829

Weather observations from January 22, 1829, are not available from Tarare, but meteorological records from elsewhere in Europe and from a city near Tarare include references to the storm that caused Turner's stagecoach to skid off the road.

The Gentleman's Magazine for 1829 includes a Meteorological Diary compiled in London by William Cary, who reported "snow" on January 21st, 23rd, and 24th as the storm front passed through England. Another 1829 London journal, *The Athenaeum*, likewise remarked on the "snow" of January 21st, 23rd, and 24th in its weekly meteorological journal. The newspaper *Le Précurseur* in Lyon, only about 20 miles to the southeast of Tarare, published stories dated January 22nd and 24th about temperatures that had fallen well below freezing and "snowdrifts which have rendered our streets impassable." The journal *Bibliothèque Universelle* for 1829 included reports from the Geneva meteorological observer, who recorded significant snowfall on January 22nd, 23rd, 24th, and 26th, as the snowstorm passed through Switzerland.

The title of this watercolor, *Messieurs les voyageurs on their return from Italy (par la diligence) in a snow drift upon Mount Tarrar, 22nd of January, 1829*, provided important clues for our analysis. Astronomical analysis for this date allows us to go further and to conclude that Turner accurately depicted not only the snowy road and the local topography, but also the lunar phase of the waning gibbous Moon in the sky above, along with Saturn near its maximum brilliancy, and the bright stars of Gemini nearby.

References

Automobile Association of Britain (2000) *Journey through France*. New York: W. W. Norton & Company.

Baedeker, Karl (1909) *Northern France: Handbook for Travellers*. Leipzig: Karl Baedeker.

Black, Charles (1884) *Touraine with Normandy & Brittany*. Edinburgh: Adam and Charles Black.

Céard, Nicolas (1820) *Mémoire et Observations Historiques et Critiques sur la Route du Simplon et Autres Objets d'Art*. Paris: Goeury.

Fodor's (2011) *Fodor's See It France: The Practical Illustrated Guide, 4th Edition*. New York: Random House.

Fuller, William H. (1899) *Claude Monet and His Paintings*. New York: J. J. Little & Co.

Gage, John Stephen (1980) *Collected Correspondence of J. M. W. Turner*. Oxford: Clarendon Press.

Herbert, Robert L. (1994) *Monet on the Normandy Coast, Tourism and Painting, 1867–1886*. New Haven: Yale University Press.

Joanne, Adolphe (1872) *Itinéraire Général de la France: Normandie*. Paris: Librairie Hachette.

Lépinasse, Jo (2000) L'horrible montagne de Tarare: Histoire de la route. *Société d'Histoire et d'Archéologie des Monts de Tarare* No. 17, 11–21.

Michelin (2006) *Le Grand Guide Michelin France*. Tielt, Belgium: Éditions Lannoo.

National Geospatial-Intelligence Agency (2007) *Sailing Directions (Enroute): English Channel*. Bethesda, Maryland: National Geospatial-Intelligence Agency.

Reichard, M. (1829) *A Descriptive Road-Book of France*. London: Samuel Leigh.

Steel, David (2006) *The Cliff, Étretat, Sunset*. In: Heather Lemonedes, Lynn Federle Orr, and David Steel, eds. *Monet in Normandy*. New York: Rizzoli, 124–129.

Stuckey, Charles F. (1995) *Claude Monet: 1840–1926*. New York: Thames and Hudson.

Toly, M. (1882) Éboulement d'une falaise à Étretat. *Le Monde Illustré* **26** (No. 1334), October 21, 1882, 262–268.

Wildenstein, Daniel (1979) *Claude Monet. Biographie et Catalogue Raisonné, Vol. II, 1882–1886, Peintures*. Lausanne and Paris: Bibliothèque des Arts.

Wildenstein, Daniel (1996) *Monet, Catalogue Raisonné*. Köln: Taschen.

2

Vincent van Gogh and Starry Skies Over France

Vincent van Gogh, in the last 2 years of his life, created some of the most spectacular and well-known paintings of twilights and night skies.

In Vincent's canvas entitled *White House at Night*, a brilliant "star" dominates the sky above a villa in the town of Auvers-sur-Oise, France. Does this painting portray morning twilight or evening twilight? How do astronomical calculations, Vincent's letters, and meteorological records allow us to determine the precise date in 1890 and the time when the artist observed the sky that inspired this work? Does the "white house" in Auvers-sur-Oise still exist? Do the maps and guidebooks available in the town direct visitors to the correct location? What is the identity of the bright object that Vincent van Gogh depicted in the twilight sky?

Vincent van Gogh painted his famous *Starry Night* in 1889 in the town of Saint-Rémy-de-Provence in southern France. In the same town and same year Vincent created another astronomical painting that shows wheat stacks in a field enclosed by a stone wall and, in the twilight sky, a prominent orange disk partly hidden behind a mountain range. This field is familiar from many other van Gogh paintings because it could be seen from his window in the Saint-Paul monastery. Can we use astronomical analysis to determine whether this canvas with the orange disk portrays a sunrise, sunset, moonrise, or moonset? How can we determine the date and the precise time, accurate to the minute, when the artist observed this scene?

Vincent van Gogh painted another dramatic sky in his *Road with Cypress and Star*, created in 1890 at Saint-Rémy-de-Provence. This canvas depicts a rural scene of two figures walking down a road, with a carriage in the middle distance. The sky above includes two bright objects, one especially brilliant,

D.W. Olson, *Celestial Sleuth: Using Astronomy to Solve Mysteries in Art, History and Literature*, Springer Praxis Books, DOI 10.1007/978-1-4614-8403-5_2,
© Springer Science+Business Media New York 2014

near a slender crescent Moon. Are these objects stars or planets? How do astronomical calculations, Vincent's letters, and meteorological records allow us to determine the date and time when the artist observed the sky that inspired this painting? What rare celestial grouping does this work commemorate?

The Story of the *White House at Night*

A brilliant "star" dominates the twilight sky above a villa in the town of Auvers-sur-Oise, as seen in Vincent van Gogh's spectacular painting entitled *White House at Night* (Fig. 2.1). This canvas mysteriously disappeared for 75 years, and catalog entries during that period included phrases like "present location unknown." Recently the *White House at Night* resurfaced at an exhibition in Russia, and our Texas State group made the first astronomical analysis of the sky in this work.

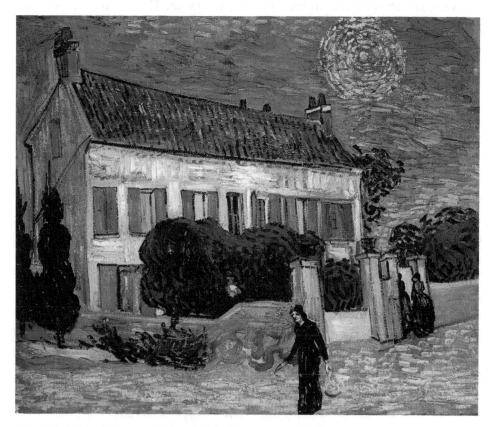

Fig. 2.1 *White House at Night, F766, Vincent van Gogh, Auvers-sur-Oise, 1890*

Art historians have debated several different locations in Auvers-sur-Oise for the "white house" seen in this canvas. We wondered whether we could use clues in the painting to resolve this controversy and to find the location of the house in the present-day town. If we could find the house, we could determine the direction of view in the painting. Knowing which part of the sky Vincent depicted might then allow us to identify the bright object in the twilight sky.

Four paintings by Vincent van Gogh have emerged as the most familiar and often-reproduced images of the night sky. *Cafe Terrace at Night* and *Starry Night Over the Rhône* feature the heavens above Arles, a town in southern France. In nearby St. Rémy he created his famous *Starry Night* as well as *Road with Cypress and Star*. In 1995 a fifth night-sky painting by van Gogh resurfaced as part of an exhibition at the State Hermitage Museum in St. Petersburg, Russia.

Our Texas State group was astonished to learn that this stunning work, *White House at Night*, still existed. In the text of the catalog for the Russian exhibition held on the 50th anniversary of the end of World War II, curator Albert Kostenevich explained the fascinating odyssey of this long-lost canvas:

> The paintings in this book were long thought to have been destroyed in the war. Only now has it been revealed that they spent the last half century hidden in the storerooms of the Hermitage, their existence a carefully guarded state secret... outstanding paintings include several by van Gogh, among them his remarkable White House at Night, painted six weeks before his death and depicting the kind of nocturnal sky seen in his well-known Starry Night. (Kostenevich 1995: notes on dust jacket)

The introduction to this catalog makes the observation: "The pictures in this book...have a most unusual history...they are virtually unknown, not only to the public but to the most conscientious scholars..." (Kostenevich 1995: 9).

During the 1920s Otto Krebs, a German industrialist in the village of Holzdorf, acquired *White House at Night* for his private collection. When the Nazis rose to power, the painting became even more inaccessible. Fearing political reprisals against collectors of what the Nazis considered "degenerate art," Krebs in the 1930s and 1940s had to avoid attracting attention to his holdings. Kostenevich described what happened during the Russian pursuit of the retreating German army in 1945: "Private collections and museum objects...found their way into specially prepared bunkers...Guns were still firing when Soviet troops began to discover these bunkers...Soviet representatives sent to the East everything they considered important...

Art objects were coming in from different places, in railroad cars..."
(Kostenevich 1995: 9).

Although much of the history of the *White House at Night* is still cloaked
in mystery, sufficient information establishes the work as an authentic van
Gogh. An early black-and-white photograph of the canvas exists, taken by
Eugène Druet prior to 1916, and the painting appeared in several exhibi-
tions in Switzerland during the 1920s and in the first compilation of van
Gogh's complete works (de la Faille 1928). Moreover, in one of his many let-
ters, Vincent provided a detailed description of *White House at Night*.

Johanna van Gogh, the wife of Vincent's brother Theo, collected the let-
ters, attempted to arrange them in chronological order, numbered them,
and published the compilation in 1914. In the 1990s the Vincent van Gogh
Museum in Amsterdam assembled a team in a venture called the Van Gogh
Letters Project, which has created an authoritative website with facsimiles of
each of the artist's letters in a revised numbering system. The website includes
both transcriptions of each letter's original language, usually Dutch or
French, and translations into English. For the passages quoted below in this
chapter, the citations will reference each letter by two numbers, both in the
original system used by the van Gogh literature prior to 2009 and also in the
revised system now used by the Letters Project.

Vincent's letter of June 17, 1890, to his brother Theo in Paris includes a
detailed description of how this painting portrayed: "...une maison blanche
dans de la verdure avec une étoile dans le ciel de nuit et une lumière orangée
à la fenêtre et de la verdure noire et une note rose sombre." ("a white house
amid greenery with a star in the night sky and an orange light in the window
and dark greenery and a note of somber rose"). (Letter 642, as numbered by
Johanna van Gogh, Letter 889, as numbered by the Van Gogh Letters
Project).

Van Gogh sent this letter from Auvers-sur-Oise, a town about 20 miles
northwest of Paris. He spent the last 70 days of his life in Auvers and pro-
duced about 70 paintings there before his death on July 29, 1890. This
remarkable pace suggests that he likely created the *White House at Night*
only a short time before he wrote his letter on June 17th.

As part of a course in the Honors College at Texas State University, my
students and I first studied the four well-known van Gogh night-sky paint-
ings and then, after seeing the illustration in Kostenevich's book, we won-
dered – could we identify the brilliant celestial object in this rediscovered
masterpiece?

Candidates for Vincent's "Star"

To see what might have caught van Gogh's eye, we set our planetarium computer programs for northern France in mid-June of 1890 and looked for bright stars and planets. The brightest stars visible at this time of year were Arcturus and Vega high overhead at evening twilight, and Capella low in the northeastern sky just before sunrise. There was a new Moon on June 17, 1890, which helps to explain the Moon's absence from the painting.

Three planets were especially prominent in mid-June. Venus shone as a brilliant "evening star," visible in the western sky for about 2 h after sunset. Mars stood low in the southeastern sky at sunset and far outshone its nearby rival, the red giant star Antares in the constellation of the Scorpion. Jupiter rose about an hour before midnight and dominated the southeastern and southern sky until sunrise.

To make a convincing identification of van Gogh's "star," we realized that we needed to answer several questions about the *White House at Night*. Does the painting show an actual house? Does this distinctive house still exist in the present-day town? Where would van Gogh have been standing to obtain this view of the house? Toward what direction was he facing? What part of the sky did van Gogh depict in the painting?

To answer these questions, during May 2000 our group traveled to France and spent 4 days in Auvers-sur-Oise (Olson et al. 2001). Because no battles during either World War I or II occurred in the town, we had reason to hope that houses from 1890 would still be standing. The townspeople warmly welcomed our group to Auvers, where municipal officials, the staff at the tourism office, and many other residents went out of their way to help us. After dividing into groups of two or three, we walked along every street and studied the windows, chimneys, walls, and gates of houses for miles in each direction from the center of town. In the course of our search we passed by dozens of van Gogh painting locations, including the Church at Auvers (Fig. 2.2), the town hall, cottages, gardens and wheat fields.

Eventually we all were certain that the *White House at Night* matched only one house, a villa (Fig. 2.3) on the south side of the main road. The house, with modern address 25/27 Rue du Général de Gaulle, stands only two blocks west of the Auberge Ravoux, the inn where Vincent resided in June 1890.

The owners made some modifications to the house between 1890 and the present day. For example, the family added dormers to the roof when converting the attic into bedrooms for their children. Van Gogh's painting shows

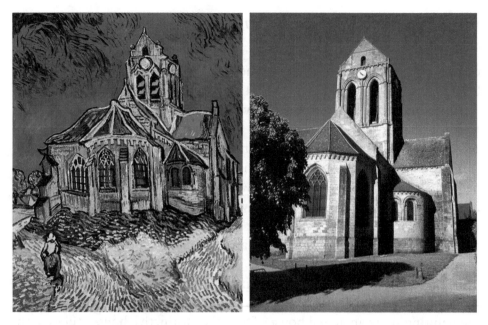

Fig. 2.2 *Church at Auvers, F789, Vincent van Gogh, Auvers-sur-Oise, 1890. The photograph dates from May 2000 (Photograph by the author)*

seven windows in the upper story, including six large windows with shutters and a narrow central window without shutters. The six large windows and their shutters remain today, along with a blank space above the center door. The family kindly invited us into the house, and we confirmed that the narrow central window was filled in during a construction project. The narrow central window originally provided light to a stairwell that was eliminated when the family added a spiral staircase in a modern tower attached to the rear of the house.

As we stood in front of the white house, the students noticed an especially distinctive architectural feature: the three windows on the left side of the upper story have noticeably uneven horizontal spacing and are not directly above the windows on the ground floor. These odd misalignments (Fig. 2.4) exactly match the windows in van Gogh's painting and confirmed that we were definitely at the correct location.

After visiting bookstores in Auvers, we were gratified to learn that a memoir by a contemporary of van Gogh's identified the *White House at Night* with exactly the same house that we found independently. Paul Gachet was 16 years old in 1890 when he met van Gogh through his father, Dr. Gachet,

Fig. 2.3 *In this photograph from May 2000, the setting Sun obliquely illuminates the north-facing front of the white house (25/27 Rue du Général de Gaulle), while leaving the left side of the house in shadow. Visitors to Auvers-sur-Oise can still recognize the White House at Night site here despite changes to the roof and the modern building at the far right (Photograph by Russell Doescher. Used with permission)*

who helped to care for Vincent during his stay in Auvers. According to Paul Gachet, the white house went by the name Villa Ponceaux and served as the Victorine residence, the home of a local merchant (Gachet 1994: 140). Users of Google Street View can see the Villa Ponceaux as house number 25/27 on the southwestern corner of the intersection where Rue des Ponceaux meets Rue du Général de Gaulle.

Venus as Evening Star in June 1890

The front of Villa Ponceaux faces generally to the north. During our visit to Auvers we stood in the exact spot where Vincent must have set up his easel. From van Gogh's point of view looking at the villa, the last rays of the Sun setting in the northwest angled across the facade from right to left, while the left end of the house remained in shadow. Our computer calculations for June 1890 place Venus in the western sky, above and to the right of the white house,

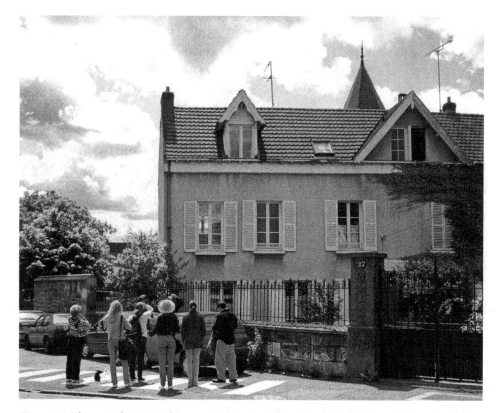

Fig. 2.4 *The windows in the upper story of the white house have uneven spacing and, more distinctively, do not align directly above the windows on the ground floor. These odd misalignments exactly match the windows in van Gogh's painting (Photograph by the author)*

exactly as seen in the canvas. The radiant "star" painted by van Gogh must actually be the "evening star" – the planet Venus in the evening twilight glow.

Vincent was not the only person in France to notice Venus then. A contemporary article in the leading French astronomy magazine, published by the science popularizer Camille Flammarion, encouraged observers to look for Venus after sunset in June 1890: "Vénus est facile à reconnaître, le soir, à l'Occident; elle brille d'un très vif éclat aussitôt après le coucher du Soleil" (Venus is easy to recognize, in the evening, in the West; it shines very brightly immediately after sunset.) (Vimont 1890: 238).

So, the *White House at Night* accurately depicts the north face of the Villa Ponceaux in Auvers-sur-Oise near sunset in June 1890, with brilliant Venus in the western sky.

Fig. 2.5 *Several guidebooks incorrectly direct visitors to this house at number 44 Rue du Général de Gaulle. The sunlight illuminates the south-facing facade in this midday photograph, but in spring and summer the Sun's rays do not illuminate the front of the house near sunrise or sunset (Photograph by the author)*

In addition to Paul Gachet's book, stores in Auvers sell half a dozen guidebooks and souvenir maps that direct visitors to the *White House at Night* location (for example, Mothe 1987: 83; Défossez 1993: 9; Auvers Tourist Office 2000: 1). But all of these other authorities incorrectly identify the white house as number 44 Rue du Général de Gaulle! The ground floor level at 44 Rue du Général de Gaulle (Fig. 2.5) now houses several businesses, including an art gallery that proudly claims the connection to Vincent van Gogh by using *White House at Night* as the illustration on its promotional material.

The house at number 44 has prominent dormers in the roof, but we used old photographs to verify that these dormers are modern additions, so their presence now does not immediately rule out this being the house. However, three pieces of evidence allow us convincingly to rule out number 44. The lighting cannot possibly match van Gogh's painting, because this house stands

on the north side of the main road. In the month of June, the Sun's rays do not illuminate the south-facing facade at either sunrise or sunset, when the light slants in from the northeast or northwest, respectively. The chimneys at number 44 also do not match those in the painting, and the upper story of this house has only five windows, instead of the correct number of seven.

The mayor's office kindly gave us access to a book with more than 300 vintage postcard photographs of Auvers as the town appeared near the time of van Gogh's stay (Club Philatélique d'Auvers sur Oise 1998). These vintage photographs showed the same wrongly-spaced chimneys and the same five windows in the upper story and allowed us to conclude that the house at number 44 was definitely not the house painted by van Gogh.

The correct identification of the white house with number 25/27 Rue du Général de Gaulle does appear now in an online guide at a website, www. museonature.com, with descriptions and a map showing more than two dozen Vincent van Gogh painting locations in Auvers-sur-Oise. The website credits our Texas State group for the identification of the celestial object: "L'étoile représentée est la planète Venus. La présence de la planète au moment de la réalisation a été confirmée en juin 2000 par un groupe d'astronomes de Texas State University à San Marcos (USA). (The star represents the planet Venus. The presence of this planet at the moment of creation [of the painting] was confirmed in June 2000 by a group of astronomers from Texas State University in San Marcos, USA.) (www.museonature.com/fr/fiches-fr/van-gogh-maison-blanche-la-nuit.pdf)

Dating the *White House at Night* by Meteorological Evidence

Before we left France, we hoped to determine a more precise date for *White House at Night* by consulting weather records for June 1890. In the Météo-France archives at the Montsouris Observatory in Paris, we examined a set of large handwritten ledgers with detailed weather observations and remarks, recorded at six times during each day.

The records show a week-long period of overcast and inclement weather extending from June 7th to June 14th, with remarks mentioning cloud cover and either rain *(pluie),* heavy showers *(forte ondée),* or thunderstorms *(orage)* on each day. The skies began to clear on June 15th. Almost certainly van Gogh worked on the *White House at Night* on June 16th, when clear blue skies prevailed all day long, and the weather observer's remarks describe the afternoon as very beautiful *(tres beau).* By June 17th, the day when van Gogh

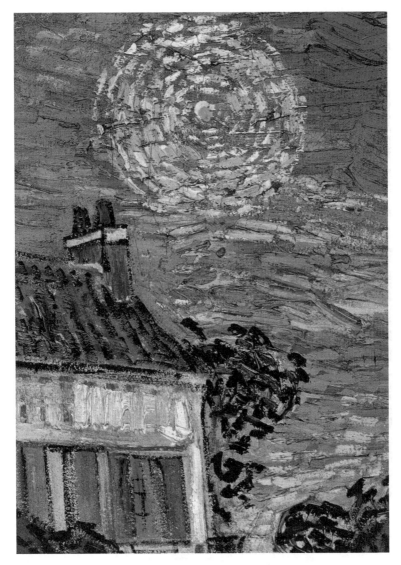

Fig. 2.6 *Venus in White House at Night, F766, Vincent van Gogh, Auvers-sur-Oise, 1890, detail*

mentioned the painting in the letter to his brother, the weather had turned bad again, with the records showing 100 % cloud cover and the threat of thunderstorms *(menace d'orage)*.

Based on the accumulated evidence, we conclude that the *White House at Night* accurately depicts the north face of the Villa Ponceaux in Auvers-sur-Oise near sunset, about 8 p.m. local time on June 16, 1890, with Venus (Fig. 2.6) in the western sky.

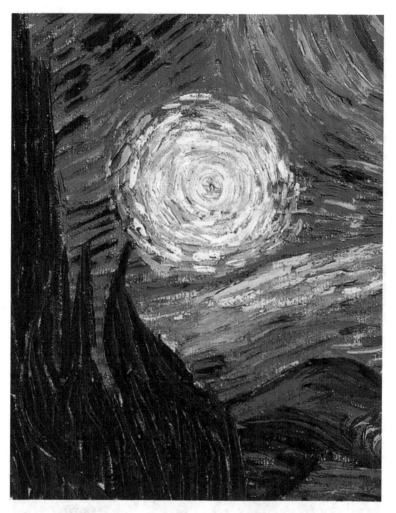

Fig. 2.7 *Venus in Starry Night, F612, Vincent van Gogh, Saint-Rémy-de-Provence, 1889, detail*

Venus and Vincent van Gogh

But *White House at Night* was not the first van Gogh work depicting this planet. This was his third painting to include Venus.

The first such canvas with Venus is none other than the famous Saint-Rémy *Starry Night*, dated to mid-June of 1889. UCLA art historian Albert Boime and Harvard astronomer Charles Whitney have independently identified Venus as the very bright object just to the right of the cypress tree (Fig. 2.7),

near the eastern horizon in *Starry Night* (Boime 1984: 87; Whitney 1986: 356). Both of these scholars used one of Vincent's many letters to prove that the artist observed Venus in June 1889, the same month when he created *Starry Night*.

A letter from Vincent, written to his brother Theo and mailed near the beginning of June 1889, describes watching Venus as "morning star." Computer calculations show that this planet rose into the eastern sky before sunrise during June 1889. In fact, Venus during that month was near its maximum possible brilliancy and especially prominent, as Vincent noticed: "Ce matin j'ai vu la campagne de ma fenêtre longtemps avant le lever du soleil avec rien que l'etoile du matin laquelle paraissait tres grande." (This morning I looked at the countryside from my window for a long time before sunrise with nothing but the morning star, which appeared very large.) (Letter 593, as numbered by Johanna van Gogh, Letter 777, as numbered by the Van Gogh Letters Project.)

The second canvas with Venus is *Road with Cypress and Star*, painted in Saint-Rémy during late April or early May of 1890. Vincent could have witnessed a rare twilight grouping of the planets Venus and Mercury near a slender crescent Moon on April 20, 1890. As explained later in this chapter, the spectacular sight may have inspired the sky in *Road with Cypress and Star*. This canvas shows two objects, one especially bright (Fig. 2.8), close to a thin crescent Moon. Several weeks later, after van Gogh had relocated to Auvers-sur-Oise, he drafted a letter that included a sketch of *Road with Cypress and Star*, and Vincent described the especially luminous object (almost certainly Venus) as: "une étoile à éclat exagéré..." (a star with exaggerated brilliance). (Letter 643, as numbered by Johanna van Gogh, Letter RM23, as numbered by the Van Gogh Letters Project.)

We realized that art historians have dated this letter recalling the sky of *Road with Cypress and Star* to June 16 or 17, 1890, exactly the same period when he was creating *White House at Night*. Our discovery of this intriguing connection between the two paintings helps to support our conclusion that both feature similar astronomical subjects – evening twilight scenes with Venus in the western sky.

In summary, Vincent van Gogh included the brilliant planet Venus in three of the most memorable night-sky depictions ever created: *Starry Night* of mid-June 1889, *Road with Cypress and Star* on April 20, 1890, and *White House at Night* on June 16, 1890.

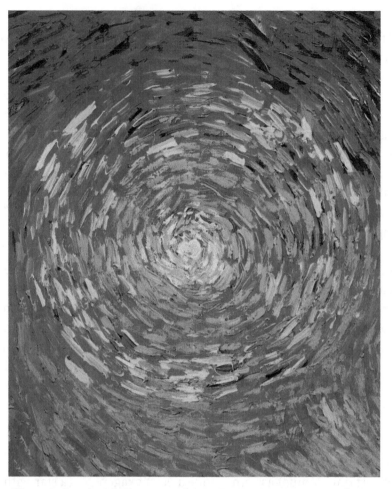

Fig. 2.8 *Venus in Road with Cypress and Star, F683, Vincent van Gogh, Saint-Rémy-de-Provence, 1890, detail*

Dating Vincent van Gogh's *Moonrise*

Vincent van Gogh painted his famous *Starry Night* at the town of Saint-Rémy-de-Provence in southern France. In a letter composed during mid-June of 1889, Vincent wrote to his brother Theo that he had just produced "a new study of a starry sky." Art historians therefore generally agree that van Gogh created *Starry Night* during that month.

No such consensus exists regarding the date of another van Gogh astronomical painting created in Saint-Rémy-de-Provence during 1889.

This work shows wheat stacks in a field enclosed by a stone wall and, in the twilight sky, a prominent orange disk partly hidden behind a mountain range. Is this orange disk a setting Sun or a rising Sun? Because the full Moon can take on a orange color when observed close to the horizon, might this canvas instead depict a rising or setting full Moon? Can we use astronomical analysis to determine whether this canvas portrays a sunrise, sunset, moonrise, or moonset? Toward which direction was the artist facing? How can we determine the date and the precise time, accurate to the minute, when the artist observed this scene?

Van Gogh and the Wheat Field in Saint-Rémy

On May 8, 1889, Vincent van Gogh moved from the town of Arles to the hospital housed in the Saint-Paul monastery at Saint-Rémy-de-Provence. By the time of his discharge on May 16, 1890, Vincent had produced there the staggering total of nearly 150 paintings and 140 drawings, works that reflected his interest in the natural light of southern France. More than a dozen of these show similar views of a wheat field enclosed by a stone wall, with houses visible among rounded hills beyond the wall and the Alpilles mountains rising on the right. Within the garden, an internal dividing stone wall makes a distinctive T-shaped intersection with the outside stone wall, with a shed visible on the right edge of the canvas.

Art historians refer to van Gogh's works by the catalog numbers assigned by Jacob-Baart de la Faille in his pioneering and monumental 1928 compilation. The painting known as F735 (Fig. 2.9) shows wheat stacks in this Saint-Rémy wheat field and, in the twilight sky, a prominent orange disk partly hidden behind the mountains. Is this orange disk the Sun or the Moon?

De la Faille's 1928 catalog listed F735 with the title *Sunset* ("Coucher du soleil") and included the descriptive text that "the yellow-orange solar globe sinks behind the dark blue mountains that limit the horizon" (de la Faille 1928: 208). A 1937 catalog by W. Scherjon and W. J. de Gruyter changed the title of the work to identify the scene as *Rising Moon (Haycocks)* and placed this canvas with the works from August or September 1889 (Scherjon and de Gruyter 1937: 219). De la Faille adopted the title *Moonrise* and the month of September 1889 for F735 in a revised 1938 edition of his catalog (de la Faille 1938: 436). But a completely different month appeared in the 1970 edition of the de la Faille catalog, completed by a committee of experts after the original author's death. This posthumous edition lists F735 with the title *Rising Moon: Haycocks* and gives the very specific date as "6 July" (de la Faille 1970: 281).

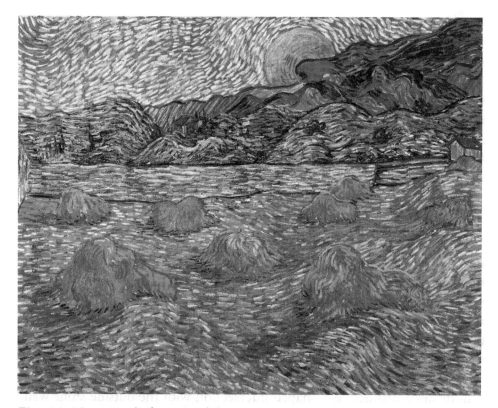

Fig. 2.9 *Moonrise (Wheat Stacks), F735, Vincent van Gogh, Saint-Rémy-de-Provence, 1889. Once thought to show a setting Sun, this Vincent van Gogh painting actually depicts a rising Moon at Saint-Rémy-de-Provence (Collection Kröller-Müller Museum, Otterlo, the Netherlands)*

Jan Hulsker was a member of the committee that completed the publication of the 1970 de la Faille catalog. Hulsker later published, on his own, two editions of van Gogh's complete works. In both of these catalogs, he gives F735 the title *Enclosed Field with Sheaves and Rising Moon* and dates this painting to "6 July 1889" (Hulsker 1977: 400, 1996: 406).

Modern experts have come to a consensus that this canvas depicts a moonrise, some even mentioning a specific date. Is this consensus correct? Does the painting show a rising Moon? Is July, August, or September the correct month for this canvas? Does the appearance of the Moon on July 6, 1889, match the painting?

All these scholars used Vincent's many letters to help determine the content and sequence of his paintings. In the case of the painting F735, the

correspondence makes it certain that the canvas depicts a view to the east and southeast with a rising Moon.

Vincent often looked at the sky from his room on the upper floor of the east side of the monastery, as he mentioned in a letter of late May 1889 to his brother Theo in Paris: "A travers la fenêtre barrée de fer j'apercois un carré de blé dans un enclos…au-dessus de laquelle le matin je vois le soleil se lever dans sa gloire." (Through the window with iron bars I can see a square enclosed wheat field…above which I see the Sun rise in all its glory in the morning.) (Letter 592, as numbered by Johanna van Gogh, Letter 776 as numbered by the Van Gogh Letters Project)

As cited earlier in this chapter, a letter mailed near the beginning of June 1889 described an observation of brilliant Venus as "morning star," rising into the eastern sky before sunrise. That Vincent was able to watch sunrises and the morning star from his window proves that the view across the enclosed field looks generally towards the east. The painting F735 therefore must depict either a sunrise or a moonrise, not a sunset or a moonset, which would necessarily occur toward the west.

During the summer of 1889, Vincent mailed an envelope containing two letters, one to Theo and another (now lost) written to the artist Paul Gauguin with a sketch of a reaper cutting the wheat in the enclosed field. The letter to Theo, numbered as 603 by Johanna van Gogh, is important for astronomical analysis because it explicitly describes a moonrise painting. In this letter, Vincent described to Theo several completed paintings and then went on to add that: "J'en ai un en train d'un lever de lune sur le même champ du cro-quis dans la lettre de Gauguin mais où des meules remplacent le blé. C'est jaune d'ocre sourd et violet. Enfin tu verras dans quelque temps d'ici." (I have one in progress of a moonrise over the same field as the sketch in the letter to Gauguin, but with wheat stacks replacing the wheat. It is dull yellow ochre and violet. Anyway, you will see it sometime soon.) (Letter 603, as numbered by Johanna van Gogh, Letter 790, numbered by the Van Gogh Letters Project)

Scholars consider this letter, which describes the moonrise painting as being "in progress," especially troublesome to date. Unfortunately, the letter itself does not bear either a handwritten date or postmark. Johanna van Gogh placed Letter 603 in the chronological sequence just before other let-ters more securely dated to September. This probably explains why the early authors Scherjon, de Gruyter and de la Faille dated the moonrise painting to August or September.

Several recent scholars argue instead that Letter 603 does not fall between Letter 602 of late August and Letter 604 of early September. But the experts differ on exactly what date to give to Letter 603 and thereby to the moonrise painting.

Jan Hulsker, an authority on van Gogh's correspondence, moved Letter 603 to "July 6" and observed that "the change in the sequence of these letters is not only important from the biographical angle but also for the chronology of Vincent's art, for it means that the canvases referred to in 603 should be dated 2 months earlier," including "the moonlit landscape with stacks of wheat" (Hulsker 1972: 26). Hulsker's assumption for the timing of Letter 603 explains why both of his catalogs dated the moonrise painting to July 6, 1889.

At some point during the summer of 1889, van Gogh's medical condition worsened, and the artist produced almost no works at all for a period of about 6 weeks. Hulsker dated Vincent's medical crisis to the days immediately after the moonrise painting, that is, Hulsker argued that the work stoppage ran from "about July 8 till about the middle of August" (Hulsker 1972: 30).

Art historian Ronald Pickvance, curator of the Metropolitan Museum of Art's 1986 exhibition "Van Gogh in Saint-Rémy and Auvers," offered a different chronology. Pickvance placed the moonrise painting in the range of July 8th to 13th and favored a date of about July 14th for Letter 603 that describes the moonrise canvas and July 16th for the onset of the medical crisis (Pickvance 1986: 37).

Our Texas State group wondered whether we could use astronomical methods to date the moonrise painting directly and thereby also resolve the controversy about the disputed date of letter 603.

Possible Dates for van Gogh's Moonrise

We can be certain that Vincent created F735 between May 8th, when he first arrived at Saint-Rémy, and late September, when he mailed the canvas to Theo in a batch of ten paintings that also included the famous *Starry Night*.

Letter 603 tells us that the bright orange body in F735 must be either a full or nearly full Moon. A full Moon appears in the region of the sky that is nearly opposite to the location of the Sun. The behavior of the rising and setting of the full Moon is also opposite to that of the Sun. That is, the full Moon rises just as the Sun sets. In fact, for these reasons early astronomers used the word "opposition" to refer to the time of the full Moon.

Computer calculations of the dates near the full Moons in 1889 quickly showed the only possible periods for van Gogh's painting were May

15th–17th, June 13th–15th, July 12th–14th, August 11th–13th, and September 9th–11th. On each of those days a full or nearly full Moon would have risen into the sky near the time of sunset.

A Cliff and a House

We noticed in van Gogh's *Moonrise* a striking topographic feature: the distinctive overhanging cliff that partially blocks the disk of the rising Moon. Vincent also included, in the foothills below the cliff, an unusual building that we called the "double house" because it had the appearance of a smaller structure attached to a larger dwelling. We were encouraged that these might be real features of the landscape because the overhanging cliff and the "double house" appear above the wheat field in fifteen of van Gogh's paintings and drawings from Saint-Rémy.

We knew that the Saint-Paul monastery still existed. If we made a research trip to Saint-Rémy, could we find the nearby "double house" and overhanging cliff? Could we determine the precise direction of the overhanging cliff, as seen from the wheat field near the monastery? Did a nearly full Moon rise in that direction on a date during 1889?

Fact-Finding Trip to Provence

To answer these questions, our Texas State group (Olson et al. 2003) traveled to Saint-Rémy in June 2002. Before leaving Texas, we contacted Les Astronomes Amateurs Du Delta, an astronomy club based in nearby Arles. Three of the group's members, Claude Suc, Vincent Suc, and Bruno Massal, helped us by scouting possible observing locations and then accompanying us during our visit.

Within minutes of our arrival in Saint-Rémy, we were gratified to see that the overhanging cliff actually does exist to the southeast of the monastery (Fig. 2.10). Measuring its precise coordinates as seen from the wheat field proved complicated, in part because Saint-Paul is still a working hospital, with both van Gogh's former room and the enclosed field, now a garden, strictly off-limits. The facility allows tourists to visit a different room called "Reconstitution Chambre Van Gogh," but this was not the actual room occupied by van Gogh in 1889.

More importantly, a forest of tall pine trees has grown up during the last century and obscures the landscape. For example, by exploring dirt roads

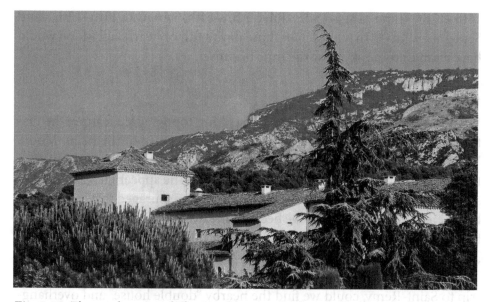

Fig. 2.10 *The overhanging cliff painted by van Gogh actually exists to the southeast of the Saint-Paul monastery. Our Texas State group determined the precise direction and altitude of the overhanging cliff by observing the Sun, Moon, and stars during a visit to Saint-Rémy. In this photograph the Moon passing behind the cliff is only faintly visible because the Sun was still above the horizon (Photograph by Russell Doescher. Used with permission)*

into the forest, we found that the "double house" (Fig. 2.11) still stands 2,100 ft southeast of the monastery, but this distinctive building can no longer be seen from locations near Saint-Paul.

The Arles group had forewarned us of these problems and helped us to find a large open field immediately northwest of Saint-Paul. From here we had a clear view directly over the monastery to the Alpilles beyond (Fig. 2.12). For 6 days and nights, we observed the Sun, Moon, and stars as they rose and thereby were able to measure the precise altitudes and directions of the peaks and cliffs of the mountain range.

Narrowing the Choices

Van Gogh's vantage point in the enclosed wheat field was near the north wall, which is barely visible at the extreme left edge of the painting. According to our topographic measurements, from van Gogh's position the artist would have seen the overhanging cliff 8,800 ft away in a direction to the southeast. More precisely, van Gogh would have seen the overhanging cliff at a

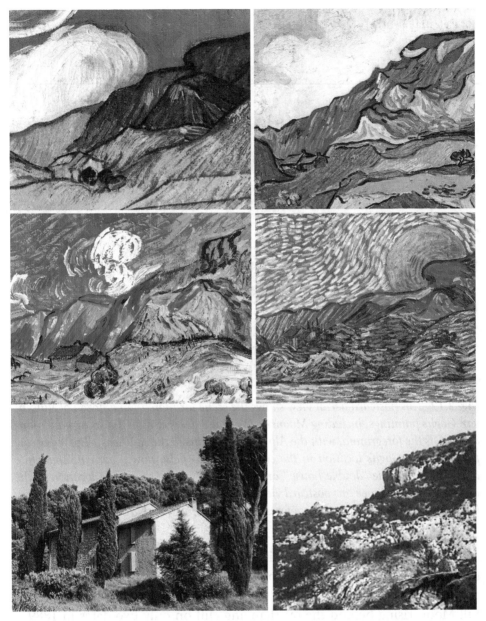

Fig. 2.11 *Vincent van Gogh, in the Moonrise painting and in more than a dozen other works, included an unusual building that we called the "double house" because it had a split-level roof, or the appearance of a smaller structure attached to a larger dwelling. The artist varied the roof colors, sometimes using tan and sometimes red. The actual "double house" – with a tan roof – still stands in the hills below the overhanging cliff, to the southeast of the Saint-Paul monastery. Upper left: "double house" and overhanging cliff, detail, F611, Wheat Field After a Storm. Upper right: "double house" and overhanging cliff, detail, F724, The Alpilles. Center left: "double house" and overhanging cliff, detail, F641, Enclosed Wheat Field. Center right: "double house" and overhanging cliff, detail, F735, Moonrise (Wheat Stacks). Lower left: "double house," photograph taken in 2002 (Photograph by the author.). Lower right: overhanging cliff, photograph taken in 2002 (Photograph by Russell Doescher. Used with permission)*

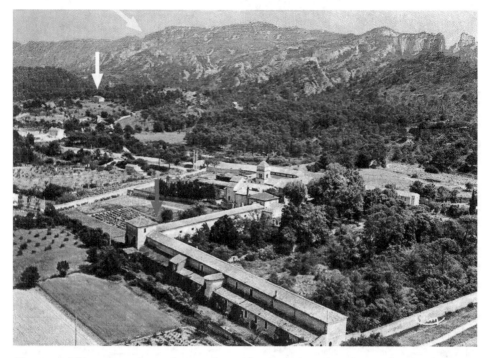

Fig. 2.12 *This postcard aerial view shows the scene for more than a dozen of Vincent van Gogh's paintings, including Moonrise (Wheat Stacks), F735. The Saint-Paul monastery fills the foreground, with the Alpilles mountains to the southeast. The red arrow points to van Gogh's location in the enclosed wheat field, now a garden. The white arrow points to the "double house," and the yellow arrow shows the location of the overhanging cliff. Since this postcard view was taken, the hillsides above the monastery have become covered with a dense forest of tall pine trees, obscuring the landscape*

compass direction of 126° (that is, 36° south of due east) and extending between altitude 4½° and 4¾° above the horizon. Computer calculations then showed that from the wheat field, van Gogh could have seen a nearly full Moon rising behind the overhanging cliff on only two dates in 1889 – May 16th and July 13th.

Weather

Meteorological observations from 1889, preserved at the Météo-France archives, show that favorable conditions prevailed on both of these evenings. Very heavy rain fell on May 14th and 15th, but skies cleared on May 16th. No rainfall at all occurred during the entire first 2 weeks of July, and the

fraction of the sky covered by clouds decreased on July 13th from 50 % to 30 %. The weather records provided a good consistency check but did not help us to establish a unique date.

Ripening Wheat

The colors in the foreground of *Moonrise* allow us to eliminate one of these dates. Shortly after arriving in Saint-Rémy in May, Vincent noted in a letter that green wheat fields surrounded the monastery. In another letter from the middle of June, he described a canvas of a field turning yellow and ears of wheat "whose tones are as warm as the crust of a loaf of bread." In late June, the artist painted reapers cutting wheat that was all yellow. The *Moonrise* painting, with reaped wheat in golden stacks, therefore, cannot correspond to a date in mid-May but fits perfectly with our astronomically derived date of July 13th.

Results for van Gogh's *Moonrise*

The Moon's disk spent less than 2 min passing behind the overhanging cliff. This allowed us to determine a precise time for van Gogh's moonrise – exactly 9:08 p. m. local mean time on July 13, 1889.

Because van Gogh produced approximately one painting or drawing per day at Saint-Rémy, our calculations therefore suggest the artist worked on the canvas perhaps later that evening or on the next day. Vincent probably wrote the letter describing the *Moonrise* as in progress on about July 14, 1889, a date that conflicts with the conclusions of many authors but agrees exactly with the chronology given by Ronald Pickvance. Based in part on our astronomical analysis, the Van Gogh Letters Project now dates this letter to July 14, 1889.

Van Gogh and the Natural World

Our topographic observations, combined with computer calculations, provide strong evidence that van Gogh was working from nature when he created *Moonrise*, a canvas with an accurate depiction of both the overhanging cliff in the Alpilles and the position of the rising Moon. The shadows of the wheat stacks do not align with the Moon, suggesting to us that van Gogh remained in the field as the evening twilight faded and the rising Moon began to swing toward the southern sky, causing the shadows to rotate.

In a letter written in 1888 to his artist friend Émile Bernard, Vincent described his reliance on the natural world: "Je ne travaille jamais de tête... Et je ne peux pas travailler sans modèle...j'ai tant peur de m'écarter du possible et du juste en tant que quant à la forme...j'ai tant de curiosité du possible et du réellement existant...J'exagère, je change parfois au motif mais enfin je n'invente pas le tout du tableau, je le trouve au contraire tout fait... dans la nature." (I never work from memory...and I cannot work without a model...I am too afraid of departing from the possible and the true in the matter of form...I have so much curiosity about what is possible and what really exists...I exaggerate, sometimes I make changes in a motif, but still I do not invent the whole picture, on the contrary, I find it all ready...in nature.) (Letter B19, as numbered by Johanna van Gogh, Letter 698, as numbered by the Van Gogh Letters Project)

When modern observers witness a summer full Moon rising in the southeast, they can think back to July 13, 1889, when van Gogh stood among the wheat stacks in the monastery field and captured a similar scene in his remarkable *Moonrise*.

Dramatic Twilight: Van Gogh's *Road with Cypress and Star*

Vincent van Gogh painted a dramatic twilight sky in his *Road with Cypress and Star*, created in 1890 at the town of Saint-Rémy-de-Provence in the south of France. This painting shows two bright objects, one especially brilliant, near a slender crescent Moon. Does this work depict morning twilight or evening twilight? In what direction did the artist face? How do astronomical calculations, Vincent's letters, and meteorological records allow us to determine the date and time when the artist observed the sky that inspired this canvas? What are the two bright objects near the crescent Moon – are they stars or planets?

Waxing Crescent Moon in *Road with Cypress and Star*

Vincent van Gogh lived at the hospital housed in the Saint-Paul monastery at Saint-Rémy-de-Provence for slightly more than a year, from May 8, 1889, to May 16, 1890. Art historians have concluded that he created *Road with Cypress and Star* (Fig. 2.13) very near the end of his year-long stay, shortly before he left Saint-Rémy by train on May 16th and returned to Paris.

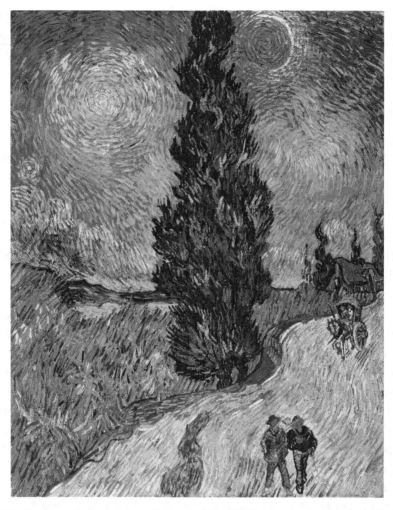

Fig. 2.13 *Road with Cypress and Star, F683, Vincent van Gogh, Saint-Rémy-de-Provence, 1890 (Collection Kröller-Müller Museum, Otterlo, the Netherlands)*

The sharp horns of the lunar crescent point to the left in *Road with Cypress and Star*. This orientation indicates that Vincent portrayed the lunar phase known as a *waxing crescent*, when the Moon is increasing in light during the period of about a week between new Moon (Moon not visible) and first quarter (Moon 50 % lit). Waxing crescents are visible in the western sky during evening twilight, and the extremely thin crescent in the painting suggests a date just a day or two after new Moon.

Working backwards from May 16, 1890, Vincent's last day in Saint-Rémy, our Texas State group began our astronomical analysis (Olson and Doescher 1988)

by asking three questions. What was the date of the previous new Moon? On what day did the waxing crescent Moon reappear in the evening sky? Were there any especially bright stars or planets in the sky near the crescent Moon on that date?

Moon and Planets

Our computer calculations determined that the relevant new Moon occurred on April 19, 1890. (By the time of the next new Moon, which fell on May 18, 1890, van Gogh was back in Paris with his brother Theo.) For an observer at Saint-Rémy, the first visibility of the waxing Moon occurred in the evening twilight near 7 p. m. local time on April 20, 1890. At that moment the Moon appeared as a very thin crescent, only 35 h after the new Moon. Our calculations showed that no bright stars shone very near the Moon on the evening of April 20th. The nearest prominent star, Aldebaran in the constellation Taurus, was more than 20° away.

But when we calculated planetary positions for April 20th, we were amazed to see that Venus was within 4° of the Moon! Radiant Venus, was much brighter than any of the nearby stars and would have dominated the western sky. Also, the planet Mercury stood only 3° from Venus. Mercury's appearance can be quite variable, but on this date the planet's light rivaled that of the "Dog Star" Sirius, the brightest star in the night sky. Mercury was below Venus in the sky, with their relative brightness similar to that shown in the painting. So, three brilliant objects – Venus, Mercury and the Moon – gathered in a tight grouping that became visible shortly after sunset on April 20, 1890.

On that night the illuminated fraction of the Moon was only 2 %. Such a lunar crescent is very thin, but spectacular and memorable when noticed, and even more remarkable here because of the close proximity of Venus and Mercury.

Because of the rapid motion of the Moon in its orbit, the three bodies grouped close together only on April 20th and became dispersed by April 21st and succeeding days.

We emphasize that we did not search through numerous dates throughout van Gogh's entire life, and we did not look randomly for celestial configurations that resembled the sky of *Road with Cypress and Star*. Our Texas State team found this extraordinary grouping on the first logical date we examined – the day of the last waxing crescent Moon that van Gogh could have seen just before he left Saint-Rémy.

Mirror Image in *Road with Cypress and Star*

A difference between the computed sky and the painted sky requires comment. The grouping Moon-Venus-Mercury formed a broken line, with spacing and angle nearly identical to that in the painting, but van Gogh would have seen the planets on April 20th below and to the right of the Moon, while the painting shows them below and to the left. This mirror-image reversal may have occurred for compositional reasons. We also noticed that there may be a similar left-to-right mirror reversal in van Gogh's famous *Starry Night*.

Mirror Image in the Swirling Sky of *Starry Night*

UCLA art historian Albert Boime and Harvard astronomer Charles Whitney have suggested that a famous nineteenth-century drawing of a spiral nebula may have inspired the spiral pattern in van Gogh's *Starry Night* (Boime 1984: 94; Whitney 1986: 358). This nebula, commonly known as the Whirlpool Galaxy, bears the scientific name M51. The Anglo-Irish astronomer Lord Rosse used his great telescope, then the largest in the world, to discover the spiral nature of this cloud of stars in the constellation of Canes Venatici, the Hunting Dogs. Lord Rosse's often-reproduced drawing (Fig. 2.14) of the swirling nebula possibly became known to van Gogh through the writings of Camille Flammarion, a French astronomer, prolific author, and a popularizer of astronomy at that time.

If van Gogh read any astronomy book, the most likely candidate is Flammarion's popular work, appropriately called *Astronomie Populaire*. This volume included a reproduction of Lord Rosse's drawing with an explanatory text: "More extraordinary, still more wonderful are the star clusters that appear organized in spirals, and among them, splendid and fantastic is the amazing nebula located in the constellation of the Hunting Dogs…the great telescope of Lord Rosse has revealed the singular structure" (Flammarion 1884: 814).

In another book, *Les Étoiles et les Curiosités du Ciel*, Flammarion reproduced the drawing with an even more florid description of the spiral nebula:

> One evening in the spring of the year 1845, just as he was putting the finishing touches on the mirror of his huge telescope and was trying it out on the most beautiful nebulae in the heavens, Lord Rosse suddenly stopped short, stunned by the picture that had appeared!…This strange nebula appeared in the field of the telescope in the form of a series of constellated spirals, wrapping around each other…A tremendous whirlpool of suns was revealed in this splendor. The spirit flying up until these starry depths crossed a new universe, forgot ours, and walked out on the dust of the stars…All of that moves, all vibrates, and it all revolves…. (Flammarion 1882: 123)

Fig. 2.14 *The spiral galaxy M51, commonly known as the Whirlpool Galaxy. The astronomer Lord Rosse used his great telescope to discover the spiral nature of this nebula in 1845. Lord Rosse's drawing, popularized in France in books by Camille Flammarion, may have influenced the swirling skies of Vincent van Gogh*

These vivid descriptions by Flammarion, along with the reproductions of Lord Rosse's drawing of the Whirlpool Galaxy, may have helped to inspire the swirling sky of van Gogh's *Starry Night*.

Our Texas State group noticed that several specific features of M51 resemble the central part of *Starry Night* much better when reversed left-to-right. In particular, the spiral motion in M51 is counter-clockwise, while van Gogh's central image appears to be rotating clockwise. This possible mirror reversal in *Starry Night* helps to make more plausible the mirror reversal of the position of the planets in *Road with Cypress and Star*.

A Rare Conjunction in April 1890

Vincent may have spotted the planetary grouping on April 20, 1890, just by chance while walking outside near sunset. But popular journals forewarned many French citizens, possibly including van Gogh, about the celestial display.

The periodical *L'Astronomie*, published in Paris by Camille Flammarion, included in the first issue for 1890 an "Agenda Astronomique" calendar that mentioned that on April 20th both Mercury and Venus would be in conjunction with the Moon. The issue for April 1890 gave more details and strongly encouraged readers to view the rare sight:

> Venus – This heavenly body is so brilliant that it remains easy to distinguish, in the west, immediately after the setting of the Sun…Conjunction with the Moon is on April 20th.
>
> On the 20th of April, starting at 7 p.m. and until 8:20 p.m., study the thin lunar crescent, on the next day after the new Moon.
>
> Mercury – This planet finds itself in conditions exceptionally favorable for observation…These events present themselves only very rarely. Moreover, there will be very interesting conjunctions which deserve full attention from the numerous friends of the noble Science of the Heavens…on April 20th….
> (Flammarion 1890: 157)

The journal *Scientific American* for 1890, though not readily available to van Gogh in France, did contain an interesting article entitled "Position of the Planets for April." The writer located Mercury near the brighter Venus as evening stars in the second half of April and advised that: "…sharp-sighted observers may find them soon after sunset, Venus serving as guide to her smaller neighbor." (Munn and Beach 1890: 194)

These words could serve as a description of the sky in *Road with Cypress and Star*, which features a dazzling object and a "smaller neighbor" nearby.

Both from our own computer simulations and from contemporary accounts, we know that in the evening twilight of April 20, 1890, the bright planets Venus and Mercury stood very near a thin crescent Moon – the last waxing crescent Moon that van Gogh could have observed at Saint-Rémy.

Confirmation from Meteorological Evidence

Charles Whitney collected weather records for Provence in April 1890. After learning about our theory regarding the planetary grouping on April 20th, Whitney pointed out how the meteorological observations supported this date: "In St.-Rémy where van Gogh was living, these data show 4 days of moderately heavy rain prior to the 18th of April, 1890…The sky in nearby Arles the morning of the 19th was six-tenths overcast, while on the next 4 days the cloud cover ranged from two-tenths to three-tenths. Thus the 20th was the first fine day in a week, and van Gogh would probably have gone out to paint" (Whitney 1989: 237).

The meteorological evidence helps to explain why van Gogh, after several days of being forced to work indoors, might have been walking outside and looking for landscape subjects on April 20th.

Confirmation in a van Gogh Letter from 1890

Two months later, in mid-June of 1890 when van Gogh had relocated to Auvers-sur-Oise in the north of France, he drafted a letter that included a sketch of *Road with Cypress and Star*. Vincent remembered his time spent down in Provence and described how the sky in that canvas included an especially brilliant object:

> J'ai encore de là-bas un cyprès avec une étoile. un dernier essai – un ciel de nuit avec une lune sans éclat, à peine le croissant mince émergeant de l'ombre projetée opaque de la terre – une étoile à éclat exageré, si vous voulez, éclat doux de rose & vert dans le ciel outremer où courent des nuages. En bas une route bordée de hautes cannes jaunes derrière lesquelles les basses Alpines bleues, une vieille auberge à fenêtres illuminées orangées et un très-haut cyprès tout droit, tout sombre. Sur la route une voiture jaune attelée d'un cheval blanc et deux promeneurs attardés. Tres romantique si vous voulez mais aussi je crois "de la Provence."
>
> (I also have from down there a cypress with a star. A last attempt – a night sky with a moon without brightness, the slender crescent barely emerging from the opaque projected shadow of the Earth – a star with exaggerated brilliance, if you like, a soft brightness of rose and green in the ultramarine sky where clouds run. Below, a road bordered by tall yellow canes behind which are the blue foothills of the Alpilles, an old inn with orange illuminated windows and a very tall cypress, very straight, very dark. On the road a yellow carriage harnessed to a white horse, and two late wayfarers. Very romantic if you like, but also I think "Provençal.")
>
> (Letter 643, as numbered by Johanna van Gogh, Letter RM23, as numbered by the Van Gogh Letters Project)

The mention of "late wayfarers" is consistent with our result that this painting shows an evening twilight, not a morning scene. Vincent's explicit statement, that *Road with Cypress and Star* is a "last attempt" from "down there" in Provence, likewise is consistent with our analysis that dates the painting to the last lunar month before the artist's departure from Saint-Rémy.

As the daylight faded and the dramatic twilight deepened on April 20, 1890, Vincent van Gogh could have witnessed a rare grouping of dazzling Venus and bright Mercury near a slender crescent Moon – an extraordinary sight that may have inspired the painted sky in his *Road with Cypress and Star*.

References

Auvers Tourist Office (2000) *Auvers sur Oise, Its History and Its Painters*. Auvers sur Oise: Auvers Tourist Office.

Boime, Albert (1984) Van Gogh's *Starry Night*: A History of Matter and a Matter of History. *Arts Magazine* **59**(4), December, 86–103.

Club Philatélique d'Auvers sur Oise (1998) *Promenade dan Auvers sur Oise à la Belle Époque*. Pontoise: Edition Services.

Défossez, Marie-Paule (1993) *Auvers-sur-Oise: Le Chemin des Peintres*. Saint-Ouen-l'Aumône: Editions du Valhermeil.

de la Faille, Jacob-Baart (1928) *L'Oeuvre de Vincent van Gogh: Catalogue Raisonné*. Paris and Bruxelles: G. van Oest.

de la Faille, Jacob-Baart (1938) *Vincent van Gogh*. New York: French and European Publications.

de la Faille, Jacob-Baart (1970) *The Works of Vincent van Gogh: His Paintings and Drawings*. New York: Reynal & Company.

Flammarion, Camille (1882) *Les Étoiles et les Curiosités du Ciel*. Paris: C. Marpon and E. Flammarion.

Flammarion, Camille (1884) *Astronomie Populaire*. Paris: C. Marpon and E. Flammarion.

Flammarion, Camille, ed. (1890) Observations Astronomiques a faire du 15 avril au 15 mai. *L'Astronomie* **9**, 157–158.

Gachet, Paul, Jr. (1994) *Les 70 jours de van Gogh à Auvers*. Saint-Ouen-l'Aumône: Editions du Valhermeil.

Hulsker, Jan (1972) Van Gogh's threatened life in St. Rémy and Auvers. *Vincent: Bulletin of the Rijksmuseum Vincent van Gogh*. **2**(1), 21–39.

Hulsker, Jan (1977) *The Complete Van Gogh: Paintings, Drawings, Sketches*. New York: Harrison House, Harry N. Abrams.

Hulsker, Jan (1996) *The New Complete Van Gogh: Paintings, Drawings, Sketches*. Philadelphia: John Benjamins.

Kostenevich, Albert (1995) *Hidden Treasures Revealed*. New York: Harry N. Abrams.

Mothe, Alain (1987) *Vincent van Gogh à Auvers-sur-Oise*. Paris: Editions du Valhermeil.

Munn, Orson Desaix, and Alfred Ely Beach, eds. (1890) Position of the Planets for April. *Scientific American* **62**(13), March 29, 1890, 195.

Olson, Donald W., and Russell L. Doescher (1988) Van Gogh, Two Planets, and the Moon. *Sky & Telescope* **76**(4), October, 406–408.

Olson, Donald W., Russell L. Doescher, Jennifer A. Burleson, Harvey E. Davidson, Lana D. Denkeler, Elizabeth D. FitzSimon, Ryan P. McGillicuddy, Dianne N. Montondon, Tomas Sanchez, Vanessa A. Voss, Jennifer L. Walker, and Amy E. Wells (2001) Identifying the "Star" in a Long-Lost van Gogh. *Sky & Telescope* **101**(4), April, 34–39.

Olson, Donald W., Russell L. Doescher, and Marilynn S. Olson (2003) Dating van Gogh's *Moonrise*. *Sky & Telescope* **106**(1), July, 54–58.

Pickvance, Ronald (1986) *Van Gogh in Saint-Rémy and Auvers*. New York: Metropolitan Museum of Art, Harry N. Abrams.

Scherjon, W., and Willem Josiah de Gruyter (1937) *Vincent van Gogh's Great Period: Arles, St. Rémy and Auvers sur Oise*. Amsterdam: De Spieghel.

Vimont, Eugène (1890) Observationes Astronomiques a faire du 15 juin au 15 juillet 1890. *l'Astronomie* **9**, 237–240.

Whitney, Charles A. (1986) The Skies of Vincent van Gogh. *Art History* **9**(3), 351–362.

Whitney, Charles A. (1989) Van Gogh's Sky. *Sky & Telescope* **77**(3), March, 237.

3

Edvard Munch: Mysterious Skies in Norway

Edvard Munch, Norway's most famous painter, created canvases depicting twilights and night skies with enigmatic features that generate lively discussion and debate among art historians.

Edvard Munch's iconic painting *The Scream* includes a spectacular blood-red sky. What is the relation between the extraordinary Norwegian sky of *The Scream* and the volcanic eruption of Krakatoa half a world away in Indonesia? Is the historical marker, encountered by tourists who visit Oslo, in the location where Munch actually had his original "*Scream* experience"? Is the figure in *The Scream* standing on a bridge, as often claimed, or somewhere else?

Edvard Munch's *Starry Night* depicts a scene at Åsgårdstrand, a resort town beloved by artists and writers and a favorite location for Munch. A brilliant celestial object dominates the night sky. Is this a bright star or a bright planet? Did previous authors correctly describe the astronomical inspiration for this painting? How can we use astronomical analysis and meteorological records to determine the date when Munch observed this celestial scene?

Edvard Munch's *The Storm* includes a bright star or planet that shines through the clouds in the sky above Åsgårdstrand's Grand Hotel. How do astronomical calculations, meteorological records, newspaper accounts, and memoirs allow us to determine a date and precise time when Edvard Munch observed this scene? What is the identity of the bright celestial object?

Edvard Munch's *Sunrise in Åsgårdstrand* features the Sun just above the horizon, with a glitter path of reflected light stretching across the fjord.

D.W. Olson, *Celestial Sleuth: Using Astronomy to Solve Mysteries in Art, History and Literature*, Springer Praxis Books, DOI 10.1007/978-1-4614-8403-5_3,
© Springer Science+Business Media New York 2014

How does the position on the horizon of the rising Sun, combined with weather records, allow us to deduce a date and precise time for this painting? During Edvard Munch's lifetime, his most admired and beloved painting was a tranquil Åsgårdstrand landscape entitled *Girls on the Pier*. What is the yellow disk in the sky of this painting? Is it the Sun (as many art historians insist) or is it the Moon (as other art historians are equally certain)? Do the mysterious reflections in the fjord defy the laws of physics? Or, can we explain the reflections using the principles of optics?

The Scream

What is the relationship between the extraordinary blood-red Norwegian sky of *The Scream* and the volcanic eruption of Krakatoa half a world away in Indonesia? How do clues in Munch's preliminary sketches for *The Scream* allow us to find the precise location of Munch's *Scream* experience? Is the historical marker, encountered by tourists who visit Oslo, in the correct location where Munch actually had his original *Scream* experience? Is the figure in *The Scream* standing on a bridge, as often claimed, or somewhere else? Toward which direction was Munch facing as he observed the scene? On what dates did the "Krakatoa twilights" appear in Norway? Does the direction of sunset and evening twilight on those dates match the direction Munch was facing? What did Munch see in the sky?

Only a few artworks have become icons of popular culture in our time. Everyone knows the enigmatic smile of the *Mona Lisa*, the farm couple with a pitchfork in *American Gothic*, the pose of the *Thinker*, and the swirling skies in the *Starry Night*. *The Scream* (Fig. 3.1) by Norwegian artist Edvard Munch (1863–1944), has uniquely become the symbol of anxiety in our modern age.

Astronomers have a special interest in *The Scream* because of the striking and lurid sky in the painting. Munch's own words, recorded in documents preserved at the Munch Museum in Oslo, make it clear that an actual event inspired the spectacular twilight in *The Scream*: "I was walking along the road with two friends – then the Sun set – all at once the sky became blood-red – and I felt overcome with melancholy. I stood still and leaned against the railing, dead tired – clouds like blood and tongues of fire hung above the blue-black fjord and the city. My friends went on, and I stood alone, trembling with anxiety. I felt a great, unending scream piercing through nature."

Fig. 3.1 *The Scream, Edvard Munch, 1895 (© 2013 The Munch Museum/The Munch-Ellingsen Group/Artists Rights Society, NY). The artist created multiple variations of this scene with the titles Despair, The Scream, and Anxiety. In each work the same blood-red twilight sky appears above figures on a road. There is also a prominent railing, a few buildings representing the city of Christiania on the right, a peninsula extending into the fjord, and rounded hills on the horizon. Although the people in the foreground vary from painting to painting, the topographic details are the same in each*

Munch never forgot that sky, and during his lifetime he wrote many such accounts of this memorable evening. Another version gives more details about the location and the remarkable colors:

One evening I was walking out along a mountain road near Christiania [Christiania, the capital city of Norway, was renamed Oslo in 1925] – together with two companions…the Sun went down…it was as if a flaming sword of

blood slashed open the vault of heaven – the atmosphere turned to blood – with glaring tongues of fire – the hills became deep blue—the fjord shaded into cold blue – among the yellow and red colors – that garish blood-red – on the road – and the railing – my companions' faces became yellow-white – I felt something like a great scream – and truly I heard a great scream.

Munch painted the most famous version of *The Scream* in 1893 as part of *The Frieze of Life*, a group of works derived from his personal experiences. As mentioned earlier, between 1892 and 1896 he created multiple variations of the scene with the titles *Despair*, *The Scream*, and *Anxiety*. Although the people in the foreground vary from painting to painting, the topographic details are the same in each, suggesting that these works might depict an actual location. Our Texas State group wondered whether this precise location could be found. Along which road did Munch have the *Scream* experience? Toward which compass direction was Munch facing for the view shown in *The Scream*? When did Munch and his two friends walk along the road? What did Munch see in the sky?

What Year? What Season?

In a monograph devoted to *The Scream*, Reinhold Heller stated that unusually colorful sunsets are "visible in Oslo…in the late months of autumn…As the sun then sets, it shines onto the clouds…and transforms them into stripes and tongues of intense reds and yellows in the blue sky. The phenomenon is an extremely impressive one, as unforgettable as it is indescribable" (Heller 1972: 72). Aware that one of Munch's prose accounts about the red sky was written on January 22, 1892, Heller judged that the original experience occurred shortly before, in the fall of 1891.

A recent BBC documentary about *The Scream* adopted the same explanation, noting that "red and yellow wave-like clouds are a climatic peculiarity of northern Europe, and were frequently painted by artists from the north" and agreeing that the event occurred "probably in 1891" during "late autumn" (Bohm-Duchen 2001: 161–167).

At the other extreme, Thomas Messer argued that "Nothing external gives a clue to the horror that impels the outcry" and observed that the "bandlike arrangements that lend intensity and swirling motion to the composition as a whole have often been identified as visualizations of sound waves" but alternately could be "externalizations of force and energy" (Messer 1973: 84).

These explanations did not seem adequate to us. Messer seemed to imply that Munch's experience was entirely internal and psychological, yet Munch's written accounts say that a blood-red sky preceded his melancholy and triggered the scream. Moreover, Munch attached great importance to this unusually awe-inspiring twilight, but the sunsets as described by Heller would occur fairly often, perhaps every autumn.

We began by searching astronomical and meteorological records from the years just prior to January 22, 1892, looking (without success) for an impressive event that could have so dramatically affected Munch. But, as we learned more about Munch, we realized that the original experience with the twilight sky could have been much earlier. In fact, many paintings created in the 1890s for *The Frieze of Life* were inspired by events from years before, as recorded in his diaries and notebooks.

For example, Munch's beloved sister Sophie died in 1877. The artist depicted this tragic scene in a series of works entitled *Death in the Sickroom* in 1893 – fully 16 years afterward. Munch's mother Laura had died in 1868, and the artist depicted one of his last walks with his mother in a series of works created during 1890–1893. We wondered whether this pattern of an autobiographical event painted much later held true for *The Scream*. We found support for this idea in a book by Arne Eggum, former chief curator of the Munch Museum, who disagreed with Heller and preferred the summer of 1886 as the probable date for Munch's walk along the mountain road (Eggum 1990: 227).

An Earlier Date for The Scream?

During a stay in Nice in the winter of 1891–1892, Munch discussed art with his friend Christian Skredsvig. A conversation from that time period indeed suggests that *The Scream* event occurred considerably earlier:

> For a long time he had wanted to paint the memory of a sunset. Red as blood. No, it was coagulated blood. But no one else would perceive it the same way he did. They would think only about clouds. He talked himself sick of this sight that had gripped him with terror. With sadness, because the paltry resources of painting were not adequate. 'He is striving after the impossible and has despair as his religion,' I thought, but I advised him to paint it. – And so he painted his remarkable 'Scream.' (Skredsvig 1908: 117)

In recalling his time spent in Nice, Edvard Munch himself explicitly mentioned the years of the original inspirations for three of the paintings in

The Frieze of Life: "...the first *Scream*...*Kiss*...*Melancholy*...For these a number of rough sketches had already – in 1885–89 – been done in that I had written texts for them – more correctly said, these are illustrations of some memoirs from 1884..." (Eggum 1990: 17)

Munch's Bohemian Days of the 1880s

Munch helped to date the origin of *The Scream* in another way in a letter to his friend Jens Thiis: "You don't have to go so far in order to explain the genesis of *The Frieze of Life* – its explanation lies in the Bohemian time itself" (Woll 1978: 230).

Although Munch's connection to the Bohemian community of artists and writers is well documented for 1884, the Bohemian days of his memory could plausibly originate in the second half of 1883, when Munch shared a studio in Christiania with six other young artists. Munch exhibited his paintings publicly for the first time at the Art and Industry Exhibition during the summer and the Fall Exhibition in December of 1883.

Moreover, art historians suggest that Munch almost certainly attended the wildly controversial Christiania premiere of Henrik Ibsen's play *Ghosts* on October 17, 1883. The play, which contrasted the honest, free life of the Bohemian artists to the hypocritical conventionality of Norwegian society, polarized the capital. Arne Eggum noted that Munch at the same time painted a portrait of one of his friends in the characteristic pose of the Bohemian Osvald in the play. (Eggum 1994: 13–14)

But this eventful season for artists was also an eventful time for sky watchers, and we now realized that science could explain the blood-red sky in *The Scream*. The end of 1883 and the first months of 1884 had some of the most spectacular twilights of the last 150 years!

Krakatoa Twilights

The volcanic island of Krakatoa (Figs. 3.2 and 3.3) erupted in a cataclysmic explosion on August 27, 1883, and sent dust and gases high into the atmosphere. Magnificent fiery sunsets and sunrises resulted, first in the southern hemisphere, then near the equator, and eventually in northern latitudes, as the cloud of volcanic aerosols spread worldwide in the following months.

A report issued by the Royal Society in London devoted more than 300 pages to "Unusual Optical Phenomena of the Atmosphere," with a section collecting the "Descriptions of the Unusual Twilight Glows in Various Parts of the World, in 1883–4" (Symons 1888).

ISLAND OF KRAKATOA, IN THE STRAITS OF SUNDA, THE CENTRE OF THE LATE VOLCANIC ERUPTION, SAID TO HAVE DISAPPEARED.

Fig. 3.2 *This woodcut of Krakatoa appeared in* The Illustrated London News *on September 8, 1883. When observers reached the scene, they discovered that much of the island had disappeared in a cataclysmic explosion*

Newspapers and scientific journals from this time period published hundreds of accounts from astonished observers worldwide. The effects had reached New York by November 1883:

> Soon after 5 o'clock the western horizon suddenly flamed into a brilliant scarlet, which crimsoned sky and clouds. People in the streets were startled at the unwonted sight and gathered in little groups on all the corners to gaze into the west. Many thought that a great fire was in progress…. People were standing on their steps and gazing from their windows as well as from the streets to wonder at the unusual sight. The clouds gradually deepened to a bloody red hue, and a sanguinary flush was on the sea… (*New York Times,* November 28, 1883)

Observers in Maine were also impressed:

> For several days past a striking and beautiful phenomenon has accompanied the sunset, and excited much comment. It is a blood-red coloring of the western sky, 10 or 12 degrees high, and appears just after sunset…. The effect upon buildings of the reflected light was similar to that of red theatrical flames…. (*New York Times*, December 1, 1883)

Colored stripes and bands in the sky, like those later painted in *The Scream*, appeared to Pennsylvania residents, who "…witnessed a most beautiful and startling phenomenon in the eastern heavens…. The sky that morning was fairly aglow with crimson and golden fires, when suddenly, to their great astonishment, an immense American flag, composed of the national colors, stood out in bold relief high in the heavens, continuing in view for a considerable length of time" (*Hanover Spectator*, December 19, 1883).

Fig. 3.3 *This woodcut of volcanic activity at Krakatoa appeared in the London illustrated paper, The Graphic, on August 11, 1883. Later that same month the island blew itself apart in a violent explosion that sent dust and gases high into the atmosphere*

In England, the journal *Nature* published a lengthy series of reports under the heading "The Remarkable Sunsets," beginning in December 1883. Newspapers printed dozens of letters with descriptions such as the following: "The sunset last evening at Eastbourne surpassed anything of the kind seen on the south coast. The sky changed from a pale orange to a blood red, and it seemed as if the sea itself were one mass of flames" (*Times of London*, November 29, 1883).

William Ascroft, an especially diligent English observer of the twilights, concluded that the "finest occurred midwinter 1883–84, when some deepened into the richest crimson, and were known as 'Blood Afterglows'" (Simkin and Fiske 1983: 159).

The English poet alfred Lord Tennyson remembered this season and later used the image in his poem titled "St. Telemachus":

> Had the fierce ashes of some fiery peak
> Been hurl'd so high they ranged about the globe?
> For day by day, thro' many a blood-red eve…
> The wrathful sunset glared….

<div align="right">(Tennyson 1892: 17)</div>

The descriptive phrase "blood-red color" ("d'une couleur rouge sang") appeared in the French journal *Comptes Rendus* in a January 1884 report from Paris (Boillot 1884: 253). Even more vivid color references appear in a January 1884 account from Provence: "…after sunset the landscape was lit up as if by an immense fireworks display…the illumination, at first golden with a predominance of yellow, passed to orange and rose, and by gradations, over 15 min, to a blood-red ["rouge de sang"]" (Gasparin 1884: 281). The group eventually found hundreds of accounts worldwide from observers describing the Krakatoa twilight skies as "blood-red" – exactly the same words used by Edvard Munch in his passages about the sky that inspired *The Scream*.

Munch definitely could have seen the Krakatoa twilights even at Christiania's high northern latitude. The reports collected by the Royal Society in London show that the unusual glows appeared in Norway from late November 1883 through the middle of February 1884. At the end of November, astronomers Carl Fredrik Fearnley and Hans Geelmuyden at the Christiania Observatory first noticed the "very intense red glow that amazed the observers" and developed into a "red band." The daily paper reported: "A strong light was seen yesterday and today around five o'clock to the west of the city. People believed it was a fire: but it was actually a red refraction in the hazy atmosphere after sunset" (*Christiania Dagbladet*, November 30, 1883).

A Different Volcano?

A literature search showed that the atmospheric scientist Alan Robock of Rutgers was apparently the first to recognize the spectacular sky in *The Scream* as a volcanic twilight. But Robock concluded that the painting "shows a red volcanic sunset over the Oslo harbor produced by the 1892 Awu eruption" (Robock 2000: 197). This cannot be the correct volcano, because one of Munch's prose accounts about the blood-red sky was written on January 22, 1892, and the eruption of Awu did not occur until June 7, 1892.

Fact-Finding Trip to Norway

If volcanic aerosols from Krakatoa colored the skies when Munch and his friends took their walk, then the date of this experience must have been between the end of November 1883 and the middle of February 1884, therefore near the winter solstice. Such a view of a Krakatoa sunset must have been toward the southwest.

Our Texas State group (Olson et al. 2004: 33) traveled to Oslo in May 2003 in part to examine documents in the archives at the Munch Museum and the National Library. To determine the direction of the view shown in *The Scream*, we also spent several days hiking in the hills near Oslo to find the precise location where Munch and his friends were walking when he saw the blood-red sky.

We wanted to compare the topographic features of Oslo with Munch's artwork. But since we were interested in the location of Munch's original experience rather than how he reworked the motif, we knew that one drawing in particular was the most important for this purpose. Art historians agree that this sketch (cataloged by the Munch Museum as T126 p. 10 R) is the initial study for the first version of *Despair*, which Munch called "the first Scream." This drawing (Fig. 3.4) contains specific topographic details: a cliff on the left; a road with a railing turning left and descending beyond the cliff; and, in the fjord beyond, an island with a prominent round hill. Ship masts extend above the horizon, showing that Munch's viewpoint for the drawing had a rather low elevation, less than 100 ft above the water level.

All of the later painted versions, including the most famous *Scream*, have a much higher viewpoint, looking down to small and distant ships in the harbor below, with the city suggested on the right.

Fig. 3.4 Top: This drawing, the first study for the earliest versions of Edvard Munch's painting series (Despair, The Scream, Anxiety) includes topographic clues that allowed us to find Munch's position. A cliff is visible on the left, and the direction of view is toward the southwest over a distinctive round hill on Hovedø island. (T126 p. 10 R, © 2013 The Munch Museum/The Munch-Ellingsen Group/Artists Rights Society, NY) Bottom: Metal and concrete guardrails now line the road at the spot where Edvard Munch saw a blood-red twilight in the southwestern sky. The road, known as the Ljabrochausséen in the nineteenth century, is now called the Mosseveien. The view of the cliff and island (partly hidden behind the modern concrete barriers) matches the artist's drawing only from this spot – the location of Munch's initial Scream experience (Photograph by Russell Doescher. Used with permission)

Christiania, from Ekeberg I. Norway.

Fig. 3.5 *This postcard from about 1900 shows the Akershus peninsula and the harbor of Christiania, as seen from high up on the Ekeberg hill. In the painted versions of The Scream, Munch combined the railings from a lower viewpoint along the Ljabrochauséen road with the vista of the harbor from an upper viewpoint on a rocky ledge*

So, we were actually searching for two locations, with the lower location the more important one because the original experience occurred there. During our visit to Oslo we found both the lower and upper viewing locations on the slopes of a 465-ft hill called the Ekeberg.

The upper location is a rocky ledge 420 ft above the harbor. From this spot, we could see the Akershus peninsula extending into the fjord, as well as the spire of Vor Frelser's Church and the dome of Trinity Church, the buildings that Munch used to indicate the city skyline. Baedeker tourist guides from the late nineteenth century encouraged visitors to be sure to visit this overlook, specifically advising tourists to "ascend the stony old road...past the farm of *Ekeberg*...beyond which we follow a field-road." After 5 min, one would leave the road and walk "to the right for a few hundred paces to a rocky platform affording a fine view of the town and harbor" (Baedeker 1889: 12). This panorama appeared on dozens of postcards (Fig. 3.5), lantern slides and stereoviews from that time. Although the view toward the fjord is generally towards the west and southwest, this upper location *cannot* be the precise spot where Munch saw the red twilight and

Fig. 3.6 *This nineteenth-century photograph proves that the Ljabrochausséen road, at the foot of the Ekeberg hill, was bordered by railings exactly like those in Munch's artwork (Used with permission of the Oslo City Museum)*

"leaned against the railing, dead tired." The Baedeker maps, along with other early maps that we examined, make it clear that no road (and railing) reached this overlook on a rocky ledge.

The lower viewpoint, the one employed for Munch's first sketch, is on a road that wraps around the bottom of the western slope of the Ekeberg hill. The road, now called the Mosseveien, appears on the nineteenth-century maps with the name "Ljabrochausséen." Following the advice of art historian Frank Høifødt, we visited the Oslo City Museum where the archive collection includes a nineteenth-century photograph (Fig. 3.6) showing the Ljabrochausséen bordered by railings exactly like those drawn and painted by Munch in *The Scream*.

This road with the lower viewpoint is only 50 ft above the water level, and dockside cranes now extend above the horizon much as the ship masts do in Munch's drawing. By studying the perspective of the cliff and the distinctive round hill on the island called Hovedø, our Texas State group could determine Munch's position (Figs. 3.4 and 3.7) with remarkable precision, within plus or minus 10 ft. The spot is 300 ft from the modern tunnel portals where the E6 motorway passes through the Ekeberg hill, measured from the tunnels in the direction toward the intersection where the Mosseveien joins with the E18 motorway. This must be the location where Munch had his "*Scream* experience." Munch's direction of view in the drawing was toward the southwest – exactly where the Krakatoa twilights appeared in the winter of 1883–1884.

Fig. 3.7 This photograph shows the view from the hillside a few feet above the Mosseveien, enabling us to see over the roof of the modern warehouse and detect the profile of Hovedø island in the fjord. The distinctive round hill on the island appears in Edvard Munch's drawing, the first sketch for the series that eventually included The Scream (Photograph by the author)

Bridge or Road in The Scream?

Many writers assume that the figure in *The Scream* is standing on a bridge. The caption for the opening illustration in a *Smithsonian* magazine article states that Munch "had a genius for creating discomfiting perspectives," exemplified by the "rapid recession of the bridge in his iconic 1893 *The Scream*" (Lubow 2006: 58). When the Museum of Modern Art recently announced that a pastel version of *The Scream* would be on view for 6 months, a writer for the *New York Times* described the scene as "Depicting a hairless figure on a bridge" (Vogel 2012). Regarding the same pastel version, the BBC began a story with the sentence, "Under a swirling, blood-red sky,

a lone figure on a bridge clasps its head in its hands" (Kelly 2012), while an essay in the *Guardian* agreed that the work showed "the man on the bridge screaming" (Smith and Smith 2012). The guidebook for Scandinavia by travel writer Rick Steves states that "Munch's most famous work shows a man screaming.... The figure seems isolated from the people on the bridge" (Steves 2012: 252). A Google search with three keywords – Munch, Scream, bridge – turns up hundreds of similar hits placing the figure on a bridge.

As explained earlier, the actual location of Munch's original "*Scream* experience" was not on a bridge but rather along a road called the Ljabrochausséen, bordered by railings. The sudden drop-off beyond the railings gives the illusion of a bridge.

The promotional materials for the 2012–2013 Museum of Modern Art exhibition of the pastel version of *The Scream* originally contained the phrase "haunting rendition of a hairless figure on a bridge under a yellow-orange sky," which was corrected in the final press release to "haunting rendition of a hairless figure on a road under a yellow-orange sky."

Scream *Marker on the Wrong Road*

Near the top of the Ekeberg hill, about 450 ft east of the rocky ledge overlook, modern tourists will find a *Scream* historical marker (Fig. 3.8) near metal railings on a horseshoe bend of a road called the Valhallveien. Many visitors stand near the marker or lean against the modern railings and imagine that they are reenacting Munch's experience and view. The legend on the historical marker reads "The Scream by Edvard Munch…the landscape was viewed from here."

However, this marker was placed on the wrong road. The numerous nineteenth-century maps that our Texas State group consulted at the Oslo City Museum show that this modern Valhallveien road with the horseshoe bend did not exist in the nineteenth century.

Some Norwegian authors are beginning to question the accuracy of the current historical marker. A recent essay in Oslo's evening paper discusses plans for future Munch commemorations and bears the heading "The Scream Viewpoint: Can Oslo come to place the Munch-marker in the wrong place at the Ekeberg hill – again?" The newspaper commentator points out that the Valhallveien cannot be the correct site because "the road was first constructed in 1937 – decades after Edvard Munch's The Scream" was created" (Sandberg 2012).

Fig. 3.8 *Marilynn and Donald Olson stand by the historical marker and metal railings on a modern road called the Valhallveien. Although the marker text reads "The Scream by Edvard Munch....the landscape was viewed from here," this is not the actual location where Munch had the initial "Scream experience." The nineteenth-century maps at the Oslo City Museum make it clear that no road (and railing) reached this spot in the 1880s and 1890s. The correct location where Munch saw the blood-red twilight is on a road near the bottom of the Ekeberg hill, about 400 ft lower in elevation and 2,000 ft west of this historical marker (Photograph by Russell Doescher. Used with permission)*

According to the survey by our Texas State group during our visit to Norway, the upper rocky ledge overlook, popular in the nineteenth century and visited by Munch but now rather overgrown by trees, can still be reached by starting at the marker and hiking 450 ft west to the northwest slope of the hill. The lower viewpoint with the road and railings, the actual location of Munch's "*Scream* experience," is near the bottom of the Ekeberg hill, about 400 ft lower in elevation and 2,000 ft west of the historical marker.

Munch's own words, along with our topographic results, provide strong evidence that the blood-red afterglows connect Krakatoa and the sky of *The Scream* – linking one of the world's most famous volcanoes and one of the world's most famous paintings.

Åsgårdstrand Skies: Starry Nights, Storms and Sunrises

The list of Edvard Munch's works from the summer of 1893 includes several paintings of astronomical interest – *Starry Night*, *The Storm*, and *Sunrise in Åsgårdstrand*. All three of these works depict the scene at Åsgårdstrand, a resort town on the west side of the Oslofjord.

In Edvard Munch's *Starry Night*, a brilliant celestial object dominates the night sky and casts a glitter path of light reflected in the fjord below. Is this a bright star or a bright planet? Toward what direction was the artist facing? Does this canvas depict an evening sky or a morning sky? Can we recognize any constellations or asterisms? Did previous authors correctly describe the astronomical inspiration for this painting? How can we use astronomical analysis and meteorological records to determine the date when Munch observed this celestial scene?

The Storm includes a bright star or planet that shines through the clouds in the twilight sky above Åsgårdstrand's Grand Hotel just as a spectacular storm breaks out. How do astronomical calculations, meteorological records, newspaper accounts, and memoirs allow us to determine a date and precise time when Edvard Munch observed this scene? What is the identity of the bright celestial object?

Sunrise in Åsgårdstrand features the Sun just above the horizon, with a glitter path of reflected light stretching across the fjord. Can we find the house, and even the precise bedroom window, from which Edvard Munch watched this sunrise? How does the position on the horizon of the rising Sun, combined with weather records, allow us to deduce a date and precise time for this painting?

Summer in Åsgårdstrand

Vincent van Gogh is not the only artist to create a painting known as *Starry Night*. In 1893 Edvard Munch, the Norwegian artist best known for *The Scream*, painted his own *Starry Night* (Fig. 3.9), now in the Getty Center in Los Angeles. A white fence and a group of linden trees dominate the foreground. A curving shoreline borders the waters of the Oslofjord, which reflects the blue sky glow of a night in the summer resort town of Åsgårdstrand. One especially bright celestial object stands out among the stars that fill the heavens.

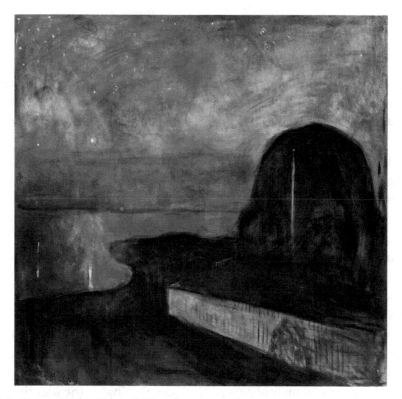

Fig. 3.9 *Starry Night, Edvard Munch, 1893, oil on canvas, 135.6×140 cm, The J. Paul Getty Museum, Los Angeles (© 2013 The Munch Museum/The Munch-Ellingsen Group/Artists Rights Society, NY)*

As a starting point for an analysis of the Getty Center's *Starry Night*, we consulted a detailed year-by-year Munch chronology, which dates this painting to 1893. The list of 1893 works also includes two other Åsgårdstrand paintings with astronomical content (Langaard and Revold 1961: 22). In *The Storm*, a bright star shines in the twilight sky above Åsgårdstrand's Grand Hotel, while *Sunrise in Åsgårdstrand* features the Sun just above the horizon.

Astronomical dating of these three paintings has some importance because the precise days when Munch visited Åsgårdstrand during 1893 are unknown. Some authors even question whether the artist traveled there at all during that year and imply that he must have created these works from memories of previous visits to the resort.

Neither of the two of the most detailed chronologies of Munch's life made any mention of a visit to Åsgårdstrand in 1893 (Langaard and Revold 1961: 22; McShine 2006: 226). Author Ketil Bjørnstad went further and explicitly

stated that Munch was not on the scene in Åsgårdstrand in 1893: "During the summer Munch does not go to Åsgårdstrand. Instead, he remains in Germany, paints landscapes with deeply atmospheric, smouldering colour, paints *Starry Night, Moonlight* and *The Storm*" (Bjørnstad 2001: 124).

A recent biography by Sue Prideaux discussed Munch's stay in Germany in 1893 and likewise concluded: "Summer came, and Munch had neither the money nor the inclination to go to Norway" (Prideaux 2005: 148).

But these chronologies and biographies are incomplete. Our research turned up a first-person account that these authors apparently overlooked. Jens Thiis, a long-time director of the National Gallery in Oslo, visited Åsgårdstrand in 1893 with several friends, including Edvard Munch and the poet Helge Rode. Thiis wrote: "I happened to meet Helge again in Åsgårdstrand. It was his friend Edvard Munch who had invited him there…. One day in August, when we were sitting together on the hotel veranda, I had the desire to sketch Helge Rode…" (Thiis 1937: 307).

This drawing bears the date of August 17, 1893, handwritten by Thiis in the corner. Because this account definitely places Munch in Åsgårdstrand, where the Norwegian skies could inspire him, we realized that we could possibly identify the celestial objects in Munch's paintings and determine dates for these works.

Venus in Munch's Starry Night?

In the articles and books that were consulted, the art historians who comment on the sky of *Starry Night* all agree that Munch included the planet Venus. The Getty museum sponsored a book devoted entirely to an analysis of *Starry Night*. The author, art historian Louise Lippincott, asserted that: "The pink 'star' on the horizon in *Starry Night* is actually the planet Venus…" (Lippincott 1988: 48) Lippincott also referred to Venus in the painting as "the red star on its horizon" (Lippincott 1988: 69).

Arne Eggum, former chief curator of the Munch Museum, was apparently the first to make this Venus identification. Lippincott acknowledged that she was "deeply indebted to A. Eggum for pointing out the star symbolism in *Starry Night*" (Lippincott 1988: 93). Eggum explained his reasoning: "The first title Munch gave the painting *Starry Night* was *Evening Star*. As we know, the evening star is the planet Venus…" (Eggum 2000: 79).

Later authors adopted the planetary identification made by Eggum and Lippincott. For example, Marit Lande asserted that the "light on the horizon is the reflection of the planet Venus," (Lande 1992: 55) and Dieter Buchhart

stated that this painting includes "the bright evening star and its prominent swath of light…the planet of Venus" (Buchhart 2003: 157).

These descriptions are somewhat confusing. Some seem to be referring to the red light on the horizon and others to the bright object up in the sky. But all of these art historians agree that Munch's *Starry Night* includes Venus.

Moon in Munch's Starry Night?

Louise Lippincott provided an astronomical explanation for the vertical white column visible in the garden: "The view depicted in *Starry Night* looks down from the Grand Hotel window and across this enclosed private garden. The great linden trees form a mound silhouetted against the night sky, and their bulky shape is pierced by a dot and a streak of light from the moon hidden behind them" (Lippincott 1988: 46).

She argued that her lunar theory was reasonable: "Munch already had developed the dot and streak as a way of representing a light source and its reflection; it seems plausible to identify the motif in the Getty Museum's *Starry Night* as the moon and its reflection seen through the trees" (Lippincott 1988: 93).

To check these planetary and lunar identifications, we wanted to carry out our own topographical and astronomical analysis.

Research Trip to Norway

Accordingly, our Texas State group traveled to Åsgårdstrand in August 2008 (Olson et al 2009). For *Starry Night* and also for *The Storm* and *Sunrise in Åsgårdstrand*, we hoped to answer several questions: Where was Munch standing? Which way was he was facing, and therefore which part of the sky did he depict? Could we determine the dates and times? Could we identify the celestial objects in these works?

We began by making a topographic survey of the town. We used a surveyor's chains and transit to measure distances and angles. Next, Åsgårdstrand resident Knut Christian Henriksen kindly shared his immense local history collection, including hundreds of photographs showing Åsgårdstrand as it appeared in Munch's time. By studying the historical photographs, we could see that many of the town's buildings from 1893 are still standing, and we could see where changes had occurred.

The white fence visible in Munch's *Starry Night* is easy to find today, and the original group of linden trees still stands in the garden of the Kiøsterud estate (Fig. 3.10). To obtain the view for *Starry Night*, Munch must have been somewhere in the nearby Grand Hotel (Fig. 3.11).

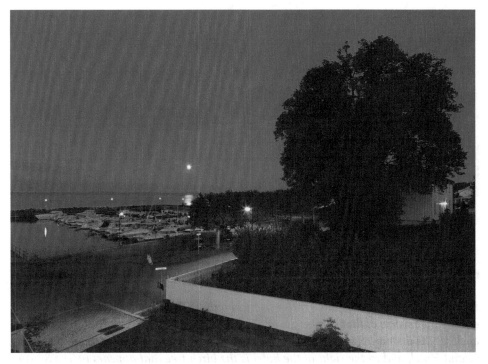

Fig. 3.10 *The setting of Edvard Munch's Starry Night, with the white fence enclosing the linden trees of the Kiøsterud estate, can still be recognized in Åsgårdstrand. The Moon rises into the evening twilight sky, and a glitter path reflects in the Oslofjord in this August 2008 photograph (Photograph by Russell Doescher. Used with permission)*

The analysis is complicated, however, because the hotel burned down in 1930 and was rebuilt. We used the historical photographs, along with our own topographic survey (Fig. 3.12), to determine the precise location of the original hotel. The southeastern corner of the modern hotel is now farther from the Kiøsterud estate by about 10 ft and closer to the fjord by about 30 ft. We used a three-dimensional computer model to simulate Munch's view from the veranda, the balcony, and the windows of the original hotel. We found that we could reproduce the view of *Starry Night* only from near the center of the upper floor of the old hotel.

Flagpole in the Garden

Louise Lippincott argued that *Starry Night*'s vertical white column with the round dot on the top is "the moon and its reflection seen through the trees." With assistance from Knut Christian Henriksen's resources, we can offer a different explanation.

Fig. 3.11 *This postcard photograph from about 1900 shows a view that is almost exactly the reverse of that seen in Starry Night. The white fence of the Kiøsterud estate encloses the linden trees and the flagpole visible in Starry Night. Near the center is the Grand Hotel, and to the right of the hotel is the birch tree that appears in The Storm. In the lower left of this photograph is a small building. This same building also can be seen in Starry Night through the foliage of the linden trees, just to the right of the flagpole in the painting*

Munch did depict summer full Moons and their glitter paths in the fjord in dozens of other works. But glitter paths are reflections in the water and cannot extend up higher than the horizon (Fig. 3.13). In Munch's other works showing glitter paths, the columns of light stop at the horizon. The vertical white column in *Starry Night* extends well above the horizon and cannot be a glitter path reflection.

More than 20 historical photographs, taken from almost all possible directions, show a flagpole with a round ball at the top standing in the Kiøsterud garden (Figs. 3.14 and 3.15). The flagpole no longer exists, but our computer model shows that it stood exactly where Munch painted it in *Starry Night* and had the correct height (about 45 ft) relative to the group of linden trees. Our Texas State group discovered a depression in the grass where the flagpole's base had been.

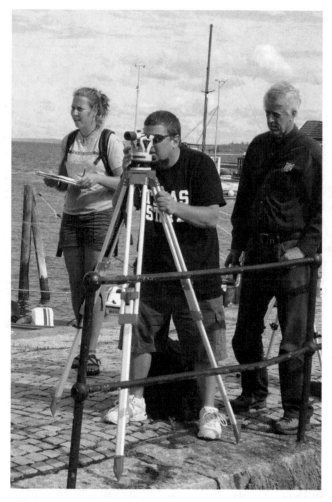

Fig. 3.12 *Our Texas State group made a topographic survey of the town during our visit to Åsgårdstrand. Ava Pope, Joseph Herbert, and Donald Olson measured distances and angles from the modern pier near the Grand Hotel (Photograph by Marilynn Olson. Used with permission)*

We agree with art historian Thomas Messer who saw the flagpole before it was removed and wrote that "the tree group with the white fence in front and even the white flagpole that stands out against the foliage like a mysterious light reflection may still be found in their places today" (Messer 1985: 76).

Fig. 3.13 *A glitter path of light – like the one painted by Edvard Munch – sparkles in the fjord below a rising Moon. Moonlight reflecting in the water forms the glitter path, which stops at the shore on the far side of the fjord and does not extend up into the sky. The characteristic blue sky glow of the Norwegian summer night illuminates the scene behind members of our Texas State group: Marilynn Olson, Ava Pope, and Donald Olson (Photograph by Russell Doescher. Used with permission)*

The hypothetical "Moon" and reflected moonlight in *Starry Night* turns out to be a flagpole with a round ball on top. What about Venus? Did Munch see Venus during the summer of 1893?

Venus Not Visible in 1893

During our visit to Åsgårdstrand we took photographs from the hotel by day, during the evening and morning twilights, and at night. We verified that Munch's direction of view for *Starry Night* was generally to the east. The stars on the left side of the painting would lie somewhat north of east, while the trees on the right side are south of east.

Our computer calculations show that Venus was never visible at or above the eastern horizon during morning twilight or at sunrise on any date in the spring or summer of 1893. At sunset and in evening twilight, Venus was to

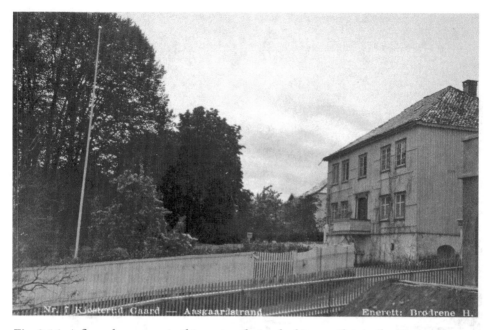

Fig. 3.14 A flagpole appears in this postcard view looking south into the Kiøsterud estate from a spot in front of the Grand Hotel. In Edvard Munch's Starry Night a vertical white column with a round ball on the top appears silhouetted against the linden trees. Some authors interpret this as the Moon and its reflection seen through the trees. We have a more mundane explanation: this flagpole, located in exactly the position depicted by Munch

the west of the hotel (the side away from the fjord), and the planet was never higher than 5° above the geometric horizon at sunset. A steep hill behind the hotel rises with a slope that we measured to be 8°. This hill would have blocked the view of Venus at sunset.

Therefore Munch could not have seen Venus from the Åsgårdstrand Grand Hotel whether from the front or back of the hotel, whether looking east toward the fjord or west toward the hill behind the hotel, whether at morning or evening twilight, on any date in the spring or summer of 1893.

The red light on the horizon in *Starry Night*, noted by Louise Lippincott, cannot be Venus and may instead be a harbor light near the town of Larkollen on the east side of the Oslofjord.

But a very bright "star" is clearly visible higher up in the sky of *Starry Night*. What did Munch see? The blue sky glow of *Starry Night* suggests a Norwegian twilight. Was there a bright star or planet visible during morning twilight or evening twilight in the summer of 1893?

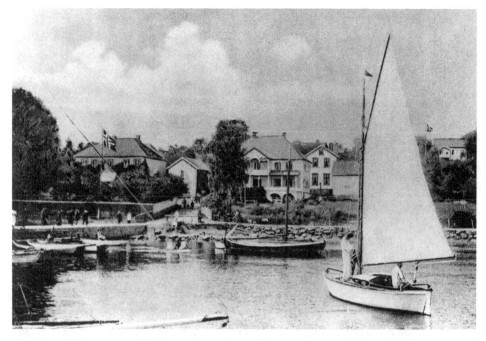

Fig. 3.15 *The setting of both Starry Night and The Storm can be seen in this postcard from about 1910. On the left the white fence of the Kiøsterud estate encloses the linden trees and a Norwegian flag flies on the flagpole that appears in Starry Night. Near the center is the Grand Hotel, partially obscured by the birch tree seen in The Storm. Edvard Munch's viewpoint for Starry Night must have been near the center of the upper floor of the Grand Hotel*

Munch's *Starry Night* Equals Evening Star

The composition now called *Starry Night* was exhibited by Edvard Munch in his lifetime with a variety of titles. According to Arne Eggum and other experts at the Munch Museum, the alternate titles used for this work include *The Stars*, *Evening Star*, *Night*, *Starry Heavens*, and finally *Starry Night*. We realized that the title *Evening Star* provides an important astronomical clue, telling us that the artist observed the bright "star" between sunset and midnight.

But like so much else about *Starry Night*, some art historians have disputed even this use of the title *Evening Star*. Several scholars identify the title *Evening Star* with a composition now known as *The Voice*, which shows a woman standing in a forest along the coastline near Åsgårdstrand, with a yellow glitter path of moonlight reflecting in the fjord.

For example, Munch biographer Sue Prideaux discussed an early exhibition and made the judgment: "The first big question of identity concerns whether...*Evening Star* in the catalogue, was *Starry Night* or *The Voice*. I have come down on the side of *The Voice*...." (Prideaux 2005: 353)

The catalog for a recent major Munch exhibition at the Museum of Modern Art came to the same conclusion – that *Evening Star* was an alternate title for *The Voice* (McShine 2006: 205).

With help from research librarians at Texas State University, the National Library of Norway, and the Munch Museum Library, we located two primary sources that clearly resolve this title controversy. A newspaper critic gave the following eyewitness description of a Munch exhibition in Oslo: "And turning to his exhibition in the Diorama Hall, I want people to focus their attention on number 1 in the catalogue – "Evening Star.... What in the world should prevent people from understanding that this is a beautiful picture? The poetry of the summer night, the great tree standing there slumbering in the garden, the fence shining white down towards the sea and the evening star shimmering up in a deep blue sky" *(Morgenbladet,* November 6, 1904).

These details match the painting exactly and leave no doubt that the writer was describing the canvas now known as *Starry Night*.

As further confirmation, the Munch Museum has a series of photographs taken at the Commeter Gallery in Hamburg, Germany. Photograph #62 definitely shows *Starry Night*, and an accompanying list in Munch's handwriting includes the title "62 – Abendstern," German for "Evening Star."

Therefore, despite the contrary claims by some authors, this evidence demonstrates that Munch did use *Evening Star* as an early title for *Starry Night*.

Identifying the Bright "Star" in Munch's *Starry Night*

During summer evenings in 1893 did any especially brilliant celestial body shine in the eastern sky over the Oslofjord? Computer calculations provided the answer – the planet Jupiter, brighter than any star in the sky and by far the most dazzling object visible to anyone looking east from Åsgårdstrand's Grand Hotel.

Above the bright object in the painting is a distinctive asterism that we recognized as the Pleiades. Computer simulations show that the Pleiades star cluster was in fact located just above Jupiter as the planet rose into the evening sky in 1893.

Jupiter appears in the painting somewhat north of east, but the lack of topographic landmarks along the coastline makes it difficult to assign a precise compass direction. Because long and narrow glitter paths like those seen in the painting occur only for objects near the horizon, Munch must have observed Jupiter at a low altitude, not long after the planet rose.

The scene cannot correspond to a date from the early part of the summer because, before July 9th, Jupiter rose after midnight, and Munch would not reasonably have called it an "evening star." A postcard in the Munch Museum archives proves that Munch had left Åsgårdstrand and was receiving mail at Nordstrand by September 24, 1893. The view in *Starry Night* must correspond to a date between July 9th and September 24th.

Determining a more precise date astronomically is difficult, because Jupiter's position among the background stars remains nearly the same for many consecutive nights. We therefore consulted weather records of the Norwegian Meteorological Institute. Rain and overcast skies were common, and we could rule out most nights as a match for the painting. We found two especially clear nights.

Describing the night of August 16–17, 1893, the local Åsgårdstrand paper recorded that the clouds present near sunset quickly disappeared and: "Until late in the night the heavens were clear with twinkling stars" (*Gjengangeren*, August 20, 1893).

The night of August 23–24, 1893, was likewise clear.

We conclude that *Starry Night* shows Jupiter and the Pleiades during evening twilight, most likely on August 16th or August 23rd, 1893.

Munch and the Sky of *The Storm*

The Storm (Fig. 3.16), it seemed, might provide an independent way to determine when Munch visited Åsgårdstrand.

A woman in white dominates the foreground of *The Storm*, while a cluster of women in the middle distance stands near the same fence depicted in *Starry Night*. A tree bends in the wind in front of lighted yellow windows of the Grand Hotel (Fig. 3.17), the same building from which Munch observed the view for *Starry Night*. Beyond these connections to *Starry Night*, *The Storm* is also of special interest to astronomers because of the bright star visible in the sky just to the north (to the right) of the hotel.

An actual storm inspired the painting, according to the same eyewitness account that places Munch in Åsgårdstrand during August of 1893. In his

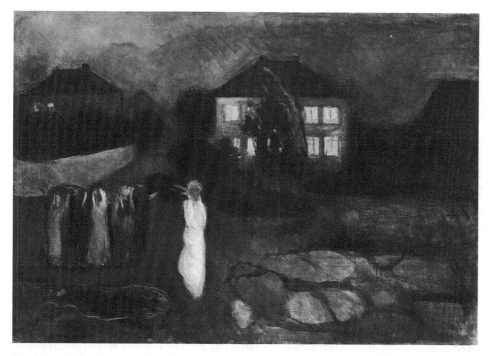

Fig. 3.16 *The Storm, Edvard Munch, 1893, oil on canvas, 92 × 131 cm, Museum of Modern Art, New York (© 2013 The Munch Museum/The Munch-Ellingsen Group/ Artists Rights Society, NY)*

memoir Jens Thiis mentioned some "beautiful sun-filled late summer days" during this visit to the resort but went on to describe a sudden change in the weather:

> One sultry evening…there suddenly began a rustling in the air and a quaking in the tree in front of the hotel…a gale broke out…the fjord stood heavy as lead in a foaming uproar…fishermen's wives huddled together in a group. All were looking out through the dusky twilight for the fishing boats that were out there – would they all manage to get home safely?
>
> The next day, Munch painted the events in his famous picture *The Storm*…. The house with the illuminated windows is the hotel where we stayed, and the woman in white in the foreground is my future wife. (Thiis 1937: 307)

The woman in white is therefore Ragna Vilhelmine Dons, who married Jens Thiis in 1895.

The weather records for July, August and September list many days with rain but only one "strong thunderstorm" – a spectacular weather event on

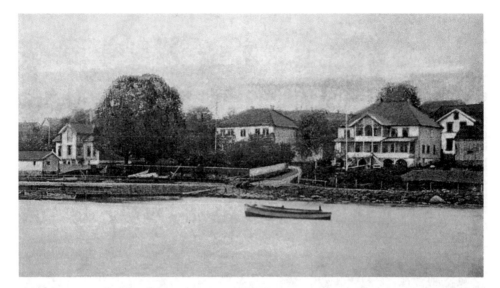

Fig. 3.17 *This postcard from about 1905 shows the setting of both Starry Night and The Storm. The white fence of the Kiøsterud estate encloses the linden trees and flag-pole that appear in Starry Night. Near the right side of this photograph is the Grand Hotel, and in front of the hotel stands the birch tree seen in The Storm. Edvard Munch's viewpoint for Starry Night must have been near the center of the upper floor of the Grand Hotel. Partially visible at the extreme left of this postcard view is a small build-ing with a red roof. This same building can also be seen in Starry Night through the foliage of the linden trees, just to the right of the flagpole in the painting*

the evening of August 19, 1893. The Oslo paper for the next day confirms that the storm hit during evening twilight: "A thunderstorm with magnifi-cent lightning passed over the city around 9 o'clock yesterday evening" (*Dagbladet*, August 20, 1893).

The almost unprecedented strength of this storm impressed another newspaper writer: "…there was a downpour so heavy and lightning so fre-quent and strong, in a manner that we can scarcely remember" (*Aftenposten*, August 22, 1893).

What bright star did Munch observe as the storm began to rage? To answer this question, we needed to know which direction the artist was facing.

The painting shows the corner of the white fence aligned with the house of the Kiøsterud estate and a birch tree aligned with the center of the Grand Hotel. Although the tree has recently been cut down, the stump is still easy to find. Several authors mistakenly identify the tree in *The Storm* as a poplar. Knut Christian Henriksen and several other Åsgårdstrand residents are

certain that it was a birch, and the caption to an early photograph describes it as the birch tree ("bjørketreet") painted by Munch. Munch's view is possible from only one location, which our Texas State group's survey determined within a few feet.

We found that the bright star in *The Storm* was in the western sky, only 3° south of due west, and at an altitude of 25° above the horizon. Computer planetarium simulations show that the star must therefore be Arcturus, an especially plausible candidate because it has the distinction of being the brightest star in the summer night sky of Norway. Arcturus is well-known to astronomers worldwide as the most prominent star in the western sky on August evenings.

Computer sky simulations show that the time depicted in *The Storm* must be during evening twilight, within a few minutes of 9:15 p.m. local mean time. The time derived from the position of the bright star is in excellent agreement with the times mentioned by Thiis and the newspaper stories.

Thus, it seems certain that *The Storm* shows Arcturus in the western sky as the tempest began on the evening of August 19, 1893.

The Case of the Missing Star

The bright star in *The Storm* is missing from some book reproductions. For example, no star appears in the sky of this painting as printed in the catalog for the important exhibition, *Edvard Munch: The Modern Life of the Soul* at the Museum of Modern Art (McShine 2006: 113). Likewise, the authoritative compilation of Munch's complete works, a massive catalog raisonné in four volumes with a total of 1,696 pages (Woll 2009a: 306), depicts the sky above the hotel as a relatively featureless blue-gray – with no star visible.

This appears to raise a fatal problem for any astronomical analysis, especially troubling because the Museum of Modern Art houses *The Storm* in its own permanent collection and the catalog raisonné was compiled by the leading experts at the Munch Museum in Norway. How can we date *The Storm*, in part from the position of Arcturus, if no bright star appears in these reproductions?

Our Texas State group determined that the star may have been mistakenly identified as a defect and removed, using Photoshop™ or an equivalent program, from the digital files used in those two books. To be certain that the actual canvas showed a bright star, we visited the 2006 exhibition in New York City and clearly saw the prominent white dot in the upper right corner of *The Storm*. The bright star, above and to the right of the hotel, is also

clearly visible in the unretouched digital photographs taken by visitors to the Museum of Modern Art in New York and posted online, as can be verified at the website www.flickr.com by using the search terms "moma munch storm."

The Munch Museum curators have since confirmed to us that the star did exist in their original high-resolution photographs, but, apparently mistaken for noise or a digital defect, it was removed from the digital file for *The Storm* at some unknown point in the printing process.

Visitors to the Museum of Modern Art in New York City can verify for themselves that *The Storm* shows a bright star in the upper right-hand corner – Arcturus shining in the western sky on the evening of August 19, 1893.

Dating Munch's *Sunrise in Åsgårdstrand*

Our Texas State group also found a way to use the Sun to determine the time of year when Munch visited Åsgårdstrand. The point on the horizon where the Sun rises varies seasonally, with it rising farthest to the northeast at the summer solstice, farthest to the southeast at the winter solstice, and directly east at the spring and fall equinoxes.

Sunrise in Åsgårdstrand (Fig. 3.18) looks across the water to a rising Sun with a long glitter path of light reflected in the fjord. We recognized, just to the left of the glitter path, the same group of trees seen in *Starry Night* and the roof of the Kiøsterud house. The small building below and to the right of the glitter path served as a boathouse.

The right side of the painting shows the house now known as Russellgården, with its roof almost exactly superimposed on the distant horizon. We found that this alignment can be seen only from the upper floor of the nearby Soelberggården house.

The current owners of Soelberggården kindly allowed us into their home. We could match Munch's view of the bend in the road only from a specific room in the upper story (Fig. 3.19). In one of the most moving moments of our research trip, we realized that we were standing on the same floorboards by the same window where the artist himself had looked out to watch the rising Sun, more than a century before.

Our modern photographs reveal several changes. The trees have grown taller, and Russellgården has undergone some structural modifications, most notably a dormer added to the roof. Knut Christian Henriksen showed us a historical photograph of Russellgården with no dormer, just as painted by Munch.

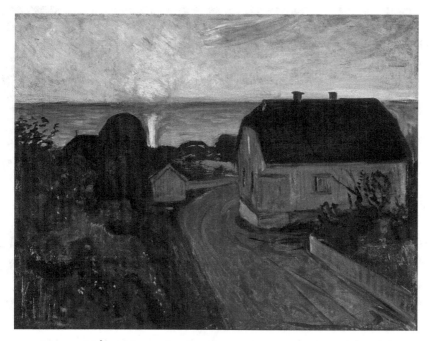

Fig. 3.18 *Sunrise in Åsgårdstrand, Edvard Munch, ca. 1893, oil on canvas, 65 × 89 cm, private collection (© 2013 The Munch Museum/The Munch-Ellingsen Group/Artists Rights Society, NY)*

Based on our survey we determined that the rising Sun in the painting was in the direction 10° north of due east. Using the angular width of the boathouse to set the scale, we estimated the Sun to be about 3° above the horizon, a low altitude consistent with the long and narrow glitter path in the fjord. Munch could have observed the rising Sun near this position only during the second week of April (ruled out because Munch was then in Germany) or during the first 5 days of September.

Weather records show many mornings in Norway plagued by overcast skies and rain. In 1893 the only date and time consistent with the Sun and the sky in the painting is September 3rd at 5:30 a.m. local mean time.

The early history of the sunrise painting is somewhat uncertain, and scholars at the Munch Museum tell us that this work may date from a year or even a few years after 1893. A later date consistent with the position of the rising Sun and the weather records is September 2, 1895, at 5:31 a.m. local mean time. Local historical records indicate that the doctor Wilhelm

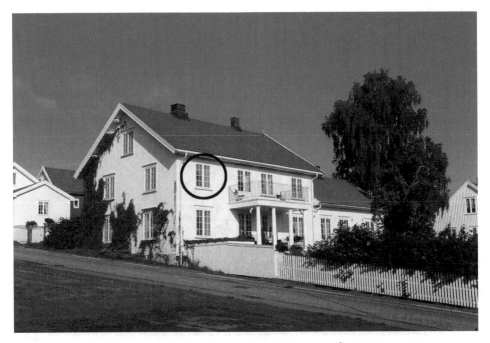

Fig. 3.19 *Edvard Munch observed the scene of Sunrise in Åsgårdstrand from a window (marked by the black circle) in the upper story of the Soelberggården house (Photograph by the author)*

Grimsgaard, a friend of Munch's, was living in Åsgårdstrand at the Soelberggården house by 1895. This raises the intriguing possibility that Munch was visiting his friend or possibly renting a room in the Soelberggården. Regardless of the year, the sunrise painting must be from the first 5 days of September, which confirms that Munch was in the habit of visiting Åsgårdstrand in late summer.

Summing Up the Findings Concerning Munch's Åsgårdstrand Paintings

Starry Night shows an evening twilight scene, with Jupiter and the Pleiades rising into the eastern sky on a date in the second half of August 1893. *The Storm* shows an evening twilight scene looking west, with Arcturus setting next to the Grand Hotel, near 9:15 p.m. on August 19, 1893. *Sunrise in Åsgårdstrand* looks east to a rising Sun and a glitter path in the fjord at a time near 5:30 a.m. on a morning in the first 5 days of September.

The three paintings studied here have been dated independently – one using stars and a planet, another using a storm and meteorological records, and the last using the Sun. All three dates fall within a 3-week period between mid-August and early September.

Starting from observations of nature during this visit to Åsgårdstrand, Munch showed his artistic genius by expressing emotional content that goes beyond literalism. Knowing the details of the celestial scenes in these paintings only increases our admiration of the artist's skill at portraying the mystery of the Norwegian summer skies.

Mirror Image Mystery: *Girls on the Pier*

Munch is best-known today for *The Scream*, with its tormented figure under a blood-red sky, now identified as the depiction of a volcanic twilight caused by the eruption of Krakatoa. But during his lifetime, Munch's most admired and beloved painting was a tranquil landscape titled *Girls on the Pier*, created in the summer resort village of Åsgårdstrand on the west side of the Oslofjord.

What is the yellow disk in the sky of this painting? Is it the Sun (as many art historians insist), is it the Moon (as other art historians are equally certain), or is it impossible to determine (as some art historians conclude)? Does the painting show a daylight scene in the resort town, or does it depict a moonlit night? The houses and trees reflect in the still waters of the Oslofjord, but no reflection of the yellow disk can be seen in the fjord. Does this arrangement defy the laws of physics? Or, can we explain the missing reflection using the principles of optics?

Munch's Masterwork

Jens Thiis, director of the National Gallery in Oslo, wrote in 1933 that "Munch's greatest and most famous masterwork is *Girls on the Pier*" (Thiis 1933: 276). Munch eventually created more than 20 versions of this scene in a series of paintings, lithographs, woodcuts, and etchings. *Girls on the Pier* (Fig. 3.20) has retained its popularity to the present day, with the image selected for the front cover of a variety of publications: a local guidebook (Aasen 1994), the authoritative collection of Munch's complete works (Woll 2009b), and the catalogs that accompanied recent Munch exhibitions (Hoerschelmann 2003; Lampe and Chéroux 2012).

Fig. 3.20 *Girls on the Pier, Edvard Munch, 1901. Art historians consider this to be the earliest example in a lengthy series of similar paintings, lithographs, woodcuts, and etchings (National Gallery, Oslo, Norway; © 2013 The Munch Museum/ The Munch-Ellingsen Group/Artists Rights Society, NY)*

The yellow disk in the sky represents an especially intriguing element. Is this a rising or setting Sun, a rising or setting Moon, or, perhaps, a "midnight Sun"? We can quickly rule out the last possibility. Because Åsgårdstrand lies well below the Arctic Circle, the midnight Sun cannot occur there. However, near the summer solstice the Sun never dips far below the Åsgårdstrand horizon, and therefore the sky never gets dark during these so-called "light nights."

Day or Night? Sun or Moon?

Jens Thiis made a lunar identification for the yellow disk and described this painting as the depiction of a night scene:

Munch is first and foremost the portrayer of the northern summer night. No one has rendered as he the mystic suggestion of those light nights, with mighty

tree tops swaying above slumbering white houses and the pale, blurred outlines of the surrounding country. Often against this soft background he masses the striking splendour of pure color, as seen in the bright summer costumes of young girls and women in the foreground. (Thiis 1913: 50)

Thiis specifically stated that a Moon graced the sky of *Girls on the Pier*, which conveyed: "…the essence of a summer night's twilight illumination… the buildings disappear away in a dream under a small and pale moon" (Thiis 1933: 278).

Modern art historian Ulrich Bischoff agrees with Thiis that the "moon is visible beyond the mighty tree" (Bischoff 1993: 70).

But the astronomical identification is less clear in an important modern catalog, published in 1978 to accompany the exhibition called *Symbols and Images* at the National Gallery in Washington, D. C. Regarding *Girls on the Pier*, one essay in this catalog asserts that "the small, pale yellow moon tells us: it is a fair, Nordic summer night" (Stang 1978: 80). On another page of the same catalog a description of the same canvas offers the contradictory statement that "we see, indeed, the sun shining over the houses to the left" (Eggum 1978: 62).

Definite statements favoring the solar theory appear in a study by Clément Chéroux, who argues that the painting must show a late afternoon scene, "as indicated by the placement of the Sun above the village" (Chéroux 1993: 17). Art historian Thomas Messer offers a composite theory, referring to the disk as the "yellow sun-moon" (Messer 1973: 112).

Recent scholarship was summarized in the catalog for a major Munch exhibition held in 2003 at the Albertina Museum in Vienna. This massive volume, with versions of *Girls on the Pier* on both the front and back covers, devoted a chapter to this Åsgårdstrand series but declined to favor either the solar or lunar theory and noted only that: "The question of whether these works show the sun or the moon – a long northern summer day or a nocturnal scene – has been a recurring focus of discussion with respect to all of the different interpretations in the picture (Hoerschelmann 2003: 294).

Our Texas State group wondered whether an astronomical analysis could give unambiguous answers to the astronomical and topographical questions. Is the yellow disk the Sun or the Moon? Where on the pier was Munch standing? What is the compass direction of the yellow disk, as seen from Munch's position on the pier? During the summer, does the Sun or the Moon appear in that part of the sky?

Fig. 3.21 *The Åsgårdstrand scene of Girls on the Pier is easy to recognize in this May 2003 photograph looking toward the southwest from the modern stone pier (Photograph by the author)*

Fact-Finding Trip to Norway

In May 2003 our Texas State group traveled to Åsgårdstrand, and our photograph (Fig. 3.21) shows that the white fence and the houses are still easy to recognize. Also still surviving after more than a century is the large tree, actually three linden trees that have grown together to share a common crown.

It was determined that the pier extends into the water toward the northeast. So, for an observer like Munch looking towards the shore, the pier aligns towards the southwest.

However, there is a complication. Frank Høifødt and Lasse Jacobsen of the Munch Museum warned us that the modern pier in Åsgårdstrand is in a slightly different location from the old pier where Munch created the painting.

Fortunately, we found dozens of old postcards and photographs (Figs. 3.22 and 3.23) showing the harbor in Munch's day. We compared the 100-year-old

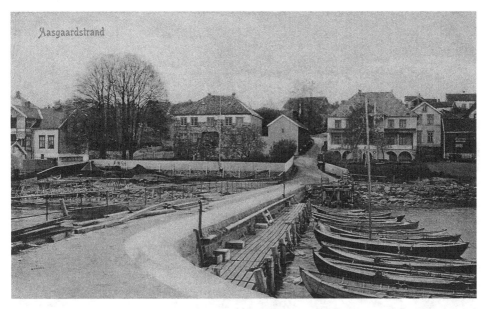

Fig. 3.22 *The Åsgårdstrand scene of Girls on the Pier in an early postcard photograph, showing the scene circa 1905 shortly after the construction of the modern stone pier*

photographs with our own photographs using a method called the parallax shift, which measures how nearby objects shift relative to distant background objects as the observer changes position. By measuring how much the nearest corner of the white fence shifted relative to the buildings in the background, we calculated that the old pier must have been 18 ft north of the modern pier. We later found confirmation in a local history publication with an article describing the replacement of the old wooden pier by the modern stone pier in 1904. According to this article, the old pier was "the site of Munch's most beloved work, *Girls on the Pier*…the old landing pier lay on the north side of the new stone pier and went parallel with it" (Nergaard 1992: 58). Our calculations also allowed for some changes to the roof of the house at the far left of the canvas.

Based on our survey, we finally determined that Munch painted the yellow disk low in the southwestern sky (Olson et al. 2006). Therefore, the yellow disk *cannot* be the Sun, which sets in the northwestern sky during the entire summer season. The Sun sets in the position matching the painting only during the third week of November and the last week of January, dates totally inconsistent with the depiction of a summer resort in Norway's summer season.

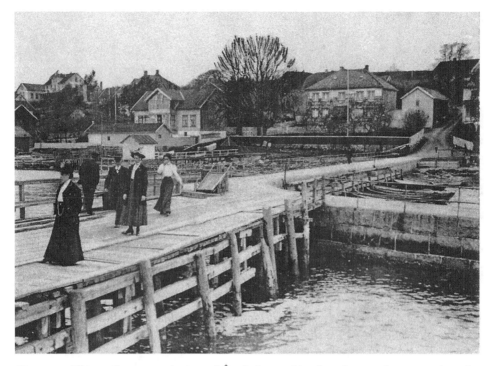

Fig. 3.23 *This early postcard view of Åsgårdstrand harbor depicts the time when the old wooden landing pier, the setting for Edvard Munch's Girls on the Pier, was being replaced by the modern stone pier. The painting is usually dated to about 1901, and this photograph must date from between 1894, when the wooden pier was constructed, and 1904, when it was replaced by the modern stone pier*

The seasonal behavior of the full, or nearly full, Moon is opposite to the pattern for the Sun. Summer full Moons rise in the southeast, then "run low" in the sky over the southern horizon, and finally sink down towards the southwestern horizon – exactly the position of the painting's yellow disk, which must be the Moon.

The "Missing Moon" Mystery

In the quiet hours of this Norwegian "light night" Munch shows the trees and houses mirrored in the calm surface of the fjord. This leads to a final intriguing question. Why does the Moon's reflection not appear in the water?

Many commentators have noticed the missing reflection and addressed this point with symbolic or psychoanalytical interpretations. For example, David Loshak noted that "the moon has disappeared altogether" from the reflection and theorizes: "Discrepancies between the background and its

Fig. 3.24 *A long-standing mystery about Girls on the Pier is the absence of the yellow disk (the Moon) from the watery reflection. In this ray diagram the red line marks the eye level of an observer on the pier. As seen by the observer on the pier, the direct light rays (solid yellow line) from the Moon pass just above the roof of the house and can reach the observer's eye, but the Moon's reflection cannot be seen in the water because the house blocks the light rays (dashed yellow lines) that would create the reflected Moon (Sky & Telescope diagram. Used with permission.)*

reflection may point to the inaccuracy of memory" (Loshak 1990: 68). Thomas Messer likewise observed that the yellow disk "is subtracted from the mirror image" and wondered whether the artist chose to "eliminate a possible flaw in a carefully balanced emotional equation" (Messer 1973: 112).

However, we realized that simple optics explains the "missing Moon" in the reflection. A key point is that Munch's eye was about 11 ft above the surface of the water. As Figs. 3.24 and 3.25 show, light rays can travel from the Moon and pass just over the roof of the house to reach Munch's eye, while the house blocks the light rays that would produce the Moon's reflection.

A more detailed explanation relies on a property of an image formed by the water's surface, which acts as a plane (flat) mirror. The house just below the Moon was about 300 ft distant from Munch, and the top of its roof stood about 46 ft above the water level. The reflected image of the roof line therefore was 300 ft away from Munch, but 46 ft *below* the water level. As seen from Munch's eye 11 ft above the water, a calculation using trigonometry shows that the elevation angle of the actual roof is 6.7° measured up from the horizontal. But Munch would see the reflected roof line at the much

Fig. 3.25 *A long-standing mystery about Girls on the Pier is the absence of the yellow disk (the Moon) from the watery reflection. The graphic on the left simulates the appearance of Munch's painting. If we imagine that the house suddenly disappeared, as shown in the right-hand graphic, then the Moon's reflection would be visible in the water (Sky & Telescope diagram. Used with permission.)*

larger *depression angle* below the horizontal of 10.8°. Therefore, if the actual Moon is visible in the sky at an altitude of 8°, just above the roof of the actual house, then the reflected Moon would have an equal depression angle of 8° below the horizontal – a direction blocked by the reflected house.

However, a trigonometric calculation is not necessary to understand the missing reflection. Figs. 3.24 and 3.25 show graphically how light rays can travel directly from the Moon to Munch's eye, while the house blocks the light rays that would produce the Moon's reflection.

Differences Between an Object and Its Reflection

A literature search turned up a description of exactly these same effects in a book by Marcel Minnaert, a pioneering authority on optical phenomena in nature.

> Most people think that the reflection of a scene in calm water resembles the scene itself upside down. Nothing could be further from the truth...
>
> The closer the objects are to us, the lower their images with respect to that of the background.... Fig. 10(a) shows why it is that an observer can see the moon direct, whereas its reflection is hidden by the tower. The effect is represented in Fig. 10(b): the reflection of the tower is lowered with respect to that of the distant moon; note also that the reflection of the tree appears taller with respect to that of the tower than it is in reality.... These phenomena are quite natural when you realize that although the reflection is identical to the object, it looks different in perspective because the two are shifted with respect to each other. We see the landscape as if we were looking at it from a point beneath the water's surface where the image of our eye is. The differences become smaller the closer we bring our eyes to the water, and the farther away the objects are. (Minnaert 1993: 12)

This book even includes a diagram (Fig. 3.26) showing exactly how an observer can witness a surprising scene, with the Moon visible in the sky above a building near a lake but with the Moon absent from the reflection. Minnaert's explanation agrees perfectly with our analysis of *Girls on the Pier*.

Confirmation in a Munch Letter

After our Texas State group had completed the analysis of *Girls on the Pier*, we were conducting a search of Munch's correspondence (much of which is unpublished) when Margaret Vaverek, a research librarian at our university, helped us to locate two especially interesting letters. On March 8, 1902, Munch described a "picture from Åsgårdstrand with the three young girls," and then on March 18, 1902, he gave this same painting the title *Summer Night* – confirming in the artist's own words that this is a night scene and that the yellow disk must be the Moon.

It seems clear that Edvard Munch was accurate, not only regarding the position in the sky of a summer full Moon but also in his observation and depiction of the "missing Moon" in the reflection. Just as Jens Thiis did, a century ago, we can admire the artist's skill as a "portrayer of the northern summer night."

Fig. 3.26 *Because the Moon is effectively at an infinite distance, incoming light rays from the Moon are parallel. In these diagrams, the observer on the hill can see the Moon directly in the sky above the tower, but the Moon's reflection cannot be seen in the water because the tower blocks those light rays. These drawings appeared as Fig. 10a, b in Marcel Minnaert's authoritative Light and Color in the Outdoors (Springer-Verlag 1993)*

References

Aasen, Guri (1994) *En vandring i Edvard Munchs fotspor*. Åsgårdstrand: Stiftelsen Kunstnerbyen Åsgårdstrand.

Baedeker, Karl (1889) *Norway & Sweden: Handbook for Travellers*. Leipsic: Karl Baedeker.

Bischoff, Ulrich (1993) *Edvard Munch*. Köln, Germany: Benedikt Taschen.

Bjørnstad, Ketil (2001) *The Story of Edvard Munch*. London: Arcadia.

Bohm-Duchen, Monica (2001) *The Private Life of a Masterpiece*. Berkeley: University of California Press.

Boillot, A. (1884) Lueurs crépusculaires. *Comptes Rendus* **98**, 253.

Buchhart, Dieter (2003) Attaction. In Klaus Albrecht Schröder and Antonia Hoerschelmann, eds. *Edward Munch: Theme and Variation*. Ostfildern-Ruit: Hatje Cantz, 157–165.

Chéroux, Clément (1993) *Edvard Munch à Aasgaardstrand: Points de Vue*. Arles, France: Ecole Nationale de la Photographie.

Eggum, Arne (1978) Major Paintings. In *Edvard Munch: Symbols and Images*. Washington, DC: National Gallery of Art, 33–75.

Eggum, Arne (1990) *Livsfrisen Fra Maleri Til Grafikk*. Oslo: Stenersen.

Eggum, Arne (1994) *Edvard Munch: Portretter*. Oslo: Munch-museet, Labyrinth Press.

Eggum, Arne (2000) *The Frieze of Life from Painting to Graphic Art*. Oslo: Stenersen.

Gasparin, M. de (1884) Lueurs crépusculaires. *Comptes Rendus* **98**, 280–281.

Heller, Reinhold (1972) *The Scream*. New York: Viking Press.

Hoerschelmann, Antonia (2003) Girls on the Pier. In Klaus Albrecht Schröder and Antonia Hoerschelmann, eds. *Edward Munch: Theme and Variation*. Ostfildern-Ruit: Hatje Cantz, 293–299.

Kelly, Jon (2012) Munch's The Scream…and the appeal of anguished art. *BBC News Magazine*, February 24, 2012.

Lampe, Angela, and Clément Chéroux (2012) *Edvard Munch: The Modern Eye*. London: Tate Publishing.

Lande, Marit (1992) Starry Night. In Mara-Helen Wood, ed. *Edvard Munch: The Frieze of Life*. New York: Harry N. Abrams, 54–55.

Langaard, Johan, and Reidar Revold (1961) *A Year by Year Record of Edvard Munch's Life*. Oslo: Aschehoug.

Lippincott, Louise (1988) *Edvard Munch: Starry Night*. Malibu, California: J. Paul Getty Museum.

Loshak, David (1990) *Munch*. London: PRC Publishing.

Lubow, Arthur (2006) Edvard Munch: Beyond *The Scream*. *Smithsonian* **36**(12), March, 58–67.

McShine, Kynaston, ed. (2006) *Edvard Munch: The Modern Life of the Soul*. New York: Museum of Modern Art.

Messer, Thomas (1973) *Edvard Munch*. New York: Harry N. Abrams.

Messer, Thomas (1985) *Edvard Munch*. New York: Harry N. Abrams.

Minnaert, Marcel G. J. (1993) *Light and Color in the Outdoors*. New York: Springer-Verlag.

Nergaard, Knut (1992) Broen i Åsgårdstrand. *Borreminne* **8**, 52–59.

Olson, Donald W., Russell L. Doescher, and Marilynn S. Olson (2004) When the Sky Ran Red: The Story Behind *The Scream*. *Sky & Telescope* **107**(2), February, 28–35.

Olson, Donald W., Beatrice M. Robertson, and Russell L. Doescher (2006) Reflections on Edvard Munch's *Girls on the Pier*. *Sky & Telescope* **111**(5), May, 38–41.

Olson, Donald W., Russell L. Doescher, Joseph C. Herbert, Robert H. Newton, and Ava G. Pope (2009) Edvard Munch's Starry Skies, Stormy Nights, and Summer Sunrises. *Griffith Observer* **73**(8), August, 2–19.

Prideaux, Sue (2005) *Edvard Munch: Behind the Scream*. New Haven: Yale University Press.

Robock, Alan (2000) Volcanic Eruptions and Climate. *Reviews of Geophysics* **38**(2), 191–219.

Sandberg, Lotte (2012) The Scream Viewpoint: Can Oslo come to place the Munch-marker in the wrong place at the Ekeberg hill—again? *Aftenposten* (Oslo), February 1, 2012.

Simkin, Tom, and Richard S. Fiske (1983) *Krakatau 1883, The Volcanic Eruption and its Effects*. Washington, DC: Smithsonian Institution Press.

Skredsvig, Christian (1908) *Dage og Naetter Blandt Kunstnere*. Oslo: Gyldendal.

Smith, Bob, and Roberta Smith [pseudonym for Patrick Brill] (2012) Scream if you want to bid higher: the high cost of art. *The Guardian*, May 8, 2012.

Stang, Ragna (1978) The Aging Munch: New Creative Power. In *Edvard Munch: Symbols and Images*. Washington, DC: National Gallery of Art, 77–85.

Steves, Rick (2012) *Rick Steves' Scandinavia*. Berkeley, California: Avalon Travel.

Symons, George James, ed. (1888) *The Eruption of Krakatoa, and Subsequent Phenomena: Report of the Krakatoa Committee of the Royal Society*. London: Trübner & Co.

Tennyson, Alfred (1892) *The Death of Œnone, Akbar's Dream, and Other Poems*. London: Macmillan and Co.

Thiis, Jens (1913) *Exhibition of Contemporary Scandinavian Art Held Under The Auspices of the American-Scandinavian Society*. New York: Redfield Bros.

Thiis, Jens (1933) *Edvard Munch og Hans* Samtid. Oslo: Gyldendal.

Thiis, Jens (1937) Minneord om Helge Rode. In *Festskrift Til Francis Bull*. Oslo, Gyldendal Norsk Forlag, 301–323.

Vogel, Carol (2012) "Scream" To Go On View At MoMA. *New York Times*, September 18, 2012, C1.

Woll, Gerd (1978) The Tree of Knowledge of Good and Evil. In *Symbols and Images*, Washington DC: National Gallery of Art, 229–256.

Woll, Gerd, ed. (2009a) *Edvard Munch, Complete Paintings: Catalogue Raisonné, Volume I, 1880–1897*. London: Thames & Hudson.

Woll, Gerd, ed. (2009b) *Edvard Munch, Complete Paintings: Catalogue Raisonné, Volume II, 1898–1908*. London: Thames & Hudson.

4

Yosemite Moonrises and Moonbows

Ansel Adams kept meticulous records of camera and darkroom data for each of his photographs, including the type of film, lens, filter, aperture, shutter speed, developer, paper, etc. But Adams never recorded the dates for any images, even his most famous works. How can we use astronomical and topographical analysis to determine dates for his famous Yosemite moonrise photographs?

Where in Yosemite did Ansel Adams set up his tripod for the photograph entitled *Moon and Half Dome*? What is the name of the rock column that frames the left side of the image? What is the name of the rock formation that casts a dramatic shadow onto the base of Half Dome? How can we use the lunar phase and the position of the rising Moon to calculate the date and precise time, accurate to the minute, when Ansel Adams tripped the shutter for *Moon and Half Dome*? Can we carry out a similar analysis to determine the date and precise time, accurate to the minute, for the Ansel Adams Yosemite photograph entitled *Autumn Moon*?

What is the relation between these two modern moonrise photographs and a lunar cycle credited to the fifth-century B.C. Greek astronomer Meton of Athens? How can we use the "Metonic cycle" to predict when these astronomical conditions will repeat, and the Moon will again appear with the same lunar phase and position in the sky? Can we predict the dates when the rising Moon will again appear near Half Dome or the dates for an *Autumn Moon Encore*?

Yosemite National Park provides a setting not only for dramatic moonrises but also for an unusual phenomenon called moonbows. Just as the Sun can produce rainbows by day, a full or nearly full Moon can produce rainbows at night. The human eye loses much of its color sensitivity at night, and most visual observers describe lunar rainbows ("moonbows") as gray, white,

D.W. Olson, *Celestial Sleuth: Using Astronomy to Solve Mysteries in Art, History and Literature*, Springer Praxis Books, DOI 10.1007/978-1-4614-8403-5_4, © Springer Science+Business Media New York 2014

or silvery in appearance. How can we be sure that both the author Mark Twain and the naturalist John Muir possessed vision sensitive enough to observe the colors in lunar rainbows? How can astronomical computations predict the dates and precise times when moonbows will appear in the mist and spray of the waterfalls at Yosemite?

Adams' *Moon and Half Dome*

On a cold and clear winter afternoon more than five decades ago, Ansel Adams set up his tripod in Yosemite Valley and focused a Hasselblad camera on the distinctive profile of the mountain known as Half Dome. He waited as the Sun sank closer to the horizon and the long afternoon shadows extended out across the granite cliffs. Adams had photographed Half Dome many times over the years, but on this day he captured an especially remarkable image (Fig. 4.1) that included the Moon rising into the sky just north of the monolith.

In his autobiography, Adams specified the year of this photograph by giving it the title *Moon and Half Dome, Yosemite National Park, 1960*. Adams recalled driving around aimlessly one winter afternoon when he spotted the Moon rising adjacent to Half Dome (Adams 1985a: 375). A more precise time of day appears in another account, which mentions that the Moon first became visible near Half Dome at about 3:30 p.m. on a winter afternoon (Adams 1983: 133). Adams parked his car and walked into a meadow in order to get a clear view without trees blocking the scene. He did not take the photograph immediately, but instead waited until the Moon had risen near the position that he deemed ideal for the best composition (Adams 1980: 21). A contact sheet shows that Adams then made ten exposures, with the Moon rising slightly higher in each successive image.

Uncertain Chronology

Although these accounts by Adams date *Moon and Half Dome* to the winter of 1960, it is not clear whether he meant the first few months (January, February, March) or the last part of the year (December). Even the stated year of 1960 could be wrong, since Adams often acknowledged that his records did not include reliable dates for even his best-known photographs. Adams admitted that his disregard for recording dates of his photographs had caused problems for historians of photography (Adams 1983: 42). The dates given in his captions were often just approximate guesses. For example,

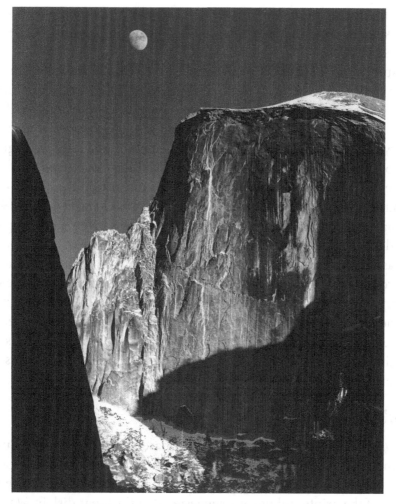

Fig. 4.1 *Moon and Half Dome, Ansel Adams, 1960. Washington Column on the left frames the view as the waxing gibbous Moon rises past the summit of Half Dome. The large overhanging ledge called the Diving Board is not visible, but the shadow of the Diving Board extends out across the lower part of the face of Half Dome (© 2013 The Ansel Adams Publishing Rights Trust)*

Adams dated his iconic Yosemite photograph *Clearing Winter Storm* to 1937, 1938, 1940, 1942, and 1944 in various exhibitions and publications.

Likewise, Adams had variously labeled his most famous composition, *Moonrise, Hernandez, New Mexico*, as being from 1940, 1941, 1942, 1943, and 1944. But the Moon in this image provided a key to establishing the correct date. Dennis di Cicco of *Sky & Telescope* magazine used astronomical

computing methods to prove that the Hernandez photograph must have been taken at 4:49 p.m. Mountain Standard Time on November 1, 1941 (di Cicco 1991a, b).

My students and I read di Cicco's articles as part of a Texas State University Honors College course titled "Astronomy in Art, History, and Literature." As a class exercise, we verified his analysis for *Moonrise, Hernandez, New Mexico* with our own computer planetarium programs. In the process, we assembled a library of books and articles to gain perspective on the long photographic career of Ansel Adams. From these, we noticed that *Moon and Half Dome* was one of his most often reproduced images and graced the covers of volumes such as *The Camera* (Adams 1980) and *Classic Images* (Adams 1985b).

We had originally intended to study just the Hernandez photograph, but my students and I decided to include astronomical dating of *Moon and Half Dome* as an exercise for the course. In our computer laboratory, we assembled a collection of Ansel Adams books, Ansel Adams posters for the walls, topographic maps of Yosemite Valley, tourist brochures of the park, and our own photographs from previous vacation trips to Yosemite. This series of class meetings proved to be some of the most enjoyable of the entire semester. Fittingly, we noticed that a Moon with the appropriate lunar phase rose into the late afternoon sky as we worked.

Moon's Position and Adams' Position

Moon and Half Dome depicts the lunar phase called waxing gibbous, the name that refers to the time period between first quarter (when the Moon is 50 % lit) and full Moon (when the Moon becomes 100 % lit). Measurements on some of the prints and posters suggested that the lunar disk in *Moon and Half Dome* was roughly 85–90 % illuminated.

Next we wanted to estimate the compass direction of the Moon and its altitude above the horizon, a task made especially difficult because the horizon is not visible in *Moon and Half Dome*. The photograph shows the Moon standing about 1½° (three lunar diameters) above the summit of Half Dome, which rises about 4,840 ft above the valley floor. But what was the apparent altitude (in degrees) of Half Dome? How far away from Half Dome was the camera positioned? The dark column in the left foreground, used by Adams to frame the image, provided the key to answering these questions.

From several park guidebooks we identified this dark rock formation as Washington Column, the corner of which stands about 1,800 ft above the valley floor. In the photograph, however, the top of Washington Column

appears almost even with the top of Half Dome. Adams was therefore much closer to Washington Column than to Half Dome. Using trigonometry and measurements from topographic maps, we found that Adams could have obtained this view only by looking east from the clearing known as Ahwahnee Meadow, about 2½ miles from Half Dome.

Although the Moon may seem to be just rising in the photograph, it is actually surprisingly high in the sky. As seen from Ahwahnee Meadow, Half Dome towers over the east end of the valley, more than 20° high, and the Moon's altitude in the photograph was even higher.

Possible Dates for Moon and Half Dome

Several members of the class went to the university library and searched for early published appearances of *Moon and Half Dome*. We found the image reproduced in 1963 in a book accompanying the exhibition called "The Eloquent Light" held at the de Young Museum in San Francisco (Newhall 1963). We also learned that Virginia and Ansel Adams used *Moon and Half Dome* during that same year as the frontispiece in an *Illustrated Guide to Yosemite* (Adams and Adams 1963). We decided to consider the years from 1955 to 1963 and looked for dates when a waxing gibbous Moon rose into the sky just north of Half Dome.

After a few hours searching with computer planetarium programs, we realized that the Moon could appear in the correct phase and near the correct position during only two periods of the year, one falling near the winter solstice and the other near the spring equinox. The snow visible in the photograph seemed consistent with either time of year.

However, a simple consideration ruled out all of the possible dates in March and April. A waxing gibbous Moon will always rise then with a noticeably different tilt from that seen in the photograph.

In the period near the winter solstice our search had produced nine possible dates in various years – one in late November, six in December, and two in early January. Our goal now was to find reasons to reject all but one of these tentative dates and thereby identify the correct date for *Moon and Half Dome*.

As our next step, we calculated the position of the Sun. The photograph shows direct sunlight illuminating trees and granite outcroppings on a snowy slope below the face of Half Dome. We quickly rejected four of the possible dates since, at the time when the Moon was in the correct position, the Sun would have already dropped behind Glacier Point, and the snowy slope would have been totally in shadow.

Librations of the Moon

Adams' tripod-mounted Hasselblad, Zeiss Sonnar 250 mm lens, and Kodak Panatomic-X 120 film combined to produce an extremely sharp 2¼ inch square negative. When we studied the poster-sized images of *Moon and Half Dome*, we were able to identify detailed features on the Moon's surface and use them to rule out two more of the possible dates.

The visibility of certain lunar features is greatly affected by the apparent oscillations called lunar librations. Many of us know the "fact" that the Moon always presents the same face to Earth. If this were strictly true, then only 50 % of the Moon's surface would be visible from Earth. However, for a patient observer willing to keep track of the Moon though many months, eventually 59 % of the Moon's surface becomes visible due to the lunar librations.

The Moon's aspect during libration in *latitude* is similar to looking at a person's head as that person nods up and down indicating "Yes." Sometimes the top of their head is more visible while the bottom of their chin is hidden, and then alternately the reverse is the case. As the Moon performs libration in latitude, sometimes the north polar region is more visible while the south polar region is hidden, and then alternately the south polar region becomes more visible.

The Moon's aspect during libration in *longitude* is similar to looking at a person's head as that person nods side to side indicating "No." Sometimes the right ear is more visible while the left ear is hidden, and then alternately the reverse is the case. For the Moon during libration in longitude, a lunar surface feature called Mare Crisium (near the edge of the Moon and analogous to the person's "left ear") sometimes librates away from the visible edge of the Moon and appears nearly round and relatively easy to see, and then alternately becomes more elliptical in shape and harder to observe when it librates closer to the Moon's edge.

The Ansel Adams photograph shows Mare Crisium very favorably placed for observation. The north polar region also appears to be tilted toward Earth, as we could see from the favorable views of the northern surface features Mare Frigoris and the Northern Highlands. Astronomers refer to the Moon in the photograph as exhibiting large *positive* librations in both longitude and latitude.

We calculated numerical values of the lunar librations in longitude and latitude for each of our possible dates. On one of these dates both of the calculated librations were large but *negative*, that is, both Mare Crisium and the

north polar regions would have been librated away from Earth and relatively difficult to observe. The Moon on that date was definitely inconsistent with the photograph.

On the Moon's face the curved line dividing the lit side from the dark side is called the terminator. Near the lunar terminator in the Adams photograph, we could see the lunar features Sinus Iridum (Bay of Rainbows) and the Jura Mountains clearly visible on the sunlit side of the Moon. On one of our tentative dates, the combination of lunar phase and lunar libration would have placed the Jura Mountains and half of Sinus Iridum on the dark side of the terminator, which is likewise inconsistent with the photograph.

Lunar librations are a relatively sophisticated aspect of the Moon's motion, not easy to describe in words but perhaps easier to visualize through the animations at the Wikipedia page for "Libration." One of the purposes of my honors course is to make unexpected connections between science and the humanities. In this case we used the phenomenon of lunar libration as a tool to study an iconic photograph of Yosemite National Park.

Fact-Finding Trip to Yosemite

At this point, we had narrowed down the possibilities to three dates when Adams could have created *Moon and Half Dome*. As our spring semester drew to a close, we planned a 5-day trip to Yosemite for mid-May, hoping to photograph star fields from Ahwahnee Meadow and to obtain more precise values for the topographic and celestial coordinates in the mountains and sky. If our calculations so far were correct, the constellation Delphinus would rise between Washington Column and Half Dome shortly after midnight and would provide the necessary stars.

After a flight from Texas, we rented vans at the San Francisco airport and made the drive past the orchards of the central valley of California and up through the foothills of the Sierra Nevada. Rain was falling when we arrived in Yosemite Valley in the late afternoon, but we were able to use binoculars and a small telescope to examine the detailed features on Washington Column and Half Dome and to see how they aligned. We definitely established that Adams took the photograph from the east end of Ahwahnee Meadow (Fig. 4.2), at a point about 250 ft southeast of the stone gate that marks the entrance road to the Ahwahnee Hotel.

We then looked forward to doing star field photography. However, for the next 3 days and nights temperatures hovered just above freezing, a cold rain

Fig. 4.2 *Don Olson (far left) and astronomy students from Texas State University in Ahwahnee Meadow, with Washington Column and Half Dome half-covered by a cloud in the background. Ansel Adams set up his camera on December 28, 1960, near the trees seen at the far left in this view (Photograph by Russell Doescher. Used with permission)*

fell steadily, and snow fell on the mountains and valley rim. We checked the state of the heavens every couple of hours each night, but only the single bright star Vega occasionally peeked through the clouds, nowhere near Half Dome, and photography was impossible. As we kept glancing up at the overcast skies, we recalled the experience of Dennis di Cicco, who had to make three trips to New Mexico before getting clear skies at Hernandez.

Weather Observations

While waiting for the rain to stop, we were able to rule out another one of the possible dates, fittingly, by considering rainfall.

On December 21, 1958, the Moon had the correct phase and position to match the photograph quite well. At the Yosemite Research Library we located an archive of detailed weather observations from the valley weather station, located less than a mile from Ahwahnee Meadow. The records show that it was raining in Yosemite Valley between 3:00 p.m. and 5:15 p.m. on December 21, 1958, so Adams could not have taken the picture on that date.

Stars Over Yosemite

The skies suddenly cleared on our fourth night in the park, and we rushed to set up our equipment in the meadow. A bright Moon, just past first quarter, shone behind us, and ahead of us the stars of Delphinus rose in the gap between Washington Column and Half Dome, just as we had predicted. During the long exposures, we had time to appreciate the scenery. Yosemite Falls was visible in the moonlight, which lit up the cliffs surrounding the valley. After the Moon set, the stars became dazzlingly bright against a velvet-black sky, and we watched as the constellation of the Scorpion passed behind Glacier Point.

There were no other people in the meadow, but we did have two visitors to our observing station. At 2:30 a.m. we noticed a bear followed by a coyote, walking along a path that brought them within about 75 ft of our equipment. Our time exposures continued undisturbed even during this event!

We were very glad that we had carried a car battery and a dew remover gun, like a small hair dryer, with us into the meadow. Our lenses began to fog up during the very first exposure, and we had to keep using the dew gun every few minutes.

By the end of the night we had obtained successful star trails, accurately timed. From the known calculated positions of the stars, we now had very accurate measurements of the precise coordinates for the region of the sky in which Ansel Adams had photographed the Moon (Olson et al. 1994: 85). When the shutter tripped for *Moon and Half Dome*, the Moon stood at an altitude of 22½° above the horizon and at a compass direction of 90°, that is, exactly due east.

Fig. 4.3 *The formation known as the Diving Board appears silhouetted against the face of Half Dome, as seen in this photograph taken from Glacier Point near noon on the fall equinox. The Diving Board, named for the way it overhangs the canyon below, cast its shadow onto Half Dome in the Ansel Adams photograph, taken from Ahwahnee Meadow in late afternoon near the winter solstice of 1960 (Photograph by Thomas Schrantz. Used by permission)*

Sunlight and Shadows *in* Moon and Half Dome

Before leaving Yosemite, we planned to perform one more crucial experiment at Glacier Point, an overlook famed for its spectacular panoramas of the valley and of the mountains of the High Sierra. From this vantage point we would have an excellent view of the Diving Board, a large overhanging ledge adjacent to Half Dome (Fig. 4.3). Adams' photograph does not include the Diving Board, but its dramatic shadow extends across the lower part of the face of Half Dome.

When we arrived in Yosemite, deep snow still blocked the Glacier Point road, which had not yet opened for the season. Every morning we checked the road conditions, but the cold rain we were experiencing in the valley was falling as snow on Glacier Point, and the road remained closed. As the week progressed, it looked as if the only way to reach Glacier Point would be by

hiking up a long trail with a vertical climb of 3,200 ft. With our telescopes we could see that snow covered the upper part of the trail. Realizing our inexperience with such conditions, we made inquiries and met an expert mountain climber who volunteered to lead our group, and we mentally prepared for the arduous climb through ice and snow.

Fortunately, on our last afternoon in the park, we learned that plows had just cleared the road, and we immediately drove our vans up to Glacier Point. We walked along the ridge south of the parking lot until we found the precise spot from which we could see the Diving Board aligned with the features at the base of Half Dome. In order to cast the long shadow as seen in the Adams photograph, the sunlight must have been slanting in from the southwest. More precisely, the Sun must have been at a compass direction of 236°, that is, 34° south of west. We now had enough information to reach a definite conclusion.

The Date of Moon and Half Dome

Ansel Adams made this exposure at 4:14 p.m. on December 28, 1960 – the only possible time with both the Moon and the Sun in the correct positions to match the photograph. The calculated lunar illuminated fraction is 86 %, in excellent agreement with measurements of the waxing gibbous Moon in the photograph.

For December 28, 1960, computer planetarium programs give the nominal time of moonrise as 2:11 p.m., but this applies to an ideal flat horizon. For an observer near Ahwahnee Meadow, we calculate that the waxing gibbous Moon would have first appeared in the gap between Washington Column and Half Dome at about 3:25 p.m. This time agrees well with Ansel Adams' accounts about spotting the rising Moon near 3:30 p.m. and then waiting to get a favorable composition.

For December 28, 1960, the calculated lunar librations in longitude and latitude were both large and positive, in perfect agreement with the favorable views of Mare Crisium and Mare Frigoris in the photograph. The calculated lunar terminator fell such that Sinus Iridum and the Jura Mountains were just on the sunlit side of the Moon, again in perfect agreement with the photograph.

The Yosemite weather observations for December 28, 1960, indicate an afternoon temperature of 42 °F, with high pressure and fair conditions, just as seen in the photograph. The Yosemite weather station records also

Table 4.1 *Anniversaries of Moon and Half Dome according to the 19-year Metonic cycle. The table lists dates and times when a waxing gibbous Moon rises near Half Dome and nearly matches the scene photographed by Ansel Adams in 1960. On each of these dates and times, the Moon's altitude is near 22½°, the Moon's compass direction is near 90° and the Moon's illuminated fraction is near 86 %*

Year and date	Time	Moon's illuminated fraction
1960 December 28	4:14 p.m.	86 %
1979 December 29	4:23 p.m.	88 %
1998 December 29	4:19 p.m.	87 %
2017 December 29	4:15 p.m.	86 %

indicate that precipitation occurred on 5 days in late November and early December of 1960, including 1 day-long snowstorm. Therefore, we can even account for the snow seen in the Ansel Adams picture near the summit of Half Dome and on the slope below Half Dome.

The 1960 date for *Moon and Half Dome* in Adams' *Autobiography* was correct, and he was referring to the end of that year.

Confirmation

A Christmas Day pageant called the Bracebridge Dinner has long been a tradition at the Ahwahnee Hotel. Ansel Adams wrote the text, selected the music, was often a leading member of the cast, and directed the staging of the annual event between 1929 and 1972. We located a Bracebridge program for 1960 that confirms Adams' presence in Yosemite Valley on December 25th and provides a consistency check with our proposed date, 3 days after Christmas, for *Moon and Half Dome*.

The Metonic Cycle: 1960 and 2017

The ancient Greek astronomer Meton of Athens is credited with recognizing a lunar period of 19 calendar years. After a Metonic cycle has elapsed, nearly the same lunar phase returns to the same calendar date, with a possible shift of plus or minus 1 day in part because of leap years. Table 4.1 shows how the Metonic cycle applies to *Moon and Half Dome* and lists years when a waxing gibbous Moon will appear near Half Dome near the end of December.

Table 4.1 shows that the year 2017 will bring an especially striking recreation, after allowing for the 1-day difference because 1960 was a leap year and 2017 will not be a leap year. The lunar phase in 2017 will be a perfect

match for 1960, and the near-repetition in clock time ensures that the Sun will be in the same part of the sky and will cast almost identical shadows across the Yosemite landscape.

If the skies are clear on December 29, 2017, observers in Ahwahnee Meadow will see the waxing gibbous Moon appear between Washington Column and Half Dome. The dramatic shadow of the Diving Board will extend out across the face of Half Dome. The Moon will rise up into the late afternoon sky and pass north of the monolith, just as it did on that winter day in 1960 when Ansel Adams captured the remarkable image known as *Moon and Half Dome*.

Adams' *Autumn Moon*

How can astronomical and topographical analysis be applied to the Ansel Adams photograph entitled *Autumn Moon*? What is the name of the mountain with the round dome that dominates the foreground, near the right side of this image? Can we identify the mountains that form the distant horizon? Toward which compass direction was Ansel Adams facing? How can we use the position and phase of the Moon to calculate the date and precise time, accurate to the minute, when Ansel Adams tripped the shutter for *Autumn Moon*? How can we predict when these astronomical conditions will repeat, and the Moon will again appear with the same lunar phase and position in the sky, creating an *Autumn Moon Encore*?

Glacier Point in Yosemite commands one of the most spectacular views in the American West. The panorama includes Yosemite Valley 3,000 ft below, with Yosemite Falls to the northwest and the distinctive profile of Half Dome to the east. But, near sunset on a warm California afternoon, Ansel Adams turned his camera instead toward the distant mountain range to the southeast, where a bright Moon was rising into the sky. He titled the resulting photograph *Autumn Moon, the High Sierra from Glacier Point* (Fig. 4.4).

Uncertain Chronology

A recent biography by Mary Street Alinder, Adams' friend and assistant, observed that "Ansel was notoriously bad at dating his own negatives… though he kept immaculate records of each negative's f/stop, lens, and exposure" (Alinder 1996: 144). The dates given by Adams in his captions were often just approximate guesses.

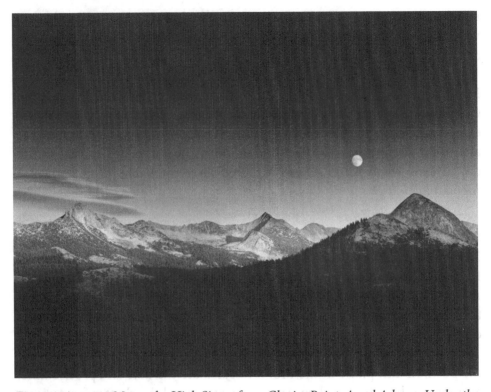

Fig. 4.4 *Autumn Moon, the High Sierra from Glacier Point, Ansel Adams. Under the clouds at the far left is Mount Clark (elevation 11,522 ft). The sharp point of Gray Peak (11,574 ft) falls just to the right of center, while the granite domes of Mount Starr King (9,092 ft) dominate the right side of the image. Although Starr King appears the tallest in the photograph, this is a result of Starr King's relative proximity to Glacier Point (elevation 7,214 ft at the benchmark near the valley overlook) (© 2013 The Ansel Adams Publishing Rights Trust)*

Our Texas State group wondered if we could use astronomical methods to find a date and precise time for *Autumn Moon*. This image was dated to 1944 in an exhibition called "Ansel Adams: Inspiration and Influence" (San Francisco Chronicle 2002), but several books give 1948 as the year instead (Adams 1992: 67, 1995: 92).

If we could determine a date for the original *Autumn Moon*, we could then verify our calculations by using lunar cycles to predict and photograph an *Autumn Moon Encore* (Fig. 4.5).

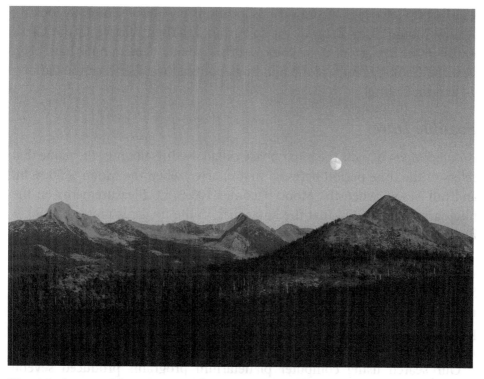

Fig. 4.5 *Autumn Moon Encore. The Moon on September 15, 2005, had nearly the same phase and position that Ansel Adams photographed on September 15, 1948 (Photograph by Russell Doescher. Used with permission)*

Mountains in Yosemite

As an initial step, we studied topographic maps and photographs to identify the mountains in *Autumn Moon*. We recognized the distinctive profile of Mount Clark (elevation 11,522 ft) under the clouds at the far left. Along the ridge of distant mountains, known as the Clark Range, the sharp point of Gray Peak (11,574 ft) is especially prominent just to the right of center in the image. In the foreground, the round granite domes of Mount Starr King (9,092 ft) dominate the right side of the composition. Although Starr King appears tallest in the photograph, this is a result of Starr King's being relatively close to Glacier Point (elevation 7,214 ft at the valley overlook).

To determine the Moon's precise compass direction in the photograph, we needed to know where Ansel Adams set up his tripod in the Glacier Point area, which extends from the parking lot for more than 1,000 ft out to the railing at the valley overlook. Park ranger David Balogh helped us by taking

a series of photographs from various locations on Glacier Point. By looking at how Mount Starr King in the foreground shifted relative to the Clark Range in the background, we could see that Adams' camera must have been near the Geology Hut, a stone building about halfway between the parking lot and the railing.

Possible Dates

Autumn Moon depicts the lunar phase called waxing gibbous, the name that refers to the time period between first quarter, when the Moon is 50 % lit, and full Moon, when the Moon becomes 100 % lit. Measurements on the photographs indicated that the lunar disk in the image is more than 90 % illuminated.

We decided to search the years from 1941 to 1959 and looked for dates when a waxing gibbous Moon rose into the sky between Gray Peak and Mount Starr King. We chose the initial year by reasoning that Adams' interest in moonrise photography may have increased following his successful Hernandez photograph in 1941. The year 1959 was a firm upper limit because the *Autumn Moon* image appeared then in the book *Yosemite Valley* (Adams 1959: 45).

Our search using computer planetarium programs produced several dozen possible dates within this time period. As it happened, two of the most promising dates fell in 1944 (as the recent exhibition states) and 1948 (as favored in several books).

Weather

Online archives of daily weather maps made it easy to determine the meteorological conditions in California on all of our possible dates. The weather records provided a good consistency check but did not help us establish a unique date for *Autumn Moon*, because northern California has such an abundance of clear skies in late summer and early autumn.

Autumn Moon in Color

Our continuing literature search then turned up something unexpected that allowed us to eliminate all the possible dates after 1954. Ansel Adams is best known for his black and white photography, but in the July 1954 issue of *Fortune* magazine we were surprised to find a color version (Fig. 4.6) of *Autumn Moon!* The Eastman Kodak company had commissioned noted photographers to test new color films and published the results in a story entitled "Test Exposures: Six Photographs from a Film Manufacturer's Files."

A three-second exposure, on Ektachrome, of the rising moon in the Sierra, by Ansel Adams

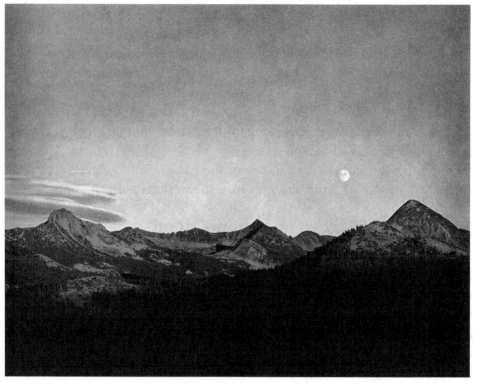

TEST EXPOSURES

Six Photographs from a Film Manufacturer's Files

Color photography, that complex and ingenious invention, is still in its infancy. But it has already reflected, in its uses, the true fresh beauties (as well as the fulsome inanities) of the age. The roundly romantic landscape above, and the several pictures on the following pages, are disparate examples of color commissioned by Eastman Kodak. They may be thought of as Eastman artistic, rather than scientific, tests. The materials, Kodachrome and Ektachrome sheet films, were sent out to selected practitioners, much as new pills are sent to physicians. The photographers—first-rate artists and craftsmen all—were given carte blanche to work on any subject they chose. —WALKER EVANS

FORTUNE *July 1954* 77

Fig. 4.6 *This color version of Autumn Moon appeared in the July 1954 issue of Fortune magazine. Eastman Kodak commissioned five noted photographers to test Kodak's new color sheet films, and Ansel Adams captured this "romantic landscape" with a three-second exposure on Ektachrome*

The article described the Ansel Adams moonrise as a "romantic landscape" captured with a "three-second exposure, on Ektachrome" (Evans 1954: 77).

Although the caption provided no date for this image, the clouds in the sky above Mount Clark prove that the color and monochrome versions were from the same day. By overlaying the two photographs and measuring how far the Moon had risen between the two exposures, we determined that the color image preceded the black and white version of *Autumn Moon* by two and a half minutes, just enough time for the expert photographer to change the film holder and adjust the settings on his 8×10 view camera. The reddening apparent on the Clark Range in the Ektachrome suggests a time in the late afternoon, with the Sun very near the western horizon.

Sunlight and Shadows in Autumn Moon

The photographs include an even more important clue to the time of day. Below Gray Peak a sharp triangular shadow extends to the left, toward the ridge of the Clark Range. Topographic maps show that this triangular shadow was cast by an unnamed peak (elevation 10,660 ft) that lies to the northwest of Gray Peak. From the length and direction of the shadow, we could determine the position of the Sun in the sky.

During the gathering of amateur astronomers called the Yosemite Star Party held on Glacier Point over Labor Day weekend in 2004, Richard Ozer of the Mount Diablo Astronomical Society assisted us by taking an accurately timed series of comparison photographs at 1 min intervals in the half hour before sunset. Ozer's photographs showed that the shadow developed only when the Sun was very low, within 2° of the horizon. Therefore, for the Ansel Adams images, we ruled out the dates with a waxing gibbous Moon in the correct part of the sky but with the Sun too high to cast a shadow like that seen in the photographs.

From the direction of the shadow in *Autumn Moon*, we established that the sunlight was slanting in from a direction just slightly north of due west, a position reached by the setting Sun on a few days in mid-September, about a week before the fall equinox.

Fact-Finding Trip to Yosemite

To complete our analysis, our Texas State group (Olson et al. 2005: 43) traveled to Yosemite during June 2005. We wanted to determine the GPS coordinates for the precise location of Ansel Adams' tripod. On Glacier Point we

Fig. 4.7 *The Texas State group traveled to Glacier Point in June 2005 and found the precise spot where Ansel Adams set up his tripod for Autumn Moon. From this viewpoint, the Clark Range and Mount Starr King form the background for Donald Olson, Louie Dean Valencia, Ashley Ralph, and Kara Holsinger, while Nevada Fall is visible in the middle distance (Photograph by Russell Doescher. Used with permission)*

used a small telescope to study how bright features in the granite on Mount Starr King aligned with distinctive features on the mountains in the background. We confirmed that we could match Ansel Adams' view only from an elevation of 7,220 ft above sea level and with GPS coordinates 119° 34.373′ West and 37° 43.754′ North. This location (Fig. 4.7) was about 20 ft east of the Geology Hut.

We took night sky photographs (Figs. 4.8 and 4.9) from this spot, as moonlight illuminated the mountains and the stars of the constellation Capricorn rose between Gray Peak and Mount Starr King. Back at our university, we used Photoshop™ to overlay our photographs onto *Autumn Moon*, with the mountains matching precisely. From the known calculated positions of the stars in our photographs, we had a precise determination of the Moon's coordinates in the Adams photograph. The combination of computer calculations with the topographical and astronomical data now provided enough information for a definite conclusion.

Fig. 4.8 *The stars of Capricorn rise into the sky between Gray Peak and Mount Starr King, as moonlight illuminates the mountains. The constellation of Delphinus is prominent at the upper left, and the stars of Pegasus, Equuleus, Aquarius, Aquila and Sagittarius also appear. Two of Yosemite's famous landmarks appear at the lower left, where the Merced River tumbles over Nevada Fall and then Vernal Fall (Photograph by Russell Doescher. Used with permission)*

Summer Moon

Ansel Adams must have created both the color and monochrome versions of *Autumn Moon* on September 15, 1948. The Ektachrome came first, at 7:01 p.m., Pacific Daylight Time, followed by the black and white image just after 7:03 p.m. The Yosemite weather records for that day show that clear skies prevailed, with a high temperature of 90 ° F. The calculated lunar illumination on this date is 95 %, in excellent agreement with the Moon's appearance in the photographs.

Fig. 4.9 *Stars of Aquarius and Capricorn rise into the sky above the Clark Range and Mount Starr King. Overlaying the star trails onto the Ansel Adams photograph provided a precise method for determining the lunar coordinates in Autumn Moon (Photograph by Russell Doescher. Used with permission)*

Behind Adams, the sinking Sun had nearly reached the horizon at a direction of 4° north of due west, exactly the position required to cast the shadow seen in the photographs. We calculated that the center of the Sun was only ½° above the horizon at the time of the color photo. As Adams tripped the shutter for the black and white photograph, the Sun's disk was just crossing the horizon, which helps to explain why Mount Starr King looks darker in the monochrome version. In both photographs the higher elevation ridge of the Clark Range is still catching the last rays of sunlight. Our analysis helped us to understand exactly how Ansel Adams captured such an interesting moment – a lighting effect that lasted for only a few minutes – to achieve the dramatic impact in the resulting photographs.

In 1948, the date of the fall equinox was September 23rd. Therefore the Ansel Adams photographs technically depict not an autumn Moon, but instead a very late summer Moon.

Adams Letters from 1948

Ansel Adams' published correspondence includes a letter dated September 15, 1948, the exact date calculated for the photographs (Adams 1988: 198) Unfortunately the text does not give the place of origin for this letter, although several references in the text suggest that Adams was in northern California, perhaps in San Francisco or Yosemite. A more definite result came from archivist Leslie Squyres of the Center for Creative Photography in Tucson, Arizona. The Ansel Adams Archive there contains many unpublished letters, and several of these prove that Adams was in Yosemite from September 10th through September 30th in 1948.

Eclipse Comet

We found a surprising link to astronomy in another letter from 1948. On November 18th, Adams was out well before sunrise and observed a "comet in the clear pre-dawn sky" (Adams 1988: 199). This must have been a sighting of the famous Eclipse Comet discovered during the total solar eclipse on November 1, 1948 (Federer 1949: 59). Ansel Adams' interest in astronomy continued a family tradition begun by his father, Charles Hitchcock Adams, a long-time officer of the Astronomical Society of the Pacific.

Autumn Moon Encore *and the Metonic Cycle*

The ancient Greek astronomer Meton of Athens is credited with recognizing a lunar period of 19 calendar years, now called the Metonic cycle. After one cycle has elapsed, nearly the same lunar phase returns to the same calendar date.

As Table 4.2 shows, visitors to Yosemite can witness a rising waxing gibbous Moon similar to that of September 15, 1948, on succeeding years separated by the 19-year cycle. The slight differences in lunar phase at each repetition cause small differences in the precise clock times that best match the view photographed by Ansel Adams.

The year 2005 offered the most recent special astronomical anniversary of *Autumn Moon*. Exactly three 19-year Metonic lunar cycles had elapsed since Ansel Adams took his photograph in 1948 on Glacier Point.

Table 4.2 *Autumn Moon Encore dates and times according to the 19-year Metonic cycle. The table lists dates and times when a waxing gibbous Moon rises between Gray Peak and Mount Starr King, nearly matching the scene photographed by Ansel Adams. Adams tripped the shutter twice in 1948 and took the color image at 7:01 p.m. and the black and white version just after 7:03 p.m.*

Year and date	Times	Moon's illuminated fraction
1948 September 15	7:01 p.m. and 7:03 p.m.	95 %
1967 September 15	6:50 p.m. and 6:52 p.m.	93 %
1986 September 15	6:54 p.m. and 6:56 p.m.	94 %
2005 September 15	6:50 p.m. and 6:52 p.m.	94 %
2024 September 15	6:46 p.m. and 6:48 p.m.	94 %

In the week leading up to September 15, 2005, our Texas State group spread the news about the upcoming event to California newspapers, television stations, and public radio stations. The media must have done their work, because on the appointed date about 300 photographers gathered from all over California and set up their tripods on Glacier Point. Four television crews did live remotes from Yosemite as the Sun sank toward the western horizon, and all of us awaited the moonrise.

At this point, our Texas State group hoped that our calculations were valid and that the Metonic cycle would work correctly! Right on schedule, the waxing gibbous Moon rose into the sky above the Clark Range, just as it had for Ansel Adams (CBS News, September 16, 2005; *New York Times*, September 17, 2005: A7; *San Francisco Chronicle*, September 19, 2005: A1; Sinnott 2006: 93–94). Under clear California skies, the modern photographers experienced the same magical low-Sun illumination that had entranced Adams 57 years earlier. The direction of the sunlight and the shadows were repeated, and everyone captured excellent images of the rising Moon above the dramatically lit landscape.

For many of our Texas State projects involving astronomy and art, knowing the place, the date, and the time when a painting scene was observed or a photograph was taken offers an opportunity for an imaginative experience. The science brings the contemporary reader closer to the moment of creation and to the artist they admire. In the special case of the *Autumn Moon Encore*, hundreds of us had the opportunity actually to see the celestial scene recreated before our eyes.

As sunset approaches on September 15, 2024, observers who travel to Glacier Point will again have a chance to share Ansel Adams' experience.

Moonbow Sightings

Just as the Sun can produce rainbows by day, a full or nearly full Moon can produce rainbows at night. The human eye loses much of its color sensitivity at night, and most visual observers describe lunar rainbows ("moonbows") as gray, white, or silvery in appearance. The author Mark Twain and the naturalist John Muir were exceptions.

How do we know that both Mark Twain and John Muir (Fig. 4.10) possessed vision sensitive enough to observe the colors in lunar rainbows? How can astronomical computations predict the dates and precise times when moonbows will appear in the waterfalls at Yosemite?

Aristotle wrote in the fourth century B.C. that both the Sun and the Moon could produce rainbows: "The rainbow occurs by day, and it was formerly thought that it never appeared by night as a moon rainbow. This opinion was due to the rarity of the phenomenon: it was not observed, for though it does happen, it does so rarely….The colors are not easy to see in the dark….The moon rainbow appears white…." (Aristotle, *Meteorologica*, Book 3)

Fig. 4.10 *Mark Twain considered himself lucky to have seen lunar rainbows on more than one occasion. The naturalist John Muir, honored by a 5¢ commemorative postage stamp in 1964, was an enthusiastic moonbow observer in Yosemite*

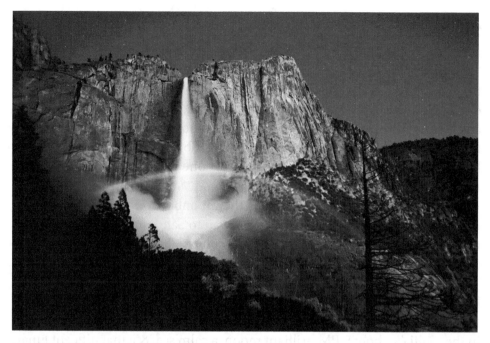

Fig. 4.11 *Photographer Brian Hawkins captured this moonbow in Upper Yosemite Fall near 1:00 a.m. on June 14, 2011. The stars of several northern constellations (Camelopardalis, Draco, Ursa Minor, Cepheus, Cygnus, Lacerta, and Pegasus) filled the sky over the north rim of Yosemite Valley, while a bright Moon (97 % lit) illuminated the scene from a position over the south rim, almost directly behind the photographer*

When rays of light from the Sun or Moon shine on spherical drops of water in a rain shower, a combination of refraction (bending of light), reflection, and dispersion (spreading of white light into colors) can create a rainbow display. The primary bow forms a circular arc with a radius of 42°, and under favorable conditions a much fainter secondary rainbow can appear with a radius of 51° and with the sequence of colors reversed. By day the center of both bows is the anti-solar direction, exactly opposite the Sun. At night the geometry is the same except that the anti-lunar direction, exactly opposite the Moon, acts as the center for the displays known as lunar rainbows, moon rainbows, or moonbows.

A time exposure photograph (Fig. 4.11) reveals that the full palette of colors is present in lunar rainbows, even though most naked-eye observers describe moonbows as colorless gray arcs. But under ideal conditions – clear air, abundant water drops, and bright moonlight from a full (or nearly full) Moon – some people have reported seeing the colors in lunar rainbows.

Mark Twain and Moonbows

Mark Twain made just such an observation in 1866 during a trip to Hawaii: "Why did not Captain Cook have taste enough to call his great discovery the Rainbow Islands? These charming spectacles are present to you at every turn; they are common in all the islands; they are visible every day, and frequently at night also – not the silvery bow we see once in an age in the States, by moonlight, but barred with all bright and beautiful colors, like the children of the sun and rain. I saw one of them a few nights ago" (Twain 1872: 513).

Twain also saw the color bands of the moonbow on a full Moon night during his 1866 passage by ship from Hawaii to San Francisco. He recorded the event in his notebook: "Spendidly-colored lunar rainbow to-night" (Anderson et al. 1975: 138).

The celebrated author reported seeing moonbow colors again in 1879 as he was returning to America from a European tour. A notebook entry from that voyage details how he again experienced near-ideal conditions: "At sea in the 'Gallia'…about 9 PM brilliant moon, a calm sea, & a magnificent lunar rainbow – a complete arch, the colors part of the time as brilliant as if it were noonday – some said not *quite* as brilliant, softened with a degree of vagueness, but to me it was not different from a daylight rainbow" (Anderson et al. 1975).

Twain considered himself very fortunate to have seen "this wonder."

Moonbows and Waterfalls

Instead of traveling by sea, visiting Hawaii, or waiting for a rain shower on a full Moon night, observers can find moonbows more reliably in the spray near waterfalls. At Victoria Falls (Fig. 4.12), on the border of Zambia and Zimbabwe, tour companies advertise "Lunar Rainbow Tours." Moonbow viewing is also a popular activity at Cumberland Falls in Kentucky, and early postcards show a hotel named the Moonbow Inn adjacent to the falls. Lunar bows provided a great tourist attraction at Niagara Falls in the years before the installation of artificial night lighting, and two topographic features there, Luna Island and Luna Falls, took their name from the phenomenon.

Fig. 4.12 *Calvin Bradshaw photographed this spectacular double moonbow in the mist from Victoria Falls, on the border of Zambia and Zimbabwe. The stars of the constellation Orion appear at the upper right*

John Muir and Yosemite Moonbows

The words of naturalist John Muir, who was largely responsible for the creation of Yosemite National Park, eloquently describe moonbows in waterfalls:

> Lunar rainbows or spray-bows also abound in the glorious affluence of dashing, rejoicing, hurrahing, enthusiastic spring floods, their colors as distinct as those of the sun and regularly and obviously banded, though less vivid. Fine specimens may be found any night at the foot of the Upper Yosemite Fall, glowing gloriously amid the gloomy shadows and thundering waters, whenever there is plenty of moonlight and spray. Even the secondary bow is at times distinctly visible.
>
> (Muir 1912: 39)

Muir encouraged visitors to explore Yosemite Valley at night and to watch for the moonbow: "This grand arc of color, glowing in mild, shapely beauty in so weird and huge a chamber of night shadows, and amid the rush and roar and tumultuous dashing of this thunder-voiced fall, is one of the most impressive and most cheering of all the blessed mountain evangels" (Muir 1912: 39).

Fig. 4.13 *The water in Lower Yosemite Fall and Yosemite Creek blurs during the time exposure for this dramatic moonbow photograph made by Grant Johnson at about 12:30 a.m. on May 13, 2006. The scene recalls the description by naturalist John Muir in 1912*

Standing alone in the night near the north rim of the valley, Muir delighted in the sights that have drawn pilgrims to this place on moonlit nights for well over a century: "...the moonbeams were pouring through....I saw a well-defined spray-bow, beautifully distinct in colors...while pure white foam-waves beneath the beautiful bow were constantly springing up out of the dark into the moonlight like dancing ghosts" (Muir 1912: 40).

Muir described his rare sighting of a double moonbow in an 1871 letter to his friend, Mrs. Jeanne C. Smith Carr: "Silver from the moon illumines this glorious creation which we term 'falls,' and has laid a magnificent double prismatic bow at its base. The tissue of the fall is delicately filmed on the outside like the substance of spent clouds, and the stars shine dimly through it" (Badè 1924: 250).

Inspired by Muir's dramatic accounts, our Texas State group had the idea of writing a computer program to predict dates and precise times when moonbows would appear in the Yosemite waterfalls (Fig. 4.13).

Computer Predictions for Moonbow Appearance

We realized that six conditions must be simultaneously met for a moonbow to be readily visible. The first two conditions are weather-dependent, but a computer program can model the last four astronomical conditions. The six conditions are:

1. CLEAR SKIES
2. ABUNDANT MIST AND SPRAY AT THE BASE OF THE FALL. The best moonbows at Yosemite occur during the snowmelt runoff season of April, May, June and sometimes early July.
3. DARK ENOUGH SKIES. Our computer program requires that the Sun be more than 9° below the horizon.
4. BRIGHT MOONLIGHT. The brightness of the Moon depends on the lunar phase, distance from Earth, and altitude above the horizon. Our computer program requires that the moonlight be brighter than a cutoff value corresponding to a Moon at an altitude of 25°, at its mean distance, and with an illuminated fraction of 95 %.
5. MOONLIGHT NOT BLOCKED BY MOUNTAINS OR CLIFFS. In order for moonlight to strike the spray at the base of a Yosemite waterfall, the Moon must have risen above the local horizon formed by the nearby mountains, domes and cliffs. Our Texas State group visited Yosemite and took photographs that we measured to determine the profile of the local horizon.
6. CORRECT RAINBOW GEOMETRY. A moonbow will appear only when the angle between the anti-lunar direction (the shadow of the observer's head) and the direction toward the base of the fall is near the rainbow angle of 42°. Understanding the topography to determine the relative positions of the viewing areas and the waterfalls provided another reason to travel to Yosemite.

Our computer program typically predicts moonbows on four or five nights near each full Moon during the snowmelt runoff period (Olson et al. 2007a, b; predictions posted online at http://uweb.txstate.edu/~do01/). This is perhaps slightly conservative but is in general agreement with the conclusions of the sharp-eyed John Muir, who judged: "…magnificent lunar bows may be found for half a dozen nights in the months of April, May, June, and sometimes in July" (Muir 1872: 2).

Making Moonbows

In addition to bows in rain showers and waterfalls, anyone can make a moonbow with a hose in the backyard. With a bright full or nearly full Moon high in the sky, direct a fine mist toward a spot 42° away from the shadow of your head. The bow is much easier to see against a dark background, such as a dark bush or a dark wall. Once seen, the ethereal silver-white of the moonbow is not easily forgotten.

References

Adams, Ansel (1959) *Yosemite Valley*. San Francisco: 5 Associates.

Adams, Ansel (1980) *The Camera*. Boston: Little, Brown and Company.

Adams, Ansel (1983) *Examples: The Making of 40 Photographs*. Boston: Little, Brown and Company.

Adams, Ansel (1985a) *Autobiography*. Boston: Little, Brown and Company.

Adams, Ansel (1985b) *Classic Images*. Boston: Little, Brown and Company.

Adams, Ansel (1988) *Ansel Adams: Letters and Images 1916–1984*. Boston: Little, Brown and Company.

Adams, Ansel (1992) *Our National Parks*. Boston: Little, Brown and Company.

Adams, Ansel (1995) *Yosemite*. Boston: Little, Brown and Company.

Adams, Virginia, and Ansel Adams (1963) *Illustrated Guide to Yosemite*. San Francisco: Sierra Club.

Alinder, Mary Street (1996) *Ansel Adams, A Biography*. New York: Henry Holt and Company.

Anderson, Frederick, Michael B. Frank, and Kenneth M. Sanderson, eds. (1975) *Mark Twain's Notebooks and Journals, Volume 1*. Berkeley: University of California Press.

Badè, William F., ed. (1924) *The Life and Letters of John Muir, Volume 1*. Boston and New York: Houghton Mifflin Company.

CBS News (2005) Just Like Ansel Adams. September 16, 2005.

di Cicco, Dennis (1991a) Ansel Adams' *Moonrise* Turns 50. *Sky & Telescope* **82**(5), November, 480.

di Cicco, Dennis (1991b) Dating Ansel Adams' *Moonrise*. *Sky & Telescope* **82**(5), November, 529–533.

Evans, Walker (1954) Test Exposures: Six Photographs from a Film Manufacturer's Files. *Fortune* **50**(1), July, 77–80.

Federer, Charles A., Jr. (1949) The Eclipse Comet of 1948. *Sky & Telescope* **8**(3), January, 59–60.

Muir, John (1872) Yo-semite in spring, May 7 [1872]. *New York Tribune*, July 11, 1872, 2.

Muir, John (1912) *The Yosemite.* New York: Century.

New York Times (2005) Like Old Times, Or at Least Very Close. September 17, 2005, A7.

Newhall, Nancy Wynne (1963) *Ansel Adams, Photographs, 1923–1963: The Eloquent Light.* San Francisco: M. H. de Young Memorial Museum.

Olson, Donald W., Russell L. Doescher, Amanda K. Burke, Mario E. Delgado, Marillyn A. Douglas, Kevin L. Fields, Robert B. Fischer, Patricia D. Gardiner, Thomas W. Huntley, Kellie E. McCarthy, and Amber G. Messenger (1994) Dating Ansel Adams' *Moon and Half Dome. Sky & Telescope* **88**(6), December, 82–86.

Olson, Donald W., Russell L. Doescher, Kara D. Holsinger, Ashley B. Ralph, and Louie Dean Valencia (2005) Ansel Adams and an "Autumn Moon." *Sky & Telescope* **110**(4), October, 40–45.

Olson, Donald W., Russell L. Doescher, Kellie N. Beicker, Ashley B. Ralph, and Hui-Yiing Chang (2007) Moonbows over Yosemite. *Sky & Telescope* **113**(5), May, 24–29.

Olson, Donald W., Russell L. Doescher, and Kellie N. Beicker (2007) John Muir and Yosemite Moonbows. *Yosemite: Journal of the Yosemite Association* **69**(2), Spring, 3–5.

San Francisco Chronicle (2002) Capturing the Sky: Ansel Adams, Inspiration and Influence, at the Oakland Museum of California. September 8, 2002, Sunday Datebook, 3.

San Francisco Chronicle (2005) Scientists search the skies to re-create famed artworks: Researcher pinpoints precise time, date of Ansel Adams photo. September 19, 2005, A1.

Sinnott, Roger W. (2006) An Ansel Adams Encore: Scores of camera enthusiasts show up at Glacier Point for a celestial scene captured 57 years earlier. *Sky & Telescope* **111**(1), January, 93–94.

Twain, Mark (1872) *Roughing It.* Hartford, Connecticut: American Publishing Company.

Part II

Astronomy in History

Part II.

Astronomy in History

5

Moons and Tides in the Battle of Marathon, Paul Revere's Midnight Ride, and the Sinking of the *Titanic*

Astronomical analysis can help to determine the dates of important historical events in ancient times and also help us to solve mysteries about more recent events for which the dates are known. Our Texas State group used calculations of tide levels, lunar phase, and the direction of moonlight to derive new results for the five examples described in this chapter.

Regarding the Battle of Marathon and the first "marathon" run, modern scholars agree that the events took place in the year 490 B.C. but disagree regarding the month and precise date. The ancient authors writing about the battle provide descriptions of the lunar phase. How can we use such astronomical clues to determine a date for the Battle of Marathon and the run from the battlefield back to Athens? Do the calculated date and season of the year help to explain why the runner died after delivering his urgent message?

In 55 B.C. an invasion fleet commanded by Julius Caesar sailed from Gaul (France) to a location on the coast of Britain. Historians ever since have debated the precise date and landing place. How do the time of the fall equinox, the direction of the tidal currents, and the phase of the Moon allow us to calculate a date for Julius Caesar's invasion of Britain? How can we be certain that the account given in virtually every history book, that Caesar drifted with the tidal stream to the northeast of Dover on the afternoon of either August 26th or 27th, 55 B.C., cannot possibly be correct? On what date did the Roman fleet approach the British coast? Where in Britain did Julius Caesar land?

D.W. Olson, *Celestial Sleuth: Using Astronomy to Solve Mysteries in Art, History and Literature,* Springer Praxis Books, DOI 10.1007/978-1-4614-8403-5_5, © Springer Science+Business Media New York 2014

For historical events in American colonial times, modern historians know the dates with certainty, but other mysteries remain.

On the evening of December 16, 1773, American colonists dressed as Native Americans boarded British tea ships in the port of Boston, broke open tea chests, and dumped the tea into the harbor. Engravings, woodcuts, lithographs, and paintings of the Boston Tea Party show a wide variety of different and contradictory lunar phases in the sky above Boston Harbor. Did bright moonlight prevail, or were the colonists forced to use lanterns and torches for illumination? What was the lunar phase that night? How did an unusual lunar configuration have an important effect on the tides and the water level in the harbor during the Boston Tea Party?

On the night of April 18–19, 1775, Paul Revere crossed Boston Harbor in a rowboat and passed just to the east of the British man-of-war *Somerset* as the Moon was rising. Revere then mounted his horse in Charlestown to make his famous midnight ride into the countryside. Historians have wondered why Paul Revere was not spotted by the *Somerset*'s British sentries, who had been ordered to stop anyone who tried to leave Boston. Were the sentries asleep or otherwise not paying attention? Why did they not easily see Revere's rowboat, silhouetted against the rising Moon? How can we use astronomical analysis of the Moon's position to explain this long-standing mystery about Paul Revere's midnight ride?

The date for the sinking of the *Titanic* is likewise well known. The liner struck an iceberg at 11:40 p.m. on April 14, 1912, and by 2:20 a.m. on April 15th the great ship had slipped beneath the waves. Did this occur on a moonless night or a bright moonlit night? What is the possible connection between a rare lunar configuration in January 1912 and the sinking of the *Titanic* about 3 months later? How could the Moon's effect on ocean tides in January help to explain why so many icebergs drifted south into the shipping lanes during the spring of 1912?

The Moon and the First Marathon Run

The Boston Marathon, the New York City Marathon, and all the other marathon races now held worldwide trace their origin to ancient Greece and the well-known story of a messenger who ran about 26 miles from the Battle of Marathon back to Athens, announced the victory of the Greeks over the Persians, and then died after having delivered his message. Much less well

known is that the ancient sources actually describe two different runs – a longer run before the battle, when the Athenians requested assistance from the Spartans, and the shorter "marathon" run after the battle.

Classical scholars agree on the year for these events but disagree regarding the month and precise dates. Can astronomical clues help to determine when the Battle of Marathon occurred? How do the lunar phases in 490 B.C. allow us to calculate a date for the run from the battlefield at Marathon to Athens? Which lunar calendar should be used for this computation – the Athenian calendar or the Spartan calendar? Why was the messenger in such a hurry to get back to Athens? If the runner was just announcing that the Greeks were victorious, what was the urgency? Is there another reason why the runner was pushing the limits of his endurance? Do the calculated date and season of the year also help to explain why the runner died after delivering his message?

The Run Before the Battle

In 490 B.C. King Darius of Persia sent his army to Greece. The invasion force landed at the plain of Marathon.

The Athenian military leaders ordered their own warriors to Marathon. They also urgently appealed to the town of Sparta, about 150 miles away in the region of Lacedaemon, for help from the formidable Spartan army. The Greek historian Herodotus does not give the calendar date for the run before the battle, but he does make an intriguing reference to the phase of the Moon:

> The generals sent to Sparta a messenger, an Athenian named Pheidippides, by profession a runner of long distances….Pheidippides reached Sparta the next day after departing from Athens. He went before the rulers and said to them: "Men of Lacedaemon, the Athenians entreat you to hasten to their aid, and not allow that most ancient city in all Greece to be brought into bondage by foreigners"…the Spartans said they wanted to assist the Athenians, but they were unable to do this immediately, because they did not wish to break the established religious laws. For it was the ninth day of the first decade of the lunar month, and they could not lead out the army on an expedition on the ninth day, they said, when the circle of the Moon was not yet full. And so they waited for the full Moon. (Herodotus, *Histories,* Book 6)

The Greeks began each lunar month at the new Moon and then divided the following 29 or 30 days into three periods: the first 10 days were the "rising" or "waxing" period as the Moon grew brighter, the next 10 days were

the "middle" period centered around a full Moon, and the last 9 or 10 days were the "dying" or "waning" period as the Moon's light diminished. The "ninth day of the first decade" is therefore the ninth day of the waxing period, and the "full Moon" mentioned by Herodotus would fall about 6 days later.

During their month of Karneios the Spartans abstained from warfare during the festival honoring Apollo Karneios. The event always ended with a full Moon, when the Moon rose at sunset, stood highest in the sky at midnight, and did not set until sunrise. The Greek playwright Euripides described the scene: "At Sparta when the time for the Karneian festival comes circling round, the Moon is aloft all night long" (Euripides, *Alcestis*, lines 445–450).

In 1879 the English poet Robert Browning published a popular work titled *Pheidippides* that recounts the Athenian appeal and the Spartan law that their army could not march out to war until the time of the full Moon:

> Run, Pheidippides, run and race, reach Sparta for aid!
> Persia has come, we are here, where is She?" Your command I obeyed,
> Ran and raced: like stubble, some field which a fire runs through,
> Was the space between city and city: two days, two nights did I burn…
> Ponder that precept of old, 'No warfare, whatever the odds
> In your favor, so long as the moon, half-orbed, is unable to take
> Full-circle her state in the sky!' Already she rounds to it fast:
> Athens must wait, patient as we – who judgment suspend.
>
> (Browning 1879: 30–34)

Modern athletes have demonstrated that Pheidippides' long-distance run is definitely possible. A race called the Spartathlon, held annually since 1983, follows a route of about 150 miles from Athens to Sparta, with winning times under 27 h.

The Battle of Marathon

The outnumbered Athenian army constructed a strong defensive position at Marathon and waited for aid from the Spartans. The Athenian and the Persian armies faced each other at Marathon for about a week as, night by night, the Moon grew brighter. Both sides knew that the Spartan army would be setting out as soon as the Moon was full and would reach Marathon a few days after that.

The Persians, near the time of the full Moon, apparently divided their forces in an effort to initiate decisive action before the Spartans could arrive. The Persians may have loaded some of the army and cavalry back on board ships, to sail around Cape Sounion and land at Phaleron, the port of Athens.

Fig. 5.1 *Greek Hoplite warriors charge the Persian army at the Battle of Marathon, as illustrated by Walter Crane for The Story of Greece (1913)*

The Greek army then had no choice but to begin an immediate battle, try to defeat quickly the Persian soldiers remaining at Marathon, and then hasten back to defend the city of Athens against the seaborne forces already on their way to Phaleron.

The Greeks attacked on the run (Fig. 5.1) to minimize the time they were exposed to the Persian archers. The Greek victory quickly turned into a rout, as the Persian army broke and ran for their ships. Herodotus tells us that 6,400 Persians were killed against only 192 dead on the Athenian side, Greek heroes buried in the mound called the Soros still visible on the battlefield today.

The importance of this event can hardly be overestimated. The great achievements in art, sculpture, drama, poetry, medicine, philosophy, mathematics, and astronomy during the Golden Age of Athens might not have occurred without the Greek victory at the Battle of Marathon.

Fig. 5.2 *The first Marathon run, from the battlefield back to Athens, as drawn for the Piers Plowman Histories (1913)*

The Run After the Battle

Robert Browning's 1879 poem credited Pheidippides with both runs – the one calling for Spartan aid and the "marathon" run after the battle (Fig. 5.2). His romantic description played an important role in the creation of modern marathon races, beginning at the 1896 Olympic Games. But Browning did not invent the heroic and fatal run announcing the victory. The Greek biographer Plutarch notes in an essay: "The news of the Battle of Marathon was brought back by Thersippus of Eroeadae, as Herakleides Ponticus relates, but most writers say that it was Eukles who ran in full armor, hot from the battle, and bursting in through the doors of the first men of the state, could say only, 'Rejoice! We are victorious!' and then immediately expired" (Plutarch, *Moralia*, Chap. 347).

A story preserved by the Greek satirist Lucian similarly states: "Philippides, the long-distance runner, reporting the victory from Marathon to the archons, who were seated anxiously awaiting the result of the battle, said 'Rejoice! We are victorious!' and saying this, he died at the same time as his report, expiring with the salutation" (Lucian, *Pro Lapsu Inter Salutandum*, Chap. 3).

Whatever his name was, the runner after the battle had a good reason for using all possible speed – not simply to announce the victory at Marathon but to deliver the urgent message that the Persians were coming by sea to attack the port of Athens.

Plutarch explains why the advance runner and the Athenians were in such a hurry after the battle:

> When the Athenians had routed the foreigners and driven them back on board their ships, they saw that the foreigners were sailing away, not toward the islands, but were being carried by wind and current toward Attica [the region including Athens]. They were afraid that the Persians might find Athens empty of defenders, and so they hastened back with nine of the tribes and reached the city on the same day. (Plutarch, *Life of Aristides*, Book 5, Chap. 4)

The *Histories* of Herodotus mentions the route of the Persian fleet and emphasizes the urgency of the Athenians:

> The Persians sailed around Cape Sounion, hoping to reach the city before the arrival of the Athenians...And so they sailed around Cape Sounion, but the Athenians marched back to the rescue, as fast as their feet could carry them, and reached the city before the foreigners....The foreigners lay at anchor off Phaleron, the harbor of Athens at that time. After riding at anchor there for a time, the Persians sailed their ships back to Asia. (Herodotus, *Histories*, Book 6)

The Moon and the Spartans

Too late to help in the Battle of Marathon, the Spartans now arrived. Herodotus mentions the full Moon (Fig. 5.3) again when he tells us: "After the full Moon two thousand Lacedaemonians [Spartans] came to Athens, making so great haste to reach it that they were in Attica on the third day from their leaving Sparta" (Herodotus, *Histories*, Book 6).

The Greek philosopher Plato makes another specific reference to the timing: "The Lacedaemonians [Spartans] arrived too late by one single day for the battle which took place at Marathon" (Plato, *Laws*, Section 698e).

These last two passages allow us to use astronomy to date the battle, provided we can calculate using the ancient Greek calendar systems.

Fig. 5.3 *According to the ancient Greek historian Herodotus, the laws of Sparta did not allow their army to march out to war "until the circle of the Moon was full," a lunar reference that helps to date the Battle of Marathon. This modern photograph shows a full Moon rising above the Parthenon in Athens on the evening of January 30, 2010 (Photograph by Anthony Ayiomamitis. Used with permission)*

Athenian Calendar: Battle of Marathon in September?

The Athenian calendar included 12 lunar months. Each month began at a new Moon, and Plato tells us when the Athenian year began: "The commencement of a new year begins with the month next after the summer solstice" (Plato, *Laws*, Section 767c).

Twelve lunar months include only 354 days, about 11 days short of the familiar solar year. To ensure that the first month, Hekatombaion, began at the first new Moon *after* the summer solstice, the Athenians were forced, every 2 or 3 years, to insert a leap month between the 6th and 7th months.

The German classical scholar August Böckh carried out an astronomical calculation, now widely adopted, for the date of the Battle of Marathon (Böckh 1855: 72). He wanted to determine the time of the Karneian full Moon – the culmination of the Karneian festival that delayed the Spartans.

Table 5.1 *Battle of Marathon on September 12, 490 B.C., according to the calcula-tion by August Böckh using the Athenian calendar. The rule adopted by Böckh was: The Spartan month Karneios corresponds to Metageitnion, the 2nd month of the Athenian year. Therefore, the Karneian full Moon is the full Moon following the 2nd new Moon after the summer solstice*

490 B.C.	
June 29	Summer solstice
July 26	New Moon begins Athenian month #1 (Hekatombaion)
August 25	New Moon begins Athenian month #2 (Metageitnion)
September 2	Pheidippides starts run from Athens to Sparta
September 3	Pheidippides reaches Sparta on ninth day of lunar month
September 9	Karneian full Moon, Spartan religious festival ends
September 10	Spartan army marches out from Sparta
September 12	Battle of Marathon, messenger runs from Marathon to Athens
September 13	Spartan army reaches Athens too late by one day

Böckh knew of a passage by Plutarch stating that certain events had occurred in: "the month Karneios, which the Athenians call Metageitnion" (Plutarch, *Nicias*, Chap. 28).

Böckh knew that Metageitnion was the 2nd month in the Athenian year. He argued that the Spartans left their own homeland on the day after the Karneian full Moon, arrived near Athens 3 days later and missed the fighting by arriving 1 day too late.

Böckh asked the German astronomer Johann Franz Encke to compute the date of the summer solstice and the lunar phases for 490 B.C. Putting it all together, Böckh had the results shown in Table 5.1, placing the Battle of Marathon on September 12, 490 B.C.

Böckh's calculation and his September result have been enormously influ-ential, adopted in authoritative editions of Herodotus by Heinrich Stein (1877: 201), Reginald Macan (1895: 375), Walter How and Joseph Wells (1912: 109), along with books and essays by John Bury (1931: 252), Charles Hignett (1963: 58), N. G. L. Hammond (1968: 40, 1988: 507), William Sheehan and Michael Armstrong (1996: 20), and Nicholas Sekunda (2002: 93). These authors and many others place the Battle of Marathon in the sec-ond week of September. The organizers of the Spartathlon schedule the "race every September as, according to Herodotus' account, Pheidippides' mission to Sparta was made at that time of the year."

Spartan Calendar: Battle of Marathon in August

But a few scholars doubted that the Battle of Marathon occurred in September, arguing that the Persians would not have invaded Attica so late in the summer. The German classicist George Busolt explained:

> The battle date does not allow itself to be determined with certainty. Only so much is known, that the battle took place near the time of a full Moon, either near September 9 or – and this is more probable – near August 10 of the year 490 B.C.…[T]he battle would not have taken place earlier than after the August full Moon. But it can hardly be placed later. For the Persian fleet departed from Cilicia early in the year and even if they were delayed somewhat among the islands, so it may hardly be allowed that they had used four months, or almost the entire good time of year, for the voyage through the Aegean Sea. (Busolt 1895: 596–597)

The historian Andrew R. Burn agreed that September seemed too late and judged that the astronomical calculation was ambiguous:

> [T]he Persians will have reached Euboia [a Greek island adjacent to Marathon] by the end of July, which, having met no effective resistance, they should have done…an element of uncertainty is introduced by the fact that there was a new moon practically at the summer solstice that year. By astronomical reckoning it comes before the solstice…and so would fall within the old year…but whether it was so reckoned would depend on when it was actually observed… and how Athens and Sparta defined the solstice. If the Karneian moon of 490 was that of August…as preferred by Busolt…one is the less puzzled by the question how the Persians had managed to spend so much time in reaching Euboia. (Burn 1962: 241)

For similar reasons, the classicist Peter Green also chose to "follow the time-scheme worked out by Burn" and to place the Battle of Marathon near the full Moon of August (Green 1996: 294).

Our Texas State group (Olson et al. 2004) became interested in the arguments of August vs. September and began our own computer calculations to check the times of the seasons and the lunar phases. We suddenly realized that Böckh had used the Athenian calendar to arrive at his calculated date in September, but the Karneia was a Spartan festival, so we should carry out our calculation in the Spartan calendar!

Unlike the Athenian year that began after the summer solstice, the Spartan year began after the fall equinox, according to the German chronologist Friedrich Ginzel (1911: 346). An essay by German classical scholar Ernst

Table 5.2 *Battle of Marathon on August 12, 490 B.C., according to our calculation using the Spartan calendar. The rule adopted is: Karneios is the 11th month of the Spartan year. Therefore, the Karneian full Moon is the full Moon following the 11th new Moon after the preceding fall equinox*

491 B.C.	
September 29	Fall equinox
October 4	New Moon begins Spartan month #1 (Spartan year begins)
490 B.C.	
July 26	New Moon begins Spartan month #11 (Karneios)
August 3	Pheidippides starts run from Athens to Sparta
August 4	Pheidippides reaches Sparta on ninth day of lunar month
August 10	Karneian full Moon, Spartan religious festival ends
August 11	Spartan army marches out from Sparta
August 12	Battle of Marathon, messenger runs from Marathon to Athens
August 13	Spartan army reaches Athens too late by one day

Bischoff agreed on the time of the Spartan new year, stating that: "In Lacedaemon [Sparta]…the beginning of the year occurred with the new Moon after the fall equinox" (Bischoff 1919: 1578).

Bischoff listed Karneios as the 11th Spartan month. Scholars are still investigating the Spartan calendar, and the list of Spartan lunar months is incomplete and uncertain. Compared to the relatively abundant texts by Athenians, few written records survive from Sparta. If we assume that Karneios was the 11th month after the preceding fall equinox, then we can calculate the date of the Karneian full Moon, with an interesting result that agrees perfectly with the date preferred by Busolt, Burn, and Green for military reasons.

If we use the Spartan calendar to calculate this Spartan festival, as shown in Table 5.2, then the Battle of Marathon falls on August 12, 490 B.C.

This calculated August date for the Battle of Marathon also explains a mystery about the run after the battle.

Death of the Runner

The herald's melodramatic death (Fig. 5.4) has contributed to some doubt that he even existed. Running guru Jim Fixx addressed this point in a skeptical account of the first Marathon run: "We know that the Battle of Marathon… occurred in September, a month when nowadays the average maximum

Fig. 5.4 *Jean-Pierre Cortot created this marble statue, "The Soldier of Marathon Announces the Victory," in 1834. Astronomical calculations based on the seasons and on the phases of the Moon can help to explain why the exhausted runner collapsed and died after running back to Athens from the battlefield at Marathon (Photograph by the author)*

temperature in Athens is 83°…the Pheidippides story is so patently improbable. Ask yourself: How likely is it, given the fact that thousands of modern marathon runners compete every weekend without mishap, that a trained runner would not have just collapsed but died?" (Fixx 1978a: 191).

Fixx offered the same opinions in an article for *Sports Illustrated* (Fixx 1978b: 62). Shortly thereafter, classical scholar Frank Frost weighed in and agreed that Fixx's "suspicions were justified." Frost himself published an article entitled "The Dubious Origins of the 'Marathon'" and argued that the story of the first Marathon run was "anecdotal embroidery…with a runner arriving at the gates of the victorious city, gasping out the good news and breathing his last." Frost concluded that there is "absolutely no historical support for a marathon race" (Frost 1979: 161–162).

Fixx, certain that the Battle of Marathon fell in September, had briefly considered the possibility of heat stroke to explain the death of the runner but eventually decided that the entire Marathon run story was a myth.

The result of our astronomical calculation moves the Battle of Marathon from the relatively cooler month of September to the hotter month of August

and allows us to estimate the temperature during the first Marathon run. Our calculated date in the Julian calendar is August 12, 490 B.C., which is 48 days before the fall equinox. The equivalent date in the modern Gregorian calendar would be August 5th or 6th, approximately 48 days before the modern fall equinox. Herodotus does not give a precise time of day for the battle, but it is plausible to place the fighting in the morning and the run back to Athens either in mid-day or during the afternoon. Climate data of the Hellenic National Meteorological Service for early August show that the expected average afternoon temperatures along the route would be 31–33 °C (88–91 °F), with maximum temperatures up to 39 °C (102 °F) possible near Athens.

To avoid such hot weather modern race organizers prefer the mornings of cooler months such as April for the Boston Marathon and November for the New York City Marathon. When the 2004 Summer Olympics took place in Athens, the marathon course began at a starting line in the plain of Marathon and ran along the ancient route to the finish line in Panathinaiko Stadium. This dramatic race was scheduled on August 29, 2004, as the final event on the last day of the Olympics. The Olympic planners set the marathon race start at 6 p.m., purposely to avoid the worst heat of an August day.

The hot afternoon of August 12, 490 B.C. could have induced the condition that can be fatal to even a trained professional athlete – heat exhaustion and heat stroke. The astronomical calculation by our Texas State group therefore suggests an explanation for the death of the runner in 490 B.C. and makes the story of the first marathon run more plausible.

Whenever a modern August full Moon occurs, this celestial event can remind us of how the movements of three armies were affected, twenty-five centuries ago, by another full Moon, a lunar phase that allows us to calculate the date of the Battle of Marathon.

The Moon, Tides, and Julius Caesar's Invasion of Britain

In 55 B.C. an invasion fleet commanded by Julius Caesar sailed from Gaul (France) to a location on the coast of Britain. Historians ever since have debated the precise date and landing place. How do the time of the fall equinox, the direction of the tidal currents, and the lunar phases allow us to calculate a date for Julius Caesar's invasion of Britain? How does the direction of the tidal stream help us to resolve the controversy over where Caesar landed?

Virtually every historian has argued that the tidal stream must have carried Caesar's fleet to a landing beach near the town of Deal, to the *northeast* of Dover. But every modern astronomer and hydrographer who has studied the problem has reached exactly the opposite conclusion. The scientists, considering how the configuration of Sun and Moon would have affected the tides, unanimously insist that the tidal stream must have carried the Romans to the *southwest* of Dover.

How can astronomical and tidal analysis resolve this contradiction? Did the Roman fleet drift with the tidal current to the northeast or to the southwest?

How can we be certain that the account given in virtually every history book, that Caesar drifted with the tidal stream to the northeast on the afternoon of either August 26th or 27th, cannot possibly be correct?

The solution offered by the scientists, that Caesar drifted with the tidal stream to the southwest on the afternoon of either August 26th or 27th, also runs into difficulties because the topography of the coastline southwest of Dover does not match the ancient accounts.

Where in Britain did Julius Caesar land? On what date did the Roman fleet approach the British coast?

Julius Caesar Invades Britain

Julius Caesar, in his memoir of the *Gallic War*, described the Roman invasion of Britain. His account, written in the third person, included details of astronomical and geographical interest:

> Only a small part of the summer was left....Caesar himself reached Britain with the first ships about the fourth hour of the day [mid-morning], and there he beheld the armed forces of the enemy displayed on all the cliffs. Such was the nature of this place, so steep were the heights that bordered the sea, that a spear could be hurled from the higher positions down on to the shore. Considering this by no means a suitable place for landing, he waited at anchor until the ninth hour [mid-afternoon] for the rest of the ships to assemble there. (Julius Caesar, *Gallic War*, Book 4)

The 12 hours of the Roman day ran from sunrise to sunset. The Roman 1st hour began at sunrise, the 4th hour fell during mid-morning, the 9th hour corresponded to mid-afternoon, and sunset marked the end of the 12th hour. Caesar's words therefore indicate that the Roman fleet (Fig. 5.5) first approached the coast in mid-morning and waited near the cliffs until mid-afternoon.

Fig. 5.5 *In August of 55 B.C., Julius Caesar commanded a Roman invasion fleet that approached the British coast near the white cliffs of Dover. Caesar waited until mid-afternoon for the ships to assemble near the cliffs and then, with both wind and tide in his favor, sailed to a more suitable landing point on a nearby open beach. This illustration appeared in Piers Plowman Histories (1913)*

Caesar's *Gallic War* continues the narrative as the mid-afternoon tidal stream carries the fleet toward a nearby landing beach: "Having got both the wind and the tide favorable at the same time, the signal was given and the anchors were weighed. They advanced about 7 miles from that place and landed the ships on an open and level shore" (Julius Caesar, *Gallic War*, Book 4).

Providing a clue to the modern scholars who have tried to pinpoint this location, Roman historian Dio Cassius described a promontory encountered by Caesar as the Roman fleet drifted with the tidal stream: "Caesar did not land at the place where he intended, for the Britons learned in advance that he was sailing against them, and they had occupied all the usual landing

Fig. 5.6 *The Britons prepare for battle as the Roman fleet approaches the landing beach. This chromolithograph appeared in Pictures of English History (1868)*

places on the coast facing the continent. Accordingly, Caesar sailed around a certain projecting headland, sailed along the other side, disembarked there in the shallows, and vanquished the enemy" (Dio Cassius, *Roman History*, Book 39). The battle on the shore (Figs. 5.6 and 5.7) between the Romans and the Britons would have occurred in the late afternoon, shortly before sunset.

A Storm Near Full Moon

Caesar also made an intriguing and specific astronomical reference to a full Moon in a passage about some ships that were delayed for several days in their departure from Gaul:

> On the fourth day after our arrival in Britain, the eighteen ships which transported the cavalry weighed anchor....When they were approaching Britain...a storm suddenly arose....On that same night it happened that there was a full

Fig. 5.7 *Julius Caesar, standing on a ship's prow at the upper left, urges on the Roman soldiers as they engage the Britons in the battle on the shore. The White Cliffs of Dover dominate the background of this illustration, created for a volume entitled History of Deal (1864)*

Moon, which day brings about the greatest maritime tides in the ocean...the tide was found to be filling up the warships in which Caesar had transported his army and which had been drawn up on dry land. (Julius Caesar, *Gallic War*, Book 4)

After campaigning in Britain for a few weeks, Caesar mentions the time of year when he returned to Gaul: "The day of the equinox was drawing near... having gotten a spell of fair weather, the ships weighed anchor a little after midnight, and all came safely back to the continent" (Julius Caesar, *Gallic War*, Book 4).

In 55 B.C. the equinox fell on September 25th, and the previous full Moon occurred in the early morning hours of August 31st. The storm that damaged the warships therefore began apparently on August 30th, called by Caesar "the fourth day after our arrival." Simple subtraction appears to place his landing on August 26th. An alternate method called inclusive counting considers the 27th, 28th, 29th, and the 30th as the 4 days described. The Roman landing appears to have occurred on either August 26th or 27th.

Halley's Calculation of Time and Place

The first person to employ this method, using astronomy and tides to determine the time and place of Caesar's landing, was the astronomer Edmond Halley, best known for determining the orbit of the comet that bears his name. He published his analysis of Caesar's account in the *Philosophical Transactions of the Royal Society*:

> [H]e arrived about the Fourth hour of the Day, viz. between Nine and Ten in the Morning, on the Coast of Britain, where he found the Enemy drawn up on the Cliffs ready to repel him....by which the Cliffs of Dover....are justly described, and could be no other Land....Here he says he came to an Anchor, and staid till the 9th. hour, or till about between Three and Four in the Afternoon....Then, viz. about Three in the Afternoon he weighed Anchor, and having gotten the Wind and Tide with him, he Sail'd about Eight Miles from the first place, and Anchor'd against an open and plain Shore. Here he made his Descent...the Landing on Britain was August 26 in the Afternoon, about a Month before the Autumnal equinox....(Halley 1691: 496–498)

Halley used the lunar phase to estimate the tide times and the direction of the tidal stream on the day of the invasion:

> [I]t was Four days before the Full Moon...that day by Three of the Clock in the Afternoon the Tide ran the same way he Sail'd...it was...Low-water about Two, whereof by Three the Tide of Flood was well made up, and it is plain that Cesar went with it, and the Flood setting to the Northward shews that the open Plain shore where he Landed was to the Northward of the Clifts. (Halley 1691: 498–499)

In the narrative by Dio Cassius, Halley recognized a description of the prominent topographic feature known as the South Foreland, an unmistakable spot on the coast to the northeast of Dover: "[H]e Sailed about a Promontory to the place where he Landed...the Promontory...must needs be the *South-Foreland*" (Halley 1691:500–501).

Fig. 5.8 *The direction of view is toward the northeast in this aerial photograph showing the town of Dover, the piers enclosing Dover harbor, and the adjacent white cliffs. According to most historians, the afternoon tidal stream carried the Roman fleet around the promontory called the South Foreland, visible near the right edge of this view. Caesar's army landed on the long stretch of open beach near the towns of Walmer and Deal, visible near the top edge of this photograph (Photograph by David Rose. Used with permission)*

Halley finally identified the landing place as an open beach near Walmer and Deal (Fig. 5.8), towns to the northeast of Dover.

Airy Finds Halley's Mistake

Halley incorrectly considered low water to be simultaneous with the beginning of the flood stream, which is the northeast-going tidal stream. Modern tidal observations show conclusively that the northeast-going tidal stream in the English Channel does not begin to run near Dover until about 3¼ h after low water. George Biddell Airy, Astronomer Royal and a tide expert, noticed

Halley's mistake, reopened the subject, and concluded that the tide must instead have carried Caesar southwest of Dover. "Supposing, therefore, that the day of landing was four days before full moon…the current off Dover would run to the westward from noon to half-past six o'clock…the direction of the current is absolutely opposed to that which would carry him from Dover to Deal" (Airy 1851: 352).

Airy was certain that his own calculations were correct and that the afternoon tidal stream could not have carried Caesar to Deal: "[A]t 3^h it would be running with a strong stream to the west. For Caesar then to have first attempted Dover and then to have landed at Walmer or Deal (as many writers have supposed) appears *absolutely impossible*….I do not see any reason for thinking that the line of coast has very sensibly changed, or that the tidal phenomena have sensibly altered, since the time of Caesar…generally, the course of the tides…will depend on the great tides of the Atlantic and the North Sea, and will not be sensibly affected by any petty changes at the east end of Kent" (Airy 1852: 239–241).

Deal or No Deal?

But historians argued that the ancient authors were unambiguously describing the coastline northeast of Dover, especially the long stretch of open beach just north of the distinctive headland called the South Foreland. Impressed by this topography, Edward Cardwell judged that Airy's calculations had been "found to terminate in incongruities and contradictions." Cardwell felt "at liberty to examine for himself" the question of the tides and deduced: "On the 27th of August, 55 B.C.…at 3 o'clock p.m. the stream had turned, and was running up the Channel…to the eastward…the evidence preponderates in favour of the coast of Deal as the landing-place of Julius Caesar" (Cardwell 1860: 14–17).

To help resolve the growing controversy, the British Admiralty sent a Royal Navy surveyor to observe the tides in the English Channel near Dover. Admiralty hydrographer George H. Richards agreed with Airy's conclusions: "[A]t 3 P.M. of 27th August, B.C. 55, the current was running to the westward, and would continue to do so until 6.30 P.M." (Stanhope 1867: 272).

Elementary, My Dear Holmes

Nevertheless, classical scholar Thomas Rice Holmes rejected this Admiralty result and felt himself qualified to make his own study of the tides. Holmes

collected nautical almanacs, tide tables, and publications for channel pilots, and finally concluded that:

> [I]f he landed on the 26th of August…it is not improbable that the stream may have turned eastward in the ninth hour…The ninth hour in the latitude of Dover lasted on the 26th of August from 2.20 till 3.30 p.m.…There is but one conclusion to which we can come, and that conclusion is absolutely certain: when Caesar weighed anchor off the Kentish cliffs, he sailed towards the north-east…he did land…between Walmer Castle and Deal Castle…the problem is solved. (Holmes 1907: 611, 647–649, 665)

Harold Dreyer Warburg, a leading tide expert and co-author of the *Admiralty Manual of Tides*, was exasperated by the historians who refused to accept the scientific findings. According to Warburg, the theories of the historians required: "such improbabilities, or impossibilities, as…the stream off Dover running to north-eastward at a time when it should be running to south-westward at nearly its maximum velocity…at about 3.30 p.m. the order was given to weigh and the fleet stood to westward with a fair wind and the stream behind them" (Warburg 1923: 237–238).

More recently, archaeologist Charles Francis Christopher Hawkes, a distinguished expert on ancient Britain, revisited the problem. Despite being aware of the assertions of all the scientists, he concluded that he could ignore their tidal expertise, and Hawkes sided with the previous historians: "27 August… Caesar…got the tide about 3 p.m. …and sailed round to Deal. By 6 he was off the beach (near Walmer Castle) and could land" (Hawkes 1977: 154–155).

An obvious pattern has emerged. Virtually all the archaeologists and historians insist that Caesar landed *northeast* of Dover in the late afternoon of either August 26 or 27, 55 B.C. The hydrographers and astronomers are equally adamant that the afternoon tidal stream on those dates must have carried Caesar's fleet to the *southwest*. How could this contradiction be resolved?

Fact-Finding Trip to Dover

Our Texas State group has a long-standing interest in amphibious landings, including the importance of tides to World War II events. We have studied the tides in 1943 at the Battle of Tarawa and in 1944 on D-Day at Omaha Beach in Normandy (see Chap. 7).

For the Caesar problem, we realized that certain dates in 2007 would provide a rare opportunity to observe almost exactly the same tidal conditions that prevailed in 55 B.C. The full Moon of August 2007 fell about 3½ weeks

Fig. 5.9 *On a boat freely drifting in the English Channel between Dover and the South Foreland, Texas State University student Kellie Beicker employed GPS to determine the direction of the tidal stream (Photograph by the author)*

before the equinox, just as happened in 55 B.C., and the distance to the Moon also nearly repeated the ancient configuration. We could therefore identify days when the tide times and the strength of the tides would be nearly the same as in the month of Caesar's landing.

Accordingly we planned a week-long trip to Kent (Olson et al. 2008). Automated tidal elevation gauges record data at Dover and Deal piers, and we also checked the water level on wooden tide staffs fastened to the piers. To determine the direction of the tidal stream, we observed the motion of floating objects in the channel from the ends of the piers, and we arranged a charter from White Cliffs Boat Tours (Fig. 5.9) in order to use GPS during a free drift. The results of our observations and calculations, with dates and times corrected to the corresponding calendar in 55 B.C., were clear and unambiguous and in perfect agreement with the conclusions of past tidal experts. On either August 26 or 27, 55 B.C., the maximum southwest-going tidal stream would have occurred in mid-afternoon during the Roman 9th hour, exactly when Caesar tells us that the Roman fleet began to move with the current. The account given in virtually every history book – that Caesar drifted with the tidal stream to the northeast to open beach near Deal on the afternoon of either August 26th or 27th – cannot possibly be correct.

Fig. 5.10 *The white cliffs at St. Margaret's Bay rise on the coastline between Dover harbor and the open beach near Walmer and Deal. According to the theory explained in this chapter, Julius Caesar sailed past this point in August of 55 B.C. (Photograph by the Dover District Council. Used with permission)*

However, we recognized the strength of the historians' argument that the topographic evidence fits the coast only to the northeast of Dover (Fig. 5.10). An appropriate promontory and a suitable beach cannot be found at the correct distance to the southwest of Dover. While trying to resolve this problem, our library research turned up another ancient source with intriguing tidal evidence.

The Falling Tide

In the first century A.D., the Roman writer Valerius Maximus collected historical anecdotes, often using ancient sources now lost. One of the stories describes a Roman soldier's bravery as the tide was falling during the battle on the British shore:

> Caesar went to war and laid his divine hands on the island of Britain. You, Scaeva, were carried by ship with four fellow soldiers to a rock close to the

island, which was occupied by a vast number of the enemy. The tide retreated, and the space which had divided the rock and the island was reduced to a shallow ford that was easy to cross. A vast multitude of the enemy streamed across, and while the other Romans were carried by ship to the shore, you held your station alone...as the enemy tried eagerly from all directions to attack you. (Valerius Maximus, *Memorable Deeds and Sayings: Of Courage*, Book 3)

The Valerius Maximus account raises serious problems for the landing beach scenarios favored by either the historians or the tide experts. Our measurements at Dover prove that on both August 26 and 27, 55 B.C., high water occurred shortly after sunset. On both dates the calculated water level was *rising* during the late afternoon – in conflict with this ancient description of the *falling* tide during the battle on the shore. The same conclusion about a rising tide applies to all nearby ports and beaches along the Kent coast, whether to the northeast or the southwest of Dover. But Caesar must have landed somewhere!

Our Solution for Julius Caesar's Invasion of Britain

We found the clue to resolving this problem in a comment by historian Robin G. Collingwood regarding the number of days between Caesar's landing and the storm just before the full Moon: "I suspect that something has gone wrong with the numeral *quartum* [4]...if the interval was more like a week, the stream would be running north-eastwards when he weighed" (Collingwood and Myres 1937:37).

Speaking more generally about numbers in the ancient manuscripts of Caesar's Gallic War, two scholars have likewise pointed out that "Numerals when expressed by symbols are of all things most subject to corruption in MSS" (Ridgeway 1891: 144), and that "copyists whose business it was to transcribe a MS correctly often blundered in copying numbers" (Peskett 1892: 195).

We can be certain that transcription errors occurred for some numerals in Caesar's text. For example, the distance sailed from Dover to the landing beach is given as "Eight Miles" according to Halley and in several editions of Caesar available in Halley's time. But all modern critical editions, based on early manuscripts, give this distance as 7 miles. At some point a transcriber apparently wrote 8 (VIII) instead of 7 (VII).

Regarding the time interval between Caesar's landing and the storm, if a transcription error occurred and 4 (IIII) days should actually have been 7 (VII) or 8 (VIII) days, then the landing may have taken place on August 22

or 23, 55 B.C. This single assumption produces a solution that matches all of the topographic, astronomical, and tidal evidence.

On both August 22 and 23, 55 B.C., the northeast-going tidal stream began to run in the early afternoon, accelerated during the Roman 9th hour in the mid-afternoon, and continued until after sunset, explaining how Caesar could sail around the South Foreland to reach the landing beach near Deal. On both August 22nd and 23rd high water occurred in the mid-afternoon, and then the water level began to drop, at first slowly and then more rapidly in the late afternoon, in perfect agreement with the story of the falling tide during the battle on the shore.

The scientific evidence of Sun, Moon and tides therefore suggests that one of these dates, 4 days earlier than those conventionally employed, correctly marks the beginning of the historic military campaign when the Romans under Julius Caesar first reached the island of Britain.

The Moon, Tides, and the Boston Tea Party

American colonists dressed as Native Americans boarded British tea ships at the port of Boston, broke open tea chests, and dumped the tea into the harbor on the evening of December 16, 1773. Engravings, woodcuts, lithographs, and paintings of the Boston Tea Party show a wide variety of different lunar phases in the sky above Boston Harbor. Which of these artistic depictions are correct? What was the lunar phase that night? Did bright moonlight prevail or were the colonists forced to use lanterns and torches for illumination? How did an unusual lunar configuration have an important effect on the tides and the water level that evening?

Tea Ships in Boston Harbor

A tavern song, popular in Boston during 1773 and 1774, began with the lines:

> Rally Mohawks! Bring out your axes,
> And tell King George we'll pay no taxes, on his foreign tea!

This ballad refers to the famous event on December 16, 1773, when a band of patriots disguised themselves as Native Americans and boarded three ships, the *Dartmouth*, the *Eleanor*, and the *Beaver*, at Griffin's Wharf in Boston Harbor. Between 6 p.m. and 9 p.m. the colonists raised 340 heavy chests of tea from the ships' holds, cut open the wooden boxes, and threw the contents overboard.

Fig. 5.11 *This magic lantern slide, part of a history series advertised by the McIntosh Stereopticon Company circa 1905 for use in schools, incorrectly shows a full Moon at the time of the Boston Tea Party*

Since the Boston Tea Party took place at night, it is natural to wonder whether moonlight aided the patriots during their work. But the existing literature gives confusing and contradictory accounts, mentioning almost all possible lunar phases.

Benson Lossing claimed the patriots at the Tea Party did their work in "the bright light of the moon" (Lossing 1851: 499) and later published a woodcut showing a full Moon over the scene (Lossing 1877: 705). A famous historical novel, Esther Forbes's *Johnny Tremain*, describes the scene similarly: "[A]s they reached Griffin's Wharf the moon, full and white, broke free of the clouds. The three ships, the silent hundreds gathering upon the wharf, all were dipped in the pure white light" (Forbes 1943: 125).

Francis S. Drake, in his monumental study of the Tea Party, likewise states that the "night was clear, the moon shone brilliantly" (Drake 1884: lxv). Most of the illustrations that we have located (for example, Fig. 5.11) depict a bright full Moon over the Tea Party.

However, some artists portray the scene differently. Some show waxing crescent Moons, with the sharp points or "horns" of the crescent directed up and to the left, while others show waning crescents, with the sharp points of the crescent directed up and to the right. At least one author has insisted that the Tea Party fell at a new Moon period, so the Moon was not visible in the night sky at all as the patriots dumped the tea into Boston Harbor (Schultz 1987: 24).

Which of these is correct? What was the lunar phase on December 16, 1773?

Waxing Crescent Moon in 1773

Our Texas State group used computer calculations to obtain the following times for lunar phases (Olson and Doescher 1993):

December 13, 1773	New Moon
December 20, 1773	First Quarter

The Boston Tea Party on December 16th therefore fell 3 days after new Moon. In the evening twilight, as the colonists destroyed the tea, the Moon would have appeared as a thin waxing crescent, 13 % sunlit, above the southwestern horizon. Colonial Boston almanacs employed a time system called local apparent solar time, the time read directly from a sundial. (The United States did not adopt modern time zones, including Eastern Standard Time, until 1883.) Using local apparent solar time, our calculations give the time of moonset as 8:04 p.m.

We were able to locate six colonial almanacs published in Boston for 1773, including those by Nathaniel Ames, Isaac Bickerstaff, John Fleeming, Ezra Gleason, Nathaniel Low and Samuel Stearns. They all mention the new Moon on December 13th. The almanacs give the time of moonset on December 16th as 8:02 p.m. (Low), 8:04 p.m. (Ames), 8:06 p.m. (Bickerstaff, Fleeming), 8:07 p.m. (Gleason), and 8:08 p.m. (Stearns), in good agreement with our calculated time of 8:04 p.m.

Of all the illustrations we have seen, the most accurate rendition of the lunar phase and position in the sky appears on the panel of four stamps (Fig. 5.12) designed by the artist William A. Smith and issued in 1973 as part of the Bicentennial commemoration. In a phone interview, Smith explained to us how he consulted with experts, checked colonial almanacs, and then carefully measured a 13 % crescent in his design (Olson and Kyle 1987). The stamps also correctly depict the compass direction of the Moon. The crowd of spectators on Griffin's Wharf would have seen the slender lunar crescent over the southwestern horizon, to the right of the tea ships.

Fig. 5.12 *This block of four stamps, designed by William A. Smith and issued in 1973 as part of the Bicentennial commemoration, accurately depicts the lunar phase and position in the sky. The crowd on Griffin's Wharf would have seen a thin waxing crescent Moon, 13 % sunlit, over the southwestern horizon during the first 2 h of the Boston Tea Party*

The Moon was in the sky during the first two hours of the Tea Party, but the slender crescent would not have thrown much light onto the scene. In fact, several eyewitness accounts of the Tea Party mention the use of torches and lanterns. The colonist Robert Sessions, a young laborer in a lumberyard owned by a Mr. Davis, recalled the use of artificial illumination:

> On that eventful evening, when Mr. Davis came in from the town meeting, I asked him what was to be done with the tea. 'They are now throwing it overboard,' he replied. Receiving permission, I went immediately to the spot. Everything was as light as day, by the means of lamps and torches; a pin might be seen lying on the wharf. I went on board where they were at work, and took hold with my own hands…other young men, similarly circumstanced with myself, joined them in their labors. The chests were drawn up by a tackle – one man bringing them forward, another putting a rope around them, and others hoisting them to the deck and carrying them to the vessel's side. The chests were then opened, the tea emptied over the side, and the chests thrown overboard… entire silence prevailed,– no clamor, no talking. Nothing was meddled with but the teas on board. (Drake 1884: lxxix–lxxx)

Tides in Boston Harbor

Initially, the intention of our Texas State group was simply to check the lunar phase and the moonlight. During our computer calculations, however, we noticed something else especially interesting related to the Moon's influence on the tides during the Tea Party.

In Boston Harbor, the mean range of the tides is about 9.5 ft. Spring tides are those of increased range occurring twice monthly near the times of new Moon and full Moon, when the alignment of Sun, Moon, and Earth allows the tide-raising forces of the Moon and Sun to combine for a greater net effect. At Boston, the spring range of the tides averages about 11.0 ft. Perigean tides of increased range also occur monthly when the Moon is near perigee, the point in the Moon's orbit that is nearest to Earth, and the lunar tide-raising force is greatest. If the time of lunar perigee falls near either a new Moon or full Moon, then perigean spring tides of exceptionally large range can occur. We discovered that this is exactly what happened in the middle of December 1773.

December 13, 1773	Lunar perigee
December 13, 1773	New Moon

When we calculated the tidal effects of this near-coincidence between new Moon and lunar perigee, the results showed that the tide range in Boston Harbor exceeded 14 ft during the 4-day period from December 13th through the 16th. Such extreme tides occur only a few times per year. Worth emphasizing is that perigean spring tides have greatly increased range, that is, both extremely high tides and also extremely low tides occur on the same day. We calculated the following schedule for the Boston Harbor tides, expressed in local apparent solar time:

December 16, 1773	12:59 p.m.	High water
December 16, 1773	7:23 p.m.	Low water
December 17, 1773	1:39 a.m.	High water

In the ideal situation for the colonists, the Tea Party would have occurred just after a high water with a strong current flowing out to sea. Instead, legal considerations set the date and time, since British customs officers could seize the valuable cargo if the merchants did not pay the duties "within twenty days after the first entry of the ship" (Labaree 1964: 126). The first tea ship arrived in Boston on November 28th, and the deadline was apparently deemed to fall at midnight on the night of December 16th to 17th.

During a late-afternoon session at Old South Meeting House on December 16th, the colonists learned that last-minute negotiations with Governor Thomas Hutchinson had failed. Amid cries of "Hurrah for Griffin's Wharf!" and "Boston Harbor a tea-pot tonight!" the meeting broke up, and the colonists carried out the destruction of the tea from about 6–9 p.m. The calculated schedule of tide times shows that the evening low water fell almost exactly in the middle of the Tea Party. During this period of perigean spring tides, all the low waters were lower than normal. Adding to the colonists' incredibly bad luck, it was the "lower low water," that is, the lower of the two low tides on December 16th, which fell during the Tea Party.

Eyewitness Accounts of Low Water at Tea Party

The reports collected by historian Francis S. Drake mention the effects of the unusually low tide. The colonist Benjamin Burton was on the scene at the Tea Party and noticed the unusually low tide:

> Happening to be in Boston on a visit on the memorable 16th of December, 1773, he went with the crowd to the Old South Meeting House, and at the close of the meeting, heard the cry "Tea party! tea party!" Joining the party that boarded the tea-ships, he labored with all his might in throwing the tea into the water. It being about low tide, the tea rested on the bottom, and when the tide rose it floated, and was lodged by the surf along the shore. (Drake 1884: ci)

The low water off Griffin's Wharf figures in a colorful account:

> Henry Purkitt, Samuel Sprague and John Hooten…were apprentices of about the same age…While at their work they heard a loud whistle, which startled them, and which they followed till it brought them to the wharf. Their part of the play was on the flats, by the side of one of the vessels, – for it was nearly low tide, – and with other boys, by direction of the commander, to break up more thoroughly the fragments of chests and masses of tea thrown over in too great haste. They found their return upon deck much facilitated by the immense pile which had accumulated beneath and around them. (Drake 1884: lxxx–lxxxi)

Purkitt, Sprague, and Hooten said that they spent much of their time on the tidal flats "trampling the tea into the mud."

Benjamin Simpson, a bricklayer's apprentice, likewise recalled: "a number of men…went on board the ships, then lying at the side of the wharf, the water in the dock not more than two feet deep. They began to throw the tea

into the water, which went off with the tide till the tea grounded...I was on board the ships when the tea was so high by the side of them as to fall in, which was shovelled down more than once" (Drake 1884: lxxvii-lxxviii).

Massachusetts Governor Thomas Hutchinson, in a letter written on the next day, reported that the tide was so low during the destruction of the tea that "three of the vessels lay aground" at Griffin's Wharf (Hutchinson 1874: 27).

A local paper told what eventually happened to the tea: "When the tide rose, it floated the broken chests and the tea, insomuch that the surface of the water was filled therewith a considerable way from the south part of the town to Dorchester Neck, and lodged on the shores" (*Massachusetts Gazette*, December 23, 1773).

The colonist George R. T. Hewes described the scene during the next low tide on the day after the Tea Party: "Early on the morning of the 17th, a long windrow of tea, 'about as big as you ever saw of hay,' was seen extending from the wharves down to the castle [Castle Island]. A party of volunteers soon turned out in boats, and stirred it up in the 'pot' pretty effectually" (Drake 1884: lxxvii).

During all of 1773, the lowest tides occurred during the week of the Tea Party. The astronomical configuration – the near-coincidence of lunar perigee and new Moon in mid-December of 1773 – explains the unusually low tide that occurred during the Tea Party and complicated the work as the patriots labored to destroy the British tea.

"Lunar Luck" and Paul Revere's Midnight Ride

On the night of April 18–19, 1775, Paul Revere crossed Boston Harbor in a rowboat, passing just to the east of the British man-of-war *Somerset* as the Moon was rising. Revere then mounted his horse in Charlestown to make his famous midnight ride into the countryside. What was the lunar phase on that night? Why was Paul Revere not spotted by the British sentries on the *Somerset*, who had been ordered to stop anyone who tried to leave Boston? Were the sentries asleep or otherwise not paying attention? Why did they not easily see Revere's rowboat, silhouetted against the rising Moon? How can an astronomical analysis of the Moon's position explain this long-standing mystery?

The Legend of the Midnight Ride

In his "Tales of a Wayside Inn," Henry Wadsworth Longfellow began the landlord's tale with these stirring lines:

> *Listen, my children, and you shall hear*
> *Of the midnight ride of Paul Revere,*
> *On the eighteenth of April, in Seventy-five;*
> *Hardly a man is now alive*
> *Who remembers that famous day and year.*

<div align="right">(Longfellow 1863: 18)</div>

The poem refers to the spring of 1775, when General Thomas Gage, British commander in Boston, received information that the colonists had concealed a considerable quantity of guns and gunpowder in Concord, a town about 18 miles west of Boston. On the night of April 18th, Gage ordered a detachment of soldiers to proceed to Concord and seize the arms. Boats began ferrying the troops from Boston across the Charles River to Cambridge.

Anticipating such a move, the patriots had wondered whether the British might go to Concord by the land route instead. Gage's choice to cross by water led to the famous signal with two lanterns ("one if by land, two if by sea") shining from the belfry of Old North Church. Paul Revere himself crossed the harbor sometime between 10 p.m. and 11 p.m. in a rowboat from Boston to Charlestown. There he began his famous midnight ride (Figs. 5.13 and 5.14) toward Lexington and Concord and intended to gallop through "every Middlesex village and farm" to warn of the British advance.

Longfellow's poem contains a number of astronomical references. For example, the poet mentions the Moon five times:

> *Silently [he] rowed to the Charlestown shore,*
> *Just as the moon rose over the bay…*
> *The Somerset, British man-of-war;*
> *A phantom ship, with each mast and spar*
> *Across the moon like a prison bar…*
> *He paused to listen and look down*
> *A moment on the roofs of the town,*
> *And the moonlight flowing over all…*
> *A hurry of hoofs in a village street,*
> *A shape in the moonlight, a bulk in the dark…*
> *He saw the gilded weathercock*
> *Swim in the moonlight as he passed.*

Fig. 5.13 *A nearly full Moon illuminates the scene of Paul Revere on his midnight ride, as seen in this illustration from an early twentieth-century calendar*

But are these astronomical references accurate? Or, does Longfellow merely invoke the Moon through poetic license? There is good reason to ask such questions, in view of other well-known historical errors in the account. For example, the poem puts Revere on the wrong side of the harbor. Actually, Revere was involved in *sending* the two-lantern signal and did not need to receive it. Also, Longfellow has Revere reach Concord, but in reality British soldiers stopped him and his friend William Dawes just past Lexington, and it was a third rider, Samuel Prescott, who reached Concord.

Was the Moon rising as Revere crossed the river? Was there bright moonlight throughout the midnight ride?

Fig. 5.14 *The Midnight Ride of Paul Revere, Grant Wood, 1931. The artist Grant Wood, best known for his iconic painting American Gothic, here masterfully depicts the bright moonlight during Paul Revere's ride – without showing the Moon itself (© Figge Art Museum, successors to the Estate of Nan Wood Graham/Licensed by VAGA, New York, NY. Used with permission)*

Lunar Calculations for 1775

Our Texas State group (Olson and Doescher 1992: 437) used computer programs to obtain the following lunar phases:

April 15, 1775	Full Moon
April 22, 1775	Last Quarter Moon

The calculations show that Longfellow was correct about the Moon, which was just past full and 87 % illuminated as it passed through the sky above Boston on the night of April 18–19, 1775. Moonrise on April 18th occurred at 9:53 p.m. local apparent solar time. This time system, equivalent to the time read from a sundial, was employed in colonial Boston; the United States did not adopt modern time zones until 1883.

We were able to locate four different almanacs published in Boston for 1775, including those authored by Nathaniel Low, Isaac Bickerstaff, Isaiah Thomas and Nathaniel Ames. The almanacs listed moonrise on April 18th as 9:45 p.m. (Low, Ames), 9:46 p.m. (Thomas), and 9:53 p.m. (Bickerstaff).

The computer calculations and the colonial almanacs all agree that the bright Moon was rising into the sky as Paul Revere crossed the harbor between 10 p.m. and 11 p.m.

Revere's Recollections

Paul Revere left several first-person accounts of the famous night. Two are in the Revere family papers, and both describe how "the Moon shone bright" (Goss 1891: 221). A third account took the form of a letter to Jeremy Belknap of the Massachusetts Historical Society, with the following lines describing how Revere:

> ...went to the North part of the Town, where
> I had kept a Boat; two friends rowed me across Charles River,
> a little to the eastward where the Somerset Man of
> War lay. It was then young flood, the Ship was winding, &
> the moon was Rising. They landed me on Charlestown
> side...I set off upon a very good Horse;
> it was then about 11 o'Clock.... (Revere 1798: 107)

Historians for 200 years have found it hard to understand how Paul Revere could have eluded detection by the *Somerset*, especially because his rowboat crossed the harbor just as the Moon was rising. Revere says that he passed a little to the east of the *Somerset*, and it seems reasonable to think that moonrise would be in the east. One historian argued that "an alert sentinel would have seen the boat against the rising moon" (French 1925: 80). Why didn't the British sentinels see his rowboat silhouetted against the Moon, or outlined in the glittering path of moonlight sparkling on the surface of the water?

"Lunar Luck"

The astronomical analysis (Olson and Doescher 1992: 439) provides a solution to this mystery by revealing the point on the horizon where the Moon rose that night.

Astronomers define an imaginary line in the sky called the celestial equator, which divides the heavens into a northern half and a southern half. (The celestial equator is therefore analogous to Earth's equator, which divides our globe into a northern and southern hemisphere.) Twice during each lunar month, the Moon passes through the points in its orbit that intersect the celestial equator, and on those nights the Moon does rise exactly due east. If that had occurred on April 18th, then British sentinels on the *Somerset* would almost certainly have spotted Revere as he rowed east of the ship – he never would have reached his horse in Charlestown, and there would have been no midnight ride.

Once each month, for a period of several days, the Moon passes through the part of its orbit farthest north of the celestial equator, and then it rises in the northeast. Also once each month, for a period of several days, the Moon is found near the part of its orbit farthest south of the celestial equator, and then it rises in the southeast.

Computer calculations show that on April 18, 1775, the Moon happened to be near the southern extreme of its orbit. If Revere crossed the harbor roughly 45 min after moonrise, the Moon would have been standing low in the sky, only 6° above the southeastern horizon. From the point of view of a sentinel on the *Somerset*, the Moon was rising behind the city of Boston, not over the open water of the bay to the east. When Revere's rowboat passed "a little to the eastward" of the ship (Fig. 5.15), there was no glitter path of moonlight to the east of the ship, and the British lookouts could not have seen the rowboat silhouetted in the water. The southeastern position of the rising Moon – a remarkable piece of "lunar luck" for Paul Revere – explains why he was successful in reaching his horse on the Charlestown shore.

Tides in Boston Harbor

Revere's 1798 letter mentions that it was "young flood" as he was crossing the harbor, meaning that the water level was beginning to rise as the flood tide entered Boston Harbor. Revere also observed that "the ship was winding," a colorful image indicating that the tidal currents and eddies were causing the *Somerset* to rotate around the point where it was anchored. Longfellow's poem likewise includes a description of the ferrying of the soldiers on "the rising tide, like a bridge of boats." As shown in Table 5.3, we can check these statements with modern computer tide programs.

Revere's letter and Longfellow's poem are again both correct. There was a rising tide between 10 p.m. and 11 p.m. as Revere passed the *Somerset*.

Fig. 5.15 *Paul Revere crossed Boston Harbor and passed the HMS Somerset shortly after moonrise on April 18, 1775. However, sentinels on the man-of-war would not have spotted his rowboat outlined in the glittering path of moonlight sparkling on the water, since the Moon rose considerably south of east that night. This illustration correctly shows the position of the rising Moon low in the sky over the city of Boston, as Revere's rowboat slips by unnoticed in the dark waters to the east of the Somerset (© Christopher Bing. Used with permission)*

Table 5.3 *Boston Harbor tide calculations*

Date	Apparent Solar Time	Tides
April 18, 1775	1:14 p.m.	High water
April 18, 1775	7:19 p.m.	Low water
April 19, 1775	1:26 a.m.	High water

Paul Revere Mystery Solved

On April 18, 1775, a bright nearly full Moon rose shortly before 10 p.m. and remained in the sky throughout Paul Revere's ride (Fig. 5.16). Our calculation of the direction of moonrise solves the mystery of why British

Fig. 5.16 *This Raphael Tuck & Sons postcard from about 1910 shows the nearly full Moon in the sky above Paul Revere on his midnight ride*

sentinels on the *Somerset* did not stop Revere as his rowboat crossed Boston Harbor to the east of the ship. If the Moon that night had risen due east, the British guards would have easily spotted Revere's rowboat, silhouetted in the glittering path of moonlight on the water. But the Moon that night was near the southern extreme of the lunar orbit and rose unusually far to the south of east, allowing Revere to elude detection, to reach his horse, and to make his famous midnight ride.

Did the Moon Sink the *Titanic*?

On April 10, 1912, the *Titanic* sailed from Southampton, England, on its maiden voyage. After stops to pick up passengers at Cherbourg, France, and Queenstown [now Cobh], Ireland, the liner headed west across the North Atlantic. But it would never reach New York City. At 11:40 p.m. on April 14th, the *Titanic* struck an iceberg, and by 2:20 a.m. on April 15th the great ship had slipped beneath the waves. Although rescuers plucked some 700 people from lifeboats, 1,500 passengers and crew drowned in the icy waters.

On January 4, 1912, an astronomical event called an extreme lunar perigee marked the closest approach of the Moon to the center of Earth for a period of more than 1,400 years. What is the possible connection between this rare lunar configuration in January and the sinking of the *Titanic* about

Fig. 5.17 *British maritime artist Simon Fisher depicts the scene on the night of April 14, 1912, as lookout Frederick Fleet used the telephone in the crow's nest to call the Titanic's bridge with the warning: "Iceberg, right ahead!" (Illustration by Simon Fisher, 2012. Used with permission)*

3 months later? Could the Moon's effect on ocean tides in January help to explain why so many icebergs drifted south into the shipping lanes during the spring of 1912?

A Starlit, Moonless Night

The stars were shining brightly but the Moon was not in the sky on the night when the *Titanic* struck the iceberg: "Night fell, cold and moonless…At night lookouts normally watched for waves breaking around the exposed portion of an iceberg; the white surf made a berg easier to spot. But on this night there was virtually no swell or wind; little surf would be generated around any icebergs that might be in the vicinity. And there was no Moon. Moonlight…might have made what foam there was, or even the berg itself, easier to see" (Rubincam and Rowlands 1993: 79) (Figs. 5.17 and 5.18).

Fig. 5.18 *For many decades after the sinking of the Titanic, the prevailing theory held that the iceberg tore a large gash extending about 300 ft along the starboard side of the ship, as depicted in this illustration widely reproduced in magazines and newspapers in 1912. Recent theories assert that there was no long gash, but rather that the iceberg deformed the steel plates that made up the hull, popped rivets, and opened relatively small gaps between the plates*

When Second Officer Charles H. Lightoller was asked to explain the circumstances of that night, he answered, "In the first place, there was no moon" (British Wreck Commissioner's Inquiry 1912).

A few of the passengers and crew watched in amazement as the iceberg scraped along the starboard side of the *Titanic* (Figs. 5.19 and 5.20) before disappearing into the night.

Passenger Lawrence Beesley, gazing around from Lifeboat 13 after the *Titanic* had gone down, was impressed by the clarity of the atmosphere and the brilliance of the starry heavens:

> First of all, the climatic conditions were extraordinary. The night was one of the most beautiful I have ever seen: the sky without a single cloud to mar the perfect brilliance of the stars, clustered so thickly together that in places there seemed almost more dazzling points of light set in the black sky than background of sky itself; and each star seemed, in the keen atmosphere, free from any haze, to have increased its brilliance tenfold and to twinkle and glitter with a staccato flash that made the sky seem nothing but a setting made for them in which to display

Fig. 5.19 *The Titanic, unable to stop or to turn in time, collided with the iceberg at 11:40 p.m. Maritime artist Richard DeRosset shows the backwash just behind the great ship's stern, as the crew reversed the propellers in a failed attempt to avoid the collision. The iceberg is rendered here following the sketch and detailed description by Able Seaman Joseph Scarrott (Illustration by Richard DeRosset. Used with permission)*

> their wonder…where the sky met the sea the line was as clear and definite as the edge of a knife…where a star came low down in the sky near the clear-cut edge of the waterline, it still lost none of its brilliance. (Beesley 1912: 99)

Shortly before sunrise on April 15th, Beesley realized that rescue was at hand when he saw the approach of a passenger vessel. The eastern sky brightened (Fig. 5.21) as his lifeboat proceeded toward the *Carpathia*:

> And then, as if to make everything complete for our happiness, came the dawn. First a beautiful, quiet shimmer away in the east, then a soft golden glow that crept up stealthily from behind the sky-line…And next the stars died, slowly,– save one which remained long after the others just above the horizon; and near by, with the crescent turned to the north, and the lower horn just touching the horizon, the thinnest, palest of moons. (Beesley 1912: 136)

Fig. 5.20 *The iceberg deposited a quantity of ice in the forward well deck of the Titanic during the collision. This 1912 illustration of the iceberg passing along the starboard side of the ship was based primarily on the account by Able Seaman Joseph Scarrott, who made his observations from the well deck*

This last remaining "star" was actually the planet Venus. The bright planet rose 41 min before sunrise, only 4° from a slender crescent Moon.

Rare Lunar Configuration in 1912

Ocean tides with unusual range may have played a role in bringing the iceberg into the path of the *Titanic*. Spring tides are those with increased range occurring at both new Moon and full Moon, when the tide-raising forces of the Sun and Moon combine for a greater net effect. Perigean tides of increased range occur when the Moon is near perigee, the point in its orbit when the Moon is nearest Earth and the lunar tide-raising force is greatest. If the time

Fig. 5.21 *At sunrise on April 15, 1912, the Titanic survivors in lifeboats saw that they were surrounded by a field of ice that included icebergs towering 150–200 ft above the water level. This depiction, entitled "L'Aurore qui suivit la nuit tragique" ("The Dawn That Followed the Tragic Night"), appeared in the French periodical L'Illustration in 1912*

Table 5.4 *Enhanced tide-raising forces on Earth's oceans in January 1912*

January 3, 1912	Earth at perihelion (Earth closest to the Sun)	Solar tide-raising force maximized
January 4, 1912	Full Moon (Sun-Earth-Moon aligned)	Solar and lunar tide-raising forces combine for greater net effect
January 4, 1912	Moon at perigee (Moon closest to Earth)	Lunar tide-raising force maximized

of lunar perigee falls near either new Moon or full Moon, then perigean spring tides with exceptionally large range can occur.

A more uncommon configuration occurs when perigean spring tides happen to occur near the time of year when Earth is near perihelion, the point in the orbit when Earth is closest to the Sun and the solar tide-raising force is greatest. Table 5.4 shows that such an astronomical coincidence occurred near the perihelion of 1912.

The effect of this remarkable alignment was to produce an exceptionally close lunar distance, with the center of the Moon only 356,375 km from the center of Earth on January 4, 1912.

The oceanographer Fergus Wood was apparently the first author to call attention to this date (Wood 1978: 219). Independently, Roger Sinnott of *Sky & Telescope* magazine alerted Belgian amateur astronomer Jean Meeus to this rare celestial event, and Meeus carefully calculated the distance to the Moon over many centuries (Meeus 1981: 110; Meeus 2002: 36). To find a closer lunar perigee distance than that of 1912, Meeus showed that it was necessary to go back in time to the year 796 (356,366 km) or forward to the year 2257 (356,371 km).

The extreme lunar perigee on January 4, 1912, therefore marked the closest approach of the Moon to Earth for a period of more than 1,400 years.

Enhanced Iceberg Calving?

The glaciers on the west side of Greenland are the source for the vast majority of the icebergs carried by ocean currents into the North Atlantic shipping lanes. When glacial ice reaches the Greenland coast, the ends of the glaciers break off and drift away as icebergs in the process known as calving. Especially prolific is the coastline's northern half, extending from Humboldt Glacier on Kane Basin down to Jakobshavn Glacier on Diskø Bay.

To explain the unusually abundant ice that reached the shipping lanes in the spring of 1912, the *New York Times* interviewed Hydrographic Office scientists for an article appearing on May 5, 1912. These experts argued that weather conditions in the Arctic during the preceding year played an important role:

> ...in the creation of an enormously large crop of icebergs from the West Greenland glaciers...ice now observed in the North Atlantic Ocean prevails because of an unusually hot Summer in the arctic last year, followed by an unusually mild Winter...this warm Summer caused a greater melting of the glaciers, perhaps a more rapid movement of them, and the formation of a larger number of icebergs, together with the liberation of congested bergs and field ice, held there perhaps for many previous seasons, and that in consequence the drift southward was larger than in normal years. Hence a greater amount of ice wintered off Labrador, and, breaking up in the Spring, moved down on the lanes of ocean traffic in heavier force than has been known in recent years. (*New York Times*, May 5, 1912)

Perhaps worth mentioning is a different meteorological idea that attempts to explain the abundant icebergs in 1912 in the opposite manner, via a preceding cold winter. This theory, that might at first seem reasonable, includes the speculation that a harsh winter in 1911–1912 would have facilitated a higher number of icebergs making their way into the shipping lanes.

The *New York Times* story specifically contradicts this idea by specifically mentioning a "hot Summer in the arctic last year, followed by an unusually mild Winter." In fact, this newspaper story ran under the headline, "Prevalence of icebergs due to warm arctic winter."

Fergus Wood was apparently the first author to suggest that the extreme lunar perigee in 1912 may have also played a role in the origin of the *Titanic* iceberg. Wood argued that tongues of ice extending from the Jakobshavn Glacier into the fjord would flex up and down in response to the increased tidal range. Wood stated that "the calving frequency of icebergs increases noticeably during spring tides" and specifically emphasized the ocean tides caused by the "precise astronomical circumstances existing on January 4, 1912…because of their extreme concentration of gravitationally augment-ing forces." He concluded that the "probable date of the *Titanic* iceberg's calving into the open sea was around January 4, 1912" (Wood 1995: 328).

However, as Wood himself recognized, there is a problem with this idea. An iceberg calved near Diskø Bay in early January would have had to travel unusually rapidly in order to meet the *Titanic* in the shipping lanes on April 14th. Wood realized that "icebergs are subject to numerous impairing, retard-ing, deflecting, and even stranding or grounding influences" that might increase travel times. He was forced to assume that the icebergs calved in Greenland in January 1912 made "their way rapidly and expediently toward their eventual destinations" and that the *Titanic* iceberg in particular followed one of the "most rapid-transportation cases" possible (Wood 1995: 330).

The well-known Bowditch *American Practical Navigator* manuals give a general rule for the time required: "If bergs on their calving at once drifted to the southward and met with no obstructions their journey of about 1,200 to 1,500 [nautical] miles would occupy from 4 to 5 months" (Bowditch 1938: 301). The distance from Diskø Bay to the *Titanic* collision site is closer to 1,640 nautical miles, suggesting a time near 5½ months for a typical iceberg moving directly south without any delays. This does not fit with the time interval between early January and mid-April of 1912.

Wood's idea that the iceberg moved directly south after being calved encounters another fundamental problem. The prevailing West Greenland Current usually carries icebergs first to the north and then counterclockwise around Baffin Bay before the icebergs even begin their journey to the south, many months later. As explained in the Bowditch manuals, "The most pro-lific source of icebergs is the west coast of Greenland…The west Greenland current carries them northward and then westward until they encounter the

south-flowing Labrador current. West Greenland icebergs generally spend their first winter in Baffin Bay. During the next summer they are carried southward by the Labrador current. In many cases, their second winter is spent in Davis Strait" (Bowditch 1962: 754).

Similarly, the book of *Sailing Directions: Arctic Canada* states that an iceberg born in the winter might not arrive south of Newfoundland until after 2 years or more (Canadian Hydrographic Service 1994: 96).

The Voyage of the Iceberg

If the *Titanic* iceberg calved from its parent glacier in Greenland in 1910 or 1911, then it might appear that the ocean tides in January 1912 have no relevance to the sinking of the *Titanic*. But we can suggest a modification of Fergus Wood's idea and a scenario (Olson et al. 2012) in which the extreme lunar perigee on January 4, 1912, played an important role in the history of the *Titanic* iceberg.

As icebergs travel southward along the coasts of Labrador and Newfoundland, they can drift into shallow water and run aground (Fig. 5.22). Some grounded icebergs remain stationary and decay without moving farther, but in other cases they refloat and resume moving south. The icebergs "find their way into the Labrador Current and begin their journey to the southward" in a stop-and-go manner, as the Bowditch manuals explain: "Many ground in the Arctic Basin and break up there; others reach the shores of Labrador, where from one end to the other they continually ground and float…So many delays attend their journey and so irregular and erratic is it that many bergs seen in any one season may have been made several seasons before" (Bowditch 1938: 301).

Richard Brown described exactly this kind of journey in his 1983 book, *Voyage of the Iceberg* (Fig. 5.23), which offers a unique look at the *Titanic* disaster – from the point of view of the iceberg! (Brown 1983) Although the text is fictional, the author intended his account to be scientifically accurate. In Brown's book, the *Titanic* iceberg calves from Jakobshavn Glacier in September 1910, moves out of Diskø Bay, and the West Greenland Current then carries it northward up the coast.

Brown's berg spends the winter of 1910–1911 in the north end of Baffin Bay, drifts westward in the summer, and begins to drift southward in August 1911. It passes through Davis Strait by September and then runs aground on

Fig. 5.22 *As icebergs travel from the Arctic to the North Atlantic shipping lanes, they can drift into shallow water and run aground along the coasts of Labrador and Newfoundland. This photograph shows a grounded iceberg near the coastal village of Dunfield, Newfoundland. Tidal streams could help to erode the bases of grounded icebergs, and the high waters during spring tides could play a role in refloating grounded icebergs, especially those that ran aground at the time of a normal high water (Photograph courtesy of the Newfoundland and Labrador Tourism. Used with permission)*

a reef off Cape Haven for several weeks. Tidal currents help to erode the base until finally the iceberg tilts over, floats back into deeper water, and resumes moving southward. In October an eddy brings the iceberg close to the shore, where it grinds to a stop for the second time to spend several months grounded on a bank off Cape Harrison. The base erodes again until the iceberg topples over in January 1912 and resumes drifting south in the Labrador Current. It runs aground for the third time on shoals off Newfoundland in February. The iceberg refloats at the beginning of March and drifts into the path of *Titanic* on April 14, 1912.

The precise origin and path of the actual *Titanic* iceberg is unknown, of course, but Brown's narrative, with the iceberg grounding and refloating several times, is a plausible scenario.

Fig. 5.23 *Richard Brown's 1983 book,* Voyage of the Iceberg, *offers a unique look at the Titanic disaster – from the point of view of the iceberg! (Photograph courtesy of James Lorimer & Company. Used with permission)*

Moon, Tides, and the Titanic

A Canadian nautical glossary defines two terms that describe stationary ice: "grounded ice" is floating ice that is temporarily aground in shoal water, while "stranded ice" is ice that, after floating, has been deposited on the shore by retreating high water (Canadian Hydrographic Service 1994: 88).

Tidal streams could help to erode the bases of grounded icebergs, and the high waters during perigean spring tides could play a role in lifting and refloating grounded and even stranded icebergs, especially those stranded at the time of a normal high water. Immediately after the time of high water, the ebb current could carry icebergs from the shallower water near the coast

Fig. 5.24 *This photograph shows five grounded icebergs near the harbor of Twillingate, Newfoundland. High waters during spring tides could play a role in refloating grounded icebergs, and then the ebb stream could carry the bergs back out of the harbor and into the south-flowing Labrador Current (Photograph courtesy of Newfoundland and Labrador Tourism. Used with permission)*

back out into the deeper water where the Labrador Current is running toward the south (Fig. 5.24).

In the winter of 1911–1912 unusually strong tide-raising forces prevailed for several days in each of three consecutive months. On December 6, 1911, a full Moon occurred less than 1 day before a lunar perigee. On January 4, 1912, only 6 min of time separated a full Moon and a lunar perigee. On February 2, 1912, a full Moon occurred less than 1 day after a lunar perigee. Perigean spring tides during each of those 3 months – especially the period near the extreme lunar perigee on January 4, 1912 – could have helped to refloat icebergs.

The *Titanic* iceberg may well have spent time among those grounded or stranded along the coast of Labrador and Newfoundland. This coastline is far enough south for refloated icebergs resuming their southward drift in the Labrador Current to have sufficient time to reach the shipping lanes by mid-April, the time when the lookout Frederick Fleet peered into a starlit night and called out the words: "Iceberg, right ahead!"

References

Airy, George Biddell (1851) On Caesar's Place of Landing in Britain. *Athenaeum* No. 1222, March 29, 1851, 351–352.

Airy, George Biddell (1852) On the Place of Caesar's Departure from Gaul for the Invasion of Britain, and the Place of His Landing in Britain. *Archaeologia* **34**, 231–250.

Beesley, Lawrence (1912) *The Loss of the SS. Titanic*. New York: Houghton Mifflin Company.

Bischoff, Ernst F. (1919) Kalender. In *Paulys Real-Encyclopädie der Classischen Altertumswissenschaft, Zwanzigster Halbband*. Stuttgart: J. B. Metzler, 1568–1602.

Böckh, August (1855) *Zur Geschichte der Mondcyclen der Hellenen*. Leipzig: B. G. Teubner.

Bowditch, Nathaniel (1938) *American Practical Navigator*. Washington, DC: U. S. Government Printing Office.

Bowditch, Nathaniel (1962) *American Practical Navigator*. Washington, DC: U. S. Government Printing Office.

British Wreck Commissioner's Inquiry (1912) witness testimony transcripts online at the Titanic Inquiry Project (http://www.titanicinquiry.org/).

Brown, Richard G. B. (1983) *Voyage of the Iceberg*. New York: Beaufort Books.

Browning, Robert (1879) Pheidippides. In *Dramatic Idyls*. London: Smith, Elder, & Co., 29–44.

Burn, Andrew R. (1962) *Persia and the Greeks*. London: Edward Arnold.

Bury, John B. (1931) *A History of Greece*. London: Macmillan and Co.

Busolt, Georg (1895) *Griechische Geschichte, Band 2*. Gotha: Perthes.

Canadian Hydrographic Service (1994) *Sailing Directions, Arctic Canada, Fourth edition, Volume 1*. Ottawa, Canada: Department of Fisheries and Oceans.

Cardwell, Edward (1860) The Landing-Place of Julius Caesar in Britain. *Archaeologia Cantiana* **3**, 1–18.

Collingwood, Robin G., and John Nowell Linton Myres (1937) *Roman Britain and the English Settlements*. Oxford: Clarendon Press.

Drake, Francis S. (1884) *Tea Leaves*. Boston: A.O. Crane.

Fixx, James F. (1978a) *Jim Fixx's Second Book of Running*. New York: Random House.

Fixx, James F. (1978b) On the Run in Search of a Greek Ghost. *Sports Illustrated* **49**(26), December 25, 1978, 60–66.

Forbes, Esther (1943) *Johnny Tremain*. Boston: Houghton Mifflin Company.

French, Allen (1925) *The Day of Concord and Lexington: The Nineteenth of April, 1775*. Boston: Little, Brown, and Company.

Frost, Frank J. (1979) The Dubious Origins of the 'Marathon.' *American Journal of Ancient History* **4**(2), 159–163.

Ginzel, Friedrich K. (1911) *Handbuch der Mathematischen und Technischen Chronologie, Band II.* Leipzig: J. C. Hinrichs.

Goss, Elbridge Henry (1891) *The Life of Colonel Paul Revere, Volume 1.* Boston: J. G. Cupples.

Green, Peter (1996) *The Greco-Persian Wars.* Berkeley: University of California Press.

Halley, Edmond (1691) A Discourse tending to prove at what Time and Place, Julius Cesar made his first Descent upon Britain. *Philosophical Transactions of the Royal Society* **17**(193), 495–501.

Hammond, Nicholas Geoffrey Lemprière (1968) The Campaign and the Battle of Marathon. *Journal of Hellenic Studies* **88**, 13–57.

Hammond, Nicholas Geoffrey Lemprière (1988) The Campaign and Battle of Marathon. In *The Cambridge Ancient History, Second Edition, Volume 4.* Cambridge: Cambridge University Press, 506–517.

Hawkes, Charles Francis Christopher (1977) Britain and Julius Caesar. *Proceedings of the British Academy* **53**, 125–192.

Hignett, Charles (1963) *Xerxes' Invasion of* Greece. Oxford: Clarendon Press.

Holmes, Thomas Rice (1907) *Ancient Britain and the Invasions of Julius Caesar.* Oxford: Clarendon Press.

How, Walter W., and Joseph Wells (1912) *A Commentary on Herodotus.* Oxford: Clarendon Press.

Hutchinson, Thomas (1874) Thomas Hutchinson to Lord Dartmouth, Boston, 17 Dec., 1773. In *Proceedings of a Special Meeting of the Massachusetts Historical Society, December 16, 1873: Being the One Hundredth Anniversary of the Destruction of the Tea in Boston Harbor.* Boston: John Wilson and Son, 26–27.

Labaree, Benjamin W. (1964) *The Boston Tea Party.* New York: Oxford University Press.

Longfellow, Henry W. (1863) "The Landlord's Tale: Paul Revere's Ride." In *Tales of a Wayside Inn.* Boston: Ticknor and Fields, 18–25.

Lossing, Benson J. (1851) *Pictorial Field-Book of the Revolution. Volume 1.* New York: Harper & Brothers.

Lossing, Benson J. (1877) *Our Country, Volume 2.* New York: Henry J. Johnson.

Macan, Reginald W. (1895) *Herodotus, the Fourth, Fifth, and Sixth Books.* New York: Macmillan and Co.

Meeus, Jean (1981) Extreme Perigees and Apogees of the Moon. *Sky & Telescope* **62**(2), August, 110–111.

Meeus, Jean (2002) *More Mathematical Astronomy Morsels.* Richmond, Virginia: Willmann-Bell.

Olson, Donald W., and Michael F. Kyle (1987) Revisiting the Boston Tea Party. *Astronomy* **15**(10), October, 32.

Olson, Donald W., and Russell L. Doescher (1992) Paul Revere's Midnight Ride. *Sky & Telescope* **83**(4), April, 437–440.

Olson, Donald W., and Russell L. Doescher (1993) The Boston Tea Party. *Sky & Telescope* **86**(6), December, 83–86.

Olson, Donald W., Russell L. Doescher, and Marilynn S. Olson (2004) The Moon and the Marathon. *Sky & Telescope* **108**(3), September, 34–41.

Olson, Donald W., Russell L. Doescher, Kellie N. Beicker, and Amanda F. Gregory (2008) Caesar's Invasion of Britain. *Sky & Telescope* **116**(2), August, 18–23.

Olson, Donald W., Russell L. Doescher, and Roger W. Sinnott (2012) Did the Moon Sink the *Titanic*? *Sky & Telescope* **123** (4), April, 34–39.

Peskett, Arthur George (1892) A Note on Caesar's Invasions of Britain. *Journal of Philology* **20**, 191–201.

Revere, Paul (1798) A Letter from Col. Paul Revere to the Corresponding Secretary. *Collections of the Massachusetts Historical Society* **5**, 106–112.

Ridgeway, William (1891) Caesar's Invasions of Britain. *Journal of Philology* **19**, 138–145.

Rubincam, David P., and David D. Rowlands (1993) The Night the *Titanic* Went Down. *Sky & Telescope* **86**(4), October, 79–83.

Schultz, Sherman W. (1987) How Dark Was the Night of the Boston Tea Party? *Astronomy* **15**(8), August, 24.

Sekunda, Nicholas (2002) *Marathon 490 BC*. Oxford: Osprey Publishing.

Sheehan, William, and Michael Armstrong (1996) Moon over Marathon. *Astronomy* **24**(12), December, 20–22.

Stanhope, Philip H. (1867) On the Day of Caesar's Landing in Britain. *Archaeologia* **41**, 270–274.

Stein, Heinrich (1877) *Herodotos*. Berlin: Weidmann

Warburg, Harold Dreyer (1923) Caesar's First Expedition to Britain. *English Historical Review* **38**(150), 226–240.

Wood, Fergus J. (1978) *The Strategic Role of Perigean Spring Tides*. Washington, DC: U.S. Government Printing Office.

Wood, Fergus J. (1995) A Combined Lunisolar Tidal-Current Forcing Function, Enhanced Calving of Coastal Icebergs, and the Sinking of the *Titanic*. *Journal of Coastal Research*, Special Issue No. 17, 327–341.

6

Lincoln, the Civil War Era, and American Almanacs

The life of Abraham Lincoln has a number of surprising and intriguing links to astronomical events. Astronomical analysis, along with the information in the immense number of books written about Lincoln, allows us to solve mysteries regarding four of these celestial connections.

Our Texas State group discovered that Abraham Lincoln as a young man observed the great Leonid meteor shower on the night of November 12–13, 1833. This display is often considered the most spectacular meteoric event ever recorded. Between midnight and dawn, meteors were falling as thick as snowflakes in a blizzard. What primary source documents prove that Lincoln was an eyewitness to the meteor storm on that memorable night?

In the most famous criminal case from his days as a lawyer, Abraham Lincoln served in 1858 as defense attorney at a trial regarding a murder that took place at night. Lincoln dramatically produced an almanac in court to discredit a key prosecution witness, who claimed to have seen the murder by the light of a bright Moon, high in the sky. The proceeding became known thereafter as the "almanac trial." Why did Lincoln's biographers worry that there was "something wrong" about the almanac? Did Lincoln employ a fake almanac, printed for the occasion, with altered lunar phases and times of moonset, in order to secure an acquittal for his client? Can astronomical analysis show that Lincoln was honest in his use of the almanac?

D.W. Olson, *Celestial Sleuth: Using Astronomy to Solve Mysteries in Art,*
History and Literature, Springer Praxis Books, DOI 10.1007/978-1-4614-8403-5_6,
© Springer Science+Business Media New York 2014

What brilliant comet in 1858 did Abraham Lincoln observe from a hotel front porch as he relaxed during the evening before one of the Lincoln-Douglas debates?

Under ideal conditions, observers can view the bright planet Venus in broad daylight, even when the Sun is well above the horizon. How can we be certain that in 1865 President Abraham Lincoln made such a daylight observation of Venus? What is the connection to Lincoln's famed Second Inaugural Address?

The dominant event of Abraham Lincoln's presidency was, of course, the American Civil War. Our Texas State group discovered that a full Moon in 1863 played an important role in changing the course of the war. In a disaster for the Confederacy, Stonewall Jackson was mortally wounded by "friendly fire" at night under a full Moon during the Battle of Chancellorsville on May 2, 1863. How do the lunar phase, the times of moonrise and sunset, and the direction of moonlight explain what happened that night? Why was the 18th North Carolina regiment unable to recognize General Jackson as he approached the Confederate lines? How did the full Moon and the fatal volley at Chancellorsville affect the events, 2 months later, at the Battle of Gettysburg?

Because of the connections between these topics and early American almanacs, our Texas State group became interested in the phenomenon of the "Blue Moon." Why do so many people now insist that a Blue Moon is the second full Moon in a month? Did American almanacs really define a Blue Moon in that way? The pages of the *Maine Farmers' Almanac* over the years include many references to the dates of Blue Moons – and not a single one of them is the second full Moon in a calendar month. What was the actual definition that these almanacs employed for a Blue Moon?

Lincoln and a Meteor Storm: Stars Fell on Illinois

The great Leonid meteor storm on the night of November 12–13, 1833, is often considered the most spectacular meteoric event ever recorded. Between midnight and dawn, meteors were falling as thick as snowflakes in a blizzard. An amazed observer could have seen several hundred thousand meteors during that memorable night. How can we prove that Abraham Lincoln, as a young man in 1833, witnessed the Leonid meteor shower? How does a document in the handwriting of Walt Whitman confirm this observation by Lincoln?

Fig. 6.1 *The spectacular Leonid meteor storm in the early morning hours of November 13, 1833, caused innkeeper Henry Onstot to awaken Abraham Lincoln and to exclaim that the "day of judgment" had come*

Lincoln's Meteor Story

The great Leonid meteor storm on November 13, 1833, dazzled observers with a celestial spectacle they would never forget. A document located by our Texas State group raises the possibility that one of the eyewitnesses to this spectacular meteor shower was a future president – Abraham Lincoln.

Startled from his slumber early one morning, a young Lincoln beheld the sky filled with falling stars and fireballs (Fig. 6.1). Decades later the flaming battlefields of the Civil War rekindled in him a memory of those fiery heavens. During one of the darkest times of the war, President Lincoln related an anecdote that contrasted the falling stars of the meteor shower with the fixed stars above, as metaphors for the conflict and the stability of the Union:

> As is well known, story-telling was often with President Lincoln a weapon which he employ'd with great skill. Very often he could not give a point-blank reply or comment – and these indirections, (sometimes funny, but not always so,) were

probably the best responses possible. In the gloomiest period of the war, he had a call from a large delegation of bank presidents. In the talk after business was settled, one of the big Dons asked Mr. Lincoln if his confidence in the permanency of the Union was not beginning to be shaken – whereupon the homely President told a little story: "When I was a young man in Illinois," said he, "I boarded for a time with a deacon of the Presbyterian church. One night I was roused from my sleep by a rap at the door, and I heard the deacon's voice exclaiming, 'Arise, Abraham! the day of judgment has come!' I sprang from my bed and rushed to the window, and saw the stars falling in great showers; but looking back at them in the heavens I saw the grand old constellations, with which I was so well acquainted, fixed and true in their places. Gentlemen, the world did not come to an end then, nor will the Union now." (Olson and Jasinski 1999: 34)

We found this account not in a Lincoln biography but rather in the writings of Walt Whitman, who was a contemporary of Lincoln and lived in Washington, D. C. during the Civil War. Whitman eventually published the story with the title "A Lincoln Reminiscence" (Whitman 1882: 335–336).

Dating Lincoln's Meteors

The narrative does not reveal a year for this dramatic meteor storm, but Lincoln himself offers two clues. He was "a young man in Illinois" (Fig. 6.2) and "boarded for a time with a deacon of the Presbyterian church." A review of Lincoln biographies suggests that the event probably dates from his days in New Salem, when he did not own a house but instead "boarded round here and there" (Sandburg 1926: 172). Lincoln lived in New Salem from 1831 to 1837 and worked at a variety of jobs as a shopkeeper, rail splitter, postmaster, and surveyor, before he moved on to Springfield to practice law. That he was a boarder between 1831 and 1837 makes it likely that the meteor shower in the story is the famous Leonid storm of 1833, but to be certain we wanted to determine the precise year when Lincoln lived with a Presbyterian deacon.

Historian Benjamin Thomas identified several families with whom Lincoln resided in New Salem and gave the religious affiliations for many of the households, allowing us to rule out almost all of the possibilities (Thomas 1934). The most likely remaining candidate was Henry Onstot, the town's cooper. He was a Presbyterian and very active in church affairs.

His son, Thompson G. Onstot, compiled a detailed county history volume that provides the last piece of the puzzle and pins down Lincoln's whereabouts in the latter part of 1833. A local family had constructed a log cabin and operated it as the Rutledge Tavern (Fig. 6.3) until the spring of 1833.

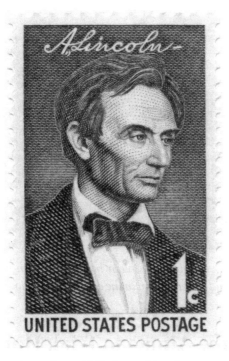

Fig. 6.2 This 1¢ postage stamp from 1959 shows Lincoln as a young man, as the future president would have appeared when he lived in New Salem, Illinois, between 1831 and 1837. The familiar portraits of Lincoln with a full beard date from the Civil War days. Lincoln did not grow a beard until after his election to the presidency in the fall of 1860

Onstot's book states that "After James Rutledge moved out of the log tavern my father, Henry Onstot, moved in and occupied it from 1833 till 1835" and "had for a boarder Abraham Lincoln" (Onstot 1902: 25). When Lincoln could not pay in cash, Onstot took some "iron well-bucket hoops" in trade for Lincoln's board "while he kept the tavern in New Salem in 1833" (Onstot 1902: 360).

Lincoln and the Leonids

This evidence makes it virtually certain that Lincoln saw the 1833 Leonids, a memorable experience that he later called on in a story to illustrate his abiding faith in the Union. Whitman's passage preserves an eyewitness account by one of America's greatest presidents describing one of history's greatest meteor storms.

Fig. 6.3 *From a window in this New Salem building, known as the Rutledge Tavern, Lincoln watched the Leonid meteor storm in the early morning hours of November 13, 1833*

Lincoln and the Almanac Trial: Honest Abe

In the most famous criminal case from his days as a lawyer, Abraham Lincoln served as defense attorney at a trial following a murder that took place at night. Lincoln dramatically produced an almanac in court to discredit a key prosecution witness, who claimed to have seen the murder by the light of a bright Moon, high in the sky.

Lincoln as a Lawyer: History and Hollywood

Abraham Lincoln, prior to his 1860 election as the sixteenth president of the United States, was a member of the Illinois bar for more than two decades. His most famous criminal case was the 1858 Armstrong murder trial, also known as the "almanac trial." A prosecution witness claimed to have seen the fatal fight at 11 p.m. by the light from a nearly full Moon standing high in the sky. As defense attorney, Lincoln had the witness repeat his statements about the bright Moon several times. Lincoln surprised the entire court by suddenly bringing forth an almanac and using astronomical evidence regarding the lunar phase and the time of moonset to discredit the testimony and obtain a dramatic acquittal for his client.

Director John Ford's classic 1939 film, *Young Mr. Lincoln*, includes a fictionalized and somewhat inaccurate version of the almanac trial (Figs. 6.4 and 6.5). The dramatic climax is the introduction of the almanac and the

Fig. 6.4 A Farmer's Almanac sits on the table next to Lincoln's hat in this scene of the almanac trial, the dramatic climax of John Ford's 1939 film, Young Mr. Lincoln

Fig. 6.5 Abraham Lincoln, played by Henry Fonda, consults astronomical evidence from a Farmer's Almanac in this scene from John Ford's 1939 film, Young Mr. Lincoln

resulting breakdown of the witness, which occurs almost like the final scene of a Perry Mason episode:

Lincoln: How'd you see so well?
Cass: I told you it was Moon bright, Mr. Lincoln.
Lincoln: Moon bright.
Cass: Yes.
Lincoln: Look at this. Go on, look at it. It's the *Farmer's Almanack*. Go ahead, look at it, look at page 12. You see what it says about the Moon? That the Moon was only in its first quarter that night and set at 10:21, 40 min before the killing took place. So you see it couldn't have been Moon bright, could it? You lied, didn't you, Cass?

Most Lincoln biographers discuss the almanac trial but provide astronomical details that are often vague and confusing, even incorrect and contradictory. The initial purpose of our Texas State group was to establish the correct astronomy of the almanac trial by using computer programs to reconstruct the skies over rural Illinois of the 1850s. In the process we made an unexpected discovery regarding the unusual behavior of the Moon on the very night of the murder. The astronomical analysis explains a long-standing mystery about the almanac case.

Camp Meeting at Virgin's Grove

In August 1857 the Methodist circuit rider Peter Cartwright convened a religious camp meeting of 3 weeks duration in Mason County, Illinois. The tents and platforms for preaching stood among the trees of Virgin's Grove. Around the fringes of the camp meeting, gambling and drinking flourished at temporary bars set up for the occasion. At one of the outdoor saloons, at about 11 p.m. on Saturday, August 29, 1857, on the final weekend of the camp meeting, William "Duff" Armstrong and James H. Norris became involved in a fight with James Preston "Pres" Metzker. Afterwards, Metzker mounted his horse and rode to a friend's home nearby, where he died of head injuries 3 days later. Both Norris and Armstrong were arrested and indicted for murder. Norris was tried first, was convicted, and began serving a sentence of 6 years.

The Almanac Trial

Hannah Armstrong, mother of the remaining defendant, then traveled to Springfield to ask for help from Abraham Lincoln, an old family friend whose gratitude to the Armstrong family dated back to his earliest days in

New Salem, Illinois. Lincoln immediately agreed to defend her son and would not accept a fee for his efforts.

On May 7, 1858, the murder trial of "Duff" Armstrong took place in Beardstown, Illinois. The evidence began to accumulate as strongly against Armstrong as it had against Norris.

The main prosecution witness, Charles Allen, stated that he was about 150 ft away from the fight but that he saw everything clearly by the light from a bright nearly full Moon high in the sky. Allen claimed that he saw Armstrong strike the fatal blows. Lincoln then produced an almanac to prove that the Moon at 11 p.m. was going out of sight near the horizon, within about an hour of setting, and was not standing overhead as the witness had claimed. A Moon near the horizon could not have shed light into the clearing in the grove. Several of the jury members later stated that "the almanac *floored* the witness" (Lamon 1872: 330). After a short deliberation, the jury acquitted Armstrong.

No one knows for certain which almanac or almanacs Lincoln consulted. Different authors have suggested *Jayne's Almanac, Goudy's Almanac, Ayer's American Almanac, The Old Farmer's Almanack*, and several others.

Was Lincoln Dishonest?

Almost immediately after the trial, serious allegations began to circulate that a fake almanac had been used, with the lunar phases and times of moonset altered in a print shop to fit Lincoln's purpose. In 1866 J. Henry Shaw, assisting prosecution counsel at the trial, pointed out in a written statement the "prevailing belief" that an almanac of a "year previous to the murder" may have been "prepared for the occasion" (Wilson and Davis 1998: 316). Aware of Shaw's statement, an early Lincoln biographer discussed the almanac and noted that there was a "question concerning its genuineness" (Lamon 1872: 329). A later historian, with Lincoln's reputation for honesty in mind, could not believe the allegation: "It is hard to account for the origin of the gossip of the false almanac; hard to explain the vitality and persistence of the story" (Beveridge 1928: 571).

Nevertheless, many townspeople at the time thought that Lincoln had prepared a fake almanac. There is a clear implication of dishonesty in the following newspaper account, quoted by a Lincoln biographer:

> [P]eople, who remember the trial…after the trial…talked the matter over. Some of them remembered as positively as the witnesses had done that there was nearly a full moon on the night Pres Metzker was beaten at the camp-meeting.

They insisted on their recollections in spite of Mr. Lincoln's documentary evidence. There was an overhauling of old almanacs in various households. Sure enough, they showed a moon nearly in mid-heavens at the hour of the affray. Then there was inquiry for the almanac which had been presented by Mr. Lincoln in court. The little pamphlet could not be found. (Barton 1925: 509)

The Moon's position "nearly in mid-heavens" is a reference to the Moon's crossing of the line in the sky known to astronomers as the meridian, which divides the heavens into an eastern half and a western half. The Moon on a given date rises at the eastern horizon, ascends into the eastern half of the sky for a number of hours, crosses the meridian, and then descends through the western sky for a number of hours, finally setting at the western horizon. At the time of meridian crossing, the Moon is due south and is at its highest point in the sky for that date.

Almanacs in the nineteenth century referred to meridian crossing as the "southing of the Moon." Rural citizens in the 1850s were more familiar with the use of almanacs than are most people now, and the skeptical townspeople after the trial would have been consulting their own 1857 almanacs for the times of the "southings" of the Moon.

Even a writer sympathetic to Lincoln, Illinois author Edgar Lee Masters, said that it was "important to observe that many people of Lincoln's time thought that there was something wrong about the use of the almanac" (Masters 1931: 135). How could Lincoln use an almanac to prove that the Moon was near the horizon and setting, since the people at the camp meeting had seen it with their own eyes, shining brightly and standing near the meridian?

Lunar Calculations

At the request of various Lincoln historians over the years, the lunar phase and time of moonset on the night of August 29–30, 1857, have been calculated by many well-known astronomers – in 1871 by Elias J. Loomis of Yale; in 1909 and again in 1925 by Joel Stebbins of the University of Illinois; in 1925 by the staff of the Yerkes Observatory; in 1928 by Harvard College Observatory; and in 1905, 1925 and 1976 by the U. S. Naval Observatory. All of the results essentially agreed on moonset, giving times near 12:04 a.m. on August 30th. These calculations support Lincoln's claim that the Moon at 11 p.m. on the 29th was low and near to setting.

When our Texas State group repeated this calculation, we made an unexpected discovery involving an 18.6-year lunar cycle and its effect on the Moon's path through the sky on August 29, 1857 (Olson and Doescher 1990). This new astronomical evidence helps to explain the mystery of why so many people thought Lincoln had faked the almanac. We can thus now resolve the apparent conflict between Lincoln's astronomical evidence and the recollections of the townspeople.

High and Low Moons

The path of the Moon through the sky and the number of hours that the Moon spends above the horizon vary greatly over the course of a month and also over the course of an 18.6-year lunar cycle. Every 18.6 years, the 23.5° tilt of Earth's axis and the 5° tilt of the lunar orbit combine in such a way that extreme paths are possible, with the Moon running exceptionally high or exceptionally low through the sky (Lovi 1987).

In exceptional cases when the Moon "runs high," it rises in the northeast, crosses the meridian at a point nearly overhead, and remains thereafter above the horizon for many hours before finally setting in the northwest. The Moon "runs low" when it rises in the southeast, skims at a relatively low altitude through the sky, crosses the meridian at a point not far above the southern horizon, and remains thereafter above the horizon for only a relatively short time before setting in the southwest.

Our Texas State group computed the years when extreme high and low Moons were possible, and we discovered that 1857 was one of these special years in the 18.6-year cycle:

… 1838 1857 1876 1894 1913 1932 1950 1969 1987 2006 2025 ….

Extreme lunar paths, with the Moon running exceptionally high or low through the sky, were possible in 1857, but the Moon actually attained these extreme behaviors only on certain days.

The Moon "Runs Low" on August 29, 1857

By a remarkable coincidence, August 29, 1857, the final Saturday of the Virgin's Grove camp meeting, was one of the dates in 1857 when the Moon ran exceptionally low (Fig. 6.6). In fact, we discovered that the lunar path on August 29th was nearly the most extreme behavior possible in the entire 18.6-year cycle.

Fig. 6.6 *This page from the 1857 Old Farmer's Almanack showed that the "Moon ran low" on August 29, 1857 – the night of the fatal fight in Virgin's Grove, Illinois*

On August 29, 1857, the Moon crossed the meridian ("mid-heavens") at 7:44 p.m. local mean time at an altitude of only 20° above the southern horizon. The bright Moon was about three-quarters lit, in the waxing gibbous phase (Fig. 6.7) with an illuminated fraction of 74 %. The Moon then passed low across the southwestern sky, traveled from the meridian to the horizon in only a little more than 4 h, and set at 12:04 a.m. on August 30th.

Was the sky clear so that the Moon could have been seen? Weather observations indicate that warm and humid conditions and winds from the southeast had prevailed earlier in the week. However, a cold front passed through central Illinois on the August 28, 1857, bringing cool and dry air to the area. At 9 p.m. on August 29th the Smithsonian meteorological observer at Athens,

Fig. 6.7 *This photograph shows a waxing gibbous Moon, about three-quarters lit, similar to the phase of the Moon that passed through the Illinois sky on the evening of August 29, 1857 (Photograph by Russell Doescher. Used with permission)*

Illinois, only 14 miles south of Virgin's Grove, reported a temperature of 56 °F, a light breeze from the northwest, and completely clear skies (Zeltmann 1976).

Honest Abe

Were the townspeople correct in remembering that they saw a bright Moon "nearly in mid-heavens" during the camp meeting? Was Lincoln correct in asserting that the Moon at the time of the murder was very low and near to setting? Based on our research, we can see that there is no conflict – both were correct! Just before 8:00 p.m., during the hymn singing and sermons of the camp meeting, the Moon crossed the meridian ("mid-heavens") in the cloudless sky over Virgin's Grove. As the camp meeting was ending only a few hours later, the Moon was already dropping from view, just as Lincoln

established at the trial. The motion of the Moon on August 29, 1857, was very unusual, near the extreme behavior possible in the 18.6-year lunar cycle. This new astronomical evidence explains how the stories of the spurious almanac began and shows that Lincoln was honest after all in his quotations from the almanac.

Lincoln and a Comet: A Rising Political Star and the Night Sky's "Strange Visitor"

What brilliant comet did Abraham Lincoln observe from a hotel front porch as he relaxed during the evening before one of the Lincoln-Douglas debates?

A Comet and a Future President

During the Illinois campaign for the U. S. Senate in 1858, Abraham Lincoln and Stephen Douglas held a series of seven oratorical contests now known as the famous Lincoln-Douglas debates (Fig. 6.8). Horace White, a reporter for the *Chicago Daily Press and Tribune,* covered the campaign and traveled with Lincoln. The third debate in the series took place in Jonesboro, Illinois, on September 15, 1858.

On the evening before the Jonesboro event, White and Lincoln relaxed after dinner on the porch of the Union House hotel (Work Projects Administration 1939: 455). White later recalled:

Fig. 6.8 *This 4¢ stamp issued in 1958 commemorated the centennial of the Lincoln-Douglas debates*

Fig. 6.9 *This illustration of Donati's Comet appeared in Bruno Bürgel's Astronomy for All (1911). The comet attained its greatest brilliance in the late summer and early fall of 1858*

It was my good fortune to accompany Mr. Lincoln during his political campaign against Senator Douglas in 1858…The only thing noteworthy that I recall at Jonesboro was not political and not even terrestrial. It was the splendid appearance of Donati's comet in the sky, the evening before the debate. Mr. Lincoln greatly admired this strange visitor, and he and I sat for an hour or more in front of the hotel looking at it. (Herndon and Weik 1895: 88, 119)

Donati's Comet, discovered in early June of 1858, had developed into one of the most spectacular comets of the nineteenth century during the late summer and early fall (Fig. 6.9). Astronomer William T. Lynn observed the comet from England and recalled later that the "comet became visible to the naked eye about the end of August, and presented a magnificent spectacle in September and October" (Lynn 1908: 352).

On October 5, 1858, Donati's Comet passed close to the bright star Arcturus, a celestial scene that became the subject of several paintings

Fig. 6.10 *Donati's Comet, James Poole, 1858. This painting shows an evening scene from October 1858 with Donati's Comet near the bright star Arcturus. The constellation of Ursa Major is visible at the upper right (Courtesy of Museums Sheffield. Used with permission)*

(Fig. 6.10). Roberta Olson, in her book on comets in art, reproduced several of these works and noted that Donati's Comet "is considered by many to be the most beautiful comet in history" (Olson 1985: 93). Roberta Olson and Jay Pasachoff devoted a chapter to this comet that "mesmerized astronomers and artists alike" (Olson and Pasachoff 1998: 227).

Horace White's memoir makes it certain that another observer of Donati's Comet was a future president – Abraham Lincoln on September 14, 1858.

Lincoln and Daylight Venus: "A Phenomenon So Rare"

When Venus is relatively far from the Sun in the sky and the atmosphere is unusually transparent, observers can view the bright planet in broad daylight, even when the Sun is well above the horizon. How can we be certain that President Abraham Lincoln made such a daylight observation of Venus? On what date and at what time of day did the sighting occur? What is the

Fig. 6.11 *At the center of this photograph is Abraham Lincoln delivering his Second Inaugural Address on March 4, 1865. Harper's Weekly published the woodcut, inset at the lower left, depicting Lincoln taking the oath of office. Immediately after the ceremony, the crowd – and Lincoln himself – witnessed a rare daylight sighting of the planet Venus*

connection to Lincoln's famed Second Inaugural Address? How did Walt Whitman describe the brilliance of Venus on that same day? After the assassination of Lincoln, how did Whitman use Venus in the opening lines of "When lilacs last in the door-yard bloom'd," his elegiac poem dedicated to Lincoln's memory?

Inaugural Planet

Only a few weeks before the end of Abraham Lincoln's life, the citizens of Washington made a rare daylight observation of the planet Venus. Sergeant Smith Stimmel, one of Lincoln's bodyguards, described the scene immediately after the famed orator delivered his memorable Second Inaugural Address (Fig. 6.11) on March 4, 1865. The presidential party left the Capitol and proceeded along Pennsylvania Avenue:

I noticed the crowd along the street looking intently, and some were pointing to something in the heavens toward the south. I glanced up in that direction, and there in plain view, shining out in all her starlike beauty, was the planet Venus. It was a little after midday at the time I saw it, possibly near one o'clock; the sun seemed to be a little west of the meridian, the star a little east. It was a strange sight. I never saw a star at that time in the day before or since. (Stimmel 1928: 71)

A driving rainstorm that morning had washed pollution from the skies, and the inauguration took place only 1 week after the configuration known as a greatest elongation of Venus. If Venus had been too close to the Sun in the sky, the glare of the Sun's light would have rendered Venus impossible to see. But near the time of greatest elongation, Venus stands relatively far away from the Sun in the sky and becomes much easier to spot. The quantity that is "greatest" at a "greatest elongation" is the angular separation between the Sun and Venus, as seen by an observer on Earth.

Sergeant Stimmel correctly noted that this remarkable daylight sighting was possible: "owing to the peculiarly clear condition of the atmosphere and the favorable position of the planet at that time" (Stimmel 1928: 72).

Stimmel went on to say that Lincoln himself saw Venus: "The President and those who were with him in the carriage noticed the star at the same time" (Stimmel 1928: 72).

A contemporary account confirms that many in the crowd could see the planet: "As the procession returned from the Capitol to the White House… hundreds of persons were gazing upward at a bright star, visible in the heavens…A phenomenon so rare – to many spectators altogether unknown hitherto – was the subject of universal comment" (Barrett 1865: 760).

Lieutenant George C. Ashmun, in the cavalry escort accompanying Lincoln, likewise reported that: "some of his men looking skyward saw the star Venus shining clear and luminous about 2 o'clock in the afternoon, 'the first and only time that most of us ever saw that star at that hour of the day'" (Sandburg 1939: 94).

Walt Whitman's Celestial Imagery

The poet Walt Whitman, who was in Washington on inauguration day, corroborated the other accounts. Whitman vividly described the rainstorm before the President's speech, the clarity of the atmosphere after midday, and the surprising sight that then appeared in the sky: "a forenoon like whirling

Fig. 6.12 *This nineteenth-century illustration, "The various appearances of VENUS as she revolves round the SUN," shows the cycle of the planet's phases and varying distances from Earth. The greatest brilliancy of Venus occurs when the planet appears as a large crescent, slightly more than a quarter lit, just as happened in March and April of 1865*

demons, dark, with slanting rain, full of rage; and then the afternoon, so calm, so bathed with flooding splendor from heaven's most excellent sun, with atmosphere of sweetness; so clear, it show'd the stars, long, long before they were due" (Whitman 1882: 65).

During the following week Whitman continued to note the bright planet: "Nor earth nor sky ever knew spectacles of superber beauty than some of the nights lately here. The western star, Venus, in the earlier hours of evening, has never been so large, so clear; it seems as if it told something, as if it held rapport indulgent with humanity" (Whitman 1882: 65).

Computer calculations (Olson and Jasinski 2009: 68) verify that Venus was near its greatest brilliancy during March and early April of 1865 and dominated the western sky after sunset (Fig. 6.12). By mid-April, the planet was still visible at sunset, but Venus' altitude above the horizon was decreasing noticeably from day to day. Each night the planet set earlier than on the previous day, as Venus appeared to be approaching closer to the setting Sun on the western horizon.

On April 14, 1865, Lincoln was assassinated at Ford's Theater, and he died the next morning. In the opening lines of the famous poem about Lincoln's death:

When lilacs last in the door-yard bloom'd, And the great star early droop'd in the western sky in the night, I mourn'd...and yet shall mourn with ever-returning spring

Whitman used the image of Venus from April 1865 as a metaphor for the President from Illinois who himself had now become a "western, fallen star."

Stonewall Jackson and the Moon at the Battle of Chancellorsville

Stonewall Jackson was mortally wounded by "friendly fire" at night under a full Moon during the Battle of Chancellorsville on May 2, 1863. With Jackson's death 8 days later, the South lost one of its greatest leaders. How do the lunar phase, the times of moonrise and sunset, and the direction of moonlight explain what happened that night? Why was the 18th North Carolina regiment unable to recognize General Jackson as he approached the Confederate lines? How were the events at the Battle of Gettysburg affected by the full Moon 2 months earlier at Chancellorsville?

Civil War Sesquicentennial

The year 2013 marks the 150th anniversary of the Battle of Gettysburg, fought on July 1–3, 1863, and often considered the turning point of the war. The Confederate army initially had some success on July 1st but failed to take the opportunity to seize the high ground of Culp's Hill and Cemetery Hill, key tactical landmarks that Federal troops eventually occupied in force. On July 3rd, Southern hopes of winning the war faded with the disaster of Pickett's Charge against the Union line on Cemetery Ridge. Union Brigadier General Régis de Trobriand described the night sky above a silent Pennsylvania field in the deadly aftermath of the Battle of Gettysburg, which fell near the time of a full Moon: "The moon, with her smiling face, mounted up in the starry heavens, as at Chancellorsville. Her pale light shone equally upon the living and the dead, the little flowers blooming in the grass as well as upon the torn bodies lying in the pools of clotted blood" (Trobriand 1889: 512).

An important player for the Confederate cause was not present at Gettysburg. By the light of another full Moon 2 months earlier Lieutenant General Thomas J. "Stonewall" Jackson had been mortally wounded by friendly fire at the Battle of Chancellorsville, on May 2, 1863 (Figs. 6.13 and 6.14). Eight days later he died. In the hours after the fatal volley, surgeons had been forced to amputate Jackson's left arm. Shortly before Jackson's death, General Robert E. Lee made it clear that Jackson was irreplaceable with the famous words: "He has lost his left arm; but I have lost my right arm" (Dabney 1866: 716).

General Lee, looking back several years after the war's end, lamented Jackson's absence at Gettysburg: "If I had had Stonewall Jackson at Gettysburg, we should have won a great victory" (Jones 1875: 156).

Fig. 6.13 *This Kurz and Allison 1889 chromolithograph entitled Battle of Chancellorsville depicts the fatal wounding of Stonewall Jackson in the right foreground, with the full Moon at the upper left*

Fig. 6.14 *Thomas J. "Stonewall" Jackson, in a photograph dated by historians to late April 1863, less than 2 weeks before the Battle of Chancellorsville*

Confederate Major General Lafayette McLaws expressed a similar view about the lack of Stonewall Jackson's initiative at this crucial battle:

> If he had been at Gettysburg on the evening of July 1st, when the enemy were in full retreat and in confusion upon the hill and ridge…there would have been no delay in the onward march of his then victorious troops; he would not have hesitated…but have gone forward, with his characteristic dash and daring, and those important positions would doubtless have been ours, and the battle of Gettysburg of the 3d would not have occurred. This was the reputation he had made for himself, to last forever. (Jackson 1895: 570)

Flank Attack and a Rising Moon

In the storied military career of Stonewall Jackson, his flank attack that routed the Union army's right wing on May 2, 1863, at Chancellorsville ranks as one of his most brilliant maneuvers. But less than 2 h of daylight remained when Jackson launched the assault, and its momentum stalled after sunset. Jackson decided to renew the attack and continue fighting into the night by the light of a nearly full Moon.

Historian Douglas Southall Freeman described the scene and Jackson's ambitious plan: "The full moon was rising, as yet a dim red orb through the low hanging smoke. A kindly Providence seemed to be lifting that lantern in the sky to light the Confederacy on its way to independence….It might be possible, ere that greatest of nights was over, to get between the Federals and United States Ford" (Freeman 1943: 561).

However, the full Moon caused instead a tragedy for the Confederacy – the fatal wounding of General Jackson by "friendly fire." Our Texas State group discovered that the direction of the rising Moon played a important role in this event.

Bright moonlight that night at Chancellorsville merited commentary in many eyewitness accounts. South Carolinian James Fitz James Caldwell remembered how his brigade continued its advance after sunset on May 2nd: "The moon…lighted our way….Night engagements are always dreadful…to hear shell whizzing and bursting over you, to hear shrapnel and iron fragments slapping the trees and cracking off limbs, and not know from whence death comes to you, is trying beyond all things. And here it looked so incongruous – below, rage, thunder, shout, shriek, slaughter – above, soft, silent, smiling moonlight and peace!" (Caldwell 1866: 78).

Fig. 6.15 *The rising full Moon shines in the sky behind Jackson and his escort in this woodcut entitled "'Stonewall' Jackson Mortally Wounded, May 2d, 1863" and published in John Casler's 1908 memoir, Four Years in the Stonewall Brigade. In the actual scene on the battlefield the horses and riders would have appeared as dark figures silhouetted by the moonlight, which helps to explain why the soldiers of the 18th North Carolina regiment failed to recognize Jackson*

Captain William Fitzhugh Randolph rode at Jackson's side on that ill-fated night and recalled: "When night closed upon the scene the victory seemed complete. The infantry of the enemy had disappeared from our immediate front…The moon was shining very brightly, rendering all objects in our immediate vicinity distinct…The moon poured a flood of light upon the wide, open turnpike" (Randolph 1903: 546).

Fatal Volley in the Moonlight

At about 9 p.m. Jackson's group rode forward to carry out a reconnaissance of the battlefield. The general was searching for a road leading to the Union rear, where he could cut off the Federals from the pontoon bridges and fords along the Rappahannock River. Jackson hoped that this night's attack would be decisive in winning the war for the South. Confederate artillery officer Colonel Edward Porter Alexander recounted the disastrous event (Fig. 6.15)

Fig. 6.16 Light from a rising Sun illuminates cannon on Fairview Heights at the Chancellorsville battlefield. Lieutenant George B. Winslow, commanding Battery D of the 1st New York Light Artillery during the night of May 2–3, 1863, explained that he was able to direct precise fire from this location because "a cloudless sky and a bright moon enabled us to sight our guns with a considerable degree of accuracy" (Photograph by Buddy Secor. Used with permission)

when soldiers of the 18th North Carolina regiment, mistaking the riders for Union cavalry, fired on them:

> The moon was full that night…the experiences of this occasion will illustrate the difficulty of fighting, even when the moon is at its best…in the dim light of the rising moon, great confusion soon resulted…Jackson, followed by several staff-officers and couriers, rode slowly forward upon an old road, called the Mountain road…Jackson, at the head of his party, was slowly retracing his way back to his line of battle, when this volley firing began. Maj. Barry, on the left of the 18th N.C., seeing through the trees by the moonlight a group of horsemen moving toward his line, ordered his left wing to fire…. (Alexander 1907: 330–341)

South Carolinian Berry Benson heard this volley: "The full moon was shining brightly and objects were visible at a good distance…About 9 or 10 o'clock we halted…a sudden volley in our front startled us…we had lost Jackson, struck down by our own men, in that volley which had made us jump so quick" (Benson 2007: 37).

As aides placed Jackson on a litter and carried him to a field hospital, the Confederate lines came under fire from dozens of Federal guns massed on a position called Fairview Heights (Fig. 6.16). Captain Thomas W. Osborn of the First New York Light Artillery reported that they opened up on the Confederates around 9:30 p.m. and the "havoc in their ranks was fearful."

Osborn observed that the opposing lines of battle were "closely engaged" but that the "beautiful moonlight night" enabled his artillerymen to arc shells just over the Union positions that "tore the rebel lines to fragments" without wounding a single Federal soldier. Union artillerist Lieutenant George B. Winslow agreed that such precise aiming was possible at night since "a cloudless sky and a bright moon enabled us to sight our guns with a considerable degree of accuracy" (Official Records 1889: 484–487).

Night Fighting

The Confederates halted their advance after Jackson was carried from the field. Fighting continued, however, when Union Major General Daniel E. Sickles launched a midnight assault. Sickles reported that the "night was very clear and still; the moon, nearly full, threw enough light in the woods to facilitate the advance" (Official Records 1889: 390).

Union Major General Abner Doubleday (best known today because he was mistakenly credited as the inventor of baseball) observed both the full Moon and the night fighting: "We heard afar off the roar of the battle caused by Jackson's attack, and saw the evening sky reddened with the fires of combat…We marched through the thickening twilight of the woods amid a silence at first only broken by the plaintive song of the whip-poor-will, until the full moon rose in all its splendor…As we approached the field a midnight battle commenced, and the shells seemed to burst in sparkles in the trees above our heads" (Doubleday 1882: 42).

The celebrated contemporary poet Walt Whitman, in his prose account written 10 days after this night battle, mentioned the moonlight several times:

A Night Battle, Over a Week Since:

The night was very pleasant, at times the moon shining out full and clear, all Nature so calm in itself…yet there the battle raging…amid the crack and crash and yelling sounds – the radiance of the moon, looking from heaven at intervals so placid…the melancholy, draperied night above, around…Who know the conflict, hand-to-hand – the many conflicts in the dark, those shadowy-tangled, flashing moonbeam'd woods…the flash of the naked sword, and rolling flame and smoke? And still the broken, clear and clouded heaven – and still again the moonlight pouring silvery soft its radiant patches over all. (Whitman 1875: 13)

Fighting eventually ceased for the night as both sides paused to regroup.

Moonlit Reflections

Major General J. E. B. Stuart assumed command of Jackson's forces and ordered Colonel Edward Porter Alexander to determine the best gun positions for the next day's engagement. The opposing armies slept as Alexander searched the woods:

> [I]t was a glorious, clear, calm, full-moon night…I shall never forget that night. From about nine o'clock to three, I was hunting out our line of battle in the woods, from the extreme right to the extreme left…following out all the roads within our limits by which our guns could be moved…our men, lying on the ground in line of battle with their guns in their hands, or by their sides, overcome with the fatigue & excitements of the previous day, looked like an army of dead men in the pale moonlight, & irresistibly suggested the thought of how many must indeed be left stretched in death in those dark woods before the rapidly coming day was many hours old. (Gallagher 1989: 206)

The stars, planets, and full Moon in the heavens over Chancellorsville that night inspired Georgian Micajah D. Martin to quote appropriate lines from Homer's *Iliad* in a letter to his parents:

> *The troops, exulting, sit in order round,*
> *And beaming fires illumine all the ground;*
> *And when the moon, refulgent lamp of night,*
> *O'er heaven's clear azure spreads her sacred light;*
> *When not a breath disturbs the deep serene,*
> *And not a cloud o'ercasts the solemn scene.*
> *Around her throne the vivid planets roll,*
> *And stars unnumbered gild the glowing pole;*
> *O'er the dark trees a yellow verdure shed,*
> *And tip with silver every mountain's head.*
> *Loud neigh the coursers o'er the heaps of corn,*
> *And ardent warriors wait the rising morn.*

(Martin 1929: 224)

Computer planetarium programs show that the Moon reached its highest point in the sky shortly after 11 p.m. on May 2nd and that the planets Jupiter and Saturn also graced the Virginia sky that night. On the next day the "ardent warriors" drove the Union forces from Chancellorsville and secured what writers often describe as "Lee's Greatest Victory."

Calculating Chancellorsville's Sky

Historians looking back at the Chancellorsville campaign generally mention the Moon but do not give calculations of the times of moonrise and sunset and the direction of moonlight.

Our computer calculations (Olson and Jasinski 2013: 35) show that the nearly full Moon, 99.6 % illuminated, rose into the sky 42 min before sunset on May 2, 1863. The Moon was rising higher into the sky as the twilight deepened, and the Chancellorsville battlefield therefore was never completely dark. The light from the rising Moon emboldened Jackson to capitalize on the afternoon's success with a night attack. By 9 p.m. local mean time the Moon was standing 25° above the southeastern horizon.

Our Texas State group realized the calculated direction of the moonlight helps to explain an especially significant point – why the soldiers of the 18th North Carolina regiment, looking to the southeast, were unable to recognize General Jackson and fired the fatal volley.

Dark Night? Bright Moonlit Night?

According to historian James Gillispie, the 18th North Carolina became famous and best known for what happened to Stonewall Jackson during the Battle of Chancellorsville. Major John Barry "felt extreme guilt over giving the command to fire," and after the war Brigadier General James Lane was "understandably touchy about any criticism of his brigade generally or the 18th North Carolina specifically for wounding Stonewall Jackson." Lane explained the tragedy as a "misapprehension caused by the darkness" (Gillispie 2012: 142).

In the 150 years since Chancellorsville, writers have offered conflicting opinions whether May 2, 1863, was a bright moonlit night or a murky dark night. Especially to those on the Confederate side, the idea that their soldiers could not recognize such a famous figure as Stonewall Jackson seemed inexplicable, and many insisted that the darkness of the night was the major cause.

For example, the publication *Confederate Veteran* printed a letter in June 1902 from E. S. Anderson of the 37th Virginia regiment, who correctly recalled, "I was in the battle of Chancellorsville, and saw Jackson when he fell. It was a beautiful moonlight night" (Anderson 1902: 64). In the October 1902 issue, I. Roseneau of the 4th Georgia Infantry retorted that Anderson's statement was not correct: "General Jackson was shot to my left, and I remember distinctly that 'it was the darkest night I ever saw'…Had it been

a beautiful moonlight night, his comrades who shot him would have recognized General Jackson and avoided the terrible catastrophe" (Roseneau 1902: 456).

Silhouetted in the Moonlight

The abundant quotes from those present at the battle demonstrate that the opposing armies did fight under a bright Moon. However, we can offer an explanation for Jackson's wounding based on the direction of moonlight. The soldiers of the 18th North Carolina were looking to the southeast, exactly the direction where the Moon was rising. The moonlight silhouetted Jackson and his party as they rode back toward the Confederate battle lines. The riders would have appeared as dark figures, not recognizable.

The astronomical analysis, 150 years after the event, partially absolves the 18th North Carolina from blame for the fatal wounding of Jackson.

Ancient and Modern Night Battles

As long as wars have been fought, confusion like this is inevitable in night fighting. Writing during the 5th century B.C., the Greek historian Thucydides described how the Athenians faced a similar problem: "In a battle by night, even when there was a bright moon, they could see the outline of the figures in front of them, but could not be sure who was friend or enemy." (Thucydides, *History of the Peloponnesian War*, Book 7, Chap. 44)

At Chancellorsville in 1863, the direction of the moonlight played a critical role by causing the riders to appear as dark silhouettes in front of the Confederate lines. The lunar phase was also important. If the Moon had been in a different phase, Jackson might not have attempted to continue the attack after twilight, and the Confederate line would never have fired the fatal volley. In those two important ways, the full Moon influenced the fateful events that night and changed the course of the Civil War.

What's a Blue Moon?

Did American almanacs really define a "Blue Moon" as the second full Moon in a month? Apparently not! The only way to fit two full Moons into 1 calendar month is to have a full Moon near the beginning of the month and another full Moon near the end of the month. But the *Maine Farmers' Almanac* for 1937 lists a Blue Moon on August 21st, the only full Moon in that month.

Fig. 6.17 Full Moon (Photograph by Russell Doescher. Used with permission)

The pages of the *Maine Farmers' Almanac* over the years include many references to the dates of Blue Moons – and not a single one of them is the second full Moon in a calendar month. What was the actual definition that these almanacs employed for a Blue Moon? Why do so many people now insist that a Blue Moon is the second full Moon in a month? How did this definition become so well-known? How did a mistake published in *Sky* & *Telescope* magazine in 1946 change popular culture and the English language in unexpected ways?

Two Full Moons in a Month

Regarding full Moons (Fig. 6.17), the last two decades of the twentieth century saw widespread popular acceptance of the following definition: When a calendar month contains two full Moons, the second full Moon is called a Blue Moon. Modern authors debating the origin of this rule often admit to uncertainty, with some stating vaguely that this usage comes from early almanacs, and others specifically mentioning the 1937 *Maine Farmers' Almanac* as the source.

Interest in the Blue Moon peaks whenever two full Moons fall within 1 month. The especially unusual pattern of lunar phases in early 1999 called forth an explosion of media coverage, with nearly every newspaper in the United States running an article about the double full Moons to begin the year (January 1st and 31st), the absence of a full Moon in February, and the double full Moons again in the next month (March 2nd and 31st). The announcers at the Super Bowl on January 31, 1999, mentioned the Blue Moon several times and showed views of the rising full Moon during time-outs during the game.

The Maine Farmers' Almanac

The increased awareness of Blue Moons in 1999 resulted in a surprising revelation. Our Texas State group, along with Richard Tresch Fienberg and Roger W. Sinnott of *Sky & Telescope* magazine, became interested in investigating the origin of the Blue Moon. With the help of Margaret Vaverek of the Alkek Library at Texas State, along with other librarians and archivists across the country, we obtained copies of the *Maine Farmers' Almanac* from many decades ago (Fig. 6.18).

We originally expected that in the pages of these quaint pamphlets we would find the source for the two-full-Moons-in-a-month rule. Instead, we realized that the popular definition of Blue Moon, now so widely accepted, is actually based on a mistake that occurred in a *Sky & Telescope* article in 1946. We found that the original almanacs contain references to the dates of more than a dozen Blue Moons (Table 6.1), and not a single one of them is the second full Moon in a calendar month!

Our research discovered the original rule for Blue Moons as intended in the early *Maine* almanacs. We also could explain the 1946 *Sky & Telescope* error and describe how it occurred.

Four Full Moons in a Season

Several clues point to a strong connection between the almanac Blue Moons and the four seasons of the year (Olson and Sinnott 1999). All of the listed Blue Moons fall on the 20th, 21st, 22nd, or 23rd day of a month. In the twentieth century, the solstices and equinoxes fall on similar dates: the winter solstice always on December 21st, 22nd, or 23rd, the spring equinox on March 20th or 21st, the summer solstice on June 21st or 22nd, and the fall equinox on September 22nd, 23rd, or 24th. We also noticed that the

Fig. 6.18 *The Maine Farmers' Almanac for 1937 listed a Blue Moon on August 21st, a date which is not the second full Moon in a month. The remarks on the page for August discuss another half dozen Blue Moons, none of which is the second full Moon in a month*

Table 6.1 Dates of full Moons identified as Blue Moons by the Maine Farmers' Almanac

1915 November 21	1932 February 21	1948 May 22
1918 August 22	1934 November 20	1951 May 21
1921 May 21	1937 August 21	1953 November 20
1924 February 20	1940 May 21	1956 August 21
1926 August 23	1943 February 20	
1929 May 23	1945 August 23	

almanac Blue Moons fell in only 4 different months, in each case immediately preceding a month containing a solstice or an equinox. Verifying the details of the seasonal pattern required calculating lunar phases and the

Table 6.2 *Full Moon names according to the Maine Farmers' Almanac*

Winter Moons	Moon after Yule
	Wolf Moon
	Lenten Moon
Spring Moons	Egg Moon
	Milk Moon
	Flower Moon
Summer Moons	Hay Moon
	Grain Moon
	Fruit Moon
Fall Moons	Harvest Moon
	Hunter's Moon
	Moon before Yule

times of the solstices and equinoxes that mark the beginnings of each season (Olson et al. 1999).

In addition to the familiar calendar year running from January 1st through December 31st, astronomers also define a time period called the tropical year, based on the seasons. The *Maine Farmers' Almanac* employed a tropical year extending from one winter solstice to the next winter solstice. The majority of such tropical years contain 12 full Moons, with three full Moons in each season, each bearing the name of an activity appropriate to the time of year (Table 6.2).

However, occasionally tropical years contain 13 full Moons, including a season with four full Moons. The Blue Moon definition employed in the *Maine Farmers' Almanac* sounds very much like the modern conventional definition, but with a twist. When a season contains four full Moons, the third full Moon is called a Blue Moon.

Why is the Blue Moon placed third in the sequence? We can give at least a partial answer, which explains why the Blue Moon cannot be the first or last full Moon of a season. Lent begins on Ash Wednesday, 46 days before Easter, and contains the Lenten Moon, which must be the last full Moon of winter. The first full Moon of spring must be the Egg Moon (also called the Easter Moon or Paschal Moon) and must fall within the week immediately preceding Easter. Likewise, the Harvest Moon traditionally must keep its place near the fall equinox.

Also worth mentioning is the treatment of "Yule" in the *Maine Farmers'*
Almanac. The word "Yule" might suggest a reference to Christmas Day. But
the commentaries in the Maine calendars follow the seasonal pattern and
identify Yule with the winter solstice. Definitive evidence comes in the 1942
almanac, which lists the "Moon before Yule" on November 22nd, describes
December 21st as "Yule, the Long Night" and then places the "Moon after
Yule" on December 24th. This example proves that the "Moon after Yule" need
not be after Christmas Day, showing that "Yule" in the Maine almanacs refers
to the winter solstice and confirming the seasonal pattern for full Moon names.

Early History of The Maine Farmer's Almanack

The publication then known as *The Maine Farmers' Almanack* first appeared in
1818 with a calendar of predictions for 1819. The founder, Moses Springer,
edited the 1819 and 1820 almanacs and then shared the editorial duties with
Daniel Robinson in 1821–1822. Robinson carried on alone as editor from
1823 until 1864. In a familiar almanac tradition, the name of Daniel Robinson
remained on the front cover thereafter, while the actual modern editors
remained anonymous in most issues and signed their notes just as "The Editor."

By the early twentieth century the editorship had passed to the Trefethen
family. Henry Emerson Trefethen, a professor of mathematics at Colby
College in Waterville, Maine, edited the 1917–1931 volumes. His son, Henry
Porter Trefethen, picked up the editorial reins and produced the almanacs
for 1932 through 1957. The son, although remaining anonymous in the
pages of the almanac, gave himself away when he submitted an article to *Sky*
& Telescope with the credit line "H. Porter Trefethen, Editor, *Maine Farmers'*
Almanac." (Trefethen 1945: 8). Almost certainly, the editor responsible for
the Maine rule – that a Blue Moon is the third full Moon in a season contain-
ing four full Moons – was H. Porter Trefethen.

Origin of the "Second-Full-Moon-in-a-Month"
Definition

If the Maine almanacs consistently gave Blue Moons derived from a rule
based on the seasons, what was the origin of the modern convention that a
Blue Moon is the second full Moon in a calendar month? We found that the
answer lies in two *Sky & Telescope* items written in the 1940s.

Laurence J. Lafleur discussed Blue Moons in a *Sky & Telescope* question-
and-answer column and cited the 1937 *Maine Farmers' Almanac* as his

source (Lafleur 1943). Lafleur must have had a copy of the almanac at his side as he wrote his comments since he gave, word-for-word within quotation marks, the commentary on the August 1937 almanac page. Lafleur mentioned situations when the Moon "comes full thirteen times in a year" but did not state whether he meant the tropical year or the calendar year. More importantly, Lafleur did not give the dates of any Blue Moons, never mentioned anything about two full Moons in 1 calendar month, and was accurate as far as he went.

The pivotal misunderstanding takes place in another *Sky & Telescope* article, authored by James Hugh Pruett and entitled "Once in a Blue Moon" (Pruett 1946). Pruett, an amateur astronomer living in Eugene, Oregon, was a frequent contributor to *Popular Astronomy* and *Sky & Telescope* on a variety of topics, especially reports of fireball meteors. In his Blue Moon article, Pruett mentioned the 1937 Maine almanac and repeated some of Lafleur's earlier comments. Then, unfortunately, he went on to say: "But seven times in 19 years there were – and still are – 13 full moons in a year. This gives 11 months with one full moon each and one with two. This second in a month, so I interpret it, was called Blue Moon" (Pruett 1946: 3).

Pruett must not have possessed a 1937 almanac, or he would have noticed that the Blue Moon fell on August 21st (obviously not the second full Moon in that month) and that the calendar year 1937 had only 12 full Moons. He would not have committed this error that has come to dominate the modern lore of the Blue Moon.

Sky & Telescope adopted Pruett's new definition and used it in a note entitled "'Blue' Moons in May" in the May 1950 issue (Federer 1950: 176) and thereafter.

Modern Lunar Folklore

In the general public, the widespread adoption of the second-full-Moon-in-a-month definition followed its use on the *StarDate* radio program for January 31, 1980. We examined this show's script, authored by Deborah Byrd, and found that it contains a footnote not read on air that cites the 1946 Pruett article in *Sky & Telescope* as the source. For several years thereafter, a version of the Blue Moon script was read on *StarDate* every time the Moon came full twice in a month. The StarDate series brought Blue Moon awareness to millions of listeners. By 1986 the second-full-moon-in-a-month definition had become the answer to a question in the immensely popular *Trivial Pursuit* game. From 2013, Byrd has served as president and on-air

Table 6.3 *Blue Moons from 2012 to 2020 according to the modern "second-full-Moon-in-a-month" definition*

	Time Zones in the USA	Time Zones in Europe
2012	August 1 and 31	August 2 and 31
2015	July 1 and 31	July 2 and 31
2018	January 1 and 31	January 2 and 31
2018	March 1 and 31	March 2 and 31

Table 6.4 *According to the original Maine Farmers' Almanac "third-full-Moon-in-a-season-with-four" definition*

	Time Zones in the USA	Time Zones in Europe	Season
2013	August 20	August 21	Four full Moons in summer 2013
2016	May 21	May 21	Four full Moons in spring 2016
2019	February 19	February 19	Four full Moons in winter 2018–2019

host for *EarthSky*, with a note on the website (www.earthsky.com) explaining her perspective on the Blue Moon definitions.

The Maine almanac original definition of the Blue Moon, the third full Moon in a season with four, is certainly the older rule. But with more than three decades of popular usage behind it, the second-full-Moon-in-a-month misinterpretation is like a genie that cannot be forced back into the bottle. Why not celebrate the upcoming Blue Moons (Tables 6.3 and 6.4) both ways?

The unusual pattern of lunar phases that last occurred in early 1999 will occur again in 2018: double full Moons in January, no full Moon during February, and double full Moons in March of 2018. If past experience is a guide, media stories about Blue Moons will peak in early 2018.

During the course of our research, *Sky & Telescope*'s founding editor Charles A. Federer, Jr., pointed out to us: "Even if the calendrical meaning is new, I don't see any harm in it. It's something fun to talk about, and it helps attract people to astronomy."

References

Alexander, Edward P. (1907) *Military Memoirs of a Confederate*. New York: Charles Scribner's Sons.

Anderson, Edward S. (1902) Letter. *Confederate Veteran* **10**(6), 64.

Barrett, Joseph H. (1865) *Life of Abraham Lincoln*. Cincinnati: Moore, Wilstach & Baldwin.

Barton, William E. (1925) *Life of Abraham Lincoln, Volume 1*. Indianapolis: Bobbs-Merrill Company.

Benson, Susan W., ed. (2007) *Berry Benson's Civil War book, Memoirs of a Confederate Scout and Sharpshooter*. Athens, Georgia: University of Georgia Press.

Beveridge, Albert J. (1928) *Abraham Lincoln 1809–1858, Volume 1*. Boston: Houghton Mifflin Co..

Caldwell, James F. J. (1866) *The History of a Brigade of South Carolinians*. Philadelphia: King & Baird.

Dabney, Robert L. (1866) *Life and Campaigns of Lieut.-Gen. Thomas J. Jackson*. Richmond: Blelock & Co.

Doubleday, Abner (1882) *Chancellorsville and Gettysburg*. New York: Charles Scribner's Sons.

Federer, Charles A., Jr., ed. (1950) "Blue" Moons in May. *Sky & Telescope* **9**(7), May, 176.

Freeman, Douglas S. (1943) *Lee's Lieutenants, Volume 2*. New York: Charles Scribner's Sons.

Gallagher, Gary W. (1989) *Fighting for the Confederacy*. Chapel Hill: University of North Carolina Press.

Gillispie, James (2012) *Cape Fear Confederates*. Jefferson, North Carolina: McFarland & Company.

Herndon, William H., and Jesse W. Weik (1895) *Abraham Lincoln: The True Story of a Great Life, Volume 2*. New York: Appleton and Company.

Jackson, Mary A. (1895) *Memoirs of Stonewall Jackson by His Widow*. Louisville, Kentucky: Prentice Press.

Jones, John W. (1875) *Personal Reminiscences, Anecdotes, and Letters of Gen. Robert E. Lee*. New York: Appleton and Company.

Lafleur, Laurence J. (1943) Can you tell me anything about a "blue moon"? *Sky & Telescope* **11**(9), July, 17.

Lamon, Ward H. (1872) *Life of Lincoln*. Boston: James R. Osgood and Company.

Lovi, George (1987) The High-Low Moon of 1987. *Sky & Telescope* **73**(1), January, 57–58.

Lynn, William Thynne (1908) Donati and His Comet. *Observatory* **31**(No. 400), 352–353.

Martin, Micajah D. (1929) Chancellorsville: A Soldier's Letter. *Virginia Magazine of History and Biography* **37**(3), 221–228.

Masters, Edgar L. (1931) *Lincoln: The Man*. New York: Dodd, Mead & Co.

Official Records (1889) *The War of the Rebellion: A Compilation of the Official Records, Volume 25*. Washington, DC: Government Printing Office.

Olson, Donald W., and Russell L. Doescher (1990) Lincoln and the Almanac Trial. *Sky & Telescope* **80**(2), August, 184–188.

Olson, Donald W., Richard T. Fienberg, and Roger W. Sinnott (1999) What's a Blue Moon? *Sky & Telescope* **97**(5), May, 36–38.

Olson, Donald W., and Laurie E. Jasinski (1999) Abe Lincoln and the Leonids. *Sky & Telescope* **98**(5), November, 34–35.

Olson, Donald W., and Roger W. Sinnott (1999) Blue-Moon Mystery Solved? *Sky & Telescope* **97**(3), March, 55.

Olson, Donald W., and Laurie E. Jasinski (2009) Abraham Lincoln's Celestial Connections. *Sky & Telescope* **117**(3), March, 66–68.

Olson, Donald W., and Laurie E. Jasinski (2013) Stonewall Jackson in the Moonlight. Sky & Telescope **125**(5), May, 32–37.

Olson, Roberta J. M. (1985) *Fire and Ice, A History of Comets in Art*. New York: Walker and Company.

Olson, Roberta J. M., and Jay M. Pasachoff (1998) *Fire in the Sky: Comets and Meteors, the Decisive Centuries, in British Art and Science*. Cambridge: Cambridge University Press.

Onstot, Thompson G. (1902) *Pioneers of Menard and Mason Counties*. Forest City, Illinois: T. G. Onstot.

Pruett, James H. (1946) Once in a Blue Moon. *Sky & Telescope* **5**(5), March, 3–4.

Randolph, William F. (1903) Manner of Stonewall Jackson's Death. *Confederate Veteran* **11**(12), 545–547.

Roseneau, I. (1902) Letter. *Confederate Veteran* **10**(10), 456.

Sandburg, Carl (1926) *Abraham Lincoln, the Prairie Years*. New York: Harcourt, Brace and Company.

Sandburg, Carl (1939) *Abraham Lincoln, the War Years*. New York: Harcourt, Brace & Co.

Stimmel, Smith (1928) *Personal Reminiscences of Abraham Lincoln*. Minneapolis: W. H. M. Adams.

Thomas, Benjamin P. (1934) *Lincoln's New Salem*. Springfield, Illinois: Abraham Lincoln Association.

Trefethen, Henry P. (1945) The Great Year or The Cycle of Precession. *Sky & Telescope* **4**(4), February, 8.

Trobriand, Régis de (1889) *Four Years with the Army of the Potomac, Volume 3*. Boston: Ticknor.

Whitman, Walt (1875) *Memoranda During the War*. Camden, New Jersey: Walt Whitman.

Whitman, Walt (1882) *Specimen Days & Collect*. Philadelphia: David McKay.

Wilson, Douglas L., and Rodney O. Davis, eds. (1998) *Herndon's Informants: Letters, Interviews, and Statements About Abraham Lincoln*. Urbana: University of Illinois Press.

Work Projects Administration, Federal Writers' Project (1939) *Illinois, A Descriptive and Historical Guide*. Chicago: A. C. McClurg & Co.

Zeltmann, Walter F. (1976) *The People vs. Armstrong Revisited: Forensic Meteorology Then & Now*. Brooklyn: Walter Zeltmann.

7

The Moon and Tides
in World War II

Astronomical factors played significant roles in many of the important battles of World War II. Our Texas State group used calculations of tide levels, lunar phase, and the direction of moonlight to derive new results for the four events described in this chapter.

World War II in the Pacific began when Japanese aircraft attacked Pearl Harbor and made December 7, 1941, one of the most well-known dates in American history. How did the phase of the Moon influence the Japanese military planners to select this date? Why do Japanese history books give December 8th as the date for the Pearl Harbor attack? How did the bright moonlight almost give the plan away by allowing a U. S. Navy minesweeper to spot a Japanese midget submarine just off the Pearl Harbor entrance 4 h before the air attack began?

On the morning of November 20, 1943, the tide failed to rise as expected during the U. S. Marines' amphibious assault at Betio Island of the Tarawa Atoll. Landing craft could not reach the beach and instead grounded on the reef that surrounded the island. The Marines took many casualties as they were forced to wade in through the water under heavy fire for 600 yards. Why did the tide fail to rise? How did an unusual lunar configuration influence the tides that morning?

Why was June 6, 1944, chosen as the D-Day date for the invasion of Normandy? Did the airborne regiments want the darkness of a new Moon or a bright full Moon in the sky as the paratroopers parachuted into France just after midnight? What was the lunar phase on D-Day? How did the planners coordinate the lunar phase with the requirements for the behavior of the tides on the invasion beaches? Did the Allied forces want a low tide, a

D.W. Olson, *Celestial Sleuth: Using Astronomy to Solve Mysteries in Art,*
History and Literature, Springer Praxis Books, DOI 10.1007/978-1-4614-8403-5_7,
© Springer Science+Business Media New York 2014

rising tide, a high tide, or a falling tide at the time of the assault at Omaha Beach in Normandy?

Only a few weeks before the end of World War II, the U. S. Navy suffered its greatest disaster at sea. After delivering the Hiroshima atomic bomb to the American B-29 air base on the island of Tinian, the heavy cruiser USS *Indianapolis* was torpedoed and sunk near midnight on July 29–30, 1945. The survivors in life jackets spent several days floating in the shark-infested waters of the Philippine Sea. Their ordeal inspired many books and a famous speech in the film *Jaws*. How did the Japanese submarine spot the American cruiser? What was the lunar phase that night? How did the direction of the moonlight play a significant role in the sinking of the USS *Indianapolis*?

Pearl Harbor 1941: The Waning Moon and the Rising Sun

The Pacific phase of World War II began when 353 planes from six Japanese aircraft carriers attacked Pearl Harbor in Hawaii. The event made December 7, 1941, one of the most well-known dates in American history. Why was December 7th chosen? How did the lunar phase influence the Japanese military planners to select this date for the Pearl Harbor attack? How did the bright moonlight almost give the plan away by allowing a U. S. Navy minesweeper to spot a Japanese midget submarine just off the Pearl Harbor entrance 4 h before the air attack began? And why do Japanese history books give December 8th as the date for the Pearl Harbor attack?

Lunar Phase on December 7, 1941

Of course, setting the Pearl Harbor attack (Figs. 7.1 and 7.2) on a Sunday morning was a deliberate choice – a time when the fewest possible American forces might be on alert. Less well known is that military planners in Japan selected this particular Sunday for astronomical reasons.

Moonlight in the hours just before sunrise was important for the maneuvers of the Japanese forces, and the lunar phase helped to determine the date. A full Moon would provide illumination all night long, for it rises at about sunset, reaches its highest point above the horizon at midnight, and finally sets near sunrise. Even better for the Japanese fleet might be a waning gibbous Moon, several days after full Moon. A waning gibbous Moon has an illuminated fraction that is less than a full Moon (so less than 100 % lit) but more than half-lit (more than 50 % lit). A waning gibbous Moon rises in the

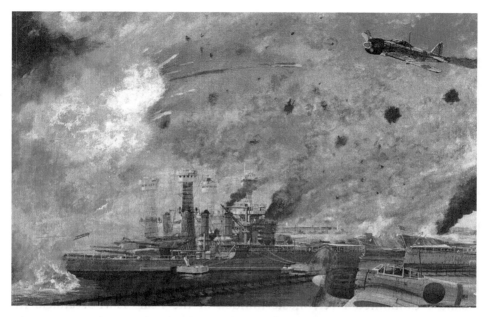

Fig. 7.1 *Richard DeRosset's painting Battleship Row shows the scene during the Pearl Harbor attack (Illustration by Richard DeRosset. Used with permission)*

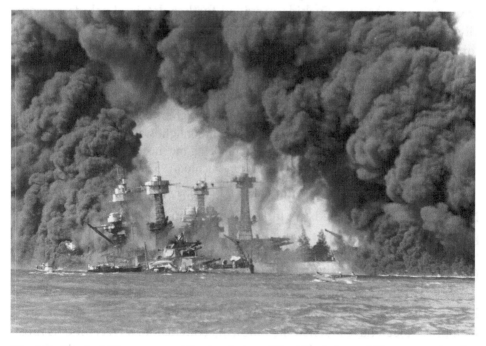

Fig. 7.2 *Smoke billows around the battleships West Virginia and Tennessee after the attack on December 7, 1941 (Photograph courtesy of the Naval Historical Center. Used with permission)*

Table 7.1 *Lunar phases and illuminated fraction (Dates according to Greenwich time)*

November 19, 1941	New Moon	0 % illuminated
November 25, 1941	First quarter Moon	50 % illuminated
December 3, 1941	Full Moon	100 % illuminated
December 7, 1941	Waning gibbous Moon	88 % illuminated
December 11, 1941	Last quarter Moon	50 % illuminated

evening, passes highest in the sky after midnight, and remains bright and relatively high in the sky until dawn.

The schedule of lunar phases in Table 7.1 shows that a bright waning gibbous Moon did prevail on December 7th.

Comments from major participants show that the lunar phase at the time of the Pearl Harbor attack was not an accident but was integral to the Japanese plan. Admiral Isoroku Yamamoto, commander in chief of the Japanese Combined Fleet, masterminded of the Pearl Harbor attack. In January of 1941 he wrote a letter that outlined his plan for carriers "to launch a surprise attack with all their air strength, risking themselves on a moonlight night or at dawn" (Prange 1981: 16).

Commander Mitsuo Fuchida provided further details. Fuchida personally led the attack, and his plane sent out the famous message "Tora, tora, tora" ("Tiger, tiger, tiger"), indicating that the Japanese forces had achieved surprise. He explained the plan:

> Why was 8 December chosen as X day? That was 7 December and Sunday, a day of rest, in Hawaii. Was this merely a bright idea to hit the U. S. Fleet off duty? No, it was not so simple as that…Favorable moonlight was a major consideration, three or four days after the full moon being the most desirable time, and on 8 December the moon was 19 days old. (Fuchida 1952: 942)

Rear Admiral Sadatoshi Tomioka, head of the Operations Section of the Naval General Staff, listed the lunar phase as one of the reasons why his group had "…decided upon December 8…the phase of the moon had to be such as to give the task force maximum moonlight for night operations" (Prange 1981: 325).

Rear Admiral Matome Ugaki, chief of staff at the Combined Fleet Headquarters, also mentioned the importance of the Moon: "We, as the Combined Fleet, have reached the following conclusion: 8 December is most preferable in view of completion of preparations, moon age and the day of the week" (Prange 1981: 326).

Admiral Osami Nagano, chief of the Naval General Staff, explained the date selection in a meeting with the emperor on December 2nd, when the Japanese fleet was already steaming east across the Pacific toward Pearl Harbor: "In order to make the first attacks by the army, navy, and air units as easy and effective as possible, we consider the best time to be a moonlit night, with the moon approximately twenty days old, sometime between midnight and dawn…We have therefore chosen December 8, when the moon will be nineteen days old, and which is a Sunday in the Hawaii area" (Agawa 1979: 214).

Americans may be surprised to read that the Japanese sources give the date for the Pearl Harbor attack as December 8th, but this is correct in the Japanese time system. The Japanese strike force did not turn their calendars back upon crossing the International Date Line but instead continued reckoning via the same date, and even the same time zone, used in Tokyo. The first bombs of the Pearl Harbor attack fell on December 7th at 7:55 a.m. local Hawaiian time, with Hawaii using a time zone 10½ h behind Greenwich Mean Time. This moment is equivalent to December 7th at 6:25 p.m. in England, and it corresponds to December 8th at 3:25 a.m. in the Japanese system, with the attacking aircraft using the Tokyo time zone 9 h ahead of Greenwich Mean Time.

At the time of the attack, an interval of 18.8 days had elapsed since the preceding new Moon, in agreement with the lunar age of 19 days mentioned in the Japanese plans. However, this waning gibbous Moon provided illumination not only for the approaching Japanese forces but also for any defenders standing watch.

Condor, Ward, Antares, **and a Midget Submarine**

In the predawn hours on that fateful Sunday, the minesweeper USS *Condor* (Fig. 7.3) was conducting magnetic sweeps just outside the entrance buoys marking the approach channel to Pearl Harbor. At 3:42 a.m. something caught the eye of Ensign Russell C. McCloy, officer of the deck. At first it appeared to be foam on a wave, but the object persisted, heading in a straight line toward the harbor entrance.

Quartermaster Robert C. Uttrick, after using binoculars, decided, "That's a periscope, sir, and there aren't supposed to be any subs in this area." In what was called the Defensive Sea Area, all American submarines were restricted to surface operation, so any submerged vessel was to be considered hostile.

Fig. 7.3 *The minesweeper USS Condor spotted one of the Japanese midget subma-rines near the entrance to Pearl Harbor at 3:42 a.m. (Photograph courtesy of the Naval Historical Center. Used with permission)*

We now know that the *Condor* had spotted one of five midget submarines, 80 ft long and carrying a two-man crew and two torpedoes. Larger subma-rines brought the midget submarines from Japan on their decks and launched them to enter Pearl Harbor during the night.

When first sighted, the midget submarine was off the port bow and on a collision course with the *Condor*. The Japanese helmsman may have spotted the American ship, for the submarine turned sharply left. Because the *Condor* was not equipped for antisubmarine operations, at 3:57 a.m. the crew flashed a blinker-light message to the USS *Ward* (Fig. 7.4), a destroyer patrolling the channel entrance.

The *Ward* at first was unable to make contact. However, at 6:37 a.m. it did sight a midget submarine attempting to follow the supply ship USS *Antares* into Pearl Harbor. The *Ward* fired two rounds from deck guns, the first a near miss and the second a direct hit near the base of the conning tower, fol-lowed by a pattern of depth charges, sinking the craft at 6:45 a.m. In August 2002, researchers from the Hawaiʻi Undersea Research Laboratory located the wreck of this midget submarine (Fig. 7.5), 5 miles off the harbor entrance and under about 1,300 ft of water. The starboard side of the conning tower had a visible hole from the 4-in. shell fired by the *Ward*.

Fig. 7.4 The destroyer USS Ward became famous for firing the first shots of the Pacific War between the United States and Japan. Rounds from the Ward's deck guns, along with a spread of depth charges, sank a Japanese midget submarine off the entrance to Pearl Harbor at 6:45 a.m., more than an hour before the Japanese planes began their aerial attack (Photographs courtesy of the Naval Historical Center. Used with permission)

Fig. 7.5 In 2002 a team from the Hawai'i Underwater Research Laboratory located this midget submarine in deep water outside the Pearl Harbor entrance. A hole at the base of the conning tower proves that this is the submarine attacked by the Ward about an hour before the first waves of Japanese planes attacked Battleship Row (Photograph courtesy of the Hawai'i Underwater Research Laboratory. Used with permission)

The *Condor*'s sighting is significant as the first contact, and the *Ward* became famous for firing the first shots of the Pacific War between the United States and Japan. The *Ward* "first shot" gun, manned during the Pearl

Harbor attack by a crew of Minnesota naval reservists, stands today as part of a memorial on the grounds of the Minnesota State Capitol in Saint Paul (Lott 1983).

Computer programs make it easy to reconstruct the heavens as seen from just outside the Pearl Harbor entrance (Olson 1991: 652). At 3:42 a.m. Hawaiian time, when Ensign McCloy saw a periscope in the water, the stars of Orion and Taurus were descending toward the western horizon. High above them the Moon, 88 % sunlit and near the border between Gemini and Cancer, stood high in the sky at an altitude of 76° above the horizon. Astronomers use a coordinate called azimuth to specify the compass direction of a celestial object, with 0° indicating north, 90° for east, 180° for south and 270° for west.

As seen from the *Condor*, the bright Moon illuminated the ocean, especially toward an azimuth of 254° (slightly south of west), where a bright path of glittering reflected moonlight sparkled in the water. The war diary entry of the *Condor* includes a diagram illustrating the submarine contact. A line drawn from the *Condor* to the position of the sub when first spotted points toward an azimuth of 254° – exactly the same direction as that of the Moon!

The computer calculation therefore gives an interesting result. The crew of the *Condor* sighted the submarine periscope silhouetted against the bright glow of moonlight in the water.

Since false submarine reports had occurred before, the warning provided by the *Condor* and *Ward* incidents was not heeded inside Pearl Harbor. Likewise, the Opana radar station at the extreme northern tip of Oahu detected the incoming Japanese planes at 7:02 a.m., nearly an hour before the attack, but because a flight of B-17 bombers was expected to arrive from the mainland, that warning was also ignored.

The Japanese had picked the date of December 7th in Hawaii in order to have bright moonlight between midnight and dawn. However, the bright waning gibbous Moon had actually given them away to the Americans more than 4 h before the air attack began.

Tarawa in 1943: The Tide That Failed

On the morning of November 20, 1943, the tide failed to rise as expected during the Marines' assault at Betio Island of the Tarawa Atoll. Landing craft could not reach the beach and instead grounded on the reef that surrounded

the island. The Marines, under heavy fire, took many casualties as they were forced to wade in through the water for 600 yards. The low water over the reef contributed to the high price, 2,292 wounded and 1,115 killed or missing, of the eventual victory. Why did the tide fail to rise? How did an unusual lunar configuration influence the tides that morning?

Across the Reef at Tarawa

An unusual astronomical event helped to produce an unusual tidal event on November 20, 1943, with significant consequences for one of the most famous battles of World War II.

The first major amphibious opposed landing of the Pacific War occurred at Tarawa Atoll in the Gilbert Islands. The first three assault waves were in tracked vehicles of the type called LVT (landing vehicle, tracked), also known as amphibious tractors or "amphtracs," which could crawl over the reef regardless of the water level. The Marines hoped to hit the beach on a flooding tide, because the succeeding assault waves were in craft called Higgins boats, both LCVP (landing craft, vehicle, personnel) and LCM (landing craft, medium), which drew 4 ft or more when heavily loaded.

Colonel David Shoup, the assault commander, told war correspondent Robert Sherrod:

> What worries me more than anything is that our boats may not be able to get over that coral shelf that sticks out about five hundred yards. We may have to wade in. The first waves, of course, will get in all right on the "alligators" [amphibious tractors], but if the Higgins boats draw too much water to get in fairly close, we'll either have to wade in with machine guns maybe shooting at us, or the amphtracks will have to run a shuttle service between the beach and the end of the shelf. We have got to calculate high tide pretty closely for the Higgins boats to make it. (Sherrod 1944: 42)

The planners hoped for 5 ft of water over the coral reef, sufficient to float loaded LCVPs and LCMs over the reef. In selecting the date for the landing, the commanders considered it essential to allow about 3 h after dawn for a preliminary naval and air bombardment, to land the first assault troops on a flooding tide about 2 h before high water, to bring in supporting logistic supplies at a high water occurring in late morning and to allow the afternoon for securing the beachhead.

The date chosen, November 20, 1943, provided sunrise at 6:12 a.m. and a midday high tide level of 4.9 ft that would occur at 10:47 a.m., according to

tide tables from the U. S. Coast and Geodetic Survey. However, in 1943 the tide predictions for the Gilberts and for other Central Pacific Islands were suspected to be unreliable because they were extrapolated from reference points as distant as Sydney (Australia), Valparaiso (Chile) and Apia (Samoa).

The task force Operation Plan also included a Tarawa tide table prepared by the "Foreign Legion," a group of Australians, British, and New Zealanders who had sailed in the Gilberts or had lived there before the war (McKiernan 1962: 40; Alexander 1995: 76). The majority opinion of this group predicted a high water of 5.0 ft at 11:15 a.m. on D-Day for Tarawa.

The Tide That Failed

In rehearsals conducted at Efate Island in the New Hebrides in early November, the landing boats grounded only 75 ft out from the beach, and the troops easily sprinted to shore through knee-deep water. In the actual Tarawa assault, the first three waves in amphtracs reached the beach beginning at 9:10 a.m. on November 20, 1943. However, the water level stood at only about 3 ft over the reef when the landing craft approached at 9:20 a.m. Thereafter, in fact for the next 48 h, the tide level failed to rise as expected. The boats grounded at the edge of the reef, and the Marines were forced to wade in, with rifles over their heads, for 600 yards in the face of machine-gun fire.

Figure 7.6 depicts the memorable image of Tarawa: the long wade in from the edge of the reef to the shore.

The momentum of the assault was lost; the low water over the reef contributed directly and indirectly to the high number of casualties incurred during the Marines' eventual victory. Authors have described the tide at Tarawa as the "tide that failed," the "laggard tide," the "anomalous tide," or the "dodging tide."

The inadequate water over the reef (Fig. 7.7) was not a complete surprise to the military planners. One of the "Foreign Legion" group, a New Zealand reserve officer named Major Frank L. G. Holland, had strongly dissented from the majority opinion and warned that the Marines would not be able to get the landing craft across the reef. Author Patrick McKiernan relates how the Foreign Legion described "a phenomenon they called a dodging tide…they had experienced, in their judgment, tidal aberrations. The tide seemed to remain steady for hours on end instead of following the usual pattern" (McKiernan 1962: 41).

Fig. 7.6 Combat artist Tom Lovell created this striking image of the Tarawa assault as the landing craft grounded on the reef. The Marines, under heavy fire, took many casualties as they were forced to wade in through the water for 600 yards. Low water on the reef contributed to the high price of the Marines' eventual victory (Courtesy of the U. S. Marine Corps Museums Art Collection. Used with permission)

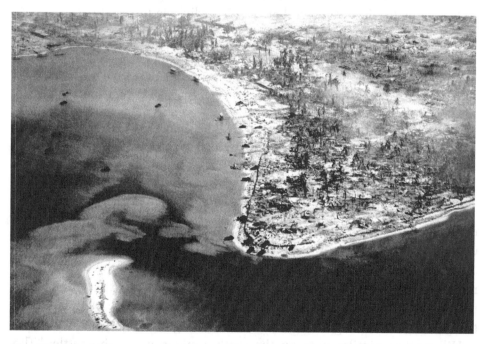

Fig. 7.7 The shallow water on the reef is apparent from the shading in this aerial photograph, taken from an observation plane during the Tarawa landing on November 20, 1943. The vehicles on the reef and also along the arc of Beach Red One are amphibious tractors ("amphtracs") disabled by enemy fire (Photograph courtesy of the U. S. Marines Corps Archives. Used with permission)

According to an analysis by Admiral George C. Dyer: "the shallow coral reef, aptly called a barrier reef, and spreading offshore like a long wide apron in all directions from Betio Island, was a major hazard....All were acquainted with the possibility of a 'dodging tide,' but the chances of it occurring on 20 November 1943 were judged slim. The risk was accepted along with dozens of other risks" (Dyer 1972: 724).

Naval historian Samuel Eliot Morison summarized the difficulty of the tide problem: "No accurate tide tables for the Gilberts existed. They were unpredictable. No one could foretell whether there would occur on 20 November a so-called 'dodging tide'....It was impossible to predict whether there would be a low or a high one or an ordinary neap tide, which would have been all right for at least six hours on the 20th..." (Morison 1951: 151).

Historian Ronald Spector likewise has concluded that this tide could not be forecast: "As for the 'dodging' tide, it was a rare and essentially unpredictable phenomenon. Yet in the case of the landing craft used at Tarawa, even a foot of difference in the tide could be important" (Spector 1985: 274).

According to Marine General H. M. ("Howlin' Mad") Smith:

> The reef was our undoing. It cost us many casualties...an unaccountably low tide...lowered the water on the reef so that only amtracks were able to get ashore. The Higgins boats stranded on the reef, half a mile from the beach... there were dozens of...anti-boat guns and machines guns in concrete emplacements and pillboxes. They were still operating, raining murderous fire on that half mile from reef to shore, where the men of the later waves jumped out of their boats and waded through the blood-stained surf into the swirling red hell that was Tarawa...the Japanese...were helped by the inexplicably low tide which held for two days. (Smith 1949: 122, 133)

A letter written in 1949 by Rear Admiral Harry W. Hill, overall commander of the attack force at Tarawa, emphasized that the cause of the unusual tide was unknown: "From the commencement of planning, the question of water over the reef at Betio was considered to be one of paramount importance...normally four feet of water could be expected over the reef at neap tide...occasionally, for no apparent reason, there was a failure in the normal functioning of the tides within the lagoon..." (Dyer 1972: 716).

Hill wrote a similar note on the tenth anniversary of the battle: "The unusual tidal conditions prevailing on the morning of the assault could not be forecast – it is the irony of fate that not until 48 hours after H-hour were the tides operating in accord with the tide tables prepared before the landing" (Sherrod 1954: 196).

Dyer's study of the Tarawa tides summarized the puzzle of the Tarawa tides: "[O]n 20 November 1943 the tides at Tarawa Atoll did not run true to form. Like other sudden variations in natural phenomena, 'Man proposes. God disposes.' The tide suddenly and dramatically failed...Tidal flow did not correspond to any pre-assault landing prediction" (Dyer 1972: 725).

Two historians writing about the amphibious war for the Princeton University Marine Corps History Project were forced to conclude: "The question of tides and the absence of sufficient water over the reef to float landing craft at Tarawa will probably never be resolved satisfactorily" (Isely and Crowl 1951: 210).

Perigean Spring Tides and Apogean Neap Tides

However, our Texas State group can now provide a qualitative explanation and a quantitative model for the Tarawa tide (Olson 1987). Astronomical reasons can help to explain why the tide failed to rise on November 20, 1943, and to understand what was unusual about that particular date and that particular tidal period.

Spring tides are tides of increased range occurring twice each month as the Sun and Moon align either at new Moon or full Moon, when the tide-raising forces of the Sun and Moon combine for a greater net effect. Mariners have known of this effect for thousands of years, and virtually every elementary astronomy book or nautical guide discusses spring tides. Perigean tides are tides of increased range occurring monthly as a result of the Moon being in perigee, the point at which the Moon is nearest Earth and exerts the greatest gravitational tide-raising forces on Earth's oceans. If the time of perigee falls near either a new Moon or full Moon, then perigean spring tides of extremely high range can occur. For a period of several days near such events, the high tides are unusually high, and the low tides are unusually low. This, of course, is not what happened at Tarawa.

Neap tides are tides of decreased range occurring twice each month as the result of the Moon being either at first quarter or last quarter, when the tide-raising forces of the Sun and Moon partially cancel each other out. Apogean tides are tides of decreased range occurring monthly as the result of the Moon being in apogee, the point at which the Moon is farthest from Earth and exerts the smallest gravitational tide-raising forces on Earth's oceans. If the time of apogee falls near either a first quarter or last quarter Moon, then apogean neap tides of greatly reduced range can occur. For a period of several days near such events, the water level fails to rise much above or fall much below the mean level. This is what happened at Tarawa.

Computer calculations determine two dates in 1943 when lunar apogee fell within 24 h of a quarter Moon:

April 12, 1943	First quarter Moon occurred 7 h before apogee
November 19, 1943	Last quarter Moon occurred 13 h after apogee

The days near these two dates were the only two periods in 1943 when apogean neap tides of unusually reduced range occurred. The celestial alignment on November 19th happened to occur just before the landing at Tarawa on the morning of D-Day, November 20, 1943.

Calculating the Tide at Tarawa

To determine quantitatively how the astronomical configuration affected the water level at the time of the Tarawa assault, our Texas State group used a method called harmonic analysis. Such a tide calculation uses a set of numbers called harmonic constants, a set of numbers that are different for every port on Earth and describe precisely how any given location responds to the motions of the Sun and Moon.

Immediately after the Marines had secured Tarawa, the Navy dispatched the hydrographic survey ship *Sumner* to the scene. On December 5th the crew of the *Sumner* erected a tide gauge and began a series of careful observations of the water level and tidal patterns in the Tarawa lagoon. Data taken between December 1943 and April 1944 allowed the harmonic constants for Tarawa to be determined.

Our harmonic analysis model for Tarawa gives a water level height of 3.1 ft at 9:20 a.m. on D-Day, the time when the landing craft began to ground on the edge of the reef. We calculate that the mid-day high water rose only to 3.8 ft at 12:31 p.m. – significantly lower in height and later in the day than the tide predictions available to the Marines before the assault. In fact, from 9 a.m. until 10 p.m. on D-Day, the calculated water level remains within 6 in. of the mean level, 3.3 ft. This is exactly what we would expect for an apogean neap tide of greatly reduced range.

To emphasize a rather subtle point, it was *not* the case that the low tides at Tarawa were unusually low. Rather, the important consequence of the reduced tide range is that the high tides would fail to rise very high, just as occurred at the Tarawa landing.

Another point worth stressing is that our calculations could not have been done by the U. S. Navy experts before November 1943, and that no blame for failing to do a harmonic analysis computation should be attached

Fig. 7.8 *Visitors to the National Museum of the Marine Corps in Triangle, Virginia, are greeted in the central gallery by this display, entitled "Across the Reef at Tarawa" and featuring an amphibious tractor ("amphtrac") like the craft used to reach the sea wall at Tarawa (Photograph by the author)*

to the Navy and Marine planners. The harmonic constants, the set of numbers that characterize the tides at Tarawa, were not available to the World War II planners and could not be measured in the lagoon prior to the invasion because the island was in Japanese hands.

Veterans of Tarawa

World War II war correspondent Robert Sherrod waded in to the invasion beach with the Marines in the fifth assault wave and authored the classic eyewitness account of the Tarawa landing (Sherrod 1944). Sherrod presented the results of our astronomical and tidal analysis to a reunion of Tarawa survivors and described the conclusions of our Texas State analysis as "a real discovery about an anomaly that cost the lives of a thousand Marines." The reaction by Sherrod and other historians confirms the Tarawa example as one of the most interesting and significant outcomes of applying astronomy to an historical event.

The continuing importance of Tarawa to the U. S. Marines becomes apparent to anyone who walks through the doors of the National Museum of the Marine Corps in Triangle, Virginia. Visitors enter the central gallery (Fig. 7.8) to be greeted by an LVT amphibious tractor breaching a defensive log wall in a full-size display that bears the title "Across the Reef at Tarawa."

D-Day 1944: The Moon and Tides at Normandy

Why was June 6, 1944, chosen as the D-Day date for the invasion of Normandy? Did the airborne regiments want the darkness of a new Moon, or did they want a bright full Moon in the sky as the paratroopers parachuted into France just after midnight? What was the lunar phase on D-Day? When did the Moon rise? How did the planners coordinate the lunar phase with the requirement for a low tide near sunrise so that the engineers could destroy the exposed beach obstacles before the main assault waves came in? How fast was the tide rising as the engineers planted their demolition charges on the obstacles that the Germans had placed to block the approach to Omaha Beach?

Invasion of Europe

In the early morning hours of June 6, 1944, airborne troops parachuted into Normandy, landing craft started the long runs in to the beaches and aerial and naval bombardment shook the German coastal strong points as the complex operation code-named "Overlord" began to unfold (Figs. 7.9 and Fig. 7.10). The 150 mm guns of the German battery at Longues-sur-Mer were located near the coast between Omaha Beach and Gold Beach.

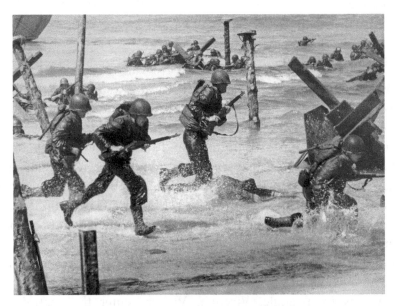

Fig. 7.9 *This publicity photograph from the 1962 film, The Longest Day, shows the early assault waves advancing on foot through mined beach obstacles, a mixture of stakes and hedgehogs*

Fig. 7.10 *The 150 mm guns of the German battery at Longues-sur-Mer were located near the coast between Omaha Beach and Gold Beach. Members of the Texas State group pictured here are Laura Bright, Don Olson, and Hannah Reynolds (Photograph by Russell Doescher. Used with permission)*

Why was June 6 chosen? Any invasion date in May or June would leave the entire summer for the planned Allied drive across France and towards the German homeland before bad weather in fall or winter could slow the advance. The invasion planners later made it clear that they selected the specific date for astronomical reasons involving moonlight, the time of sunrise, and the effects of the lunar phase of the tides. The configuration of Sun and Moon determines both the strength of the tides and the times of high and low waters. The Allies required a low tide near sunrise and, on this part of the Normandy coast, such a tide occurs only near the times of either a new Moon or full Moon.

Moon, Sun and Tides in 1944

General Dwight D. Eisenhower, Supreme Commander of the invasion forces, realized that preparations were not complete in May and postponed the assault until June. He explained why a low tide was important:

[T]he next combination of moon, tide, and time of sunrise that we considered practicable for the attack occurred on June 5, 6, and 7. We wanted to cross the Channel with our convoys at night....We wanted a moon for our airborne assaults. We needed approximately forty minutes of daylight preceding the

ground assault to complete our bombing and preparatory bombardment. We had to attack on a relatively low tide because of beach obstacles which had to be removed while uncovered. These principal factors dictated the general period; but the selection of the actual day would depend upon weather forecasts. (Eisenhower 1948: 239)

Admiral Chester W. Nimitz, in his account of the U. S. Navy during World War II, likewise recalled the importance of the lunar phase and the tide times as the planners:

...began to look for the combination of natural conditions most favorable for the landing. They desired a moonlit night preceding D-day so that the airborne divisions would be able to organize and reach their assigned objectives before sunrise....The crucial requirement, to which the others would have to be geared, was the tide. It must be rising at the time of the initial landings so that the landing craft could unload and retract without danger of stranding....Yet the tide had to be low enough that underwater obstacles could be exposed for demolition parties. The final choice was one hour after low tide for the initial landings...Eisenhower accordingly selected June 5 for D-day, with H-hours ranging from 0630 to 0755 to meet the varying tidal conditions at the five assault beaches. (Nimitz 1960: 166)

Prime Minister Winston Churchill stressed the astronomical and tidal factors in his memoirs:

It was agreed to approach the enemy coast by moonlight, because this would help both our ships and our airborne troops. A short period of daylight before H-Hour was also needed to give order to the deployment of the small craft and accuracy to the covering bombardment....Then there were the tides. If we landed at high tide, the underwater obstacles would obstruct the approach; if at low tide, the troops would have far to go across the exposed beaches....But this was not all. The tides varied by forty minutes between the eastern and western beaches, and there was a submerged reef in one of the British sectors. Each sector had to have a different "H-Hour," which varied from one place to another by as much as eighty-five minutes....Only on three days in each lunar month were all the desired conditions fulfilled. The first three-day period...was June 5, 6, and 7...If the weather were not propitious on any of those three days, the whole operation would have to be postponed at least a fortnight – indeed, a whole month if we waited for the moon. (Churchill 1951: 591)

The Allies initially intended to invade on June 5th, but bad weather forced a postponement of one day, to the morning of June 6, 1944.

Calculating the D-Day Moon and Sun

Computer calculations show that a full Moon fell on June 6th, so the bright moonlight occurred just as planned (Olson and Doescher 1994; 2012). The Moon rose into the sky 1½ h before sunset on June 5th. The nearly full Moon, more than 99 % illuminated, then moved across the sky during the night of June 5–6th and reached its highest point for that night at 1:22 a.m., just as the airborne assault began. The slanting moonlight was sufficient to illuminate the ground below for the troops of the 82nd and the 101st Airborne as they started dropping from the sky between 1:15 and 1:30 a.m., following pathfinders who had jumped about an hour earlier.

Brigadier General James Gavin of the 82nd Airborne provided an eyewitness account. As his C-47 aircraft approached a drop zone west of Sainte-Mère-Église (Fig. 7.11), Gavin could clearly see the ground below: "[T]he roads and the small clusters of houses in the Normandy villages stood out sharply in the moonlight" (Gavin 1947: 57).

The planners arranged the preparatory naval bombardment of the French coast to begin in the bright twilight just before sunrise, as shown in Table 7.2. The schedule set H-Hour for Omaha Beach at a time when the tide level was rising shortly after sunrise.

Importance of the D-Day Tides

General Omar Bradley, commander of the American ground forces, considered that the tidal conditions were even more important than the moonlight and the time of sunrise:

> [O]n the question of tides the army had to be insistent, for there we could not give in. Twice each day the Normandy beach was flooded by a mountainous Channel tide that rose approximately 19 feet from low to high water. At low tide the beach defenses lay exposed more than a quarter mile behind a moist sandy shelf. At high tide the Channel lapped almost to the sea wall behind Omaha Beach.
>
> The choice, therefore, would have been a simple one in favor of high tide had it not been for the underwater obstacles Rommel had planted on those Normandy beaches. For had we sailed in on a high tide, those obstructions would have pinioned our craft and torn open their bellies. The assault might then have foundered....Eventually by trial and error we learned that 30 minutes would be required to blow paths through a belt of underwater obstructions. The engineers could dynamite those obstacles in water up to two feet deep. And since the tide rose at the rate of a foot every 15 minutes, two feet would allow them 30 minutes.

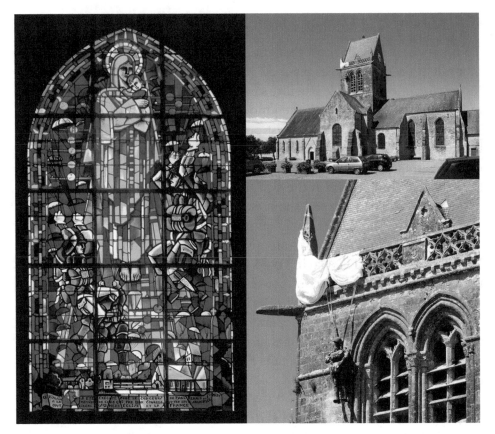

Fig. 7.11 *Sainte-Mère-Église became the first village liberated in France. Left: This remarkable stained glass window in the church at Sainte-Mère-Église depicts Allied airborne troops on either side of the Virgin Mary. The dedication at the bottom reads "To the memory of those who, by their courage and by their sacrifice, liberated Ste-Mère-Église and France." Upper right: The church as it looks today. Lower right: On D-Day, the parachute of Private John Steele snagged on the church. He was left suspended there for several hours and survived by pretending to be dead. Today a mannequin of John Steele hangs from the church steeple as a memorial to this famous incident, which became a scene in the 1962 film The Longest Day (Photographs by the author)*

Table 7.2 *Omaha Beach on June 6, 1944. The Allied forces on D-Day employed British Double Summer Time, 2 h ahead of Greenwich Mean Time*

5:17 a.m.	Beginning of civil twilight
5:23 a.m.	Low water exposes the beach obstacles on Omaha Beach
5:50 a.m.	Naval bombardment of Omaha Beach begins
5:59 a.m.	Sunrise
6:30 a.m.	H-Hour for the first assault wave on Omaha Beach
10:12 a.m.	High water covers the beach almost to the sea wall

With that, the answer fell into place. We would assault when a rising tide reached the obstacle line and give the engineers 30 minutes to clear it before the water became too deep. Successive assault waves would then ride the rising tide nearer the sea wall through gaps in the obstacle belt. (Bradley 1951: 260)

General Bernard Montgomery, commander of the British ground forces, agreed on the importance of clearing the beach obstacles: "There were a lot of obstacles on the beaches and we had to be able to tackle them dry, i.e., not under water....At least 30 minutes had to be available for this" (Montgomery 1958: 221).

The entire Overlord operation depended on the demolition teams, who would clear the way for the vast invasion forces on the following landing craft. Since the phase of the Moon determines the schedule of tide times, the clearance of the beach obstacles was a component of Overlord significantly affected by the astronomical factors.

Beach Obstacles

On the Normandy beaches, the invasion forces were confronted by several types of mined obstacles (Figs. 7.12, 7.13, and 7.14): "stakes," "ramps," "hedgehogs," "tetrahedrons," and "Belgian Gates." The stakes were simply posts, deeply buried in the sand and slanting to seaward with a mine for a cap. Ramps were composed of timbers sloping up towards the shore, with supports in the shape of an inverted "V," making an incline that would force an incoming landing craft to slide up the ramp and explode the mine at the tip. Hedgehogs were about 4 ft high and were made of three angle irons, joined and crossing in the middle in "X" shapes. Tetrahedrons looked like pyramids with four faces. According to demolition team member Lieutenant Carl Hagensen, the most difficult type of mined obstacle was the Belgian Gate:

[T]he Belgian Gate. This was a lattice-faced steel gate propped up on the landward side by 14-foot steel bracings. The grilled face was 10 feet high and 10 feet wide, the whole structure made of six-inch angle iron, one half inch in thickness, welded and bolted together and having a gross weight of about three tons. These monsters could be rolled onto the beach at low tide and were strong enough to withstand any surf. (Fane 1956: 42)

To deal with the Belgian Gates, Hagensen devised a method employing canvas packs with the newly developed plastic explosive called C-2. Sixteen of these packs, tied at various points and exploded simultaneously using primacord fuses, were required to demolish each gate.

After the beach obstacles, Allied troops would find a few yards of dry sand above the high-water mark, a bank of rounded, water-worn rocks called

Fig. 7.12 *Left: This German plan of beach obstacles shows barbed wire connecting stakes, ramps, hedgehogs, Belgian Gates, and tetrahedrons, as the beach would appear near low tide. Upper right: This Belgian Gate beach obstacle is preserved at the Omaha Beach Memorial Museum in Saint-Laurent-sur-Mer (© John Hamill. Used by permission.) Lower right: The author poses with a tetrahedron beach obstacle in the collection of the Battle of Normandy Memorial Museum in Bayeux (Photograph by Marilynn Olson. Used with permission)*

shingle, and a seawall topped by concertina barbed-wire. Above the beach, a level grassy area extended to the steep bluffs where the German defenders had built their strong points.

Demolition Teams on Omaha Beach

The initial assault troops were scheduled to land at 6:30 a.m. and proceed to the seawall and the bluffs. The demolition crews would follow within 2 or 3 min. Chief Bill Freeman directed the efficient work of a combined team, including Army engineers and Navy demolition men, near the west end of Omaha Beach:

> As Freeman's landing craft scrunched onto the sloping, sandy bottom and the ramp dropped, the chief checked his watch – 0633....

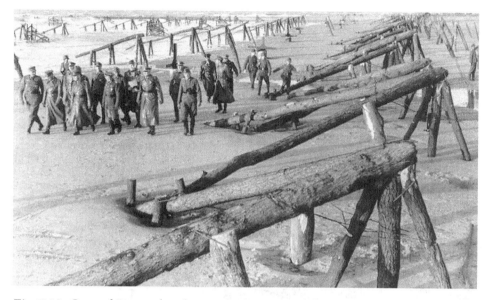

Fig. 7.13 *General Rommel and a group of German officers inspect beach obstacles on the coast of France before D-Day. Pictured are ramps, along with a few stakes at the upper right and "Belgian Gates" at the upper left*

The men, loaded with 40-pound packs and combat gear, leaped into the waist-deep water and splashed toward the line of 10-foot steel gates on the sand ahead. Sniper fire increased after the ramp dropped, and the men wasted no time getting to the dubious shelter of the mined steel-latticed wall on the dry sand.

....

[E]ngineers took some of the team's Hagensen packs to work on the seaward line of gates. Freeman and his Navy crew filtered through the gates into the gunfire to work on the next rows, mixed ramps and posts. They were the first men on their beach.

....

[A]head of the advancing surf, Gunner's Mate Bob Bass raced from obstacle to obstacle unreeling the heavy drum of primacord, tying the main fuse to each of those on the obstacles…he looked to Freeman for the signal to fire… The signal was given at last -- twenty minutes after the team had landed – and Bass pulled the fuse. The purple warning signal smoked skyward.

"Hit the deck!" Freeman yelled.

A heavy roar drowned out the battle's din for the prone men. The whole gap area spouted water, smoke, wood, sand, and steel high into the air…The gap was blown clean. (Fane 1956: 53–57)

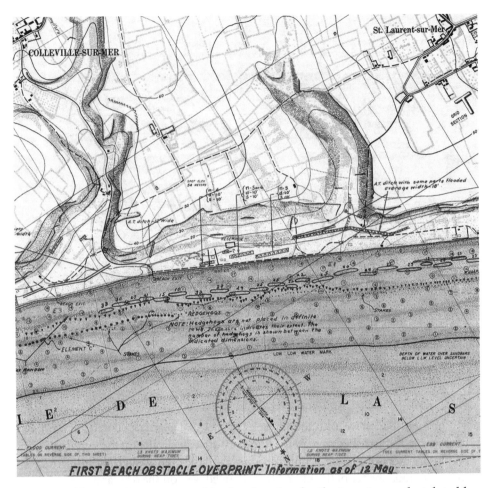

Fig. 7.14 *This wartime map, used in the planning for the invasion and updated less than a month before D-Day, shows the eastern section of Omaha Beach with the field of beach obstacles marked in red. Today the Normandy American Cemetery and Memorial, on the cliff in the center of this map between Colleville-sur-Mer and St. Laurent-sur-Mer, receives approximately one million visitors each year*

So ran the report of a successful gap clearance. Not many teams were so lucky. Of the sixteen channels to be blown, only five were cleared along the entire front of Omaha Beach that morning.

Another successful effort occurred in the "Easy Green" sector on Omaha Beach, where the demolition crew arrived to find that infantrymen were pinned down among the obstacles and were using them as shields from the heavy fire coming from the shore. The demolition teams placed their

explosives and then: "went among the troops, pulling fuse igniters one at a time and yelling at the men to move out or be blown up in two minutes. They moved....A gap varying from fifty to a hundred yards was blown clear, and traffic moved through" (Fane 1956: 58–59).

But the advancing tide soon drove the infantry and the demolition men towards the seawall. Heavy casualties had occurred during this operation, and the teams in the "Easy Green" sector concluded that "easy" was the wrong name for anything around Omaha (Fane 1956: 59).

In fact, most of the other crews suffered delays from currents, faulty navigation, mechanical problems, and the intense gunfire. After 7:00 a.m. the tide was rising so quickly that the delayed demolition crews had to abandon their attempts at blowing up the obstacles and were forced to wade ashore to wait for the afternoon low water.

The novelist Ernest Hemingway, acting as a war correspondent for *Collier's* magazine, encountered the beach obstacles that remained. He remembered the promise that he heard during the invasion planning: "'The Army is going to clear the obstacles and the mines out in the first thirty minutes,' Captain Leahy had told me. 'They're going to cut lanes in through them for the landing craft'" (Hemingway 1944: 13).

However, the reality was different as Hemingway's boat approached Omaha Beach:

> It was difficult to make our way through the stakes that had been sunk as obstructions, because there were contact mines fastened to them, that looked like large double pie plates fastened face to face. They looked as though they had been spiked to the pilings and then assembled. They were the ugly, neutral gray-yellow color that almost everything is in war...the ones that we could see we fended off by hand...The famous thirty-minute clearing of the channels was still a myth, and now, with the high tide, it was a tough trip in with the stakes submerged. (Hemingway 1944: 57)

D-Day Tide Calculation

To understand the Normandy D-Day tides, our Texas State group wrote a computer program to calculate the tide levels for Port-en-Bessin, a small fishing village just east of Omaha Beach (Table 7.3).

The calculated morning tide range was about 18 ft. Perhaps the most interesting feature of the Normandy tide curve is the asymmetry, with a very rapid rise from low water to high water in about 5 h, followed by a slow fall in the water level over the next seven and a half hours.

Table 7.3 *Tides on June 6, 1944, at Port-en-Bessin, near the east end of Omaha Beach. The times are given in British Double Summer Time, 2 h ahead of Greenwich Mean Time*

5:23 a.m.	Low water
10:12 a.m.	High water
5:42 p.m.	Low water

This rapid rise had a significant effect. H-Hour was 6:30 a.m., and in the next 30 min the water level rose 2.4 ft as the demolition teams who had been able to land were struggling to place explosives while the obstacles were still exposed. By 7 a.m. the water level was rising at the remarkable rate of 1 ft every 10 min, and this rapid tide rise accelerated even further after 7 a.m. Even a small delay had serious consequences. The tide calculations help to explain why the demolition crews were able to clear only five of the planned sixteen gaps in the obstacles on Omaha Beach before the advancing tide forced them to wade ashore.

Tidal and astronomical considerations, including bright moonlight for the airborne assault, meant that the date of the Normandy invasion had to fall near a full Moon. However, the gravitational effects of the full Moon were then responsible for the rapidly rising tide that posed such a problem for any demolition teams delayed even by a few minutes. The remaining fields of mined beach obstacles contributed to the loss of momentum of the following assault waves and helped to earn Omaha Beach its nickname – "Bloody Omaha."

USS *Indianapolis* 1945: Silhouetted in the Moonlight

Shortly after delivering the Hiroshima atomic bomb to the American B-29 air base on the island of Tinian, the heavy cruiser USS *Indianapolis* was torpedoed and sunk near midnight on July 29–30, 1945. The survivors in life jackets spent several days floating in the shark-infested waters of the Philippine Sea. Their ordeal inspired many books and a famous speech in the film *Jaws*. How did the Japanese submarine spot the American cruiser? What was the lunar phase that night? When did the Moon rise? How did the direction of the moonlight play a significant role in the sinking of the *Indianapolis*?

Sinking of the USS *Indianapolis*

Water was still cascading down the sides of the surfacing Japanese submarine I-58 as the navigator scrambled through the hatch and out onto the bridge to scan the night with his binoculars. Almost immediately he spotted a dark shape on the horizon under the Moon and called out "Bearing red nine zero degrees, a possible enemy ship!" Within three-quarters of an hour an American heavy cruiser was plunging toward the bottom of the ocean. Many ships were lost on both sides during World War II in the Pacific Ocean, but the sinking of the USS *Indianapolis* stands out over all others for reasons that can be expressed in two words: Hiroshima and *Jaws*.

When the uranium-235 produced for the atomic bomb by the Manhattan Project was ready for shipment to the forward theater of war, the Navy selected the *Indianapolis* to make a high-speed run departing from Hunters Point in San Francisco on July 16, 1945, pausing at Pearl Harbor in Hawaii on July 19th for refueling, and then continuing to Tinian in the Marianas Islands on July 26th. The *Indianapolis* carried the uranium and the firing mechanism for the weapon dropped at Hiroshima by the B-29 *Enola Gay* aircraft on August 6th.

After delivering the cargo at Tinian (Fig. 7.15), Captain Charles McVay took the *Indianapolis* to Guam for refueling and there received orders to proceed to Leyte in the Philippines. The cruiser was about halfway across the Philippine Sea when, near midnight on the night of July 29–30, two torpedoes from the I-58 exploded on the starboard side of the ship (Fig. 7.16). Of the 1,197 men on the sailing list, about 300 died in the explosions or went down with the ship, leaving almost 900 cast into the shark-infested waters.

For more than 4 days, no shore bases realized that the *Indianapolis* had been sunk. When the pilot of a Lockheed Ventura happened to spot the crew by chance on August 2nd, nearby naval vessels responded to the alert, picked up the exhausted sailors, and took them to hospitals. The Navy was horrified to learn that only 317 survivors remained (Stanton 2001: 8).

Many people become aware of this disaster through a memorable scene in Steven Spielberg's 1975 film *Jaws*. While swapping stories with icthyologist Matt Hooper (played by Richard Dreyfuss) about previous encounters with sharks, Quint (played by Robert Shaw) tells harrowing details of the ordeal suffered by him and his shipmates from the ill-fated *Indianapolis*.

Fig. 7.15 Top: *The heavy cruiser USS Indianapolis off Mare Island, California, on July 10, 1945, only 6 days before departing from San Francisco on its high-speed run across the Pacific with the Hiroshima atomic bomb. Many authors have mistakenly identified this top image as the last photograph of the cruiser. Bottom: Taken at Tinian shortly after the delivery of the atomic bomb on July 26, 1945, this bottom image is probably the last photograph taken of the USS Indianapolis (Photographs courtesy of Naval Historical Center. Used with permission)*

The Question of Moonlight

Considering the magnitude of the tragedy, previous authors have understandably focused on human stories. Many books and articles mention the moonlight, but with details often frustratingly unclear, incomplete, or even contradictory. For example, Dan Kurzman describes two officers standing on the bridge of the *Indianapolis* at 7:30 p.m., studying the heavy cloud cover, and occasionally seeing a "half-moon shine through in bright flashes" (Kurzman 1990: 55). But a pioneering study by Richard Newcomb twice states that the Moon that night did not rise until 10:30 p.m (Newcomb 1958: 59, 63).

Fig. 7.16 On July 30, 1945, at about 12:03 a.m. (ship's time), two terrific explosions sent towering columns of water and red flame skyward on the starboard side of the USS Indianapolis, as depicted by maritime artist Richard DeRosset. The Japanese submarine I-58 fired a spread of six torpedoes from a range of about 1,500 m and scored the two hits shown here (Illustration by Richard DeRosset. Used with permission)

To add to the confusion, Newcomb then contradicts his own earlier passage and informs the reader that "at 10:30 P.M. on July 29, in the position of the *Indianapolis*, the moon would have been in the east, about 23° above the horizon" (Newcomb 1958: 198). A book by Raymond Lech places a "full moon" on August 1, 1945. This statement, if true, would imply that a bright waxing gibbous Moon, more than 90 % illuminated, filled the sky with moonlight on the night of the sinking (Lech 1982: 85). Yet other authors describe and even include illustrations with a slender waning crescent Moon in the sky above the cruiser (Dykman 1995: 30). The summary by a magazine author that there was "some moonlight" but that the "brightness of the night is disputed" may even be an understatement of the conflicting descriptions of the moonlight (Teller 1958: 40).

Faced with all these different versions, our Texas State group wondered what were the actual astronomical conditions on July 29, 1945. What was the lunar phase? When did the Moon rise? Did the moonlight play a significant role in the sinking of the *Indianapolis*?

I-58

The commander of the I-58, Mochitsura Hashimoto, wrote a book about his wartime service, and his recollections establish the importance of the moonlight. Regarding the sky on the evening of July 29, 1945, he recalled that: "toward nightfall the visibility deteriorated…it was almost nil. We decided to wait for the visibility to improve and dived to await moonrise" (Hashimoto 1954: 218).

Hashimoto brought the I-58 (Fig. 7.17) to the surface at 11:05 p.m.:

> I ordered the night periscope to be raised just clear of the surface and quickly took a look round. The visibility was much better and one could almost see the horizon. The moon was already high in the eastern sky and there were few clouds in its vicinity.…I gave the order, "Surface," and, "Blow main ballast."…As soon as the upper deck was awash, the order was given to open the conning-tower hatch and the yeoman of signals who was standing by opened up and climbed onto the bridge. He was followed by the navigator. I myself was watching through the night periscope.…At that moment the navigator shouted, "Bearing red nine-zero degrees, a possible enemy ship." I lowered the periscope, made for the bridge, and turned my binoculars in the direction indicated by the navigator. Without doubt there was a black spot which was clearly visible on the horizon on the rays of the moon. I ordered, "Dive." (Hashimoto 1954: 219–220)

Because the submarine was cruising south, the relative bearing "red" 90°, measured from the submarine's bow towards the left or port side, places the *Indianapolis* to the east of I-58.

Hashimoto provided additional details in his testimony, recorded in the third person by a translator at the December 1945 court martial of Captain McVay. Hashimoto was asked why he surfaced at "2305," that is, at 11:05 p.m.:

> Q. *If anything happened at or about 2305…on the evening in question…tell the court what it was.…*
>
> A. *On the supposition that at that time the visibility would have improved and the moon would be out, he brought his submarine to the surface. Thereupon, under the moon, he discerned a dark object and crash-dived immediately, and then swung his ship around to head in its direction.*

Fig. 7.17 *Top: The I-58 was a type B-3 submarine, with an overall length of 108.9 m (357 ft). Bottom: A lookout on the bridge of the I-58 would have his binoculars about 25 ft (7.6 m) above the waterline, high enough to spot a cruiser at a distance exceeding 10 statute miles (16 km). This photograph dates from April 1, 1946, shortly before the I-58 was sunk by demolition charges into the waters off Sasebo, Japan (Photographs courtesy of the Naval Historical Center. Used with permission)*

> Q. At the time he saw this dark object, did he make any estimate of the range of that dark object?
>
> A. At that time he estimated the range as being in the vicinity of ten thousand meters.
>
> Q. And what – from his knowledge now – was the position of his ship relative to the dark object at that time?
>
> A. His position was established still, roughly, at ten thousand meters…with the target bearing ninety degrees true…

This reference to "target bearing ninety degrees true" confirms that the cruiser was directly east of the submarine. Hashimoto had spotted the dark outline of the *Indianapolis* "under the moon," that is, in the direction of

moonlight reflecting from the water and producing a column of sparkling light called the glitter path.

> Q. *Then what did you do after sighting this dark object?*
> A. *He submerged and headed towards the object and prepared to fire torpedoes...*
> Q. *And what speed, average speed, over this period was he making?*
> A. *An average speed of about three knots...*
> Q. *Then what did you do?*
> A. *...when the target had approached within a distance of...1500 meters, he fired his torpedoes...*
> Q. *How long after sighting this target did you fire this salvo?*
> A. *About twenty-seven minutes.*

Hashimoto was asked in a pre-trial interview how he was able to keep the *Indianapolis* in view. The submarine commander recalled the excellent visibility in the glitter path below the Moon:

> Q. *During this twenty-seven minutes, what was the visibility?*
> A. *In the path of the moon I could see as far as the horizon. In areas other than that it was poorer; I could hardly discern the horizon.*

Hashimoto fired a fan-shaped spread of six torpedoes and, about 1 min later, towering columns of water and red flame erupted on the starboard side of the *Indianapolis*.

Calculating the Moon's Position

Our Texas State group wanted to calculate the Moon's position, and therefore the direction of the glitter path in the water, at the 11:05 p.m., the time when the lookouts on the I-58 first spotted the *Indianapolis*. Planetarium computer software is now widely available and easy to use for such calculations, but these programs require certain input: the position of the observer expressed as longitude and latitude, the date, the time, and the time zone.

Regarding the position, several expeditions have attempted to locate the wreck of the *Indianapolis* on the ocean floor, but so far without success. For now, the best estimate is an approximate position determined in 1945 by the Navy by starting from the locations where the survivors were found and working backwards in time, allowing for more than 4 days of drift in the prevailing winds and currents. By this method, the sinking must have occurred near longitude 134° 48' east, and latitude 12° 2' north.

For events of World War II in the Pacific, determining the correct date, time, and time zone can be surprisingly tricky, in part because the International Date Line passes through the heart of the Pacific. For example, virtually every American knows the December 7, 1941, date of the Pearl Harbor attack, but, as explained earlier in this chapter, the Japanese history books give the date as December 8th!

In the case of the *Indianapolis*, the vast majority of the books and articles we have consulted describe the high-speed bomb delivery as a 10-day run, allowing 3 days from San Francisco to Pearl Harbor and then counting 7 days from Hawaii to Tinian. But these authors have ignored the International Date Line. By our reconstruction, the time at sea between the departure from Pearl Harbor and the arrival at Tinian occupied about 140 h, or 5.8 days, when correct allowance is made for the International Date Line.

To ensure that our Texas State group would get accurate results for the lunar conditions on the night of the *Indianapolis* sinking, we carefully sorted out the time zones, the clock times, and the calendar date systems used onboard the cruiser and also the I-58. We consulted "tide and light" charts from western Pacific ports in 1945, radio messages and routing instructions for the unfinished Guam to Leyte run of the *Indianapolis*, official Japanese Navy records for the last combat patrol of the I-58, transcripts from several interrogations of the submarine commander conducted shortly after the war's end by U. S. Navy officers as part of the inquiry into the sinking and transcripts of the U. S. Navy official inquiry.

The abundant evidence from primary sources allows us to conclude that the I-58 first sighted the USS *Indianapolis* on July 29, 1945. The time of the sighting was 11:05 p.m. according to the submarine's clocks set to Zone "I," 9 h ahead of Greenwich Mean Time. (Zone "I" is so named because "I" is the 9th letter in the alphabet.) The U. S. Navy time of the sighting was 11:35 p.m, according to the cruiser's clocks, which were set to Zone "I*," 9½ h ahead of Greenwich. The half-hour difference between the submarine's clocks and the ship's clocks is essential to comparing the timelines of events in the Japanese and American narratives. The half-hour difference also has an interesting consequence – the torpedoes can be considered to have struck home either late on July 29th (11:33 p.m. submarine's time) or early on July 30th (12:03 a.m. ship's time). That the events occurred near midnight required an especially careful check of the primary sources to be sure of the correct times and dates. After this analysis of calendars and times, our astronomical calculations then produced two interesting conclusions regarding the correct lunar phase and the direction of the moonlight.

Fig. 7.18 *This photograph shows a waning gibbous Moon, three-quarters lit, the same lunar phase as the Moon that rose into the sky shortly before the torpedo attack on the USS Indianapolis (Photograph by Russell Doescher. Used with permission)*

Cruiser Silhouetted by the Moonlight

The results of our Texas State group (Olson et al. 2002: 36) show that the I-58 lookouts first sighted the cruiser under a bright waning gibbous Moon, which stood 15° above the eastern horizon at a compass direction of only 6° south of due east. Our value for the Moon's illuminated fraction, 75 %, may come as a surprise to some. Previous authors mention almost every possible lunar phase, with probably the greatest number of authors employing the colloquial term "half moon." Our computer calculations show that the face of the Moon (Fig. 7.18) was actually three-quarters lit.

The brightness of the Moon was significant, but even more important was the direction of the Moon. The cruiser was approaching the submarine from the east, the same direction where the bright Moon was rising into the sky. The three objects – the submarine, the cruiser to the east, and the rising Moon near the eastern horizon – were almost perfectly aligned. If the ship had been passing to the north or south when the I-58 surfaced, the tragic event for the U. S. Navy would not have unfolded. As it actually happened that night, in the binoculars of the I-58's lookouts the *Indianapolis* was easy to spot as a dark silhouette against the moonlit part of the eastern sky, just above the glittering path of moonlight reflecting from the water.

USS *Indianapolis* Distance

Our Texas State group wondered whether it would be possible to calculate the distance from the submarine to the ship at the time of the sighting.

Based on the Hashimoto 1945 testimony, virtually all previous authors give the same figure: 10,000 m (equivalent to 10 km, 5.4 nautical miles or 6.2 statute miles). But the submarine commander's 1954 book makes it clear that this was just a very rough round number estimate made at a time when the ship was just a "black spot" on the horizon (Hashimoto 1954: 220). Hashimoto admitted that for some time after the initial sighting he could not estimate the range accurately, since he did know whether he was watching a cruiser, a battleship or some other class of ship.

It might seem impossible to determine a more accurate value for the distance between the two vessels at the moment of the first sighting. But in fact this calculation is relatively easy, because the relevant speeds and times are known.

Documents from the Navy inquiry place the *Indianapolis*, just before the explosions, on a "steady course of 262° true, speed 17 knots." The Japanese records establish that the I-58 crept forward at three knots as Hashimoto watched the *Indianapolis* in the night periscope for 27 min before firing the torpedo salvo that found its mark 1 min later. The range calculation then requires only the simplest of all equations: distance = rate x time. During the 28-min interval, the *Indianapolis* traveled 14.7 km on its course, progressing westward by 14.5 km. The I-58 traveled along an "S"-curve path and then fired its torpedoes, for a net eastward advance of about 2.0 km. The range between the vessels at sighting must have been near 16,500 m (equivalent to 16.5 km, 8.9 nautical miles or 10.3 statute miles). That the sighting could occur at this remarkably great distance is a consequence of the near-perfect alignment of the *Indianapolis* and the rising Moon, as seen from the I-58.

USS *Indianapolis* Visibility

Was the night of July 29–30, 1945, bright or dark? Was the visibility good or bad? The answers from witnesses vary considerably depending on where they were standing, what time they were there, and which way they were looking. Lieutenant Richard Redmayne, in his testimony at the McVay court martial, described the period from 11 p.m. to midnight as "intermittent moonlight with the visibility good when the clouds weren't in front of the moon, and the visibility poor when the clouds were in front of the moon." The sky and ocean were darkest to the west, ahead of the ship, and brightest almost directly behind the ship, where the Moon was rising up into the eastern sky. The I-58 happened to be perfectly positioned to view the dark ship silhouetted against a brighter moonlit sky above the glittering path of moonlight reflecting from the ocean.

Compared to previous studies that mention a variety of lunar phases, most often a "half moon," and that give the separation of the two vessels as 10,000 m at the initial contact, both our astronomical and topographical calculations give significantly different results. We find that the Moon was actually 75 % lit and that the moonlight was bright enough at 65 min after moonrise to allow lookouts on the I-58 to spot the back-lighted *Indianapolis* at the remarkable distance of 16,500 m.

Those near a body of water can watch a bright Moon rise over the water and thereby may gain a better appreciation for the experience of Seaman Second Class Clarke Seabert, who emerged from a dark-adaptation room of the *Indianapolis* and then, shortly before the torpedoes struck home, took his position in a lookout chair on the starboard wing of the navigation bridge. At the McVay court martial, Seabert recalled the glitter path of moonlight: "Well, the only thing I can remember right now is the glow of the moon on the water, because I remember saying to Sinclair, who had the watch with me, that it was a pretty nice night out."

Seabert was not the only one watching the reflections of the moonlight. The USS *Indianapolis* was doomed from the moment the Moon came out from behind the clouds, the lookouts on the I-58 used their binoculars to scan the glitter path stretching out to the eastern horizon and the navigator called out: "Bearing red nine zero degrees, a possible enemy ship!"

References

Agawa, Hiroyuki (1979) *The Reluctant Admiral: Yamamoto and the Imperial Navy*. Tokyo: Kodansha International Ltd.

Alexander, Joseph H. (1995) *Utmost Savagery: The Three Days of Tarawa*. Annapolis, Maryland: Naval Institute Press.

Bradley, Omar N. (1951) *A Soldier's Story*. New York: Henry Holt and Company.

Churchill, Winston S. (1951) *Closing the Ring*. Boston: Houghton Mifflin.

Dyer, George C. (1972) *The Amphibians Came to Conquer: The Story of Admiral Richmond Kelly Turner, Volume 2*. Washington, DC: U. S. Government Printing Office.

Dykman, J. T. (1995) Secret Mission and Disaster of U.S.S. *Indianapolis. World War II* **10**(2), July, 30–36.

Eisenhower, Dwight D. (1948) *Crusade in Europe*. Garden City, New York: Doubleday.

Fane, Francis D., and Don Moore (1956) *The Naked Warriors*. New York: Appleton-Century-Crofts.

Fuchida, Mitsuo, Roger Pineau, ed. (1952) I Led the Air Attack on Pearl Harbor. *United States Naval Institute Proceedings* **78**(9), September, 939–952.

Gavin, James M. (1947) *Airborne Warfare*. Washington, DC: Infantry Journal Press.

Hashimoto, Mochitsura (1954) *Sunk*. New York: Henry Holt and Company.

Hemingway, Ernest M. (1944) Voyage to Victory. *Collier's* **114**(4), July 22, 1944, 11–13, 56–57.

Isely, Jeter A., and Philip A. Crowl (1951) *The U. S. Marines and Amphibious War: Its Theory, and Its Practice in the Pacific*. Princeton: Princeton University Press.

Kurzman, Dan (1990) *Fatal Voyage*. New York: Atheneum.

Lech, Raymond B. (1982) *All the Drowned Sailors*. New York: Stein and Day.

Lott, Arnold S. (1983) *USS Ward Fires First Shot WWII*. Saint Paul, Minnesota: Leeward Publications.

McKiernan, Patrick L. (1962) Tarawa: The Tide That Failed, *United States Naval Institute Proceedings* **88**(2), February, 38–49.

Montgomery, B. L. (1958) *Memoirs*. London: Collins.

Morison, Samuel E. (1951) *Aleutians, Gilberts and Marshalls*. Boston: Little, Brown and Company.

Newcomb, Richard F. (1958) *Abandon Ship!* New York: Henry Holt and Company.

Nimitz, Chester W. (1960) *The Great Sea War*. Englewood Cliffs, NJ: Prentice-Hall.

Olson, Donald W. (1987) The Tide at Tarawa. *Sky & Telescope* **74**(5), November, 526–528.

Olson, Donald W. (1991) Pearl Harbor and the Waning Moon. *Sky & Telescope* **82**(6), December, 651–655.

Olson, Donald W., and Russell L. Doescher (1994) D-Day: June 6, 1944. *Sky & Telescope* **87**(6), June, 84–88.

Olson, Donald W., Brandon R. Johns, and Russell L. Doescher (2002) "Ill Met by Moonlight," The Sinking of the USS *Indianapolis*. *Sky & Telescope* **104**(1), July, 30–36.

Olson, Donald W., and Russell L. Doescher (2012) Tides, moonlight, machines, and D-Day. *Physics Today* **65**(1), January, 8.

Prange, Gordon W. (1981) *At Dawn We Slept*. New York: McGraw-Hill.

Sherrod, Robert L. (1944) *Tarawa: The Story of a Battle*. New York: Duell, Sloan and Pearce.

Sherrod, Robert L. (1954) *Tarawa: The Story of a Battle, Tenth Anniversary Edition*. New York: Duell, Sloan and Pearce.

Smith, Holland M. (1949) *Coral and Brass*. New York: Charles Scribner's Sons.

Spector, Ronald H. (1985) *Eagle Against the Sun: The American War with Japan*. New York: Free Press.

Stanton, Doug (2001) *In Harm's Way: The Sinking of the USS Indianapolis and the Extraordinary Story of Its* Survivors. New York: Henry Holt and Company.

Teller, Walter M. (1958) Disaster at Sea. *Saturday Review* **41**, September 20, 1958, 40.

Part III

Astronomy in Literature

8

Literary Skies Before 1800

From ancient times until the present day, authors have created poetry, stories, plays, and novels that contain passages about the Sun, Moon, stars, planets, and other celestial displays. In the four examples discussed in this chapter, we investigate whether an actual celestial event inspired the literary passage.

The skies above Persia in the time of Omar Khayyam (A.D. 1048–1131) provide the first example. The phenomenon known by the phrase "false dawn" or "false morning" refers to a faint glow visible in the eastern sky under ideal conditions and appearing shortly before the more familiar morning twilight. What causes the "false dawn"? Did the astronomer-poet-mathematician Omar Khayyam observe this elusive sky glow and employ the phrase "false dawn" in his famous book of poems, *The Rubaiyat*?

Geoffrey Chaucer (ca. 1340–1400) was a skilled amateur astronomer, sufficiently expert in fourteenth-century science that he wrote *A Treatise on the Astrolabe*. Chaucer's astronomical passages in *The Canterbury Tales* may be the most complex, sophisticated, and interesting celestial references in all of English literature. In the tale told by the Franklin, the central plot device of the story involves a lengthy description of an astronomical calculation of the Moon's position. The lunar configuration causes a high tide that covers all the rocks on the coast of Brittany. How often do the Sun, Moon, and Earth align in configurations that produce extreme tide-raising forces? Can we identify such an event in Chaucer's lifetime?

William Shakespeare (1564–1616) describes a bright star that "burns" in the sky in the opening scene of *Hamlet*. How can we use the play's clues to season of the year, direction of view, and time of night to suggest an identification for this brilliant celestial body? What are the possible links between Shakespeare, the play *Hamlet* set in Denmark, and the Danish astronomer

D.W. Olson, *Celestial Sleuth: Using Astronomy to Solve Mysteries in Art,*
History and Literature, Springer Praxis Books, DOI 10.1007/978-1-4614-8403-5_8,
© Springer Science+Business Media New York 2014

Tycho Brahe? Is this celestial object in *Hamlet* a star, a planet, or something else more unusual and spectacular?

The famous poem "The Tyger" by William Blake (1757–1827) begins with the memorable lines "Tyger Tyger, burning bright, In the forests of the night." Some previous scholars have suggested that other lines in this poem may involve allusions to meteor showers. Our Texas State group has searched the scientific literature from the late eighteenth century, and we can support these general suggestions with specific evidence. What are the dates of meteor events from the late eighteenth century that might have inspired Blake's lines in which "the stars threw down their spears, And water'd heaven with their tears"? For which meteor shower were the falling stars known in Blake's time as the "fiery tears of St. Lawrence"? What meteor showers and spectacular bright fireballs might Blake have witnessed?

The Rubaiyat of Omar Khayyam and the "False Dawn"

The phenomenon called the "false dawn," known scientifically as the zodiacal light, refers to a faint glow visible in the eastern sky under ideal conditions and appearing shortly before the more familiar morning brightening. The name "false dawn" is appropriate because observers often confuse the appearance of the zodiacal light with the initial stages of the true dawn. Did the astronomer-poet-mathematician Omar Khayyam employ this term to describe the zodiacal light in his famous book of poems, *The Rubaiyat*? What is the origin of such lines as "Dawn's Left Hand was in the Sky" and "the phantom of False morning"?

False Dawn and Omar Khayyam?

The source of the zodiacal light (Fig. 8.1) is sunlight illuminating dust between the planets in the plane of the Solar System. The scientific name was chosen because the light appears most prominently in the constellations of the zodiac that lie along this plane.

Discussing the zodiacal light in 1905, William T. Lynn stated that perhaps "the earliest reference to this interesting phenomenon is that contained in the poem of Omar Khayyam" (Lynn 1905b: 356). A more recent author likewise mentions *The Rubaiyat* (Figs. 8.2 and 8.3) in connection with the "false dawn": "Over the centuries countless individuals have been fooled into thinking the Zodiacal Light was the first vestige of morning twilight.

Fig. 8.1 *This panoramic photograph taken in Namibia captures the zodiacal light as the pyramid-shaped glow on the right. The arc of light curving to the upper left is the southern Milky Way, and the faint nebula at the lower left is the nearby galaxy called the Large Magellanic Cloud (Photograph by Rudolf Dobesberger. Used with permission)*

Fig. 8.2 *Edmund Joseph Sullivan created this illustration of a scene from The Rubaiyat of Omar Khayyam for a 1913 edition*

Fig. 8.3 *Edmund Dulac created these illustrations of night and sunrise for a 1909 edition of The Rubaiyat of Omar Khayyam*

In fact, the Persian astronomer, mathematician and poet Omar Khayyam, who lived around the turn of the 12th Century, made reference to it as a 'false dawn' in his one long poem, *The Rubaiyat*" (Rao 2002).

A modern observing guide also refers to Omar Khayyam when pointing out how sky watchers can mistake the zodiacal light for a faint morning twilight glow: "That same confusion, incidentally, led the twelfth-century Persian astronomer Omar Khayyam to refer to it as a 'false dawn' when he saw it in the morning sky" (Harrington 2010: 77).

Many other authors down to the present day have made similar statements about zodiacal light, "false dawn," and Omar Khayyam (Moreux 1928: 418; Marshall 1971: 158; Roosen 1974: 231; Schaaf 1983: 82; Ottewell 1988: 21; Horkheimer 1998; Battersby 2010: 40; and Byrd 2012).

This issue involves two independent aspects: (1) that the ancients referred to the zodiacal light as the "false dawn" – which is correct; and (2) that Omar Khayyam mentioned the "false dawn" in his famous *Rubaiyat* – which turns out not to be true.

False Dawn in Persian Poetry

The British scholar James W. Redhouse compiled many examples of Persian poets using the phrase "subhi kazib," meaning the "False Dawn" or "False Morning" (Redhouse 1878, 1880). Other synonyms include the First Dawn, the Tall Twilight, the White Ascending Light, and the Wolf's Tail, the last derived from its pyramidal shape. Redhouse quoted relevant lines from the sixteenth-century Persian poet Hatafi: "The splendour of the False Dawn exists at a time, when no ray of the True Dawn is in existence."

A modern compilation (Dehkhoda 1959: 128) includes two earlier examples, the first in lines from the poet Attar in the thirteenth century: "your love, it is always like a False Dawn..."

The second is from the poet Jami in the fifteenth century: "The False Dawn speaks of truth, but its light lasts only one or two breaths."

Early Arabic lexicons, including the eleventh-century *Sahah* of Jauhari and the fifteenth-century *Qamus* of Fairuzabadi, also distinguished the false dawn from the true dawn (Redhouse 1880).

Enter Edward Fitzgerald

In the first edition of Edward Fitzgerald's translation of Omar Khayyam's poetry, the second quatrain begins with the line: "Dreaming when Dawn's Left Hand was in the Sky..." (Fitzgerald 1859).

This was later modified in the second edition to read: "Before the phantom of False morning died..." (Fitzgerald 1868).

These are the lines that have generated modern interest. Unfortunately, the phrases are Fitzgerald's rather than Omar Khayyam's.

Fitzgerald's Free Adaptation

Our Texas State group (Olson and Olson 1988; Olson 1989) researched early observations of the zodiacal light and, whenever possible, we consulted primary sources. Omar Khayyam's original word is "sahari," which simply means "one morning" or "at dawn" (Arberry 1959: 193). At least ten other translations exist for this same quatrain (Dole 1896; Heron-Allen 1899), with this Persian phrase given in those ten versions as: "at dawning," "Un matin," "one morn," "At dawn," "One Morn," "The rosy dawn," "Morgens," "Heut Morgen," "one morning," and "One morning." None of the other translators mentions the false dawn! The phrase "subhi kazib" (false dawn) does not appear in the Persian manuscripts of *The Rubaiyat*.

Scholars have long known that Fitzgerald's work was a rather free adaptation and that some of Fitzgerald's most brilliant images have no prototype in Omar Khayyam's original quatrains (Heron-Allen 1899). As Fitzgerald himself wrote to his friend Edward Cowell on March 20, 1857, "It is an amusement to me to take what Liberties I like with these Persians" (Fitzgerald 1901: 319).

And so we conclude that the "false dawn," the ghostly pyramid of faint light rising up from the eastern horizon before the true dawn, makes a haunting and memorable image – but does not appear in the original quatrains written by Omar Khayyam.

Chaucer and High Tides in "The Franklin's Tale"

Geoffrey Chaucer was an advanced amateur astronomer, sufficiently expert in science that he wrote *A Treatise on the Astrolabe*. In Chaucer's *Canterbury Tale* told by the Franklin, the central plot device involves an astronomical calculation of the Moon's position and a high tide that covers all the rocks on the coast of Brittany. How often do the Sun, Moon, and Earth align in configurations that produce extreme tide-raising forces? Can we identify such an event in Chaucer's lifetime?

Chaucer and *The Canterbury Tales*

When the English poet Geoffrey Chaucer (Fig. 8.4) died in the year 1400, he left behind an unfinished collection of stories known as *The Canterbury Tales*. The tales, told by each member of a group of pilgrims, contain unusually complex and interesting celestial references.

The Franklin's story includes intriguing astronomical allusions central to the plot. The lady Dorigen, inconsolable over the absence of her husband the knight Arveragus, walks along the cliffs near her castle on the Brittany shore. She sees the menacing black rocks (Fig. 8.5) that have caused the deaths of so many mariners and will endanger her husband when he returns from England. A young squire named Aurelius secretly loves Dorigen and finally dares to reveal his love and ask for her favors. She replies playfully that she will agree to his embraces if he will remove all the rocks from the coast of Brittany (Fig. 8.6).

Fig. 8.4 *Chaucer holds an astrolabe and explains the night sky in Sir Edward Burne-Jones's woodcut from an 1896 edition known as the Kelmscott Chaucer*

Fig. 8.5 *Sir Edward Burne-Jones's woodcut of Dorigen and the rocks appeared in an 1896 edition known as the Kelmscott Chaucer*

Fig. 8.6 *Warwick Goble's illustration of Dorigen and Aurelius on the Brittany coast appeared in a 1912 collection of Chaucer's works. The central plot device of "The Franklin's Tale" involves a complex astronomical calculation to find the time of an extremely high tide – one that will cover the menacing rocks off the coast of Brittany*

Aurelius at first despairs, but he then returns home and prays to the Sun to cooperate with the Moon in causing an exceptionally high tide that will cover up the rocks so that he might then hold Dorigen to her promise. Aurelius specifically asks for a flood tide "so great that by at least five fathoms [30 ft] it oversprings the highest rock in Brittany." But the high tide does not come during that spring or summer, and Aurelius languishes as he waits in vain. Finally, Aurelius and his brother travel to the town of Orleans to consult a scholar who possesses much special knowledge of the workings of the heavens. The scholar agrees to help for an enormous fee, and the three proceed to the Brittany coast where "through his magic" he seems to make the rocks disappear under the waters of a high tide. The Franklin ends the story by relating how each of the characters shows nobility: Dorigen tells her husband of her rash promise and agonizes over being unfaithful, Arveragus tells his wife she must keep her word, Aurelius releases her from her promise, and the clerk of Orleans waives his fee.

The central plot device of this tale poses a problem – the ordinary recurrences of high and low tides involve nothing that Chaucer's audience would find at all surprising or even magical. Our Texas State group discovered an explanation.

Chaucer may be describing the circumstances of a very rare astronomical configuration related to a high tide that actually occurred in the fourteenth century.

The Cold, Frosty Season of December

The wording of the tale is quite specific regarding the weather and the time of year, even naming December as the month when the three travelers arrive at the Brittany coast:

> And this was, as thise bookes me remembre, The colde, frosty seson of Decembre.
> And this was, as these books make me remember, The cold, frosty season of December.
> Phebus wax old, and hewed lyk laton, That in his hoote declynacion
> Phoebus [the Sun] was old, with a hue like copper, That in his hot declination,
> Shoon as the burned gold with stremes brighte; But now in Capricorn adoun he lighte,
> Shone as the burnished gold with streams bright; But now in Capricorn adown he lights,
> Where as he shoon ful pale, I dar wel seyn. The bittre frostes, with the sleet and reyn,
> Whereas he shone full pale, I dare well say. The bitter frosts, with the sleet and rain,
> Destroyed hath the grene in every yerd. Janus sit by the fyr, with double berd,
> Hath destroyed the green in every yard. Janus sits by the fire, with double beard,
> And drynketh of his bugle horn the wyn; Biforn hym stant brawen of the tusked swyn,
> And drinketh from his bugle horn the wine; Before him stands brawn of the tusked swine,
> And "Nowel" crieth every lusty man.
> And "Noel" cries every lusty man.

The cry of "Noel" suggests a time in the latter part of December, near Christmas. The mention of Janus, an allusion to the approach of January, also indicates the same part of December. Illustrated medieval calendar pages for December show two-faced Janus with his "double beard" eating or drinking from a horn, as he awaits the beginning of the month that bears his name (Tuve 1933: 166; Hodgson 1960: 97). Chaucer's reference to the Sun in Capricorn gives us yet another independent way to pin down the time of year. The Sun entered Capricorn on the day of the winter solstice, about December 13th during Chaucer's lifetime. The abundant seasonal clues show that this passage describes a "cold, frosty" day between December 13th and December 31st.

Calculation by the Clerk of Orleans

At the Brittany coast the clerk of Orleans works night and day until "at last he hath his time found" for the high tide. The clerk calculates lunar and solar positions from a set of "Toledan tables," a reference either to those prepared in the eleventh century by the astronomer al-Zarqali at Toledo, Spain, or to the Alfonsine Tables compiled in the same city in the thirteenth century under the direction of King Alfonso X (Gingerich 1985: 206). In a sequence that may be the most complex astronomical passage in all of English literature, Chaucer describes the calculations and the resulting high tide that hides the rocks:

> *His tables Tolletanes forth he brought, Ful wel corrected, ne ther lakked nought,*
> *His Toledan tables forth he brought, Full well corrected, there he lacked nothing,*
> *Neither his collect ne his expans yeeris, Ne his rootes, ne his othere geeris,*
> *Neither his collect nor his expans years, Nor his roots, nor his other gear,*
> *As been his centris and his argumentz And his proporcioneles convenient*
> *As are his centers and his arguments, And his proportionals convenient*
> *For his equacions in every thyng. And by his eighte speere in his wirkyng*
> *For his equations in everything. And by the eighth sphere in its working*
> *He knew ful wel how fer Alnath was shove Fro the heed of thilke fixe Aries above,*
> *He knew full well how far Alnath was shoved From the head of that fixed Aries above,*
> *That in the ninthe speere considered is; Ful subtilly he kalkuled al this.*
> *That in the ninth sphere considered is; Full subtly he calculated all this.*
> *Whan he hadde founde his firste mansioun, He knew the remenaunt by proporcioun,*
> *When he had found his first mansion, He knew the remnant by proportion,*
> *And knew the arisyng of his moone weel, And in whos face, and terme, and everydeel;*
> *And knew the arising of his moon well, And in whose face, and term, and everything;*
> *And knew ful weel the moones mansioun Accordaunt to his operacioun,*
> *And knew full well the moon's mansion According to his operation,*
> *And knew also his othere observaunces For swiche illusiouns and swiche meschaunces*
> *And knew also his other observances For such illusions and such mischances*
> *As hethen folk useden in thilke dayes. For which no lenger maked he delayes,*
> *As heathen folk used in those days. For which no longer made he delays,*
> *But thurgh his magik, for a wyke or tweye, It semed that alle the rokkes were aweye.*
> *But through his magic, for a week or two, It seemed that all the rocks were away.*

In this sophisticated passage Chaucer employs exactly the language employed by scholars using the Toledan Tables. To find the Moon's position on any given date, a medieval astronomer would begin by consulting tables for the Moon's coordinates at an initial epoch, called a radix or "root," and

then would reach the desired date by adding up the tabulated motions during the elapsed time interval, expressed as a sum of "collect years" (centuries and 20-year periods), "expans years" (individual years counted from 1 to 19), months, days, hours, and minutes. Careful calculations to find the true place of the Moon involved tables for such quantities as the "equation of center," "proportional minutes," and "equation of argument" – exactly the scientific terms employed by Chaucer in this passage.

Finding the Sun's position required a similar use of arguments and equations, with an additional complication alluded to by Chaucer's mention of "Alnath," a medieval name employed both for the brightest star in the constellation Aries and also for the stars in Aries that formed the first lunar "mansion." The 28 lunar mansions were groups of stars used as reference stations for the Moon, which moved into a different lunar mansion during each day of the lunar month. Chaucer mentions the changing distance between Alnath "in the eighth sphere" and the "head of that fixed Aries…in the ninth sphere," using the language of medieval astronomy to describe what modern astronomers call the phenomenon of precession. Medieval theory placed the Sun in an orbit around Earth with the directions of closest approach to Earth and farthest distance from Earth at fixed positions among the stars in the "eighth sphere," which performed both a steady motion and an oscillating motion called trepidation relative to the "ninth sphere." Medieval scholars performed this complex precession calculation, a necessary intermediate step in finding the true position of the Sun and thereby determining the lunar phase, with the angle between the Sun and Moon determining how the Sun's light illuminates the face of the Moon.

Chaucer scholars have long referred to this section of "The Franklin's Tale" as a problem passage, notorious in its difficulty. Some modern analyses of the astronomy do not go much beyond noting that a new or full Moon will produce a high tide. Phyllis Hodgson went so far as to judge that "this passage with its involved and highly technical account of the Clerk's astrological calculations need not be taken too seriously. Though Chaucer himself was a master of the subject his purpose here is artistic – to emphasize the Clerk's expertness and surround the central event of the tale with an aura of mystery" (Hodgson 1960: 99).

Our Texas State group draws a different conclusion. The sophisticated terminology, correctly employed in "The Franklin's Tale" to describe lunar and solar calculations, confirms Chaucer's expertise in medieval astronomy.

Moreover, the complexity of this passage suggests to us that the clerk of Orleans is making a very difficult calculation, perhaps to find the time of an astronomical configuration that a medieval scholar would associate with the most extreme possible tide range. His trick resembles that of Mark Twain's *Connecticut Yankee in King Arthur's Court* who, because he is able to predict a solar eclipse, makes people believe he caused it.

High Tides in Brittany

Four known independent factors contribute to produce exceptionally high tides. Spring tides of increased range occur twice monthly at either a new Moon or full Moon, when the Sun, Moon, and Earth are approximately aligned and the individual tide-raising forces of the Sun and Moon can combine for a greater net effect. Solar eclipses or lunar eclipses, with a closer alignment of the Sun, Moon, and Earth and an additional enhancement of the combined tide-raising forces, take place at the times known as eclipse seasons, which occur twice a year. Perigean tides of increased range occur once per month when the Moon is nearest Earth and the lunar gravitational effects are greatest. Finally, perihelion in Earth's orbit occurs once per year, when Earth is closest to the Sun and the solar tide-raising forces are maximized.

In certain years, all four of the preceding conditions can be met almost simultaneously. The Swedish oceanographers Otto and Hans Pettersson described such remarkable events and observed that "this situation, which at the same time satisfies all...conditions and produces an absolute maximum of the tide-generating force, must be an extremely rare occurrence" (H. Pettersson 1913: 8). The Petterssons give a few examples, but none from Chaucer's lifetime.

A book by Fergus Wood considers the same factors and agrees that for eclipses "to occur simultaneously with both the Moon and the Sun being at their closest distances from the Earth...is a very rare astronomical circumstance" (Wood 1978: 219). Wood makes a passing reference to an event that he calls the "absolute high tide experienced in A.D. 1340," describing it by the phrase "maximum perigee springs, a very rare circumstance" and stating that the high tide took place "near the perihelion of A.D.1340" (Wood 1978: 203). A literature search also turned up an article with the title "Years of peak astronomical tides," with the author David Cartwright including 1340 in a list of years when "the maxima of the tide-raising forces" took place (Cartwright 1974).

Fig. 8.7 *During an eclipse, the tide-raising forces of the Sun and Moon combine for a greater net effect. This woodcut of a solar eclipse appeared in the 1488 edition of Sacrobosco's Spaerae Mundi*

Computer Calculations

Intrigued by these references to an extreme tide-raising event in the fourteenth century, when Chaucer wrote *The Canterbury Tales*, our Texas State group wrote computer programs to search for the dates of eclipses (Fig. 8.7) with the Moon near lunar perigee and Earth near perihelion. Perfect alignments never occur. Our method found eclipses within 10 days of perihelion and within 24 h of a lunar perigee (Olson et al. 2000: 48).

After we searched the years ranging from −2500 to +5000, an interesting pattern became evident (Table 8.1). The dates of these tide-raising configurations fall into groups, separated by intervals of more than 1,000 years when no such events can occur at all.

Our calculations make precise the rarity of these alignments and also confirm the 1340 date mentioned by Wood and Cartwright. Not only did our computer search turn up a date from the fourteenth century, we discovered that the resulting high tides fell in the second half of December, just after the winter solstice, with the Sun in Capricorn – exactly matching the circumstances described by Chaucer in "The Franklin's Tale"!

Table 8.1 *Eclipses with Earth near perihelion (Earth near its closest approach to the Sun) and with the Moon near lunar perigee (Moon near its closest approach to Earth)*

−1868 November 12	Lunar eclipse
−1775 November 19	Solar eclipse
−1700 November 15	Lunar eclipse
−1691 November 6	Lunar eclipse
−1598 November 13	Solar eclipse
−1505 November 20	Lunar eclipse
−399 December 1	Lunar eclipse
−306 December 8	Solar eclipse
−222 November 25	Lunar eclipse
−129 December 2	Solar eclipse
−36 December 7	Lunar eclipse
48 November 24	Solar eclipse
1247 December 13	Lunar eclipse
1340 December 19	**Solar eclipse**
1424 December 6	Lunar eclipse
1442 December 17	Lunar eclipse
1517 December 13	Solar eclipse
1535 December 24	Solar eclipse
1610 December 30	Lunar eclipse
1712 December 28	Solar eclipse
3089 January 18	Lunar eclipse
3182 January 26	Solar eclipse
3275 February 2	Lunar eclipse
3284 January 24	Lunar eclipse
3359 January 21	Solar eclipse
3377 January 31	Solar eclipse
3452 January 29	Lunar eclipse
3554 January 27	Solar eclipse

Medieval scholars, although lacking a concept of tidal forces in the modern sense, listed a number of associations between tidal ranges and astronomical phenomena. A thirteenth-century treatise by Robert Grosseteste described spring tides by saying that "when the Sun and Moon are in conjunction, the power of the Moon becomes stronger, and the tide increases and becomes strong" (Grant 1974: 642). The same medieval author referred

Fig. 8.8 *The last rays of a setting Sun illuminate a rising tide at Saint-Malo on the coast of Brittany. Chaucer visited France several times during the 1360s and 1370s and may have witnessed the remarkable tides either at Saint-Malo, where ranges of 44 ft can occur, or at nearby Mont Saint-Michel, where even greater tides are possible (Photograph by the author)*

to perigean tides by observing that when the Moon "approaches the point nearest the Earth, its power increases, and then the rise of the sea is strong" (Grant 1974: 643). Several treatises associated a period of high tides with the winter solstice and therefore, indirectly, with the time of closest approach between Earth and the Sun. Chaucer would have understood, at least in a qualitative way, that the celestial alignments in December 1340 would significantly affect the tides. Our calculations may help explain why Chaucer used a December high tide in his tale, even though the Brittany coast is also known for its "great equinoctial tides" ("grandes marées d'équinoxe") when perigean spring tides occur in March and September.

Brittany has long been famed for its remarkable tides. At Saint-Malo (Fig. 8.8) the mean tide range is 26 ft, spring tide ranges reach 35 ft and perigean spring tides with ranges exceeding 44 ft are possible. Even greater tides occur at Mont Saint-Michel (Fig. 8.9), only a short distance east of Saint-Malo. For centuries, tourists and pilgrims have walked out to the abbey of Mont Saint-Michel at low water and then watched the rapidly rising flood tide make an island of the site at high water.

Scholars do not know the precise ports visited by Chaucer on his trips to France, but Englishmen definitely passed through Saint-Malo during the fourteenth century (Tatlock 1914: 48). Chaucer could have been personally familiar with the large tide ranges on the Brittany coast.

Fig. 8.9 *Some of the greatest tides in the world occur near Mont Saint-Michel. For centuries, tourists and pilgrims have been able to walk out to the abbey of Mont Saint-Michel at low water and then watch the rapidly rising flood tide make an island of the site at high water (Photograph by the author)*

Chaucer lived centuries before Newton developed his laws of gravitation. However, Chaucer could very well have used medieval methods to calculate the astronomical alignments that occurred in December 1340, and he could have associated them with an exceptionally high tide.

Chaucer and 1340

However, if Chaucer visited France in the 1360s and 1370s and wrote *The Canterbury Tales* during the 1390s, why would he be aware of a high tide that occurred in 1340? We can suggest an intriguing possibility to explain Chaucer's knowledge of the 1340 event. In a recent edition of the tales, the section on the poet's life notes that "the date and place of his birth are not precisely known…it is usual, then, to accept a birth date in the early 1340s" (Benson 1987: xii). A modern biography likewise places Chaucer's birth "around 1340, possibly early in 1341" (Gardner 1977: 21). When Chaucer

was learning about astronomy, astrolabes, and astronomical tables during the 1380s and 1390s, it is plausible to imagine that he might have investigated his own horoscope. Chaucer may have discovered the remarkable configuration of Sun and Moon in 1340 while using the Alfonsine tables to calculate solar and lunar positions near the time of his birth!

By the time he wrote *The Canterbury Tales*, Chaucer was skilled in the celestial science of his day. Several modern scholars have surveyed the poet's use of astronomy in his tales (Wood 1970; Carter 1982; Weitzenhoffer 1985). Our specific results suggest that Chaucer called on this expertise and used the configuration of the Sun and Moon in December 1340 as the inspiration for the time of year and for the central plot device in "The Franklin's Tale."

Shakespeare and the Stars of *Hamlet*

What is the bright star that "burns" in the sky in Act One, Scene One, of *Hamlet*? How can we use the play's clues to season of the year, direction of view, and time of night to suggest an identification for this brilliant celestial body? Is it a planet, a star, or something else more unusual and spectacular? What are the possible links between Shakespeare, the play *Hamlet*, set in Denmark, and the Danish astronomer Tycho Brahe? What is the connection between passages in the novel *Ulysses* by James Joyce, a celestial event that occurred in Shakespeare's lifetime, and the sky in the opening scene of *Hamlet*?

Star in the November Sky

Hamlet begins after midnight on a bitter cold night. The soldiers standing guard on the ramparts of Elsinore Castle in Denmark explain to the scholar Horatio that they have seen a ghost on two previous nights. Just before the ghost of Hamlet's father reappears, one of the soldiers uses an astronomical reference to describe the time when the spirit is accustomed to walk:

> Bernardo:
> Last night of all,
> When yond same star that's westward from the pole
> Had made his course to illume that part of heaven
> Where now it burns, Marcellus and myself,
> The bell then beating one, – [ENTER GHOST]
> (Hamlet, Act One, Scene One)

Fig. 8.10 *William Shakespeare (1564–1616)*

The rest of the scene reminds us that in Shakespeare's plays heavenly portents often paralleled dramatic human events. Horatio asserts that "stars with trains of fire," "disasters in the sun," and the Moon "sick almost to doomsday with eclipse" accompanied the death of Julius Caesar. Within this context, could this reference to a star west of the pole have meant more to Shakespeare and his audience than it does to us? Our Texas State group can suggest both an identification for Hamlet's star and an explanation why William Shakespeare (Fig. 8.10) might choose to begin the play with this celestial reference.

The bell tolling 1 a.m. sets the time of night, but to determine which stars lie "westward from the pole" we also need to know the time of year. Fortunately, the text of the play provides sufficient clues. The soldier Francisco complains that this night is "bitter cold," and Hamlet agrees on the next night that the "air bites shrewdly; it is very cold," suggesting a date in late fall or winter. The guard Marcellus, shortly after encountering the ghost, comments that when "that season comes, Wherein our Savior's birth is celebrated…then, they say no spirit can walk abroad." For this reason we can conclude that the opening scene does *not* take place during the season of Advent, which begins on the Sunday closest to November 30th and ends by Christmas Day on December 25th.

Hamlet tells us that the death of his father ("two months dead") occurred approximately 2 months before the beginning of the play, and the ghost reveals that the murder occurred while he was taking an afternoon nap in the open air ("sleeping within my orchard"). The death of Hamlet's father therefore appears to have taken place near the end of summer, perhaps in September, when the afternoons still could be warm enough to sleep outside, while the opening scene of the play would fall 2 months later on a cold night in November. On this point we agree with the German scholar Max Moltke, who used similar reasoning to argue that the opening scene takes place in November, "a little before the time of Advent" (Moltke 1869: 30).

Candidates for *Hamlet's* Star

For an observer in northern Europe at 1 a.m. in November, is there an obvious choice for a bright star "westward from the pole"?

Technically speaking, of course, every star in the sky is located to the *south* of the north celestial pole (this is analogous to the idea that every country on Earth's globe lies *south* of the north geographic pole). We assume that the phrase "westward from the pole" describes a position in the sky with nearly the same altitude as the north celestial pole but with a compass direction slightly toward the west. A sky watcher facing north could reasonably describe a star in this location as being on the "west" side (or "to the left") of the pole and the star Polaris.

We used planetarium computer programs to find the dates, in the Julian calendar still used in England during Shakespeare's lifetime, when various prominent northern stars appeared "westward from the pole" at 1 a.m.

Ursa Major?

Several editions of *Hamlet* have stated that the star in the opening scene is probably a member of the Great Bear, the constellation formally known as Ursa Major and less formally as the Big Dipper. These scholars point out that Elizabethans used this constellation to tell time (Chambers 1906: 124; Craig 1951: 904). Shakespeare indeed does have the characters in *Henry IV, Part I* deduce the hour of the night from the position of Ursa Major. But this constellation cannot match the cold season in the opening scene of *Hamlet*, since our calculations show that Elizabethans would have seen the bowl of the Big Dipper "westward from the pole" at 1 a.m. only in the second half of April.

Ursa Minor?

Shakespeare was also certainly aware of the Lesser Bear, specifically the stars Beta and Gamma in Ursa Minor, because he refers to them as the "guards of the ever fixed pole" in *Othello*. However, these stars fail to satisfy the description in *Hamlet* because they fell west of the pole at 1 a.m. in the first week of July.

Vega? Deneb?

We can likewise rule out the bright northern stars Vega and Deneb, which form the northern side of the Summer Triangle, because they were "westward from the pole" at 1 a.m. near the end of July and the end of August, respectively.

Capella?

G. T. Buckley suggested Capella as Hamlet's star and specifically mentioned January 19th as a possible date for Act One, Scene One (Buckley 1963: 412). An important modern edition of *Hamlet* in the Arden Shakespeare series adopted this identification of Capella (Jenkins 1982: 167). It is true that Capella passed west of the celestial pole at 1 a.m. in mid-January, when the nights are indeed "bitter cold" and Advent has ended. However, this identification requires the murder of Hamlet's father 2 months earlier to fall in November, which seems too late in the year to be sleeping outdoors in Denmark.

A Planet?

The brief reference by George Rylands to "a planet west of the Polar star" (Rylands 1947: 197) and a similar deduction by T. J. B. Spencer that Shakespeare "seems to imply that the *star* is a planet" (Spencer 1996: 207) are not plausible astronomically. Planets always remain in or near the familiar zodiacal constellations and can never venture near the north celestial pole.

Cassiopeia?

None of these authors offered as candidates the stars of Cassiopeia, the northern constellation with the distinctive shape of the letter "W" (or "3," "M," or "Σ," depending on the time of night). Cassiopeia deserves consideration because it lies so close to the north celestial pole. Indeed, our computer calculations for Shakespeare's lifetime show that this constellation did stand

"westward from the pole" at 1 a.m. in the first half of November. Cassiopeia is a perfect fit to the position, time of night, and season specified in *Hamlet*. One problem remains, however. Although the shape of Cassiopeia is familiar and striking, no single star is especially bright.

The New Star of 1572

But our Texas State group (Olson et al. 1998) realized that a remarkable star once did shine in Cassiopeia – the supernova of 1572. Moreover, this brilliant star suddenly appeared in November, precisely the month during which its position would have matched Bernardo's description. Modern astronomers refer to this object as Tycho's supernova, after the Danish astronomer who made the most detailed study of its properties. Amazed naked-eye observers of the time called it a "nova," meaning "new star."

Although we can imagine that Shakespeare, who was 8 years old and a student at the grammar school in Stratford-on-Avon, would never forget when he first saw the new star, we have detailed information about Tycho's reaction. Tycho Brahe (1546–1601), a contemporary of William Shakespeare's (1564–1616), was 26 when the new star appeared, and the event helped inspire Tycho to devote his life to the serious study of astronomy.

The supernova was first seen at Wittenberg on November 6, 1572, and then at five other locations in Europe before Tycho independently discovered it. Tycho offered his first impressions of the new star in a short 1573 book called *De Nova Stella*. In a longer 1602 volume, Tycho published a detailed compilation of all known observations, including this vivid account of his own original sighting (Fig. 8.11):

> I first observed it on the 11th day of November [1572], because for many days preceding this the sky above our horizon was not at all clear....During a walk on the evening of the above-mentioned day, I was contemplating the heavens, because the clearer air seemed to promise that astronomical observations could continue after dinner. I suddenly and unexpectedly beheld near the zenith an unaccustomed star with a bright radiant light. Astounded, as though thunderstruck by this astonishing sight, I stood still and for some time gazed with my eyes fixed intently upon this star. It was near the stars which have been assigned since antiquity to the asterism of Cassiopeia. I was convinced that no star like this had ever before shone forth in this location....At this incredible sight I hesitated, and I was not ashamed to doubt that I could trust my own eyes....As it happened at that time some country people were passing by, so I asked whether any of them perceived this star in the high heavens. They cried out that they clearly saw this enormous star.

Fig. 8.11 *This engraving from Camille Flammarion's Astronomie Populaire (1880) depicts Tycho Brahe's first sighting of the new star on November 11, 1572. The supernova shone forth near the familiar "M" asterism of Cassiopeia, high above Polaris in the evening sky depicted here. By 1 a.m., the diurnal rotation of the heavens carried Cassiopeia and the new star to a position "westward from the pole," as described in Act One, Scene One, of Hamlet*

At the beginning, its apparent magnitude exceeded all of the fixed stars, including those of the first magnitude, and even the Dog Star itself and the brightest star in Lyra. Indeed, the new star appeared brighter than Jupiter...when closest to the Earth. It rivaled the brilliant aspect of Venus when nearest to the Earth. During November the new star was so bright that, when the air was clear, many people with sharp vision were able to see it in the daytime, even at midday.

(Tycho Brahe, 1602, *Astronomiae Instauratae Progymnasmata*)

The supernova remained visible for 16 months before fading from sight.

An Astronomer and a Novelist

Writing about the 1572 event, the Harvard astronomer Cecilia Payne-Gaposchkin concluded that Shakespeare himself "must have seen Tycho's nova" (Payne-Gaposchkin 1954: 162).

James Joyce in his novel *Ulysses* likewise conjectured that Shakespeare would have observed the new star. Joyce's complex novel contains dozens of astronomical allusions, including at least two that refer to the 1572 supernova. In the following passage from Chap. 9 of *Ulysses* the novelist emphasized the brilliance of the object that appeared near the normal star Delta Cassiopeiae and imagines a youthful Shakespeare watching the new star: "A star, a daystar, a firedrake, rose at his birth. It shone by day in the heavens alone, brighter than Venus in the night, and by night it shone over delta in Cassiopeia, the recumbent constellation which is the signature of his initial among the stars. His eyes watched it, low-lying on the horizon..." (Joyce 1934: 206).

Joyce's visual image of "his initial among the stars" compares the "W" shape of Cassiopeia to the first letter of the name William Shakespeare.

Chapter 17 of *Ulysses* includes a long series of about fifty astronomical references, one of which concerns the 1572 supernova and the behavior of the constellation that contained the new star. For British observers, Cassiopeia is a circumpolar constellation, forever circling around the north celestial pole without rising or setting. Joyce alluded to this as he links Shakespeare to: "the appearance of a star...of exceeding brilliancy dominating by night and day...about the period of the birth of William Shakespeare over delta in the recumbent never-setting constellation of Cassiopeia..." (Joyce 1934: 684).

Both Payne-Gaposchkin and Joyce suggest that Shakespeare would have seen the supernova of 1572, but neither author went on to make the connection to the bright star in the opening scene of *Hamlet*.

Supernova Worries England in 1572

To Elizabethan observers, the new star was not only a memorable sight but an event with disturbing religious and philosophical implications. In the two millennia since Aristotle, the fixed stars had been regarded as unchanging celestial symbols of security and order, with transitory phenomena such as comets and meteors assigned to the "elemental" regions below the Moon. The unprecedented new star shook people's confidence. The chronicler Raphael Holinshed expressed this mixture of scientific interest and concern in his entry for the year 1572:

A STRANGE STAR APPEARED

The eighteenth of November in the morning was seene a star northward verie bright and cleere, in the constellation of Cassiopeia, at the backe of hir chaire.... This starre in bignes at the first appeering seemed bigger than Jupiter, and not much lesse than Venus when she seemeth greatest. Also the said starre never changing his place, was caried about with the dailie motion of heaven, as all fixed starres commonlie are...it was found to have beene in place celestiall far above the moone, otherwise than ever anie comet hath beene seene, or natural-lie can apeere. Therefore it is supposed that the signification therof is directed purposelie and speciallie to some matter, not naturall, but celestiall, or rather supercelestiall, so strange, as from the beginning of the world never was the like.

(Raphael Holinshed, 1587, *Chronicles*)

Holinshed also provides another connection to Shakespeare, who consulted the *Chronicles* when he was doing historical research for some of his best-known plays. His boyhood memory of the new star could have been reinforced at the time he was writing *Hamlet*.

The historian William Camden, himself an eyewitness to the 1572 event, gave another vivid English account:

A NEW STAR

I know not whether it bee worth the labour to mention that which all Historiographers of our time have recorded, to wit, that in the moneth of November, a new Starre, or if you will, a Phaenomenon, was seene in the Constellation of Cassiopeia, which (as I my selfe observed) in brightnesse excelled Jupiter in the Perigee or neerest point of the Eccentric, and Epicycle: and in the same place it continued full sixteene moneths, being carried about with the daily motion of the heaven.

Thomas Digsey, and John Dey, Gentlemen, and Mathematicians amongst us, have learnedly proved by Parallactic Doctrine, that it was in the celestiall, not in the Elementary Region.

(William Camden, 1625, *Annales*)

The two scientists mentioned by Camden were the most prominent astronomers in Elizabethan England, Thomas Digges (1546–1595) and John Dee (1527–1608), whose observations appeared prominently in Tycho's final volume on the new star.

While the supernova was still visible in the northern sky in 1573, Digges published a book entitled *Alae seu Scalae Mathematicae*, which used mathematics "to investigate the distance, immense magnitude, and position of this extraordinary star." Dee also wrote several works devoted to the new

star, including in 1573 a book entitled *Parallaticae Commentationis Praxeosque*, showing how measurements of angles could theoretically be used to calculate its distance from Earth. In practice, pre-telescopic instruments were unable to measure an accurate distance for a star, and the first reliable measurements of stellar distances did not occur until the years 1838–1840. But Tycho, Digges, and Dee were successful in establishing at least that the new star must lie much farther away than the Moon. Holinshed's phrase, "far above the moone," shows that this significant result became common knowledge.

The supernova faded below naked-eye visibility after 16 months, but the discussion of its meaning continued for decades. Shakespeare's life has left remarkably little personal information behind, but several biographical clues point to a connection with Digges, Dee, and Tycho Brahe – the scientists most closely associated with the study and debate about the new star of 1572.

Tycho, Rosencrantz, Guildenstern and *Hamlet*

Shakespeare uses the Danish names Rosencrantz and Guildenstern for two of Hamlet's old Wittenberg friends. How did Shakespeare happen to come up with these very distinctive names?

The family names "Rosenkrans" and "Guldensteren" appear in a portrait (Fig. 8.12) showing Tycho surrounded by the coats-of-arms of his relatives. We can be certain that copies of this engraving were circulating in London in the 1590s. In a letter to the English scholar Thomas Savile, Tycho writes: "Respectfully greet on my behalf the most noble and most eminent master John Dee…Also do not leave ungreeted the most noble and equally most erudite mathematician Thomas Digges, whom I also sincerely praise and wish well." He adds in a postscript: "I have included four copies of my portrait, recently engraved in copper at Amsterdam" (Tycho Brahe to Thomas Savile, December 1, 1590).

Shakespeare lived near Digges in London and may have seen this astronomer's copy of the portrait, as several scholars have pointed out (Hotson 1938: 123; Meadows 1969: 77; Gingerich 1981: 395). Leslie Hotson, in fact, devotes three chapters of his Shakespeare biography to tracing associations between the playwright and the Digges family. Victor Thoren notes that two of Tycho's relatives with the names "Rosenkrantz" and "Gyldenstierne" visited England in 1592 (Thoren 1990: 428).

Fig. 8.12 *The names "Rosenkrans" and "Guldensteren" appear on the left arch and column in a famous portrait of Tycho Brahe. The Dutch artist Jacob de Gheyn engraved the likeness in 1590, and similar designs appeared as frontispieces to the 1596 and 1601 editions of Tycho's collected astronomical letters*

Although the theory linking these two character names in *Hamlet* and the names on the Tycho portrait is usually credited to Leslie Hotson's 1938 book by modern authors (Usher 1997: 23, Berney 2004: 12), the idea had actually circulated in print much earlier. The librarian Sandford Arthur Strong advanced the same theory, as described in a 1904 memoir, and an article in 1905 by the astronomer William T. Lynn also made the connection between *Hamlet* and the Tycho portrait (Simpson 1904: 731; Lynn 1905a: 184).

Fig. 8.13 *The Atlas of the Principal Cities of the World, published by Braun and Hogenberg in 1588, included this engraving of the strait known as the Sound of Denmark. Tycho Brahe's castle observatory Uraniborg (Uraniburgum in the Latin spelling) stands in the center of the island of Hven (Hvena). Only a short distance away, dominating the left foreground of this view, is the castle at Elsinore (Helschenor), chosen by Shakespeare for the setting of Hamlet*

So, we conclude that Shakespeare, as he was planning the names for the characters in *Hamlet*, may have found inspiration in the Danish names "Rosenkrans" and "Guldensteren," found on the engraved portrait of Tycho Brahe.

Tycho, Elsinore, and *Hamlet*

While doing background research for *Hamlet*, Shakespeare may have consulted maps of Denmark in the 1588 Braun and Hogenberg atlas, the most famous pictorial atlas of the period, in order to round out his knowledge of Hamlet's country. He would have seen Tycho's castle observatory immediately adjacent to the castle at Elsinore (Fig. 8.13) that he eventually chose for the Danish setting of the play.

Stars and Spheres

A striking passage in the play suggests yet another link between *Hamlet* and the astronomers Digges and Dee. Shakespeare uses imagery borrowed directly from astronomy:

> Ghost:
> *I could a tale unfold whose lightest word*
> *Would harrow up thy soul, freeze thy young blood,*
> *Make thy two eyes like stars start from their spheres....*
> (*Hamlet*, Act One, Scene Five)

Although the idea of a star leaping out of its sphere may seem odd to modern readers, whether the "new star" had done it or not was a matter of spirited debate in 1572 and 1573. John Dee attempted to explain why the supernova suddenly became so brilliant, for example, by proposing that the star had left its accustomed sphere and dropped directly towards Earth. Dee elaborated this theory in a 1573 manuscript with a Latin title that we translate as "On the astonishing star, in the asterism of Cassiopeia, which descended from the heavens as far down as the sphere of Venus and again drew back perpendicularly into the secret places of the heavens, after the sixteenth month of its appearance." This explanation of the supernova, that the star had started from its sphere in 1572 and then returned to its sphere in 1573, was repeated in the *Annales* of William Camden, who noted that Digges and Dee were of the opinion "that it vanished by little and little in ascending."

The connections between William Shakespeare's *Hamlet* and the astronomers Thomas Digges and Tycho Brahe, the leading European authorities on the new star in Cassiopeia, make it more plausible that the spectacular supernova of 1572 was the inspiration for the celestial portent in the opening scene of the most famous play ever written.

Further Reading on Shakespeare and Astronomy

Several authors have surveyed the astronomical passages in all of Shakespeare's works (Harmon 1898; Dean 1924; Chappell 1945; McCormick-Goodhart 1945; Guthrie 1964; and Levy 2011).

William Blake's "The Tyger": Celestial "Spears" and Fiery "Tears"

William Blake's poem "The Tyger" begins with the memorable lines "Tyger Tyger, burning bright, In the forests of the night." This famous poem, first published in his collection *Songs of Experience* in 1794, may include astronomical references. What meteor events from the late eighteenth century might have inspired the lines in which "the stars threw down their spears, And water'd heaven with their tears"? What meteor showers and bright fireballs might Blake have witnessed?

"The Tyger"

William Blake's "The Tyger" (Fig. 8.14) has reached iconic status, ranking first in popularity on a recent list of the top 500 poems most often included

Fig. 8.14 *"The Tyger" originally appeared in Songs of Experience, a book that Blake wrote and published himself in 1794 (Lessing J. Rosenwald Collection, Library of Congress. Copyright © 2013 William Blake Archive. Used with permission)*

Table 8.2 Years with recorded observations of the Perseid meteor shower, with early Oriental accounts in normal type and Western accounts in **bold type**

36	841	1042	**1779**	**1806**
466	924	**1243**	**1781**	**1809**
811	925	1451	**1784**	**1811**
820	926	1581	**1789**	**1813**
824	933	1590	**1798**	**1815**
830	989	1625	**1799**	**1818–1820**
833	1007	1645	**1800**	**1822–1831**
835	**1029**	**1709**	**1801**	**1833–now**

in poetry anthologies (Harmon 1992: 1077). The poem includes striking visual images like these from the fifth stanza:

When the stars threw down their spears
And water'd heaven with their tears....

These intriguing lines, associating stars with both "spears" and "tears," may be related to some notable meteors that occurred in the poet's lifetime. A spectacular procession of fireballs passed over England in 1783, and the Perseid meteor shower may have been especially prominent in the late eighteenth century, inspiring a legend about "fiery tears" falling from heaven.

Sky watchers noted the famous Perseid meteor shower long before Blake's time, with observations dating back to A.D. 36, the year of the earliest known Chinese sighting. Table 8.2 gives a list of the years in which Perseids were observed and recorded (Olson and Olson 1989: 192).

The last decades of the eighteenth century clearly saw an increase in activity of either this meteor shower or Western observers, or both. Looking back at the history of the Perseid shower, meteor expert William F. Denning noted that "it was not till the latter part of the 18th century that it received special notice" (Denning 1894: 268). William Blake may well have seen spectacular displays in the years just prior to the 1794 publication of "The Tyger."

Public and scientific interest in meteors ran unusually high during this period. The pages of the *Gentleman's Magazine* in England recount many instances of meteors observed by readers who attempted to determine their paths, estimate their brightness, and recall the amount of time that elapsed while they passed. Scientists were just beginning to realize that meteors are not terrestrial phenomena like lightning, St. Elmo's fire, and the will-o'-the-wisp, but instead are cosmic bodies entering Earth's atmosphere

(Burke 1986). Coincidentally, Ernst Chladni published the first treatise to make a convincing case for the cosmic origin of meteors and meteorites in 1794, the same year as Blake's *Songs of Experience*.

Perseid Meteors as "Fiery Tears"

Blake in 1794 could not have known the meteors of August as the Perseids, because that name was coined in 1866 by Giovanni Schiaparelli, the Italian astronomer known for his descriptions of *canali* on Mars. Schiaparelli discussed "the falling stars of August 10th, stars which from now on I will call 'Perseids' for short, after the constellation from which they appear to spread out to us" (Schiaparelli 1866: 31).

Before 1866 the Perseids were known as the "tears of St. Lawrence," because they fell from heaven most abundantly every year near his feast day, August 10th. According to tradition, in the third century St. Lawrence was martyred by burning on a gridiron.

L. A. J. Quetelet, writing in 1837, discussed the meteors of August and recalled "a tradition that the falling stars, which present themselves in greater numbers at this time, are the burning tears of Saint Lawrence whose feast day arrives exactly on 10 August" (Quetelet 1837: 378).

Edward Herrick of Yale University likewise recounted a popular legend "that St. Lawrence weeps tears of fire, which fall from the sky every year on his fête" (Herrick 1839: 333). Herrick stated that this "superstition has 'for ages' existed among the Catholics of some parts of England and Germany, that the burning tears of St. Lawrence are seen in the sky on the night of the 10th of August" (Herrick 1839: 337).

Alexander von Humboldt, in his monumental compilation *Kosmos* (Humboldt, 1845a: 406, b: 403), also discussed the tradition of the August meteors described as "the fiery tears of St. Lawrence" ("der feurigen Thränen des heil. Laurentius").

When did the Perseid shower first become known as the "fiery tears"? Many authors state that the metaphor dates back to early medieval times, but Table 8.3 shows this cannot be true. Associating the shower with August 10th must date from after the adoption of the Gregorian calendar, for in medieval times the Perseids came in July.

The date of Perseid maximum activity slowly advances, at an average rate of about 1 day in 150 years relative to the Julian calendar and 1 day in 70 years relative to the Gregorian. The orbit of the Perseids is extremely stable, with the interval between the dates of maximum activity nearly equal to

Table 8.3 *Calendar date of maximum activity of the Perseid meteor shower*

Year	Julian calendar	Gregorian calendar
0	July 17	–
500	July 20	–
1000	July 24	–
1500	July 27	–
1600	July 28	August 7
1700	July 28	August 8
1750	July 29	August 9
1800	–	August 10
1900	–	August 12
2000	–	August 12

365.2564 days. This is slightly longer than the average Julian calendar year (365.2500 days) or Gregorian calendar year (365.2425 days), and these small differences accumulate over the centuries.

During the lifetime of William Blake (1757–1827), the date of Perseid maximum first began to fall near August 10th. If the poet saw the meteors, perhaps during the remarkable showers of 1779, 1781, 1784 or 1789, the popular tradition would have associated stars, fire and tears in his mind (Olson and Olson 1990: 17).

Bolide Meteors as "Spears"

Just as falling stars can resemble fiery tears (Fig. 8.15), brighter meteors also receive names based on their appearance. Since antiquity, the term "bolide" has indicated very bright fireballs, especially those that explode near the end of their path. Such a trail gradually broadens out, then narrows quickly at the very end as the light fades away. The trail has the appearance of a spear, and in fact bolide comes from the Greek word meaning "thrown spear." French chroniclers also called such meteors *lances de feu* – spears of fire.

Great Meteor of August 18, 1783

While searching journals from the eighteenth century, we discovered that Londoners saw during Blake's lifetime a spectacular bolide: the Great Meteor of August 18, 1783. This fireball, one of the most remarkable ever seen, appeared shortly after 9 p.m. and dazzled onlookers as it passed over Scotland and England, crossed the Channel, and continued beyond Paris and

Fig. 8.15 *Writing about "The Tyger" in 1942, George Winchester Stone conjectured that Blake's choice of words "may conjure up a picture of cascades of falling stars as though heaven were weeping." This nineteenth-century chromolithograph shows the 1833 Leonid meteor storm in the skies above Niagara Falls and suggests the image of meteors as fiery tears falling from heaven*

Burgundy. Witnesses in England reported loud sounds resembling thunder or cannon fire. Astronomer J.-C. Houzeau compiled early meteor reports and judged that "The most remarkable bolides of the eighteenth century, which first began to attract serious attention to these phenomena, and thus have a kind of historical importance, were those of 17 July 1771 [seen from Paris but not from London] and 18 August 1783" (Houzeau 1882: 800).

Although this meteor appeared in August, the direction of motion shows it was not a Perseid. Observers compared the fireball in apparent size to the full Moon, but described it as very much brighter with a procession of smaller meteors and an orange train of fire trailing behind. According to many reports, the meteor remained visible for about 30 s. It lit up the landscape brilliantly (Fig. 8.16) and cast sharp shadows as it passed slowly overhead.

Fig. 8.16 *This print, published by Henry Robinson, shows the procession of fireballs passing over Winthorpe, England, on August 18, 1783 (© Trustees of the British Museum. Used with permission)*

The spectacular nature of this phenomenon called forth no fewer than twelve accounts in *The Gentleman's Magazine* for 1783 and six articles in the *Philosophical Transactions of the Royal Society of London* for 1784. The great meteor was the subject of an aquatint (Fig. 8.17), watercolors, and prints by the artists Paul and Thomas Sandby, who pictured a group of six people viewing the fireball from the terrace of Windsor Castle (Olson and Olson 1989: 193; Olson and Pasachoff 1998: 68–74). A member of that group on the terrace published a detailed account of the August 18, 1783, observations from Windsor Castle (Cavallo 1784).

At this time William Herschel, discoverer of Uranus in 1781, occupied the position of King's Astronomer at Datchet, just 1½ miles (2.4 km) northeast of Windsor Castle on the Thames River. In fact, Herschel's observatory is among the trees in the middle distance of the Sandby painting. Herschel's practice was to observe every hour of every clear night, so the great meteor did not escape his notice. He followed the fireball for 45 s as it passed across the sky (Blagden 1784: 217).

Fig. 8.17 *This aquatint, published by Paul Sandby, shows the appearance of the Great Meteor of August 18, 1783, as seen from a terrace of Windsor Castle (© Trustees of the British Museum. Used with permission)*

Fireballs of such long duration are exceedingly rare. In this respect the great meteor of 1783 resembles the daylight fireball seen over western North America on August 10, 1972. That 1972 bolide performed a remarkable feat as it grazed Earth's atmosphere. It descended over Utah and Idaho, reached its closest approach to Earth's surface over Montana (the only place where witnesses heard loud sonic booms) and then ascended over Alberta and escaped back into space.

The 1783 meteor may have followed a similar Earth-grazing scenario. Over Scotland the descending fireball must have been too high for sonic booms to reach the ground; one account emphasized that "all observers of credit in Scotland deny that they heard anything." The meteor may have been closest to Earth's surface when passing over southeastern England, where many witnesses heard loud noises like thunder or cannon fire shortly after the meteor passed by. In England many independent observers reported a buzzing noise or a hissing, whizzing, or crackling as it passed by.

If the 1783 meteor had continued to descend, even louder sounds should have been reported from France. But though French sky watchers described the body as a brilliant skyrocket followed by sparks in a luminous cone of

Fig. 8.18 *This untitled drawing, generally attributed to William Blake's young brother Robert, may portray the Great Meteor of August 18, 1783 (© Trustees of the British Museum. Used with permission)*

fire, reports collected for the *Journal de Paris* by astronomer J. J. Lalande agreed that the beautiful visual effects occurred "sans bruit" – without any sound (Lalande 1783: 975). The main body of the meteor was last seen disappearing over the southeastern horizon, heading toward Switzerland.

Blake and the Great Meteor of 1783

William Blake depicts a mysterious celestial event in an unusual etching variously called "Approach of Doom" or "Awe-struck Group." The design of this work is based on a drawing (Fig. 8.18) generally attributed to his younger brother Robert Blake (1767–1787), who entered the Royal Academy Schools in 1782. Both Blake pictures have some similarity to the Sandbys' depiction of the scene at Windsor Castle: all show a group of six or seven people on an overlook, illuminated by an awe-inspiring celestial object bright enough to cast shadows behind them.

The object in the Blake pictures does not resemble lightning or a comet, as some authors have conjectured. Indeed, it cannot be a contemporary comet. Spectacular naked-eye comets appeared in 1744, 1759 (Halley) and 1769, but no such brilliant comets graced the skies again until 1807 and 1811. The historic bolide of 1783, with its luminous train, may have inspired these Blake works (Olson and Olson 1989: 194).

In its power to inspire awe, to generate loud sounds like thunder or a sonic boom, and to cast shadows by its brilliant light, the fireball of August 18, 1783, is similar to the great meteor observed over Chelyabinsk, Siberia, on February 15, 2013.

Meteors and "The Tyger"

Writing about "The Tyger," George Winchester Stone conjectured that Blake's words "may conjure up a picture of cascades of falling stars as though heaven were weeping" (Stone 1942: 19), and David V. Erdman mentioned in passing that an allusion to "falling stars" may be involved in this poem (Erdman 1954: 180). The astronomical analysis by our Texas State group supports these general suggestions with specific evidence that William Blake would have been aware of both St. Lawrence's "fiery tears" and the more spectacular bolides or heavenly "spears." These memorable visual events, with their popular names, may have appealed to Blake as images to use both in his poems and in his engravings.

References

Arberry, Arthur J. (1959) *The Romance of the Rubaiyat*. London: G. Allen & Unwin.

Battersby, Stephen (2010) Zodiacal Light. *New Scientist* **207**(No. 2767), July 3, 2007, 40–41.

Benson, Larry Dean (1987) *The Riverside Chaucer*, 3rd edition. Boston: Houghton Mifflin Co.

Berney, Charles V. (2004) In Search of Rosencrantz and Guildenstern. *Shakespeare Matters* **3**(3), 1, 12–17.

Blagden, Charles (1784) An account of some late fiery Meteors; with Observations. *Philosophical Transactions of the Royal Society of London* **74**, 201–232.

Buckley, G. T. (1963) What Star Was Westward from the Pole? *Notes and Queries* **208**(11), November, 412.

Burke, John G. (1986) *Cosmic Debris*. Berkeley: University of California Press.

Byrd, Deborah (2012) Everything You Need to Know: Zodiacal Light or False Dawn. EarthSky online at: http://earthsky.org/astronomy-essentials/look-for-the-zodiacal-light-or-false-dawn.

Carter, Tom (1982) Geoffrey Chaucer: Amateur Astronomer? *Sky &Telescope* **63**(3), March, 246–247.

Cartwright, David Edgar (1974) Years of peak astronomical tides. *Nature* **248**(No. 5450), 656–657.

Cavallo, Tiberius (1784) Description of a Meteor, Observed Aug. 18, 1783. *Philosophical Transactions of the Royal Society of London* **74**, 108–111.

Chambers, Edmund K., ed. (1906) *The Tragedy of Hamlet, Prince of Denmark*. Boston: Heath.

Chappell, Dorothea Havens (1945) Shakespeare's Astronomy. *Publications of the Astronomical Society of the Pacific* **57**(No. 338), October, 255–259.

Craig, Hardin, ed. (1951) *The Complete Works of Shakespeare*. New York: Scott, Foresman and Company.

Dean, John Candee (1924) The Astronomy of Shakespeare. *The Scientific Monthly* **19**(4) October, 400–406.

Dehkhoda, Ali-Akbar (1959) *Loghat-nama, Volume 26*. Tehran: University of Tehran.

Denning, William F. (1894) The August Perseids. *Popular Astronomy* **1**(6), 267–272.

Dole, Nathan Haskell (1896) *The Rubaiyat of Omar Khayyam*, variorum edition. Boston: J. Knight Co.

Erdman, David V. (1954) *Blake, Prophet Against Empire*. Princeton: Princeton University Press.

Fitzgerald, Edward (1859) *Rubaiyat of Omar Khayyam, the Astronomer-Poet of Persia*. London: Quaritch.

Fitzgerald, Edward (1868) *Rubaiyat of Omar Khayyam, the Astronomer-Poet of Persia, Second Edition*. London: Quaritch.

Fitzgerald, Edward (1901) *Letters of Edward Fitzgerald, Volume 1*. New York: Macmillan Company.

Gardner, John (1977) *Life and Times of Chaucer*. New York: Knopf.

Gingerich, Owen (1981) Great Conjunctions, Tycho, and Shakespeare. *Sky & Telescope* **61**(5), May, 394–395.

Gingerich, Owen (1985) The Astronomy of Alfonso the Wise. *Sky & Telescope* **69**(3), March, 206–208.

Grant, Edward (1974) *Source Book in Medieval Science*. Cambridge: Harvard University Press.

Guthrie, W. G. (1964) The Astronomy of Shakespeare. *Irish Astronomical Journal* **6**(6), 201–211.

Harmon, Orrin E. (1898) The Astronomy of Shakespeare. *Popular Astronomy* **6**(4), 232–241; **6**(5), 263–268; **6**(6), 321–326.

Harmon, William (1992) *The Top 500 Poems*. New York: Columbia University Press.

Harrington, Philip S. (2010) *Cosmic Challenge: The Ultimate Observing List for Amateurs*. Cambridge: Cambridge University Press.

Heron-Allen, Edward (1899) *Edward Fitzgerald's Rubaiyat of Omar Khayyam with Their Original Persian Sources*. London: Quaritch.

Herrick, Edward C. (1839) On the Shooting Stars of August. *American Journal of Science* **37**, 325–338.

Hodgson, Phyllis (1960) *The Franklin's Tale*. London: Athlone Press.

Horkheimer, Jack (1998) "The 'False Dawn' of Omar Khayyam, and How To Find It." PBS television, script for *Jack Horkheimer: Star Gazer*, Episode #SG 045-I, Show

1081, August 24 to 30, 1998. Online at: http://www.jackstargazer.com/JHSG_ DNLD.html.

Hotson, Leslie (1938) *I, William Shakespeare, do appoint Thomas Russell Esq.* New York: Oxford University Press.

Houzeau, Jean-Charles (1882) *Vade-Mecum de l'Astronome.* Bruxelles: F. Hayez.

Humboldt, Alexander von (1845a) *Kosmos.* Stuttgart and Tubingen: J. G. Cotta.

Humboldt, Alexander von (1845b) *Kosmos.* London: H. Baillière.

Jenkins, Harold, ed. (1982) *Hamlet: The Arden Shakespeare.* London: Methuen & Co.

Joyce, James (1934) *Ulysses* (first American edition). New York: Random House.

Lalande, Joseph Jérôme Lefrançois de (1783) Lettre sur le Météore du 18 de ce mois. *Journal de Paris* (No. 236), August 24, 1783, 974–975.

Levy, David H. (2011) *The Sky in Early Modern English Literature: A Study of Allusions to Celestial Events in Elizabethan and Jacobean Writing, 1572–1620.* New York: Springer.

Lynn, William Thynne (1905) Rosencrantz and Guildenstern. *Notes and Queries,* Tenth Series, 3(No. 63), March 11, 1905, 184.

Lynn, William Thynne (1905) The "False Dawn," or Zodiacal Light. *The Observatory* **28**(No. 361), 356–357.

Marshall, Roy K. (1971) Rambling Through September Skies. *Sky & Telescope* **42**(3), September, 158–160.

McCormick-Goodhart, Leander (1945) Shakespeare and the Stars. *Popular Astronomy* **53**(10), 489–503.

Meadows, Arthur J. (1969) *The High Firmament: A Survey of Astronomy in English Literature.* Leicester: Leicester University Press.

Moltke, Maximilian (1869) *Shakespeare's Hamlet, Englisch und Deutsch.* Leipzig: Albert Fritsch.

Moreux, Théophile (1928) *Le Ciel et l'Univers.* Paris: Doin.

Olson, Donald W. (1989) Who First Saw the Zodiacal Light? *Sky & Telescope* **77**(2), February, 146–148.

Olson, Donald W., and Marilynn S. Olson (1988) Zodiacal Light, False Dawn, and Omar Khayyam. *The Observatory* **108**, 181–182.

Olson, Donald W., and Marilynn S. Olson (1989) William Blake and August's Fiery Meteors. *Sky & Telescope* **78**(2), August, 192–194.

Olson, Marilynn S., and Donald W. Olson (1990) Celestial 'Spears' and Fiery 'Tears' in Blake's 'Tyger.' *Notes & Queries* **37**(1), 17–18.

Olson, Donald W., Marilynn S. Olson, and Russell L. Doescher (1998) The Stars of *Hamlet. Sky & Telescope* **96**(5), November, 68–73.

Olson, Donald W., Edgar S. Laird, and Thomas E. Lytle (2000) High Tides and *The Canterbury Tales. Sky & Telescope* **99**(4), April, 44–49.

Olson, Roberta J. M., and Jay M. Pasachoff (1998) *Fire in the Sky: Comets and Meteors, the Decisive Centuries, in British Art and Science.* Cambridge: Cambridge University Press.

Ottewell, Guy (1988) *Astronomical Calendar*. Greenville, South Carolina: Astronomical Workshop.

Payne-Gaposchkin, Cecilia Helena (1954) *Introduction to Astronomy*. New York: Prentice-Hall.

Pettersson, Hans (1913) Long Periodical Variations of the Tide-generating Force. *Conseil Permanent International pour l'Exploration de la Mer, Publications de Circonstance*, No. 65, 3–23.

Quetelet, Lambert-Adolphe-Jacques (1837) Etoiles filantes. *Bulletin de l'Academie Royale des Sciences et Belles-Lettres de Bruxelles* 4(9), 376–380.

Rao, Joe (2002) False Dawn: All About the Zodiacal Light. Essay posted on SPACE.com.

Redhouse, James W. (1878) On the Natural Phenomenon Known in the East by the Names Sub-hi-Kazib, etc., etc. *Journal of the Royal Asiatic Society* 10(3), 344–354.

Redhouse, James W. (1880) Identification of the "False Dawn" of the Muslims with the "Zodiacal Light" of Europeans. *Journal of the Royal Asiatic Society* 12(2), 327–334.

Roosen, Robert G. (1974) The Light of the Night Sky. *Sky & Telescope* 47(4), April, 231–234.

Rylands, George, ed. (1947) *Hamlet*. Oxford: Clarendon Press.

Schaaf, Fred (1983) *Wonders of the Sky*. New York: Dover.

Schiaparelli, Giovanni V. (1866) *Intorno al Corso ed all'Origine Probabile delle Stelle Meteoriche*. Rome: Tipografia delle Scienze Matematiche e Fisiche.

Simpson, Percy (1904) Rosencrantz and Guildenstern. *Athenaeum* No. 3997, June 4, 1904, 731–732.

Spencer, T. J. B., ed. (1996) *Hamlet*. London: Penguin Books.

Stone, George Winchester (1942) Blake's The Tiger. *Explicator* 1(No. 3), December, 19.

Tatlock, John S. P. (1914) *The Scene of the Franklin's Tale Visited*. London: Chaucer Society, Kegan Paul, Trench, Trübner & Co.

Thoren, Victor E. (1990) *The Lord of Uraniborg: A Biography of Tycho Brahe*. New York: Cambridge University Press.

Tuve, Rosemond (1933) *Seasons and Months*. Paris: Librairie Universitaire.

Usher, Peter D. (1997) Shakespeare's Cosmic World View. *Mercury* 26(1), 20–23.

Weitzenhoffer, Kenneth (1985) Chaucer, Two Planets, and the Moon. *Sky & Telescope* 69(3), March, 278.

Wood, Chauncey (1970) *Chaucer and the Country of the Stars*. Princeton: Princeton University Press.

Wood, Fergus J. (1978) *The Strategic Role of Perigean Spring Tides in Nautical History and North American Coastal Flooding, 1635–1976*. Washington, DC: National Oceanic and Atmospheric Administration.

9

Literary Skies After 1800

The previous chapter investigated references to astronomical phenomena in the poems, tales, and plays of Omar Khayyam, Geoffrey Chaucer, William Shakespeare, and William Blake, with all of those literary works created prior to the year 1800. The three astronomical passages in this chapter come from more recent novels and poems. The examples range from the moonlight shining on Mary Shelley's window, as she conceived of the idea for *Frankenstein*, and a spectacular meteor procession observed by Walt Whitman, to a meteor that dropped from the sky over James Joyce's Dublin.

Mary Wollstonecraft Shelley (1797–1851) had the idea for her novel *Frankenstein* during the "haunted summer" of 1816. The story began as a tale told to an audience including the famous poets Lord Byron and Percy Shelley, with the group gathered around a fireplace of a villa overlooking Lake Geneva, Switzerland. On what night did Mary Shelley conceive of the idea for *Frankenstein*? Was it a dark night or a moonlit night? Is her account of the origin of *Frankenstein* accurate? How can astronomical analysis of the phase and position of the Moon, along with meteorological records, solve a long-standing mystery about the precise date when she began her tale and, more importantly, about the accuracy of Mary Shelley's account?

Walt Whitman (1819–1892) observed a "strange huge meteor procession" that inspired him to write the poem "Year of Meteors" in *Leaves of Grass*. Previous authors have tried to understand what Whitman witnessed, but none of their various conflicting explanations matches well with the poem's description. How can we resolve this controversy? What is the connection to the artist Frederic Church and a painting that depicts a spectacular string of fireballs crossing the night sky? When did this remarkable event occur? What was the celestial phenomenon that moved Frederic Church to create a painting and Walt Whitman to write a poem?

D.W. Olson, *Celestial Sleuth: Using Astronomy to Solve Mysteries in Art, History and Literature*, Springer Praxis Books, DOI 10.1007/978-1-4614-8403-5_9, © Springer Science+Business Media New York 2014

The novel *Ulysses* by James Joyce (1882–1941) contains many references to astronomy. As the novel's characters conclude a day and night of wandering, they observe a meteor "precipitated with great velocity across the firmament." Joyce's text mentions the specific constellations along the meteor's path. How does this evidence, along with clues to date and time of night, allow us to identify the meteor shower that produced this "celestial sign" in the sky above Dublin?

The Moon and the Origin of *Frankenstein*

During summer nights in June 1816, as jagged lightning bolts filled the sky and thunder echoed from the nearby mountains, a group including Lord Byron, Percy Shelley, and Mary Wollstonecraft Shelley told ghost stories around a fireplace in a villa overlooking Lake Geneva, Switzerland. The tales invented during this time created horror's two most famous characters: the Vampyre (which later inspired Bram Stoker's *Dracula*) and Frankenstein's monster. What is the connection to a volcanic eruption in Indonesia in 1815? Why was 1816 called the "year without a summer"? On what night did Mary Shelley conceive of the idea for *Frankenstein*? Is her story of the origin of *Frankenstein* accurate? How can astronomical analysis, along with meteorological records, solve a long-standing mystery about the precise dates of these "dark and stormy nights" and about the truthfulness of Mary Shelley's account?

The Haunted Summer of 1816

During an evening in June 1816, Mary Wollstonecraft Shelley first began to narrate her tale of *Frankenstein*, an enduring and iconic creation that has inspired classic horror films (Fig. 9.1) and countless popular culture references. The group that listened to Mary in Villa Diodati included two of England's most famous poets, Lord Byron and Percy Bysshe Shelley, along with Mary's stepsister Claire Clairmont and the physician John Polidori. Byron and Polidori lived in Villa Diodati (Fig. 9.2) during the summer of 1816, while the Shelley party rented a nearby house known as Maison Chappuis.

A volcano played a role in the stormy weather that accompanied the origin of *Frankenstein*. Mount Tambora in Indonesia had exploded in April 1815, and the cloud of ash, dust, and aerosols from this event, one of the greatest eruptions in historic times, affected weather worldwide for several years. The year 1816 became known as the "year without a summer," with

Fig. 9.1 *Boris Karloff as the monster in a publicity photograph for the 1931 Frankenstein film (Sara Karloff, Karloff Enterprises. Used with permission)*

cold temperatures and nearly constant rain that drove the Byron-Shelley group inside.

Many modern authors have retold the story of what happened in Villa Diodati, but the detailed chronology of that summer is still a matter of dispute.

Mary Shelley's Account

Mary Shelley added an Introduction to the 1831 edition of *Frankenstein* to describe how it all began: "I shall thus give a general answer to the question, so frequently asked me – 'How I, then a young girl, came to think of, and to dilate upon, so very hideous an idea?'…In the summer of 1816, we visited Switzerland, and became the neighbours of Lord Byron….[I]t proved a wet, ungenial summer, and incessant rain often confined us for days to the house. Some volumes of ghost stories, translated from the German into French, fell into our hands" (Shelley 1831: v–vii).

Fig. 9.2 *This hand-colored steel engraving from circa 1835 shows Villa Diodati and the Moon reflecting in the waters of Lake Geneva*

At first the group read the published stories aloud, but Mary recalled that Byron had an idea:

"We will each write a ghost story," said Lord Byron; and his proposition was acceded to…I busied myself to think of a story…One which would speak to the mysterious fears of our nature, and awaken thrilling horror – one to make the reader dread to look round, to curdle the blood, and quicken the beatings of the heart…I thought and pondered – vainly. I felt that blank incapability of invention which is the greatest misery of authorship, when dull Nothing replies to our anxious invocations. Have you thought of a story? I was asked each morning, and each morning I was forced to reply with a mortifying negative. (Shelley 1831: viii–ix)

After several days of such embarrassment, a talk around the fireplace gave Mary the spark of an idea:

[V]arious philosophical doctrines were discussed, and among others the nature of the principle of life…Night waned upon this talk, and even the witching hour had gone by, before we retired to rest. When I placed my head on my pillow, I did not sleep…My imagination, unbidden, possessed and guided me…I saw the pale student of unhallowed arts kneeling beside the thing he had put together. I saw the hideous phantasm of a man stretched out, and then, on the working of some powerful engine, show signs of life…. (Shelley 1831: ix–x)

Fig. 9.3 *Mary Shelley first related her tale of horror in the Villa Diodati on the shores of Lake Geneva, Switzerland. The events in Villa Diodati during the summer of 1816 are the subject of The Yellow Leaf, a play produced in 2009 by the Pioneer Theatre Company of Salt Lake City. In this scene from the play, Christopher Kelly appears as Percy Bysshe Shelley, and Ellen Adair as Mary Wollstonecraft Godwin Shelley (Photograph by Robert Clayton for the Pioneer Theatre Company. Used with permission)*

As she returned to reality, Mary noticed that moonlight was shining outside her bedroom window: "I wished to exchange the ghastly image of my fancy for the realities around. I see them still; the very room, the dark *parquet*, the closed shutters, with the moonlight struggling through, and the sense I had that the glassy lake and white high Alps were beyond....On the morrow I announced that I had *thought of a story*...a transcript of the grim terrors of my waking dream" (Shelley 1831: xi).

That evening Mary Shelley began to tell her story (Fig. 9.3). At first she planned on only a few pages, but Percy Shelley encouraged her to develop the tale into a full-length novel, *Frankenstein*. Lord Byron and Percy Shelley soon lost interest in the ghost story project, but a fragment by Byron was later completed by Polidori as a novel titled *The Vampyre*. This book helped to inspire similar vampire tales throughout the nineteenth century, culminating in Bram Stoker's famous story. Horror's two most famous characters – Frankenstein's monster and Count Dracula – both trace their origins back to the evenings around the fireplace in Villa Diodati.

Given this significance to literature and popular culture, somewhat surprisingly the precise dates for Byron's suggestion and for Mary's "waking dream" are still the subject of a controversy in which some authors have

questioned Mary Shelley's memory and truthfulness. We wondered whether the astronomical reference – Mary's mention of moonlight outside her bedroom window – might allow us to test the accuracy of her recollections and to determine a precise date for the origin of *Frankenstein.*

Date of Byron's Ghost Story Suggestion?

The journals and letters written by the party during their stay in Switzerland help to establish the chronology of this famous summer. The overwhelming majority of scholars conclude that Byron probably made his ghost story proposition on June 16th. For example, James Rieger asserts in an article: "16 June is the probable date of Byron's suggestion" (Rieger 1963: 467).

Anne Mellor's biography of Mary Shelley names the same date: "June 16 (this is presumably the evening in which they read and agreed to write ghost stories)" (Mellor 1988: 53).

Another biographer, Emily Sunstein, suggests that the Shelley party was unable to return to Maison Chappuis because of the storms that night: "The excitement intensified during the week of June 16. On the sixteenth [the group from] Chap[p]uis was caught at Diodati by a wild downpour and spent the night. They all gathered at the fireplace and read aloud a…book of ghost stories.…[T]his inspired Byron to propose that they each write a ghost story" (Sunstein 1989: 121).

The same June 16th date for Byron's proposition was likewise adopted in an essay by Burton Pollin (1965: 98), a *Life* magazine article by Samuel Rosenberg (1968: 80), in biographies by Richard Holmes (1975: 328) and Miranda Seymour (2000: 154) and a study by Dorothy and Thomas Hoobler (2006: 143), along with books and essays by many other authors.

The evidence for this June 16th date comes from a diary kept by Polidori during the summer of 1816 (Rossetti 1911: 124). Polidori mentions that the entire group spent the night at Villa Diodati: "June 16…Shelley came, and dined and slept here, with Mrs. S[helley] and Miss Cla[i]re Clairmont."

Polidori's diary entry for the next night clearly implies that Mary had begun her story with all the others, except Polidori himself: "June 17.…The ghost-stories are begun by all but me."

Therefore, identifying June 16th as the night of Byron's proposal conflicts with Mary's definite and detailed description of how she agonized for several days – not just a few hours – while trying to come up with an idea for a story. Some authors have considered this apparent inconsistency as a stumbling block to accepting Mary Shelley's account.

Was Mary Shelley Being Dishonest?

Some scholars dismissed Mary Shelley's version of the origin of *Frankenstein* as a romantic invention. James Rieger offered especially harsh criticism of Mary Shelley's 1831 Introduction: "The received history of the contest in writing ghost-stories at Villa Diodati during the 'wet, ungenial' June of 1816 is well known to every student of the Byron-Shelley circle. It is, as we shall see, an almost total fabrication....No statement in her account of the writing party at Diodati, or even of the inception of her own idea, can be trusted... the entire chronology of conception is altered" (Rieger 1963: 461–469).

Anne Mellor likewise agreed that a "different chronology" is needed and argued that the 1831 Introduction makes a "significant error": "lengthening the lapse of time between Byron's proposal and her dream-invention of a plot for her ghost story from a few hours to several days" (Mellor 1988: 53).

Miranda Seymour concluded that Mary's account is simply a lie: "She wrote the 1831 Preface in order to help sell the book; telling the best possible story mattered more than the truth" (Seymour 2000: 158).

Or Was Mary Shelley Being Honest?

Other authors, perhaps more sympathetic to Mary Shelley, have tried to produce a chronology consistent with Mary's account by including a delay of several days between Byron's ghost story suggestion and Mary's "waking dream" that gave her the idea for *Frankenstein*. These scholars still place Byron's proposition on June 16th and then assign Mary's "waking dream" to the night immediately preceding June 22nd, the date when the fireside group temporarily broke up as the weather improved and Byron and Shelley departed to sail around Lake Geneva. Burton Pollin advanced this theory: "On June 16 the group read aloud a collection of ghost stories....Byron then suggested that each one write a ghost story...it must be assumed that her tale first took the shape of her hideous dream, described in the preface, just before Shelley and Byron departed on their tour of Lake Leman [Lake Geneva]..." (Pollin 1965: 98).

Emily Sunstein likewise dated the origin of *Frankenstein* to the night before the poets' departure:

> On June 22 Byron and Shelley were to leave to sail around the lake....The night before their departure....When Mary went to bed, still worrying about her ghost story, she had a "waking" hypnagogic nightmare...Next morning after the poets sailed off, she sat down at her work table and...began a tale of a few pages narrating her dream. When Shelley returned on June 30, he was impressed and urged her to go on. (Sunstein 1989: 122)

Similar arguments, dating the origin of *Frankenstein* near June 22nd, appear in the biography by Richard Holmes (1975: 330) and the study by Dorothy and Thomas Hoobler (2006: 148).

When Did the Ghost Stories Begin?

Most modern authors adopted June 16th as the probable date for Byron's ghost story proposition. But we realized that Polidori's diary has no description of Byron making his original suggestion, and a specific date appears nowhere else in the primary sources.

The editors of Mary Shelley's journals recognized this dating uncertainty and cautiously stated that "Byron proposed that they should each produce a ghost story" at "some time" after "10 June, when Byron and Polidori moved into the Villa Diodati" (Feldman and Scott-Kilvert 1987: 118).

Charles Robinson, in his facsimile edition of Mary Shelley's manuscripts, surveyed the original sources and lists three possibilities: "... the ghost stories could have begun (1) *before 15 June* (as is suggested by M[ary] W[ollstonecraft] S[helley]'s recollection of her delay in conceiving a story); (2) on 15 June ... or (3) on 16 June (the date often given for the start of the stories)" (Robinson 1996: lxxvii).

Based on the surviving letters, journals and memoirs, Byron's ghost story proposal appears to fall between June 10th and June 16th. In addition to this written material, our analysis can make use of natural phenomena – moonlight and stormy weather.

The Moon in Nature and Novel

In particular, the astronomical reference in Mary Shelley's 1831 Introduction might help to resolve the dating controversy. Mary noticed the moonlight outside her bedroom window at the point in her waking dream when she imagined the monster confronting his sleeping creator, as she explained in her 1831 Introduction:

> He sleeps; but he is awakened; he opens his eyes; behold the horrid thing stands at his bedside, opening his curtains, and looking on him with yellow, watery, but speculative eyes.
>
> I opened mine in terror....I wished to exchange the ghastly image of my fancy for the realities around. I see them still; the very room, the dark parquet, the closed shutters, with the moonlight struggling through. (Shelley 1831: xi)

Mary mentioned that her story had its origin as "a transcript of the grim terrors of my waking dream," and indeed this description of moonlight and window shutters was copied almost verbatim into the novel. The following passage appears in Chap. 4 in the 1818 edition and Chap. 5 in the 1831 edition of *Frankenstein*, as Dr. Frankenstein recalls the night of the monster's creation: "I started from my sleep with horror…by the dim and yellow light of the moon, as it forced its way through the window-shutters, I beheld the wretch – the miserable monster whom I had created. He held up the curtain of the bed; and his eyes, if eyes they may be called, were fixed on me" (Shelley 1818: 100, 1831: 44).

So far as we know, no previous scholars have made use of this astronomical clue, yet Mary Shelley's use of other natural phenomena suggests that we should take seriously this lunar reference.

The Storm in Nature and Novel

For example, Mary also transcribed a description of a June 1816 storm directly into her novel. One of Mary Shelley's letters, begun on June 1st and continued at intervals over the next 2 weeks, includes a passage about the most spectacular thunderstorm that she witnessed over Lake Geneva:

> The thunder storms that visit us are grander and more terrific than I have ever seen before. We watch them as they approach from the opposite side of the lake, observing the lightning play among the clouds in various parts of the heavens, and dart in jagged figures upon the piny heights of Jura, dark with the shadow of the overhanging cloud, while perhaps the sun is shining cheerily upon us. One night we enjoyed a finer storm than I had ever before beheld. The lake was lit up – the pines on Jura made visible, and all the scene illuminated for an instant, when a pitchy blackness succeeded, and the thunder came in frightful bursts over our heads amid the darkness. (Shelley 1817: 99–100)

A scene based on this event appears in *Frankenstein*, in Chap. 6 of the 1818 edition and Chap. 7 of the 1831 edition, with almost identical wording about the thunder and the alternation of light and darkness: "I saw the lightnings playing…in the most beautiful figures…the thunder burst with a terrific crash over my head…vivid flashes of lightning dazzled my eyes, illuminating the lake, making it appear like a vast sheet of fire; then for an instant everything seemed of a pitchy darkness" (Shelley 1818: 145–146, 1831: 60).

Byron almost certainly watched this especially spectacular storm. He devoted five stanzas in Canto III of *Childe Harold's Pilgrimage*, written in

Villa Diodati during that summer, to a nearly identical account of the thunder and the intermittent illumination of the lake, including these passages:

> XCII.
> The sky is changed! – and such a change! O night,
> And storm, and darkness...
> From peak to peak, the rattling crags among,
> Leaps the live thunder! Not from one lone cloud,
> But every mountain now hath found a tongue;
> And Jura answers, through her misty shroud,
> Back to the joyous Alps, who call to her aloud!
>
> XCIII.
> And this is in the night: – Most glorious night!
> Thou wert not sent for slumber! let me be
> A sharer in thy fierce and far delight –
> A portion of the tempest and of thee!
> How the lit lake shines, a phosphoric sea,
> And the big rain comes dancing to the earth!
> And now again 'tis black....

Byron added a remark, published as his note 21 with his Third Canto, that provides a precise date for this storm: "The thunder-storms to which these lines refer, occurred on the 13th of June, 1816, at midnight. I have seen among the Acroceraunian mountains of Chimari several more terrible, but none more beautiful."

Polidori's diary entry for June 13th likewise mentions a "thunder and lightning" storm so strong that Polidori, attempting to walk from Geneva back to Villa Diodati that evening, lost his way and was forced to spend the night at the Hotel Balance in town.

Some authors (Wolfson and Levao 2012: 138) have dated this storm to May 1816, while others have deduced that the storm occurred in mid-June (Moskal 1996: 45). The primary sources show that the correct date for the storm is June 13, 1816.

The weather event of June 13th copied into *Frankenstein* supports the possibility that Mary may have derived her description of moonlight in the introduction and the novel from a real event.

Trip to Switzerland

In June 1816, which nights were moonless? On which nights could bright moonlight have shone on Mary Shelley's bedroom window after midnight

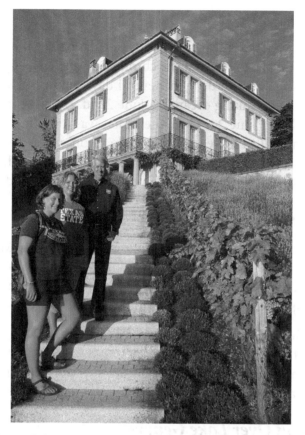

Fig. 9.4 *Members of the Texas State University group, Ava Pope, Kelly Schnarr, and Donald Olson, on the steep slope just below Villa Diodati (Photograph by Roger Sinnott. Used with permission)*

(after "the witching hour had gone by")? On which night would the Moon have been hidden behind the hill slopes that surround Lake Geneva?

To help answer these questions, our Texas State group traveled in August 2010 to the town of Cologny, about 2 miles northeast of downtown Geneva. Villa Diodati still stands there on a steep slope overlooking the lake (Fig. 9.4). Maison Chappuis no longer exists, but a monograph devoted to the history of this cottage includes archival photographs and maps that show its exact location (Häusermann 1952: 1–7). Maison Chappuis stood closer to the lake and lower down on the slope, approximately 850 ft to the northwest of Villa Diodati. From the windows of both of these houses, relatively clear views prevailed to the west, but the hill would block the view of the eastern sky. From our GPS measurements of distances and elevations in Cologny (Olson et al. 2011: 73), we determined that the average slope of the hill is 15°.

June 22, 1816, Ruled Out

Combining our topographical result with calculations of the Moon's phase and position allows us to rule out the chronology suggested by authors who accept Mary's account of a delay of several days before she conceived her idea and assign her "waking dream" to June 22nd. During the hours before morning twilight on June 22, 1816, the Moon was a waning crescent, only 13 % lit, and the hill to the east of Mary's location would have completely blocked the view of the rising Moon. Moonlight could not have fallen on Mary's bedroom window in the pre-dawn hours on June 22nd.

Lunar Observers

However, we can suggest an earlier date, consistent with Mary Shelley's account in her 1831 Introduction. Three lunar references in the primary source material show that Mary and her friends were interested observers of the sky and help to strengthen the argument:

1. A waxing Moon near the end of May and early June 1816
2. A nearly full Moon on June 9, 1816
3. Bright moonlight shining on Mary Shelley's window on the night of her "waking dream."

Waxing Moon Over Lake Geneva

In a letter started in the second half of May 1816 and continued at intervals over the next 2 weeks, Mary Shelley mentioned boating on Lake Geneva (Fig. 9.5) in the moonlight: "[E]very evening at about six o'clock we sail on the lake....Twilight here is of short duration, but we at present enjoy the benefit of an increasing moon, and seldom return until ten o'clock" (Shelley 1817: 95–96).

Polidori's diary entries provide the precise dates for several of these evening excursions on the lake:

- May 30. I, Mrs. S[helley], and Miss G[odwin], on to the lake till nine…
- May 31. …went into a boat with Mrs. S[helley], and rowed all night till 9…
- June 2. Dined with S[helley]; went to the lake with them and L[ord] B[yron]. Saw their house; fine. Coming back, the sunset, the mountains on one side, a dark mass of outline on the other, trees, houses hardly visible, just distinguishable; a white light mist,

Fig. 9.5 *Mary Shelley noted in a letter that the Byron-Shelley group was able to continue boating expeditions on Lake Geneva into the evening hours because they enjoyed "the benefit of an increasing moon." Polidori's diary likewise described how the scene was "lighted by the moon which gilt the lake." This photograph captures the Moon and Jupiter over Lake Geneva on October 21, 2010 (Photograph by Daniel Shalloe. Used with permission)*

> resting on the hills around, formed the blue into a circular dome bespangled with stars only and lighted by the moon which gilt the lake. The dome of heaven seemed oval. At 10 landed....

At 9 p.m. on the evenings of May 30th, May 31st, and June 2nd, 1816, we calculate that the Moon was a waxing crescent, with illuminated fractions of 15 %, 24 %, and 46 %. This is consistent with Mary's mention of an "increasing moon." Sunset was at about 7:45 p.m., and moonset occurred after 11 p.m. on each of these days, in perfect agreement with the descriptions by both Mary Shelley and Polidori that the moonlit boating excursions continued until 9 p.m. or 10 p.m.

Full Moon and Move to Villa Diodati

Another Polidori diary entry from a week later makes a passing remark about the Moon:

- June 9. …came home. Looked at the moon, and ordered packing-up.

On June 9, 1816, the Moon was nearly full, more than 99.9 % illuminated, as it rose over Mont Blanc at about 8 p.m., explaining why it caught Polidori's eye. Polidori's mention of "packing-up" refers to the impending move with Byron from their temporary hotel lodgings, as mentioned in the next day's diary entry:

- June 10. Got things ready for going to Diodati…went to Diodati… Shelley etc. came to tea, and we sat talking till 11….

Byron's suggestion to write ghost stories could have fallen between June 10th (the first evening in Villa Diodati when the group gathered around the fireplace) and about June 13th (the night of the spectacular storm). This allows time, in the following days, for Mary's struggle to think of a story. Polidori's diary mentions that the combined Byron-Shelley group met at Diodati on June 15th:

- June 15. Shelley etc. came in the evening…a conversation about principles, – whether man was to be thought merely an instrument.

This may be the conversation about the "principle of life" that gave Mary the spark of her idea.

The Moon and the Origin of Frankenstein

Mary Shelley's "waking dream" and the origin of *Frankenstein* could therefore have occurred in the early morning hours of June 16, 1816. A bright waning gibbous Moon (Fig. 9.6), 67 % lit, rose into the southeastern sky that night. Standard computer programs for Cologny will give the time of moonrise as 12:01 a.m. on June 16th, but this calculation assumes a flat horizon. The Moon actually would not have cleared the 15° slope until just before 2 a.m. and then would have illuminated the windows of the houses. This calculated time is in good agreement with Mary Shelley's description in her 1831 Introduction that "the witching hour had gone by…I see them still; the very room…the closed shutters, with the moonlight struggling through."

Because June 16th was only 5 days before the summer solstice, morning twilight came early. Sunrise occurred at 4:07 a.m., and the brightening sky would have overpowered the moonlight by roughly 3 a.m. Our calculations

Fig. 9.6 *The waning gibbous Moon pictured here is two-thirds illuminated. Light from a bright waning gibbous Moon illuminated Mary Shelley's bedroom window on the night of her "waking dream" that was the origin of Frankenstein (Photograph by Anthony Ayiomamatis. Used with permission)*

and chronology (Table 9.1) therefore suggest that Mary Shelley's "waking dream" happened between 2 a.m. and 3 a.m. on June 16, 1816.

If the Moon had not been shining on her window that morning, the astronomical analysis would have uncovered a fabrication on her part. Instead, the bright waning gibbous Moon, together with the chronology we suggest, supports the idea that Mary Shelley's 1831 Introduction gave a generally accurate account of the origin of *Frankenstein* (Olson et al. 2012).

Table 9.1 *Chronology consistent with Mary Shelley's 1831 introduction, Polidori's diary and the astronomical analysis*

1816	
May 27	New Moon
May 30–June 2	Boating on the lake in the evenings by the light of an "increasing Moon"
June 3	1st quarter Moon
June 9	Polidori observes the nearly full Moon
June 10	Full Moon; Byron and Polidori move into Villa Diodati
June 10–13	Byron proposes ghost stories on one of these evenings; Mary Shelley is initially unable to think of a story
June 13	Spectacular lightning and thunderstorm over Lake Geneva, witnessed by Mary Shelley and Byron
June 15	Evening conversation at Villa Diodati about the principle of life
June 16	The origin of *Frankenstein*: Mary Shelley's "waking dream" (2 a.m. to 3 a.m.) with light from a waning gibbous Moon struggling through the closed shutters; that evening Mary Shelley begins to tell her story to the others at Villa Diodati
June 17	Third quarter Moon; all of the group (except Polidori) have begun their stories
June 22	Byron and Percy Shelley depart to tour Lake Geneva
June 25	New Moon

Walt Whitman's "Year of Meteors"

A "strange huge meteor procession" inspired Walt Whitman to write the poem "Year of Meteors" in *Leaves of Grass*. Previous authors have tried to understand what Whitman observed, but none of their various conflicting explanations matches well with the poem's description. How can we resolve this controversy? What is the identity of "the comet that came unannounced, out of the north, flaring in heaven," also mentioned in Whitman's poem? What is the connection to the artist Frederic Church and a painting that depicts a spectacular string of fireballs crossing the night sky? When did this remarkable event occur? How rare are meteors of the type witnessed by Whitman and Church? What was the celestial phenomenon that moved Walt Whitman to write a poem and Frederic Church to create a painting?

Fig. 9.7 *Walt Whitman (1819–1892). The portrait on the left shows Whitman as he appeared circa 1860, while the image on the right shows the celebrated poet in his old age*

Whitman's "Year of Meteors"

Leaves of Grass, the great collection by American poet and avid sky watcher Walt Whitman (Fig. 9.7), includes a poem with the intriguing title "Year of Meteors (1859–60.)."

The verses make topical references to the most newsworthy events of that time: the hanging of John Brown on December 2, 1859; the arrival of the giant steamship *Great Eastern* in New York harbor on June 28, 1860; the visit of the Prince of Wales to New York City in October 1860; and the presidential election won by Abraham Lincoln on November 6, 1860 (Fig. 9.8). Of special interest to astronomers, Whitman describes a comet and a meteor event:

> *Nor the comet that came unannounced, out of the north, flaring in heaven,*
> *Nor the strange huge meteor procession, dazzling and clear, shooting over our heads,*
> *(A moment, a moment long, it sail'd its balls of unearthly light over our heads,*
> *Then departed, dropt in the night, and was gone;)* (Whitman 1865: 52, 1867: 52)

Despite the significance of *Leaves of Grass*, no previous scholars have precisely determined the celestial events that served as the inspiration for these two astronomical images.

Whitman's Comet

Identifying the "comet that came unannounced, out of the north, flaring in heaven" is relatively straightforward. Both the direction of motion and

Fig. 9.8 *Top left: John Brown in a woodcut from Frank Leslie's Illustrated Newspaper. Top center: A beardless Abraham Lincoln on an ornate 1860 campaign button. Top right: The Prince of Wales in a woodcut from Harper's Weekly. Bottom: The Great Eastern steamship in a chromolithograph from the Illustrated London News*

brilliance make it clear that Whitman is referring to Comet 1860 III, also known as the Great Comet of 1860 (Fig. 9.9). Discovered in the northern constellation Auriga on June 18th, this comet rapidly grew in brightness and developed a tail about 15–20° long. By the second half of July 1860 the comet moved southward through the constellations Crater and Corvus and thereafter was visible only to observers in the Southern Hemisphere.

Fig. 9.9 *Whitman's poem mentions a comet. Both the direction of motion and brilliance make it clear that Whitman is referring to Comet 1860 III, also known as the Great Comet of 1860. This woodcut of the comet appeared in an 1865 French volume, L'espace céleste et la nature tropicale by Emmanuel Liais*

Whitman's mysterious reference to a "strange huge meteor procession" poses a much more difficult problem in identification. The previous explanations of this poetic image have included a wide variety of nineteenth-century sky phenomena interesting in their own right – none of which is a satisfactory match to the poem's description of meteors.

1833 Leonids?

Joseph Beaver asserts that the "short poem, 'Year of Meteors,' is based upon the meteor shower of November 12 and 13, 1833" (Beaver 1951: 58). We know that Whitman observed this spectacular Leonid meteor storm in 1833, because the New York Public Library manuscript collection includes his handwritten account: "The shower of meteors – this occurred in the night of 12th–13th Nov. 1833 – toward morning – myriads in all directions, some with long shining white trains, some falling over each other like falling water – leaping, silent, white, apparitions around up there in the sky over my head." (Walt Whitman manuscript, M1231694, Berg Collection of English and American Literature, New York Public Library)

During the 1833 event, thousands of meteors descended all over the sky for several hours, from about midnight to dawn, with many brilliant fireballs visible even after sunrise. But the *Leaves of Grass* meteor poem describes a meteor procession that lasted for a "moment, a moment long....Then departed, dropt in the night, and was gone." The year 1833 is inconsistent with the poem's title, and the visual appearance is completely wrong.

1858 Leonids?

Some modern authors have been misled by the wording in another text fragment, handwritten by Whitman and preserved in the Library of Congress:

> *And there is the meteor-shower, wondrous and dazzling, the 12th – 13th Eleventh*
> * Month, year 58 of The States,*
> *between midnight and morning.*
> *See you! the spectacle of the meteors overhead –*
> *See you! myriads in all directions, some with long shiny trains,*
> *Some rolling over each other like water poured out and falling – leaping, silent,*
> * white apparitions of the sky.*
> (Walt Whitman manuscript, Feinberg collection #705, Library of Congress)

The phrase "year 58" in this fragment apparently caused Whitman scholars to link this description to the meteor poem in *Leaves of Grass*. It might at first seem logical to think that the "year 58" means 1858, a year which is at least close to the years in the title "Year of Meteors (1859–60.)."

Indeed, an important edition of *Leaves of Grass* claims that the poet observed a meteor shower on "November 12–13, 1858" (Blodgett and Bradley 1965: 238). An essay by Larzer Ziff reiterates the assertion that on "the night of 12 November 1858, Walt Whitman witnessed a meteor shower." (Ziff 1984: 581).

This theory, though, has two significant problems. The nineteenth-century astronomical journals that we consulted show no Leonid meteor activity at all in November 1858. More importantly, these modern scholars fail to understand the meaning of Whitman's phrase "year 58 of The States." By the conventional method of counting employed in almanacs in the nineteenth century (and used on the title pages of some books by Whitman himself):

- 1st year of Independence = (July 4, 1776, to July 4, 1777)
- 58th year of Independence = (July 4, 1833, to July 4, 1834).

The great Leonid meteor storm that astonished observers, including Whitman, on the night of November 12–13, 1833, therefore happened during the 58th year of the United States. The Library of Congress manuscript definitely refers to the 1833 Leonids, even using much of the identical language found in the New York Public Library manuscript that explicitly includes the date of 1833. The 1833 Leonid meteor storm does not match the year or the visual appearance of the meteors in the *Leaves of Grass* poem.

1859 Daylight Fireball?

Most recently, scholars have connected Whitman's meteor poem to a spectacular fireball seen from New York City on November 15, 1859. This seems at first plausible since the year 1859 does match the poem's title. This identification appears in a Whitman biography (Kaplan 1980: 257). A scholarly article developed the same theory about the November 1859 fireball in more detail (Ljungquist 1989), and several more authors thereafter have repeated this idea.

However, the November 1859 event involved only one fireball, and Whitman refers to multiple meteors in a "procession" that "sail'd its balls of unearthly light over our heads." Moreover, contemporary newspaper stories and scientific journals establish that the November 15, 1859, meteor fell from the daytime sky over New York City near 9:30 a.m., while the poem describes fireballs "in the night." The number of fireballs is wrong, and the time of day is completely wrong.

Meteor Mystery

If all of these identifications are incorrect, then what did Whitman see in the sky? For more than a dozen years, our Texas State group tried to solve this meteor mystery, without success. The solution eventually came about through a combination of astronomy and art. The astronomy involves the celestial phenomena known as Earth-grazing meteors and meteor processions. The connection to art comes through a painting by the nineteenth-century American artist Frederic Edwin Church.

Earth-Grazing Meteors

During familiar meteor showers such as the Perseids of August, the Leonids of November and the Geminids of December, the meteor paths in the sky appear to diverge from a point called the radiant. Astronomers name the shower after the constellation containing the radiant. A meteor observer, tracing the path of a meteor backwards across the sky, will find the line appearing to come from the constellation containing the radiant. When the shower radiant is high in the sky, each individual meteor descends vertically through Earth's atmosphere in a relatively short time, ranging from a fraction of second to perhaps a few seconds.

Table 9.2 *Meteor processions in history*

Date	Ground track
1783 August 18	Scotland, England, English Channel, France
1860 July 20	Wisconsin, Michigan, Ontario, western New York, Pennsylvania, eastern New York, Atlantic Ocean
1876 December 21	Kansas, Missouri, Illinois, Indiana, Ohio, Pennsylvania
1913 February 9	Alberta, Saskatchewan, Manitoba, Minnesota, Michigan, Ontario, New York, Pennsylvania, New Jersey, Atlantic Ocean

However, when a shower radiant is near the horizon, a viewer can follow an Earth-grazing meteor as it moves nearly parallel to Earth's surface and remains visible for a much longer time. Such meteors can follow paths that can extend almost from horizon to horizon. When the speed of an Earth-grazer is unusually slow, the fireball can remain visible to a single observer for about 1 min and can take a total time of about 2 min to pass over a ground track on Earth's globe that can extend for more than a thousand miles.

1972 Daylight Fireball

The most spectacular recent example of such an Earth-grazing meteor is the daylight fireball sighted in the American West on August 10, 1972. The meteor entered the atmosphere over Utah, was moving horizontally at 9 miles per second when it approached closest to Earth's surface at a point 36 miles above Montana (the only place where loud sonic booms were heard), and then left the atmosphere over Alberta and escaped back into space. Eyewitnesses viewed the event from both sides of a ground track that extended for 900 miles. A still photograph by James Baker and a Super 8 movie by Linda Baker, both taken at Jackson Lake, Wyoming, show the daylight fireball passing over the Teton mountain range. Observers at Jackson Lake were able to follow this Earth-grazing meteor for about fifty seconds as it passed slowly northward across the sky.

Meteor Procession of February 9, 1913

An even more striking phenomenon can occur if a large Earth-grazer breaks into fragments early in its encounter with the atmosphere and multiple meteors travel in nearly the same path. Such an occurrence, when amazed sky watchers can witness the slow, stately passage of a series of fireballs overhead, is known as a meteor procession. Only a handful of these events have ever been recorded (see Table 9.2). The most remarkable known meteor

Fig. 9.10 *The Meteor of 1860 by Frederic Edwin Church (Judith Filenbaum Hernstadt. Used with permission)*

procession took place on February 9, 1913. Canadian astronomer C. A. Chant collected eyewitness accounts, primarily from Ontario, and noted: "To most observers the outstanding feature of the phenomenon was the slow, majestic motion of the bodies; and almost equally remarkable was the perfect formation which they retained" (Chant 1913: 148). Dozens of fireballs in three main groups passed over a ground track that extended from Alberta through Ontario and New York to ships in the Atlantic Ocean (Olson and Hutcheon 2013: 33).

Frederic Church and the Meteor Procession of July 20, 1860

The breakthrough that allowed our Texas State group (Olson et al. 2010) to identify the inspiration for Walt Whitman's meteor imagery in *Leaves of Grass* occurred when we received the catalog written by Gerald Carr to accompany an exhibition of paintings by Frederic Edwin Church, an important figure in the group of nineteenth-century American landscape painters known as the Hudson River School. The back cover of the catalog (Carr 2000) featured a canvas (Fig. 9.10) showing a group of fireballs that we immediately recognized as a meteor procession.

Research by Gerald Carr established that the artist observed this spectacular scene on July 20, 1860. Accounts of this meteor appeared in several publications from 1860, including reports in *Harper's Weekly* and *Frank Leslie's Illustrated Newspaper* (Figs. 9.11 and 9.12).

Our Texas State group searched through newspapers, scientific journals, and popular journals from 1860 and turned up literally hundreds of additional eyewitness accounts of this "strange huge meteor procession" that exactly matched Walt Whitman's description and fell within the time period covered by his poem.

On the evening of July 20, 1860, a large Earth-grazing body fragmented during its nearly horizontal passage through Earth's atmosphere and became a meteor procession with multiple fireballs. The ground track extended at least 1,000 miles, from the Great Lakes through New York State to the Atlantic Ocean (Fig. 9.13). Newspapers in cities and towns on both sides of the path published stories from amazed citizens as far north as Middlebury, Vermont, and as far south as Washington, D. C., and Virginia.

A New Jersey observer sent an account to the *New York Tribune* and used wording reminiscent of the details in Whitman's meteor poem:

> A meteor of immense size, and casting a bright glare of light upon the earth, burst apparently from a cloud in the west, a little to the north, and, passing slowly and with uniform speed toward the east...it...moved so slowly and with such regularity. Its head resembled two large flaming stars, one close behind the other...leaving a long, brilliant streamer in its wake...Near the end of the tail were three red fire-balls, of different magnitudes...All these bodies moved as if connected by an invisible string, so perfectly did they keep their distances...it moved on in silence, and disappeared in the distance. (*New York Tribune*, July 23, 1860)

Most reports came from the general public, but the astronomers C. H. F. Peters (Hamilton College Observatory, Clinton, New York), Ormsby McKnight Mitchel (Dudley Observatory, Albany, New York), Albert Hopkins (Williams College Observatory, Williamstown, Massachusetts) and George P. Bond (Harvard College Observatory, Cambridge, Massachusetts) also witnessed the passage of the great meteor. Mitchel estimated the apparent size from his location: "Two principal fragments, each followed by a train of light, and not more than two degrees apart, pursued an easterly course, while at the distance of about eight or ten degrees several smaller fragments, less brilliant than the first two, followed in a straight line" (Mitchel 1860: 482).

HARPER'S WEEKLY.

A JOURNAL OF CIVILIZATION.

VOL. IV.—No. 188.] NEW YORK, SATURDAY, AUGUST 4, 1860. [PRICE FIVE CENTS.

Entered according to Act of Congress, in the Year 1860, by Harper & Brothers, in the Clerk's Office of the District Court for the Southern District of New York.

THE METEOR.

WE engrave herewith three fine pictures of the METEOR which was witnessed in this section of country on Friday, 20th, from sketches by Mr. J. A. ADAMS at Saratoga Springs, by Mr. AVERY at Brooklyn, and Mr. M'NEVIN on Long Island.

The phenomenon is stated on all sides to have been one of the most wonderful of the kind ever witnessed. It was seen at Washington, District of Columbia, and in Virginia; at Buffalo, on Lake Erie, and at Detroit, Michigan; in the mountains of Pennsylvania; throughout New England; and at sea, 200 miles east of the Bay of New York.

By this time several volumes have been written and printed in the newspapers on the subject. Astronomers professional and astronomers dilettanti have all had their say; and now that we have heard it, what do we know about the meteor?

First, as to its shape. We have before us the reports of some forty observers, who declare that they saw it from various points, ranging from the Great Lakes to Norfolk, and from Pennsylvania to Boston. Most of them describe it as "two large balls of fire." But observers at Buffalo, Syracuse, Boston, Philadelphia, New York, Newburgh, and Long Island say that there was but "one ball."

An observer at Washington and others say that there were two balls connected; another at Norfolk describes it as "two dumb-bells tied together;" and another at Poughkeepsie says that it was in the shape of a "bar." A sharp amateur at Brooklyn says that it was composed of five balls; or, as an observer in Orange County puts it, "five distinct nuclei;" while another at New Haven is not disposed to admit that there were more than three, but allows that each had a distinct tail. At Philadelphia a leading authority saw "several distinct bodies."

Had it a tail? Several observers state that the meteor had a tail. Some, however, distinctly state that it had no tail, and was thus distinguishable from a comet. At Tarrytown a careful observer noticed a train of sparks following it, but separated from it; and most of the reports from this city confirm this view, though several do not. Those who deny the tail and say nothing about sparks, declare that it was followed by a train of smaller balls; which are variously stated at 2, 3, 5, and "several." At Newburgh, Poughkeepsie, Albany, in Connecticut, and in Pennsylvania, observers declare that the meteor threw off pieces, which were luminous—some say with a loud report, others say noiselessly.

As to the size of the meteor proper, and the length of the train, tail, or series of satellites, opinions are vastly divided. Many observers thought it was the moon, as it was about that size; a sapient watchman in Albany remarked naively that the moon was traveling more quickly than usual that night. Others report that it was the size of the planet Venus; at Newburgh it was found to measure three feet in diameter; several observers say that it was "as big as a man's head;" while two declare that it was "the size of a man's fist;" and in Westchester that it was only three inches in diameter. The length of the tail was reported at Boston to be ten feet lineal measure; on Long Island the tail measured 200 feet; at Albany, it extended "several degrees in length."

The color is as uncertain as the rest. On Staten Island it appeared red; red is also the color which met the eye of observers at New York, Buffalo, Hartford, and generally on the Hudson. But at Washington, District of Columbia, it was white; at Syracuse, New York, it was blue; in Jersey it was green; in Philadelphia, greenish; in Orange County, New York, bluish-white; on the Sound, silver and orange mixed.

It will thus be seen that, so far as the cause of astronomical science is concerned, but little advantage can be expected from the popular observations of the meteor. This will not surprise scientific students. The power of accurate observation of physical phenomena is an art only acquired by study and practice. Despite the proverb, very few men can afford to trust their own eyes. To say nothing of color blindness, which is more common than is supposed, there are but few persons in the world whose eye sight is so quick, and whose memory of perceptions so sure as to enable them to report accurately, even after a brief lapse of time, an image which has been impressed upon and then suddenly withdrawn from the retina. We do not suppose that any one of the forty observers whose reports are before us desired to mislead the public; yet, as the body seen by them all was the same (for all agree as to time and the direction taken by the meteor), it is evident that not much more than half a dozen of them saw and remembered it correctly. We are fortunate in being able to lay before the public the report of some whose profession it is to observe such phenomena, and to record them for future study. The astronomer Mitchell writes to the Herald:

"ALBANY, July 21, 1860.

"The brilliant meteor seen by your correspondent at Brooklyn was seen at this place by several persons. One

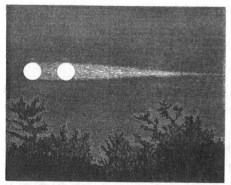

THE METEOR OF JULY 20, AS SEEN BY J. A. ADAMS, ESQ., AT SARATOGA SPRINGS.

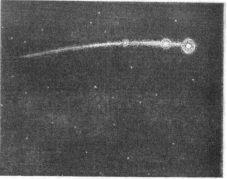

THE METEOR AS SEEN BY S. P. AVERY, ESQ., AT BROOKLYN.

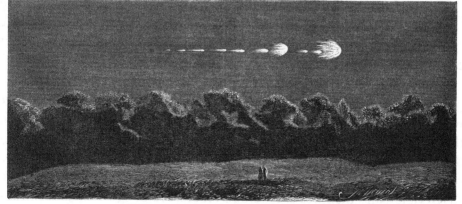

THE METEOR AS SEEN BY J. M'NEVIN, ESQ., NEAR BEDFORD, LONG ISLAND.

Fig. 9.11 *The multiple fireballs moving in a meteor procession on July 20, 1860, provided the subject for an article and three woodcuts on the front page of Harper's Weekly, August 4, 1860*

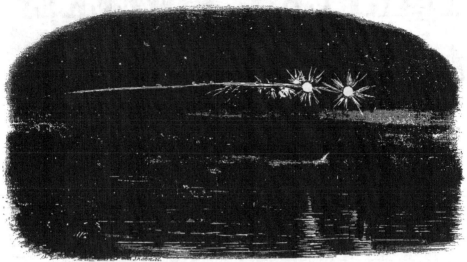

THE WONDERFUL METEOR, AS IT APPEARED ON THE NIGHT OF JULY 20, 1860.—SKETCHED FROM HOBOKEN BY OUR OWN ARTIST.

Fig. 9.12 *This illustration, entitled "The wonderful meteor, as it appeared on the night of July 20, 1860," appeared in Frank Leslie's Illustrated Newspaper on August 4, 1860, and depicts the view from Hoboken, New Jersey*

Mitchel watched as the meteor passed: "just under the southern star Antares…and pursuing a line nearly horizontal it passed under the planet Mars…and continuing its course toward the east, it finally disappeared, while yet some eight or ten degrees above the horizon…the meteor faded out at fifty minutes past nine" (Mitchel 1860: 482).

Many reports mentioned the unusually slow motion, nearly parallel to Earth's surface. A report from Albany, New York, described: "…its course being horizontal…its velocity more majestic than swift…a more sublime spectacle than the meteor itself I never witnessed. Its light was first pale, then clear, then blue, amber, and purple." (*New York Tribune*, July 23, 1860)

James Coffin of Lafayette College in Easton, Pennsylvania, eventually published a lengthy compilation in *Smithsonian Contributions to Knowledge* with more than 200 observations that he used to calculate the meteor's path through the atmosphere (Coffin 1870). He concluded that the meteor slowly descended as it traveled from the Great Lakes through western New York, reached its closest point to Earth's surface at 39 miles above the Hudson River Valley, and then was ascending as it crossed Long Island and continued out over the Atlantic Ocean.

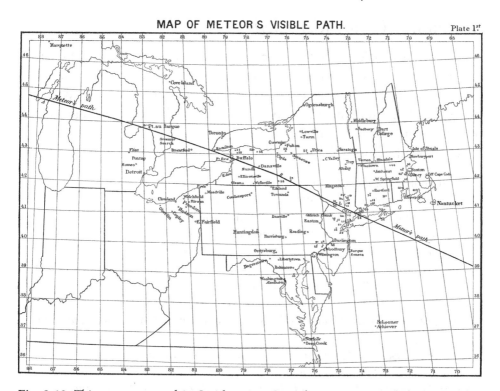

Fig. 9.13 *This map appeared in Smithsonian Contributions to Knowledge in 1870 as part of the monograph by James Coffin entitled "The Orbit and Phenomena of a Meteoric Fire-Ball, Seen July 20, 1860." The map shows the meteor's passage from west to east. Observers in New York City (including Walt Whitman and two of the Harper's Weekly correspondents) saw the meteor moving from left to right in the northern sky. Observers in upstate New York (including Frederic Church in the Catskills and a Harper's Weekly observer in Saratoga Springs) saw the meteor moving from right to left in the southern sky*

George P. Bond of Harvard College Observatory combined his own observations with records from other locations and likewise concluded in a letter published on August 1, 1860, in the *New York Times* that "the great meteor… instead of falling upon our globe, or being consumed…may have passed beyond the limits of the atmosphere, and resumed its original character as a wanderer in the planetary spaces."

The main bodies of the July 20, 1860, meteor procession may have performed the same remarkable feat as the daylight fireball of August 10, 1972 – escaping back into space after a grazing encounter with Earth's atmosphere.

Whitman's Meteors Identified

The meteor procession of July 20, 1860, may have resulted in more published eyewitness accounts than any other meteoric event in recorded history. The spectacular parade of fireballs inspired Frederic Church to create a painting and Walt Whitman to include a poem referring to the "strange huge meteor procession" in his *Leaves of Grass*.

Here is Walt Whitman's "Year of Meteors" (1859–60.):

YEAR of meteors! brooding year!
I would bind in words retrospective, some of your deeds and signs;
I would sing your contest for the 19th Presidentiad;
I would sing how an old man, tall, with white hair, mounted the scaffold in Virginia;
(I was at hand – silent I stood, with teeth shut close – I watch'd;
I stood very near you, old man, when cool and indifferent, but trembling with age
 and your unheal'd wounds, you mounted the scaffold;)
I would sing in my copious song your census returns of The States,
The tables of population and products – I would sing of your ships and their
 cargoes,
The proud black ships of Manhattan, arriving, some fill'd with immigrants, some from
 the isthmus with cargoes of gold;
Songs thereof would I sing – to all that hitherward comes would I welcome give;
And you would I sing, fair stripling! welcome to you from me, young prince of England!
(Remember you surging Manhattan's crowds as you pass'd with your cortege of nobles?
There in the crowds stood I, and singled you out with attachment;)
– Nor forget I to sing of the wonder, the ship as she swam up my bay,
Well-shaped and stately the Great Eastern swam up my bay, she was 600 feet long,
Her moving swiftly, surrounded by myriads of small craft, I forget not to sing;
Nor the comet that came unannounced, out of the north, flaring in heaven,
Nor the strange huge meteor procession, dazzling and clear, shooting over our heads,
(A moment, a moment long, it sail'd its balls of unearthly light over our heads,
Then departed, dropt in the night, and was gone;)
– Of such, and fitful as they, I sing – with gleams from them would I gleam
 and patch these chants;
Your chants, O year all mottled with evil and good! year of forebodings!
Year of comets and meteors transient and strange! – lo! even here, one equally
 transient and strange!
As I flit through you hastily, soon to fall and be gone, what is this chant,
What am I myself but one of your meteors?

James Joyce and a "Celestial Sign" in *Ulysses*

James Joyce's *Ulysses*, which appears consistently on lists of the greatest novels of the twentieth century, contains abundant references to astronomy. Joyce's Chap. 17 alone includes a long series of about fifty passages of astronomical interest. In one of these, the novel's characters observe a meteor "precipitated with great velocity across the firmament." Joyce's text mentions the specific constellations Lyra, Coma Berenices, and Leo along the meteor's path. How does this evidence, along with clues to date and time of night, allow us to identify the meteor shower that produced this "celestial sign"?

Bloomsday, June 16

Every year on June 16th, Dublin and many other cities around the world celebrate "Bloomsday" in honor of the novel *Ulysses* by James Joyce (Fig. 9.14). The story parallels the epic *Odyssey* by Homer, which relates the adventures of Odysseus in the Mediterranean while returning from the Trojan War. Joyce's odyssey chronicles the wanderings of Leopold Bloom and Stephen Dedalus around Dublin, beginning at 8 a.m. on the morning of June 16, 1904. Joyce chose June 16, 1904, because the date had personal meaning for him as the day that he first walked around the town with his future wife.

Fig. 9.14 *Portrait of James Joyce (Joel Tropp, 2004. Used with permission)*

In this complex novel, the journey concludes in Chap. 17 with both characters together in the backyard of Bloom's house in the north end of Dublin, during the early morning hours of June 17th. Just as Dedalus is about to leave, a meteor streaks through the constellations. "What celestial sign was by both simultaneously observed? A star precipitated with great apparent velocity across the firmament from Vega in the Lyre above the zenith beyond the stargroup of the Tress of Berenice [Coma Berenices] towards the zodiacal sign of Leo" (Joyce 1934: 687).

Astronomy in Ulysses

Throughout the novel the characters discuss or think about astronomical topics. Bloom buys a book with "fine plates in it…the stars and the moon and comets with long tails. Astronomy it was about." (Chap. 10 of *Ulysses*) He has a copy of Sir Robert Ball's *The Story of the Heavens* in his library and is familiar with Ball's discussion of the distances to the stars (Chap. 17). Among many other astronomical references, Joyce's novel mentions an upcoming solar eclipse and the phase of the Moon (Chap. 8), and Tycho's supernova of 1572 (Chap. 9). The text also refers to the constellations of "the great bear and Hercules and the dragon" (Chap. 10), the Pleiades, the Hyades with the bright red giant star "Alpha, a ruby and triangled sign upon the forehead of Taurus" (Chap. 14), the Northern Crown, Cassiopeia, Orion, and the Orion Nebula. The book includes passages about the upcoming summer solstice, surface markings on Mars, the appearance of a "new star" in the constellation Perseus in 1901, and the astronomical discoveries of the astronomers "Galileo, Simon Marius, Piazzi, Le Verrier, Herschel, Galle" (Chap. 17).

Joyce based some of the most precise and accurate astronomical references in *Ulysses* on a copy of a Dublin almanac, *Thom's Official Directory* for 1904. For example, near the novel's end, set in the early morning hours of June 17, 1904, Bloom describes the "moon invisible in incipient lunation, approaching perigee" (Chap. 17 of *Ulysses*). Both Thom's almanac and our computer calculations agree that the Moon at that time was indeed near the beginning of the lunar month, only 3 days after new Moon (Thom 1904). The slender waxing crescent Moon would have set before 11 p.m. on June 16th and was therefore invisible on the morning of June 17th. The term lunar perigee refers to the time when the Moon reaches the point in its orbit closest to Earth. Both the almanac and the computer place a lunar perigee near midday on June 17th, exactly as stated by Joyce.

Times and Time Schemes

Joyce associated each of his chapters with an hour of the day, and the novel contains many references to clocks, church bells, and hours. But confusion still exists, particularly toward the latter part of the novel. Joyce himself added to the confusion by providing two conflicting timetables listing the clock time appropriate to each chapter, one time scheme created for Carlo Linati in 1920 and another time scheme published by Stuart Gilbert in 1930.

After Bloom and Dedalus see the meteor, they hear the "sound of the peal of the hour of the night by the chime of the bells in the church of Saint George…Heigho, heigho, Heigho, heigho." This ringing pattern, well known as the Westminster Chimes and fashioned after the chimes of Big Ben in London, definitely indicates the half-hour. But which half-hour? Modern Joyce scholars have assigned the section of Chap. 17 with the meteor observation to the period between 1:00 a.m. and 1:30 a.m. according to the Linati time scheme, between 2:00 a.m. and 2:30 a.m. according to the Gilbert time scheme, and possibly even between 3:00 a.m. and 3:30 a.m. according to a recent analysis by Don Gifford and Robert Seidman (Ellman 1972: 186; Gilbert 1930: 30; Gifford and Seidman 1988: 586).

Constellations Overhead

Our Texas State group (Olson and Olson 2004: 76) realized that we could determine the time from Joyce's statement that the meteor originated near the "Lyre above the zenith." The zenith is the point in the sky directly overhead. Using computer planetarium programs, we determined that four bright stars of Lyra reached their highest elevations in the Dublin sky, not far south of the zenith point, at 12:54 a.m. (Alpha Lyrae), 1:07 a.m. (Beta), 1:16 a.m. (Gamma), and 1:11 a.m. (Delta). Dublin in 1904 had not yet adopted modern time zones, so these times are expressed in Dublin local mean time, 25 min behind Greenwich Mean Time. The astronomical analysis therefore supports the Linati time scheme, with Bloom and Dedalus observing the meteor between 1:00 a.m. and 1:30 a.m.

Identifying Joyce's Meteor Shower

The meteor described by Joyce descended from the vicinity of Lyra near the zenith, passed downward through the constellation Coma Berenices, and then disappeared near the horizon where Leo was setting in the northwest (Fig. 9.15). Can we associate this meteor with a known annual shower?

Fig. 9.15 *This chart shows the sky above Dublin at 1:00 a.m. local mean time (equivalent to 1:25 a.m. Greenwich Mean Time) on June 17, 1904. The path of the meteor descends from Lyra near the zenith (the point directly overhead) and passes through the constellations Coma Berenices and Leo near the northwestern horizon, as described in Chap. 17 of Ulysses (Sky & Telescope diagram. Used with permission)*

In the early 1900s astronomers did not recognize any meteor shower in mid-June. The June Lyrid meteor shower was first announced in 1966, in a letter from California observer Stan Dvorak to *Sky* & *Telescope* magazine:

On the evening of June 15th, I camped in the San Bernardino Mountains, about 70 miles east of Los Angeles...I noticed a very bright meteor moving swiftly to the northeast and passing through Lyra...In 1½ hours, I had recorded 16 meteors, all but three of which were members of the shower... The majority were very swift...appearing to radiate from roughly...near the Lyra-Hercules border. Their colors ranged from bright white to blue-green, turning yellow as they neared their burnout points...I would be interested to hear from other observers who may have seen this short-lived shower. It is not mentioned in the literature that I searched. (Dvorak 1966: 237)

Astronomers worldwide confirmed the existence of this shower through-out the 1960s and 1970s.

Interestingly, the passage in *Ulysses* suggests that James Joyce may have observed a June Lyrid while walking in Dublin on June 16–17, 1904, more than six decades before meteor observers generally recognized this shower.

Joyce's readers worldwide celebrate Bloomsday every year on June 16th. Perhaps after a toast or two in an Irish pub, those commemorating the anniversary could look up, observe the constellation Lyra near the zenith and, with luck, witness another "celestial sign."

References

Beaver, Joseph (1951) *Walt Whitman—Poet of Science*. New York: King's Crown Press.

Blodgett, Harold William, and Sculley Bradley (1965) *Leaves of Grass: Comprehensive Reader's Edition*. New York: New York University Press.

Carr, Gerald L. (2000) *In Search of the Promised Land*. New York: Berry-Hill Galleries.

Chant, Clarence Augustus (1913) An Extraordinary Meteoric Display. *Journal of the Royal Astronomical Society of Canada* 7(3), 145–215.

Coffin, James H. (1870) The Orbit and Phenomena of a Meteoric Fire-ball, Seen July 20, 1860. *Smithsonian Contributions to Knowledge* 16(Article 6), 1–50.

Dvorak, Stan (1966) Unexpected Meteor Shower from Lyra. *Sky & Telescope* 32(4) October, 237.

Ellman, Richard (1972) *Ulysses on the Liffey*. New York: Oxford University Press.

Feldman, Paula R. and Diana Scott-Kilvert, eds. (1987) *The Journals of Mary Shelley 1814–1844*. Baltimore: Johns Hopkins University Press.

Gifford, Don, and Robert J. Seidman (1988) *Ulysses Annotated: Notes for James Joyce's Ulysses*. Berkeley: University of California Press.

Gilbert, Stuart (1930) *James Joyce's Ulysses: A Study*. New York: Alfred A. Knopf.

Häusermann, Hans Walter (1952) *The Genevese Background*. London: Routledge and Kegan Paul.

Holmes, Richard (1975) *Shelley: The Pursuit*. New York: E. P. Dutton.

Hoobler, Dorothy, and Thomas Hoobler (2006) *The Monsters: Mary Shelley and the Curse of Frankenstein*. New York: Little, Brown and Company.

Joyce, James (1934) *Ulysses* (first American edition). New York: Random House.

Kaplan, Justin (1980) *Walt Whitman, A Life*. New York: Simon and Schuster.

Ljungquist, Kent (1989) Meteor of the War: Melville, Thoreau, and Whitman Respond to John Brown. *American Literature* 61(4), 674–680.

Mellor, Anne K. (1988) *Mary Shelley: Her Life, Her Fiction, Her Monsters*. New York: Methuen.

Mitchel, Ormsby McKnight (1860) The Meteor. *Harper's Weekly* 4(No. 188), August 4, 1860, 481–482.

Moskal, Jeanne, ed. (1996) *The Novels and Selected Works of Mary Shelley, Volume 8, Travel Writing*. London: Pickering & Chatto.

Olson, Donald W., and Marilynn S. Olson (2004) The June Lyrids and James Joyce's *Ulysses*. *Sky & Telescope* **108**(1), July, 76–77.

Olson, Donald W., Marilynn S. Olson, Russell L. Doescher, and Ava G. Pope (2010) Walt Whitman's "Year of Meteors." *Sky & Telescope* **120**(1), July, 28–33.

Olson, Donald W., Marilynn S. Olson, Russell L. Doescher, Ava G. Pope, and Kelly D. Schnarr (2011) The Moon and the Origin of *Frankenstein*. *Sky & Telescope* **122**(5), November, 68–74.

Olson, Donald W., Marilynn S. Olson, Russell L. Doescher, Ava G. Pope, Kelly D. Schnarr, and Jayme L. Blaschke (2012) Frankenstein's Moon. New York Public Library, Biblion web site. (http://exhibitions.nypl.org/biblion/outsiders/frankenstein/essay/essayfrankensteinsmoon)

Olson, Donald W., and Steve Hutcheon (2013) The Great Meteor Procession of 1913. *Sky & Telescope* **125**(2), February, 32–34.

Pollin, Burton R. (1965) Philosophical and Literary Sources of *Frankenstein*. *Comparative Literature* **17**(2), 97–108.

Rossetti, William Michael, ed. (1911) *The Diary of Dr. John William Polidori*. London: Elkin Matthews.

Rieger, James (1963) Dr. Polidori and the Genesis of *Frankenstein*. *Studies in English Literature* **3**(4), 461–472.

Robinson, Charles E. (1996) *The Frankenstein Notebooks, Volume 9, Part 1*. New York: Garland Publishing.

Rosenberg, Samuel (1968) Happy Sesquicentennial, Dear Monster. *Life* **64**(11), March 15, 1968, 74–84.

Seymour, Miranda (2000) *Mary Shelley*. New York: Grove Press.

Shelley, Mary Wollstonecraft (1817) *History of a Six Weeks' Tour*. London: T. Hookham, Jun., and C. and J. Ollier.

Shelley, Mary Wollstonecraft (1818) *Frankenstein; or, the Modern Prometheus*. London: Lackington, Hughes, Harding, Mavor, & Jones.

Shelley, Mary Wollstonecraft (1831) *Frankenstein*. London: Colburn and Bentley.

Sunstein, Emily W. (1989) *Mary Shelley: Romance and Reality*. Boston: Little, Brown and Company.

Thom, Alexander, and Company (1904) *Thom's Official Directory of the United Kingdom of Great Britain and Ireland for the Year 1904*. Dublin: Alex. Thom & Co.

Whitman, Walt (1865) "Year of Meteors. (1859–60.)" in *Drum-Taps*. New York: s.n., 51–52.

Whitman, Walt (1867) "Year of Meteors. (1859–60.)" in *Leaves of Grass*. New York: s.n., 51–52.

Wolfson, Susan J., and Ronald Levao (2012) *The Annotated Frankenstein*. Cambridge: Belknap Press of Harvard University Press.

Ziff, Larzer (1984) Whitman and the Crowd. *Critical Inquiry* **10**(4), 579–591.

Index

D.W. Olson, *Celestial Sleuth: Using Astronomy to Solve Mysteries in Art,
History and Literature*, Springer Praxis Books, DOI 10.1007/978-1-4614-8403-5,
© Springer Science+Business Media New York 2014

CPSIA information can be obtained at www.ICGtesting.com
Printed in the USA
LVOW01s0334140215

426953LV00003B/7/P